A Multi-Modal Approach to Creative Art Therapy

of related interest

What Do You See?
Phenomenology of Therapeutic Art Expression
Mala Betensky
ISBN 1 85302 261 6

Art Therapy with Offenders
Edited by Marian Liebmann
ISBN 1 85302 171 7

Art Therapy in Practice
Edited by Marian Liebmann
ISBN 1 85302 057 5 hb
ISBN 1 85302 058 3 pb

Arts Therapies and Eating Disorders
Edited by Ditty Dokter
ISBn 1 85302 256 X

A Multi-Modal Approach to Creative Art Therapy

Arthur Robbins

Jessica Kingsley Publishers
London and Bristol, Pennsylvania

First published in the United Kingdom in 1994 by
Jessica Kingsley Publishers Ltd
116 Pentonville Road
London N1 9JB, England
and
1900 Frost Road, Suite 101
Bristol, PA 19007, U S A

Library of Congress Cataloging in Publication Data

A CIP catalogue record for this book is available from the Library of Congress

British Library Cataloguing in Publication Data

A CIP catalogue record for this book is available from the British Library

ISBN 1-85302-262-4

Printed and Bound in Great Britain by
Biddles Ltd., Guildford and King's Lynn

Table of Contents

Part II: Case Studies

Acknowledgements

I want to express my appreciation to Linda Sibley Seaver, who co-authored my first book *Creative Art Therapy*. Linda was responsible for bringing to my attention the need for sophisticated theory in the field of art therapy. The chapters in this text that have been either modified or completely reproduced from my first text could not exist without her thoughtful contributions. I owe a special debt to the publishers of *The Arts in Psychotherapy*, who have given me permission to reproduce the following articles in this book: 'Integrating the Personal and Theoretical Splits in the Struggle Towards an Identity as Art Therapist', Vol.9, No.1, pp.1–9, 'Creative Development' Vol.1, No. 2, pp.177–186, 1973, 'The Use of Imagery', Vol. 1, No. 3–4, pp.181–184, 1973, 'A Creative Approach to Art Therapy', Vol. 11, No.1, pp. 7–14, 'The Play of Psychotherapeutic Artistry and Psychoaesthetics', Vol. 19, No.2, pp. 177–186, 1992, and 'Developing Therapeutic Artistry: A Joint Countertransference Supervisory Seminar/Sculpting Workshop', Vol. 19, No. 4, pp.367–377, 1992. I also wish to express my appreciation to the editor of *Art Therapy*, the journal of the American Art Therapy Association, who has permitted me to include in the text, 'Resistance in Art Therapy: A Multi-Model Approach to Treatment', Vol.10, pp.208–218, 1993.

I would also like to thank Jeff Olmsted and Gail Elkin who helped in the editorial revisions of this text. Finally, I want to voice my appreciation and gratitude to the emotional support of my wife Sandra who was always available as my most thoughtful critic.

Preface

In the late fifties and early sixties, a group of artists and therapists created a unique and original expression of their professional identities. They were truly pioneers in their field, combining art and therapy in a very new form of treatment. Margaret Naumberg, Edith Kramer, Hanna Kwiatkowska, Ellen Ullman and Myra Levick (to name a few), often had great difficulty being accepted as serious workers in the field of mental health.

The period in which they worked was characterized by a good deal of excitement and turmoil. The sixties presented the possibilities of change, and created a climate that made change possible. In this atmosphere the field of art therapy was ripe for an expansion. In 1970, four programs, independently and without consultation with each other, initiated courses of study leading to a graduate master's degree in art therapy. Each program was a unique outgrowth of both the particular institution where their roots were fed, whether a psychology department, medical school or arts school, and the personality of the particular director and his or her creative expression of the nature of art therapy.

At the onset there was a good deal of polarization among the various leaders and pioneers in the field. Each believed that their particular notion of art therapy represented the true path to becoming an art therapist. Many of the above pioneers became important leaders in these programs, and viewed training in terms of their highly personalized experience that was a composite of their particular educational and therapeutic backgrounds, as well as their orientations as artists.

Art therapy at Pratt Institute was certainly influenced by the excitement of the sixties. The art school, in spite of its reservations regarding the place of 'therapy' in an art curriculum, supported the program and gave a good deal of latitude to the faculty to present their own unique brand of art therapy to a very enthusiastic student body. I was a founder of Pratt's first graduate program in art therapy.

At first, few applicants had any real notion of what art therapy was about. However, it seemed interesting and exciting, and students wandered in from

allied departments wanting to taste the newest offering in the curriculum. I still remember encountering three very enthusiastic applicants to our department whose major was food services and who wanted to try their hands in this new field. At that time, our entrance standards were fairly loose, and we decided to take a chance and see what could happen when we enrolled these students in our program. They were soon given a field assignment in the local VA and put their talents to use by forming a catering unit with the hospitalized veterans. The gastronomic concoctions created with their patients were aesthetic, therapeutic and socially useful. In fact, some of the patients went on to form a catering unit themselves. We felt that these students were successful, though when I reported these developments in an annual meeting of the Art Therapy Association, a chairman of a training program rose indignantly and said, 'My mother makes bagels, but that's not art therapy.' So, we became known for a brief period as the bagel therapists of the Eastern seaboard.

What were we about, besides making bagels? One of the early enrolled students in the Pratt art therapy program, Linda Beth Sibley, approached me about developing a text that would formulate some of the ideas about art therapy which we were developing at Pratt. For her master's thesis, she collected an impressive array of techniques that were currently being employed by art therapists all over the country. Her enthusiasm sparked my own, and we decided to embark upon a text entitled *Creative Art Therapy*. The text, published in 1976, quickly sold out its first edition. We continued to publish another edition at Pratt, for there seemed to be a continuing demand for a book with this orientation.

The book attempted to amalgamate the creative and therapeutic processes. Therapy was placed in the framework of the creative process. Personality issues that interfered with the creative expression of the patient became the subject of treatment intervention. To facilitate creativity, we believed, was to improve psychological health. Furthermore, the more creative the therapist could be in his or her approach, the greater the opportunity for making contact with the patient's creative process. Art was an important bridge to the patient's inside world. Art therapy could ultimately free up the patient's creative resources. Within this orientation there was a good deal of emphasis on ego psychology, though secondary attention was paid to object relations theory.

A further articulation of this point of view was made in *Expressive Therapy: A Creative Arts Approach to Depth Oriented Treatment* (1981). My aim was two-fold: first, to argue against the limitation of our practice to visual forms of expression only. If a patient and therapist at Pratt were comfortable in

working with dance, puppetry, or music, I made no objection. I believed a valuable form of contact would be lost if we confined art therapy to working with visual media only. A creative arts approach incorporated the notion that though a particular art therapist may have a particular strength in terms of his background and education, training ought to aim to stretch the boundaries of creative expression, since the underlying unifying core among therapists was an interest in the creative process itself.

Second, I attempted to offer a rationale for the use of creative arts in therapy through reference to split-brain research. The work of the two brain hemispheres is uniquely synthesized in the creative process. We saw, for instance, that some patients could be most effectively worked with in a spatial or visual dialogue, which engages the right side of the brain rather than the verbally oriented left side. The left brain is all too often constrained by the rational order of words and the logic of social conformity. Primary process thinking, handled by the right brain, is governed by the spatial and temporal laws of the preconscious, and presents different levels of complexity and expression than rational left-brain ideation. Of course, rational or secondary process thinking also contributes to the development of the art work. The ultimate aim of therapeutic and creative efforts was integration of both sides of the brain.

My own psychoanalytic background was influenced by object relations theory. Winnicott's notion of transitional space seemed applicable both to my experience as an artist and as a therapist. Gilbert Rose (1980) wrote about 'oneness and separateness', and described another aspect of my relationship to my patients and to my artwork (which is chiefly sculpture). Also important to me was the idea of 'primary creativity' elaborated by Winnicott (1971). Pathology, in this view, was seen as primary creativity gone wrong. Treatment was postulated as rediscovering and fulfilling the mirroring function of primary characters in the patient's life, while holding and containing the dysrhythmic patterns and the pathology acted out in the therapeutic environment. I outlined an object relations approach to art therapy in the text *The Artist As Therapist* (1987).

Between Therapists: The Processing of Transference and Countertransference Material (1988) was an attempt to train creative arts therapists in processing transference and countertransference communications. Without this training, I believe, the most basic tool of the therapist will be underutilized. The therapist must develop his ability to hold and contain the toxic communications that enter the therapeutic dialogue even when the focus is mainly on art work. The therapist is a creative artist who needs to expand his or her ego skills to function on multiple levels of consciousness, and is also required

to transform his or her inner experience of the patient into an empathic response. Only with empathy is it possible to creatively discover the health in toxicity and mirror this back to the patient. The study of transference and countertransference cannot be put aside until the student enters a later stage of professional development. The fundamentals of treatment technique are often compromised by highly charged emotional reactions on the part of the therapist. When opportunities are presented for processing these reactions through artwork, blocks towards learning are often lifted, leading the artist/therapist to a deeper comprehension of therapeutic process.

The Psychoaesthetic Experience: An Approach To Depth-Oriented Treatment, published in 1989, was a further elaboration of the therapeutic assumptions stated above. Viewing therapeutic communication as an aesthetic process was the central concern of this text. Ego rhythm and dysrhythm was also a focus of this text. Say more about this book. The creative work of the therapist was in the area of holding, containing and mirroring. The projected toxicity of the patient was then transformed into a life-giving bridge from the inside of the patient to the outside object world.

All the above stated notions have filtered into the current text. *Creative Art Therapy* is now out of print, but some of its chapters, with revisions, can still be helpful in the development and training of an art therapist. The importance of the creative process, the development of the art therapist's personal resources, issues of personal identity, and the synthesis technique requisite to professional practice are among the subjects covered in the original and the present texts.

In light of the preceding theoretical assumptions, what can be said about learning art therapy? Obviously we need skills and discipline; information is likewise important, but if we cannot integrate this information with experience, then faculty and students must find a means to regenerate the educational atmosphere. Training in art therapy is not a matter of taking notes and learning how to apply art to treatment. We are dealing first and foremost with patients, and the art is a vehicle for our connection with them. It is important to make the learning environment as safe and nonintrusive as the therapeutic environment. Just as we find our limits and possibilities with patients, so also do we find these limits in teaching and learning therapy. Needless to say, these limits are elastic, and change from student to student, as well as from classroom to classroom. What needs to be emphasized is that the student cannot do work of this nature without personal therapy as an important part of their training. A training program cannot order a student into treatment, nor would I push anybody into such a personal and intimate endeavor. It is to be hoped, however, that students will understand why their

own personal treatment, particularly with another trained art therapist, could be so vital in terms of learning their new art form/profession. Yet, regardless of the length and depth of one's personal treatment, the integration of emotional and cognitive material that is part of the treatment process does not come automatically. Part of the responsibility for this synthesis lies with the training facility, and the utmost care and consideration must be given to students, who require a respect for their defenses. Without this respect, students will be unable to explore their emotional understanding of this very complex therapeutic process.

Though object relations theory has had a profound impact on the author, not all patients can be worked with within this framework. This becomes increasingly apparent as we see a large number of patients who are helped by behavioral modification techniques. There are other patients for whom treatment will focus on the self, touching their hunger for mirroring and self-affirmation. With others, there is a needed emphasis on the struggle with sexual and aggressive drive material. Therapists are increasingly sophisticated in the use of multiple models that shift and change according to the patient's particular stage of treatment. Certain cornerstones of treatment, however, do not change: the processing of transference and countertransference, the sensitivity to ego organization and the understanding of adaptive and maladaptive defenses. Sophisticated ways of reaching the self, particularly through altered states of consciousness or a 'spiritual' approach are now becoming part of many art therapists' basic training.

In light of these developments, I've decided to recast *Creative Art Therapy* into a multi-model approach to art therapy. The creative emphasis remains in this new text. There is an underlying thread of object relations theory that intertwines with other models of treatment. The emphasis on transference and countertransference also remains. My core belief is that every art therapist must possess and develop the soul and sensitivity of an artist. As artists, we value authenticity, and maintain a respect for and sensitivity to the uniqueness of personal expression. Perceptiveness and understanding of the art form can help us to understand the entire personality organization of the patient.

In this text, diagnosis will not be used for categorization or nomenclature, but in a more classical sense, offering us indications for possible treatment. This book is an attempt to preserve the spirit and soul of the artist while applying modern day psychodynamic concepts to treatment practice. It is the artist who will come up with an art evaluation that reflects the depth of the patient's art expression. From this evaluation a number of indications for treatment will point to a treatment plan. Some patients will need the reinforcement and development of ego skills and defenses in order to be

prepared to hear their own 'insides'. Others will need mirroring; some will need to deal with object loss and attachment, while others must cope with and integrate their drives so that they are not so overwhelmed with anxiety. What should be emphasized is that many of our patients will require from treatment some other kind of experience than insight. Some will indeed demand the verbal insight that is to them analogous to clarity, but for others, the deep nonverbal holding of art experience may be most helpful. A creative art therapist is not bogged down by cumbersome role definitions, and is willing to take the same sort of risks that the creative process requires. This is the creative intent of this text: to offer a structure that is not limited to one therapeutic model, and opens up the doors for the creative art therapist to be effective with a wide range of patient populations.

References

Robbins, A. and Sibley, L.B. (1976) *Creative Art Therapy*. New York: Brunner/Mazel.

Robbins, A. (1981) *Expressive Therapy: A Creative Arts Approach to Depth-Oriented Treatment*. New York: Human Sciences Press.

Robbins, A. (1987) *The Artist as Therapist*. New York: Human Sciences Press.

Robbins, A. (1988) *Between Therapists: The Processing of Transference/Countertransference Material*. New York: Human Sciences Press.

Robbins, A. (1989) *The Psychoaesthetic Experience: An Approach to Depth-Oriented Treatment*. New York: Human Sciences Press.

Rose, G. (1980) *The Power of Form: A Psychoanalytic Approach to Aesthetic Form*. New York: International University Press.

Winnicott, D.W. (1971) *Playing and Reality*. New York: Basic Books.

Part One

Theoretical and Technical

Integrating the Personal and Theoretical Splits in the Struggle Towards an Identity as Art Therapist[1]

Arthur Robbins

As a sculptor, art therapist and teacher of art therapists both at beginning and advanced levels, I have struggled to find a theoretical position which integrates that verbal, objective psychologist part of myself with the nonverbal, symbolic artist. I have weighed the theoretical positions of thinkers in art therapy as well as in psychoanalytic, Gestalt, humanistic and Jungian schools. What has consistently stood out throughout my quest for meaning is the intimate interplay between my own personal inner development and my professional growth as an art therapist. This process has led me to believe that the splits within the field of art therapy that pit one approach against another are doing us all a disservice. Art therapy can be cast in many different frames depending upon any number of factors including the setting, population, length of treatment, depth and extensiveness of the therapist's personality, as well as the receptivity of any given patient. I have come to feel that there must be room within our profession for individual quests for identity, differences in definition, and variance in approach if, as a professional group, we are to grow and be whole.

I would like to share with you my own evolution as a creative arts therapist through the symbols, imagery, and theories that have marked my development.

As for many other art therapists, symbol and image have become the inner codifications of my experiences. They defy the reductionism of words as they hold and mirror the complexity of my early attachments, link past to present, and point to my future. As organizer of my past, this world of symbol and image holds my polarities of hate and love, bad and good.

If I am to share with you my struggle for meaning, I must talk in brief about my own personal symbols and how they have interfaced with my conflicts about art therapy theory. Please join me and picture, if you will, a dirty-faced kid who seems to be completely lost in his play in the sandbox. This was my world, where I built sand castles and deep tunnels immersed in the gooey texture of sand and water. Here, I defined and redefined my boundaries and found a retreat from a family that wanted too much conformity, too much neatness, and all too much order. The sandbox was a place where I was King, and where I was left alone to find my own pleasures. The other world was that of my sister. She was the star: an aesthetic, beautiful girl who won trophies, drew pretty pictures and was always very neat and put together. The pursuit after 'the aesthetic' was an important shared commonality between my mother and sister. It was a realm from which I felt excluded, yet secretly envied. I dared not enter this world for I feared the competition and comparison.

As I developed, I became rebellious. My play in the sandbox extended itself to many areas of my life. I became a disheveled, disordered, often nonconforming young student who metaphorically plugged up drains and generally attempted to defy the existing order of things.

In my young adult years, the dark, nonconforming part of myself found some outlet in creative work as a psychologist, but the aesthetic, the world that I saw as truly creative, was not mine: I could not draw or paint and, indeed, was often frightened when I entered an art room. At the same time I knew that if I wanted to find inner harmony, I needed to bring together this dark, rebellious part of myself with the light, aesthetic, creative part that was represented by art.

In my analysis, the dark and light parts fought, rebelled and sought a concrete synthesis. Going back to the sandbox seemed to be an ideal avenue to explore this integration. The sandbox, however, transformed into my sculpting teachers studio.

I remember initially approaching her studio scared and trembling. The teacher, a wise old Russian lady, took one look at me at the doorway and said in a provocative way, 'Well, what are you waiting for?' I was both awed and impressed by the freedom of this studio where there was no right or wrong, no instruction, but plenty of space. Here I received permission to

completely involve myself in the clay and dirt, to smell and touch my medium. Indeed, I received approbation and encouragement. Slowly, through an interplay between the medium and myself which felt like a form of meditation, I healed. I became more expansive and secure in the studio and something aesthetic and creative evolved. As I progressed in sculpting, my professional world also expanded. My private practice developed and I became a teacher of other therapists. Still, the two worlds seemed too separate.

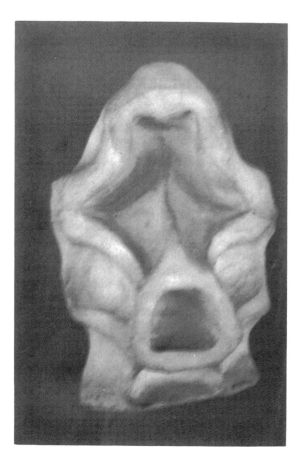

Figure 1

During the initial period of clay exploration, a profound and important event happened: my father became cancerous and soon died. It was an awful, emotional, wrenching experience. I felt depressed, moody and at odds with

myself. I wanted some symbolic way to express the conflicting emotions inside me, for words could not describe my pain. As my hands tried to capture this intense experience through clay, I had my first glimpse of art therapy. A head emerged with deep hollow eyes and a mouth reaching endlessly inward that captured my sense of death: all the hollowness, emptiness and loneliness as well as my ultimate despair. As I dug my nails deeper inside each crevice, I felt a release, a feeling of contact with my piece. I showed this representation to my analyst and expected comment regarding my feelings of despair and depression. I remember how he picked up the piece and felt the various parts in his hands and then, to my surprise, commented, 'You know, everything is balanced, everything seems so controlled. One side seems exactly to reflect the opposite.' He wondered if the piece reflected my being too balanced, too fair, too controlled inside. He wondered if I really felt so sad, or if there was a component of feeling obliged to be depressed. Was there something else behind the balance and control, he pondered. Soon I admitted that I felt a sense of relief at being released from the burden of caretaking and the emotional strain of my fathers illness. I also recognized that I wanted to get on with my life. What struck me in my analyst's approach to my piece was his awareness of my defenses as well as my mood and effect, and it was his sensitivity in responding to my defenses that helped me to see beyond the manifest image.

Gradually I became interested in the entire field of art therapy. I found the life of being a full-time private practitioner somewhat wearing between long hours and seeing patients one after another. I wanted something more active, more participatory and involving. I was fortunate enough to find a part-time position teaching psychology to art students at Pratt Institute. This experience was certainly different from teaching psychologists. Pratt students perceived and understood people through the symbolically oriented eyes of artists rather than the logical eyes of scientists.

There was a reciprocity between what went on at Pratt and my work as a sculptor, which by now had moved from stone to metal. I soon recognized that there was a startling similarity between the process of creation and the therapeutic encounter. I began to write about the creative therapeutic process, and in 1973 I formulated the image of the art therapy relationship having qualities of a love affair or an early mother–child relationship where so much communication is through touch and nonverbal modes (Robbins 1973). What I saw as primarily important was the building of a generative partnership through the use of art and symbolization. Because I knew that the most primitive layers of the psychic organization could be easily mobilized and could overwhelm the ego, I noted the importance of the art therapist's

sensitivity to closeness and distance and to creating an environment where a patient might find the courage to brave the isolation of being with himself and create an authentic statement.

As I explored my own interest in art therapy, I also reviewed the literature. First I read the two giants in the field, Margaret Naumberg and Edith Kramer (1979). Naumberg presented a relatively orthodox structural theory of psychoanalytic work as applied to art therapy. Within this approach, art became a bridge and a means to obtain insight as the basic curative force in treatment. Although this approach seemed appropriate in working with neurotics, I had some major reservations. I wondered if there was an inherent conflict between an insight-oriented approach and the creative process and, after reviewing some of her case studies, I became convinced that the orthodox psychoanalytic model did not mesh very well with the process of creation. Analyzing art and being open and spontaneous seem mutually exclusive. A further problem was that art therapists usually seemed to find themselves working with patients who came under the general category of primitive mental states: psychotics, borderlines, and severe character disorders. Here, integration of dim use and separate internalized systems rather than insight *per se* were the major goals in treatment.

In looking for a more sympathetic theoretical framework that would combine the excitement of creation with a means of working through deep personal conflicts, I read Edith Kramer's text (1979) which emphasized the centrality of art in the art therapeutic experience. Rather than addressing resistance and transference phenomena, she emphasized the idea of competency and mastery of feelings through artistic expression. I remembered my own pleasure of artistic mastery and the exquisite sense of wholeness that I received through my own personal art experience. I also realized that the majority of artists would be comfortable with this approach that played down such concepts as resistance and transference. As I proceeded to study her theory and appreciate her rationale, Kramer's ideas about sublimation stood out as particularly thought provoking: 'Sublimation depends on partial renunciation, for instinct that expends itself through gratification is not available as a source of energy for any modified activity.' She further elaborated:

> 'The neutralization of aggressive and sexual energy characteristic of sublimation occurs in the area of artistic execution. No matter what emotion he expresses towards the act of painting and towards his medium, the painter must maintain a positive feeling equally removed from obsessive sexual excitement and aggressive fury. This state is not easily maintained. It is constantly menaced by untamed drives on the

one hand, and on the other by the ego's tendency to apply radical, stifling mechanisms of defense.'

Kramer recognized the limitations of her tools and constructs. She lamented, 'As therapists we are more accustomed to failure than success. We are used to seeing paintings of volcanoes become a mess of red and black because explosive feelings were not depicted, but acted out.'

Thus, for Edith Kramer, the criterion for therapeutic success could be summed up in the following statement: 'Since the artist's artistic value of the work produced is a sign of successful sublimation, the quality of the work becomes a measure, but not the only measure of therapeutic success.'

This approach at that time had special meaning for me since it preserved the centrality of art as the fulcrum of my own professional work.

In spite of Kramer's approach being a very comfortable frame of reference, nagging doubts turned into sharp questions as the reality of day-to-day professional experiences penetrated my consciousness. I found myself wondering both about those patients who wanted to take or use other modalities rather than art materials and those who were removed from using art as a creative expression of themselves. I questioned whether they were not appropriate candidates for art therapy or if I simply needed more perseverance and belief in my work. As I studied some of Kramer's source materials, however, further doubts crept into my mind. Freud said in his introductory lectures on psychoanalysis:

> 'There is a limit to the amount of unsatisfied libido that human beings on the average can put up with. The plasticity of free mobility of libido is by no means preserved in everyone. And sublimation is never able to deal with more than a certain fraction of libido. Quite apart from the fact that many people are not gifted, there is only a small amount of capacity to sublimate. The most important of these limitations is evidently that upon the mobility of the libido, since R makes a person's satisfactions depend upon attainment to only a small amount and number of aims and objects.'

What then, I asked, was I to do with the patients who indeed could not sublimate their conflicts through artistic expression? Were the boundaries of an art therapist's professional identity limited to those patients who are able to work towards sublimation?

This doubt crystallized when I read Lawrence Kubie's critique (1973) of the entire concept of sublimation and its applicability to the theory and practice of art therapy. He noted:

'In general…the concept of sublimation has carded the implication that the social value of behavior can somehow neutralize or resolve the unconscious "id" forces, the neurotogenic forces and the conflicts from which the behavior derives. If clinicians have learned anything from analysis, it is that none of this is true…'

In addition, he stated:

'Our misuse of the concept of sublimation has deceived us, giving us the illusion that we have solved the problem when it remains unsolved. The question remains: Why do express ions of unconscious conflicts and forms that are socially valuable, creative, or even beautiful, leave unaltered both the unconscious conflicts from which they derive and their destructive potentials?'

Much of what he said made sense, in spite of the fact that Edith Kramer (1973) replied that Kubie distorted and misinterpreted her position and her notion of sublimation as it applied to the role of the art therapist. It was the pleasure of mastery, she claimed, that enabled the patient to redirect instinctual gratification to more pleasurable outlets. Were there shades of behavior modification here or was I being too limited in my perception, for Kramer stated that the patient, through sublimation, found new goals and objects in his creative work. Some issues were left unexplained however. How did the discovery of new goals and objects occur? Did one find new identifications within the process of sublimation? If so, we needed further elaboration of this theory. Furthermore, it seemed that neutralization as part of the theory of sublimation necessarily included the conversion of primary process imagery into secondary process communication, and that required words. Kramer's theory of sublimation and its applicability to art therapy, as I saw it, ultimately had too many gaps to explain the full dimension and expression of the therapist's role.

Mildred Lackman-Chapin (1980) shed light on the role of identification in the art therapy process. Kohut's theoretical framework, according to Mildred Chapin, emphasizes the development and cohesion of the self as expressed through art. I was excited by these notions, for there seemed no better vehicle than art for the expression of the self. Utilizing this framework, Chapin described the role of the art therapist as nurturing the patient's search for a cohesive sense of self. She saw the art therapist as facilitating the patient's quest for internal integration stunted by developmental difficulties in parent–child relationships. Thus the patient would go through such stages as grandiosity and idealization and express these feelings both within the therapeutic relationships and through the artwork. The author emphasized

the importance of the real relationship and how the narcissism and grandiosity of the art therapist harmonized and resonated with that of his patients. Thus to quote Chapin:

> 'I see us different from remaining neutral and thereby encouraging patients to react to us as remembered figures from the past. The patient seeks a mirroring response, does not remember a crucial person from the past because a dramatic failure in empathy occurred during the early preverbal stages before the memory function ego was well-organized.'

For Mildred Chapin, the nurturing art therapist was especially equipped to help others find their 'self-objects' (the internalized relation that we carry within ourselves) by assisting them in creating through their art a valid and authentic self-representation. Her synthesis of Kohut's theory had a ring of truth. She further elaborated:

> 'We are used by patients, reflect them and their possibilities. We are there to encourage them to act on their possibilities and to respond with a gleam in our eyes when they achieve new self-objects that lifting them to a more cohesive sense of self. At times we allow patients to merge with this part of ourselves, giving them a temporary strength through their identification with us until their accomplishment in the art product frees them from needing us.'

Relieved and gratified, I finally found, I thought, a theory and framework compatible with the background and values of an artist.

Even with this, something still nagged at me when I considered those patients who simply could not or did not want to paint or draw. They were the borderlines or psychotics who were overrun with primitive impulses towards different members of the therapeutic team, or sat alone, wary of contact or intrusions. Developmentally, they seemed to be damaged at a much earlier age than those who had narcissistic afflictions. For the psychotic, the symbiosis barely seemed to have started before massive disruption within the nurturing environment occurred, whereas the borderline appeared to be inundated with unintegrated and disparate introjects from the mid phases of symbiosis. Masterson (1976) described the borderline as fluctuating through periods of regression to a state of fusion, or, in their quest for autonomy, being overwhelmed with feelings of abandonment. In both the borderline and psychotic, the focus of treatment was to be directed towards issues of ego integration and impulse control.

Many of these patients were so lost in primary process that they were swallowed up by primitive imagos that blurred their sense of reality. I saw

their chaos and fragmentation in the artwork as well as being directed outward at the whole therapeutic team. Splitting and disorganization virtually flooded an entire staff as the polarities of the patient's hate and love fragmented and split any cohesion in therapeutic approach. At times I did find that art could contain this chaos and become a frame in which to begin to differentiate inner and outer realities. This containment, however, was often unstable and would often need the binding and structuring of limit setting and confrontation to give added clarity to images that were all too blurred and primitive. A reflection and mirroring of these images was simply not enough.

I found myself wondering if the nonconformist part of myself was looking for trouble, if I was setting myself apart from my peers and losing my special identity as an art therapist.[2] The analytic part of myself answered that it didn't seem possible to have a theory of treatment which included the treatment of psychotics and borderlines unless it fully synthesized the process of neutralization. Experience showed me that art gave people a place where they felt more centered, if only because they could drink in a new level of consciousness; it could not produce the enormous working through of leave taking and separation required to form new identifications and involvements. Here, I realized, we must call upon the therapist to feed back to patients in a more digestible form the pain, hurt and despair, as well as the love inherent in pathological relationships. I saw this as being done on both verbal and nonverbal levels, but within a process of action and interreaction rather than one of the therapist feeding insight to his patients.[3]

A short case illustration may amplify some of these points in more detail.[4] I'd like to tell you about a 72-year-old man who was in a nursing home recovering from a stroke. At the time he was working with one of my students and was in his third year of art therapy treatment. In spite of his years, he was quite a hellion, and could often be seen running after women volunteers in the facility. At times he would threaten not to eat. He approached art as if it was a big endless feast, food to be gobbled up, one piece of material after another, as if nothing could fill him. I might add that his childhood was one of marked absence of mothering and frequent changes in caretaking figures. At times his father would take care of him and at others a distant uncle would. Obviously, there was a good deal of emotional and affect

2 In focusing so much of my attention on the therapeutic relationship.

3 Art, then, became part of a total therapeutic context where the creative challenge of art therapy is to apprehend, organize, and send forth old messages into new frames and orders.

4 I am indebted to Maria Meltzer for offering this case material.

impoverishment and a very strong deficiency in self-cohesion. Issues of impulse control were paramount, and management problems were particularly acute. He would run after the women, trying to grab and hug them, while alternately idealizing and depreciating his therapist. At times, he would go on a hunger strike if she were absent from the facility; at others, he would whine and complain and demand alcohol. His artwork was full of big breasted, powerful women with no hands. He would depict himself as minuscule. This he would run from one big bosomed drawing to another, trying somehow to capture a fantasy that was always beyond his grasp. People were merely seen as sources of food and nourishment. Some of his drawings exhibited a fusion of male and female characteristics indicating a deep split in sexual identification.

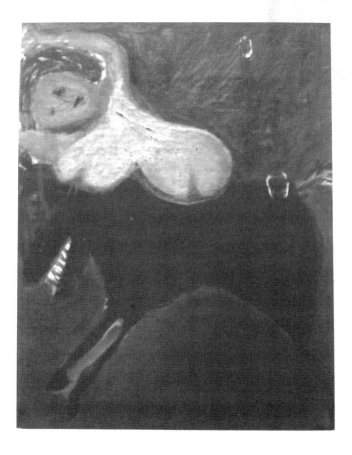

Figure 2

Figure 3

In one of his first works of art, he painted a black, angry horse, with prominent teeth, carrying a white, big breasted woman who seemed on the verge of falling off the horse. This picture showed the split between the white, bosomy, unobtainable woman and his dark angry incorporative side. From his therapist, he received a good deal of empathy, joy and encouragement in his artwork. Slowly I saw the beginning of real internalization of his art therapist emerge. In spite of this, his acting out continued. What was clear was that empathy was not enough. He also needed a structure to set limits and restrict acting out. It was necessary to provide boundaries and a protection for him against his own anxious wish to merge with his fantasied imago of an endless breast. If he was to become whole, he would require a deep understanding of his wish for the imagined breast as well as his need to punish himself for his greed and hunger. He needed a structure within which he could see that his thirst to reach out and grab at life, which was seen in his envy and hunger, could not only be managed, but also put to good use.

This vignette demonstrates how empathy alone cannot do the entire job of helping a patient find an inner sense of integration. This man's search for food both through the artwork and the entire institutional framework needed confrontation so that his hate and love could find some sense of internal integration. Without this confrontation or structure, I believe that the anxiety regarding his fusion wishes and his splitting of tenderness would remain unresolved.

We also see here the interplay of real and transferential relationships. The therapist was real and supportive as well as the source of much envy and hate. I believe the real relationship helped this man to face the terrors and fears connected with his fusion wishes. Art became therapy when the therapist heard and responded appropriately to this man's inner world. For this to occur, she called upon her own ego resources and her own source of symbols to resonate and respond empathetically to this man's struggle regarding loss and separation.

This theoretical position finally became crystallized in the text *Expressive Therapy: A Creative Arts Approach to Depth Oriented Treatment* (1980). In this book I attempted to integrate within one framework a theory that addressed itself to both verbal and nonverbal therapy treatment. The following reference will give the reader a sense of this position.

To summarize, as through nonverbal communication the creative arts therapist makes contact with the most primary and basic core of his patient, he experiences the subtle expressions of pain, loss and loneliness that are unfolded in his patient's stunted capacity for relatedness (Balint 1965). Within a therapeutic relationship of play, the subtle symbolic representations of self and object move into a new world of meaning. The various splits and part objects, with their attending affects of love and hate, need to be touched, heard, and visualized. But most important, the therapist must himself experience and make contact with this early developmental field in order to reproduce a transitional space for reparation. In this transitional space there is room for resonance and dialogue and for complex affective and perceptual systems to become increasingly integrated. We believe that such a process is nonverbal and demands the utmost on the part of the therapist in his ability to play, symbolize, and employ a variety of sensory–spatial modalities.

My early concern with the parallels between the creative and therapeutic processes became a part of this ability on the part of the therapist to use a variety of modalities, to symbolize, to play. It was here that the therapist himself not only needed to be able to switch from primary process to secondary process communication, but also to be able to facilitate the patient's shifting. I came to believe that the therapist's nonverbal concern

may be one property of the healing experience, but that there were also clearly times when the therapist must be able to use his ego to help the patient attend, investigate, contrast; in short, to help the patient objectify his perceptions and better cope with his inner worlds.

Having solidified my theory, I now was faced with the challenge of my students over the usefulness of a complicated theory of depth-oriented treatment when the majority of art therapists ended up working in short-term settings. Ironically, it was apparent to me that for art therapists to be effective in these settings, a sophisticated understanding was needed if treatment were to be anything but vague and poorly defined.

To illustrate this point, I'd like to offer a brief case which was presented in one of my classes by a student who was working in a short-term treatment center.[5] Here, the average stay was five weeks. She described a frightened, paranoid man who was ready to kill as he retreated to his corner and glared at people. Both covertly and overtly he gave the message to stay away. The clinical picture was one of vague hallucinations, extreme withdrawal, rage, and a tenuous contact with reality. When the student displayed some of the patient's artwork we saw clutching hands, hanging spiders, carnivorous lions and images of the patient being swallowed and destroyed. In class we started to investigate the theory of paranoid schizophrenia. We examined the difference between defensive and reactive hostility and ultimately connected anger to guilt and issues of grandiosity. As is common in paranoid schizophrenic reactions, the patient found it difficult to discriminate what was inside from outside. Metaphorically, the hungry lion inside of him was now outside chasing him into a corner.

The treatment plan was to addresss this man's ego in light of the dynamics and the time limitation of the facility. I pointed out that one did not have to be a lion to need a lot of space and want to eat meals alone. This metaphor seemed an apt one with which to address this man's ego, in that it contained both support of his need for distance and recognition of his deep hunger. By using symbols in a playful way, it was hoped that the therapist could connect with the patient's inner images in a nonthreatening way while working towards eliciting whatever adaptation efforts were at work. What was clear was that ego work with many patients would be on this nonverbal level, that first and foremost it would be the creative art experience that would be the fulcrum for regeneration.

As I now think of this kind of patient who cannot utilize the playful interplay of metaphor and image in a verbal way, I realize that I have

5 I am indebted to Karen Nielson for offering this case material.

theoretically come full circle. Again I think how important h is for art therapists to respect the differences in theory and approach and to learn from one another.

In summary, I have modified the original theoretical framework of sublimation to include the ideas of Kohut, object relations, and ego theory, but I have found that a whole kaleidoscope of theories move in and out of my awareness. At times, Jungian archetypal images have connected a patient to the broad stream of the collective unconscious and further extended notions of the self, while at other points Gestalt therapy has been a meaningful tool to help a patient confront the split-off parts of self and object representations.

My professional identity as an art therapist is no longer static, but ebbs and flows with each session and patient. Every individual has his own developmental deficiencies and concomitant patterns of ego and self-expression of which I must be cognizant as I look and react to the therapeutic relationship and his or her creative expressions.

Furthermore, play is no longer seen as an intermediary stage that will facilitate art expression, but a cognitive and ego state that helps and facilitates image and symbolic expression. Materials and media are no longer limited, but to be flexibly utilized depending upon the need of each patient to frame and organize different levels of communication.

Theory, then, has become organic, a part of myself rather than a defense to interfere with my experience with patients. In fact, with each therapeutic encounter, I rediscover theory with fresh eyes and assimilate and accommodate the complex visions, sensations and images that touch me at my very core. Within this process remains the core of myself who is the artist and has merged with the psychologist to discover a new sense of wholeness and professional mastery.

Historically, art for me has been a connecting force to a humanistic tradition. The artist within me has been most sympathetic to man's eternal struggle with society. Likewise I, as an art therapist, am not concerned with adjustments, but with making the inner life of our patients find expression that is both adaptive and self-affirming. Within this humanistic framework, knowledge and artistic expression constantly shift and are rediscovered to meet the individual needs of my patients.

As a therapeutic artist I carry the conviction that knowledge invariably transcends the limits of words, but psychiatric theory can no longer be seen as a necessary evil or, worse, an infringement on the professional identity as an artist. At its best, it is a background that can facilitate humanism, real experience with patients, and the depth and complexity of interactions. Art

therapy, then, becomes a connecting link to that broader base of collective archetypes that merges man's eternal quest for healing and his need for communication.

References

Freud, S. (1970) *Introductory Lectures on Psychoanalysis.* New York: Norton.

Kramer, E. (1979) *Childhood and Art Therapy: Notes on Theory and Application.* New York: Schocken.

Kramer, E. (1973) Dialogue, Edith Kramer and Lawrence S. Kubie. *American Journal of Art Therapy 12,* 4, pp.225–237.

Kubie, L. (1973) Unsolved problems concerning the relation of art to psychotherapy. *American Journal of Art Therapy 12,* 2, pp.225–237.

Lackman-Chapin, M. (1980) Kohut's theories on narcissism: Implication for art therapy. *American Journal of Art Therapy 19,* 1, pp. 3–9.

Masterson, J. (1976) *Psychotherapy of the Borderline Adult. A Developmental Approach.* New York: Brunner/Mazel.

Naumberg, M. (1961) *Dynamically Orientated Art Therapy: Its Principles and Practices.* New York: Grune and Stratton.

Robbins, A. (1980) *Expressive Therapy: A Creative Arts Approach to Depth Oriented Treatment.* New York: Human Sciences Press.

Robbins, A. (1973) Creativity development. *The Arts in Psychotherapy 1,* 2, pp.7–12.

Becoming an Art Therapist

Arthur Robbins

This chapter was originally part of the text of *Creative Art Therapy*, published in 1976. Since that time, the students entering the field have become a very sophisticated consumer. Entering applicants in admissions interviews have already received from the central office of The American Art Therapy Association the requirements for registration. Potential students make the rounds of the various departments and may note that although all the accredited programs meet the standards for The American Art Therapy Association, the emotional tone and atmosphere of each department, as well as the theoretical emphasis, varies greatly from place to place. At times the student may shake his or her head and wonder how such great divergence can all be part of one field. The wise student makes an assessment of each program by speaking with students and alumni. Published articles and texts also reveal the philosophy and the underlying value system of each curriculum. The student who knows who he or she really is will choose the program that mirrors his or her own internal belief system and temperament. Those who believe that one program will be as good as another may be in for a shock, as well as a sense of disillusionment.

Assuming that the student has made a wise choice of schools, the same issues that were so prevalent in learning art therapy are still very much in the foreground. Defining the boundaries of art or therapy is an open invitation to get lost in a metaphorical muddle, conjuring up exquisite ambiguities. Nevertheless, the beginning student rightly demands clarification from professional role models. Definitions are presented, cases are illustrated; yet an unsettled and anxious feeling often pervades the initial classes in art therapy. The interlocking processes of art, therapy, and personal development, the basic understructure of this field, are prodigious in scope and make

enormous demands upon one's emotional and cognitive resources. Consequently, the sense of anxiety and excitement found during the introductory classes slowly transforms into waves of confusion and despair. Complex concepts and powerful affects emanating from patients, institutions and her own unresolved intrapsychic conflicts literally inundate the neophyte professional.

Learning art therapy demands a good deal of openness and self-confrontation. For many, this mode of learning is challenging to their sense of privacy and control. For many students, a respect for the right to withhold until they are ready to be more open is an absolute necessity if progress is to be made. The demand for openness can often be a strong conformity pressure that in and of itself needs some confrontation. Many a student will be able to receive support from peers and learn to counteract a sense of alienation by sharing strange and puzzling feelings. Even with this support, however, the art therapist soon finds personal therapy an absolute necessity and an aid in keeping an emotional hold on these difficult pressures. Defenses are constantly disrupted as the student becomes immersed in primitive impulses and imagos that erupt in the art therapy process. This constant preoccupation with the unconscious makes it virtually impossible for an intern to stand still in his or her own growth and expansion. This can be one of the most exciting parts of learning a new discipline. Hopefully, personal therapy will not be seen as a requirement but a challenge to enhance a sense of professional growth.

The issues discussed in this chapter can be best approached within a supportive and enlightened supervisory relationship, which is an integral part of the learning experience whereby a student becomes a professional. An ongoing relationship exists between a student and an experienced practitioner of art therapy throughout the training period. Although there are many conceptions of supervision the kind of relationship consistent with the philosophy of this text deals with both the cognitive and the emotional development of a student. Thus, the art therapy supervisor is a resource person as well as someone who can subtly relate to the emotional issues that interfere with therapeutic effectiveness. A supervisor may also offer various art experiences that will stimulate the student's own creative development. Ideally, the student who maximizes supervision is the one who has enough ego strength to be open to and share with others his or her unconscious and also to hear and utilize available technical information.

The appropriate line between supervision and therapy may be unclear even to the most skillful supervisor. When complex resistances develop regarding problematic learning issues and the student's subjective experience

outweighs her objective understanding, he may more effectively deal with these issues in personal therapy. Such resistance to taking a creative and autonomous stance to one's individual growth and learning can be seen in a number of ways, e.g., taking a passive, incorporative attitude towards the supervisor ('Tell me what to do, to say, to feel,') etc.

Each student intern requires an individual approach within the context of her characterological orientation. One may view supervision as a feeding, i.e., emotional nourishment that will ease the growth process. Another wants to use the power of the supervisor through submission and conquest. Still another may set up competitive situations and test out his or her mettle against the supposed superior authority. Fears regarding exposure often enter into the relationship and a need to be invulnerable may exist. The complexity of the attitudes seems as broad as any found in the therapeutic encounter. The underlying principle, therefore, is that each student attempts to utilize supervision to maximize his or her autonomous development. His or her resistances to learning and changing are recognized and respected. A sense of support and nonjudgment would seem to be the ideal atmosphere for such a relationship to flourish. The student's goal in supervision is toward developing a personal therapeutic style consistent with his or her own growth, rather than mimicking or idealizing a role model set forth by his or her supervisor. Without an effective and open dialogue with a supervisor, a student will be missing a most enriching part of his or her entire learning process.

Roughly speaking, problems in learning this difficult process can be broken down into two areas: First, issues relating to the development of a professional role, and second, the particular strengths and vulnerabilities an artist brings to a training program as he or she attempts to apply creativity to the interpersonal as well as the inanimate.

A constant refrain seems to resound through opening courses: 'Who am I? What am I doing? Where am I going? How will this field make an effect on me?' Some students already have very definitive notions pertaining to these questions. Others seem completely lost and have but vague stirrings relating to these matters. Sooner or later, most students realize that ready-made definitions and roles are not appropriate or sufficient.

'What do I do with patients who only want to tale?' 'Am I really doing art therapy when it sounds so much like psychotherapy?' 'How about patients who like to dance or sing? Do they belong to another department?' 'What if I am also drawn to these areas? Am I in the right program?' A developing art therapist may face these role dilemmas very early in his or her training. She receives little help from institutions or her professional elders in

resolving these issues. Unfortunately, both parties may be much more comfortable with role definitions based on specified skills and functions.

The range of institutions where art therapy is practiced is broad; each setting presents a new set of opportunities and limitations. Superficially, art therapy can be practiced in so many different ways, it becomes difficult to comprehend a unifying concept. Art teacher, creativity specialist, social catalyst, psychotherapist: all seem to emerge and have special emphasis depending on the institution and/or the practitioner. Slowly, some students give up their quest for a role definition centered on skills or functions. Grudgingly for some, with relief for others, a process-oriented conception of art therapy develops. Creativity and therapeutic change become the internal anchor of a professional image. But this self-image does not appear without a good deal of soul-searching and anguish.

For those students who have not undergone personal therapy, the stirring up of intrapsychic material coused by transferential or induced reactions can be a threatening experience. Some respond to this challenge and accept a new conception of a therapeutic process; the healer and the healed often exchange roles or occasionally provide a mutual function. An art therapy intern soon realizes the great similarities between the patient and him- or herself. However, he or she is simultaneously expected to maintain boundaries and keep appropriate professional distance from the patient. The demands of this emotional balancing act are excruciating. A student responds at the deepest intrapsychic levels and must be able to separate these communications into the proper channels, i.e., induced reaction versus countertransference. Problems may be selectively shared with the patient. This juggling takes a tremendous amount of time and maturity before any professional works comfortably at so many levels. Old conceptions of humanism and authenticity are challenged. 'How can I be responsive and caring and still give a patient room to grow and breathe?' When the complexities of this integration become too much to bear, the plea sounds once again: 'What is an art therapist? Define the role so that I can avoid the pain of not knowing!'

In response to the ambiguities and complexities of a new learning situation, polarization of role models erupts. These conflicts often serve as resistances to learning; one easily becomes caught up in an endless dialogue that offers few creative answers to perplexing issues. The theoretical orientation of an intern may be either a strong art background or a strong psychology background. The resistances toward integration of an art experience approach with a more psychotherapeutic emphasis can be traced to the internal dynamics constelled within each person. Art for some has

become a means of protection as well as an expression mediating the pressures of the inside and outside world. Explanations and psychological understanding are experienced as an intrusion. Art is an inexplicable and very private affair. Therapeutic implications of art are resented as they jar the student's personal homeostasis and manner of coping with threat. On the other hand, many trainees are drawn to the field of mental health as a means of gaining understanding of their own internal dynamics. Art therapy becomes an entree into their own personal therapy. Frequently, this type of student feels compelled to have tight intellectual control over the learning process and wards off any breakthrough of spontaneous impulsive material that is part of a genuine art experience. The psychology-oriented student may well be more comfortable in approaching the creative process as a cognitive endeavor. For both the art-oriented student and the psychology-oriented student, a polarized debate as to the place of art in therapy avoids the integration that occurs through the joys of creativity and of self-discovery.

The person with an art education background brings to the therapeutic relationship a repertoire of projects that can be excellent vehicles for self-expression and development. These very same exercises can also be used as a means of avoiding the subtleties of interpersonal contact. Those who come from the field of occupational therapy may also be influenced by a task orientation. Perceptual retraining or socialization is overemphasized at the cost of an open, creative attitude and may well be a defensive maneuver to avoid overwhelming, alien and difficult feelings. Taking a step in the direction of having both patient and therapist discover the appropriate task or project makes the broad jump into creativity development.

In many settings, administrators have little conception of the scope of art therapy. Art therapists are seen as recreation workers, paraprofessionals, hybrid occupational therapists, or enlightened art teachers. As a consequence, the intern is constantly called upon to define his or her position and educate others. For many students, this is a very painful and endless struggle. At times, the intern is neglected and ignored. The young art therapist deals with fears of being assertive and aggressive in order to challenge preconceived notions and the political structure. He or she must also be sensitive to the institution's political undercurrents and not alienate herself from the working team. Many students do not want to be encumbered by these forces. They resent being part of a social matrix. Often the lament is heard, 'Why can't I be left alone so I can do my thing?' Occasionally, deep transferences are acted out upon the institution, which only serves to make the student confused and ineffective.

A process definition of a professional role model is unacceptable in most institutions. This notion violates the pecking order and homeostasis of the prevailing structure. Psychiatrists, psychologists, and social workers often have short memories and forget their past battles to have an equal and expanding role on the mental health team. Now art therapists are forced to go through the same painful ordeal if they are to overcome a paraprofessional or technical image. To handle rage, withdrawal and acting-out, and be able at the same time to communicate to one's peers and elders with a sense of dignity and forthrightness are tall orders for a novice professional.

An instructor who has the opportunity to teach both psychology and art students will be aware of some discernible differences between the two groups. Art students enter training programs with very special assets and liabilities. Although generalizations are difficult to make, over the years, experienced faculty often are aware of broad trends that demand recognition. Instructors would do well to avoid the error of relating to artists solely as psychological trainees.

The prototypical art-oriented student is full of inconsistencies and para-doxes. Wary of the obvious, suspicious of anything that smacks of the manipulative, art has often been a means to channel a distinct sense of individuality; for others, it has been a means of survival. Now outspoken and nonconforming, now insulated and private, an artist searches for contact and relatedness. Education programs in the past have proved a dreary disappoint-ment. Many hope art therapy will provide an answer for the channeling of original expression within the human and social context. Action-oriented and often impulsive, theory gets in their way. Many are more than willing to risk leaps into the unknown if only to find meaning and significance in their work. Soon, massive doses of affects emanating from the work shake the very underpinnings of their psychic foundations. Loneliness and depres-sion that have been masked through art and symbolism break through into consciousness. Many wonder if they have gotten much more than they bargained for. The following comments attempt to highlight some of these growing pains and critical issues the typical artist encounters in a training program.

If students come to a new program frustrated in their ability to find their own creative energy, they may hope that art therapy will give them answers to their own creative blocks. These fears are often exhibited in the manner in which a trainee approaches her patient. Some students are frightened of a patient's losing control because of their own internal anxieties: he or she subtly sabotages any attempt by the patient to loosen up by the use of structured materials and by being overly interpretive. Another, because of his

or her own inner problems regarding structure and limits, finds it difficult to transmit an inner sense of discipline. Students' fear of the cognitive area ultimately has its genesis in dependency, power and hostility; however, many do not see the connection between their resistances toward cognitive material and their personal anxieties in helping patients deal with structure and reality. This dissociation between a student's academic and professional life is a manifestation of a splitting process that makes learning and change so difficult.

A common controversy in the field centers in the area of aesthetic judgment. Those who have strong investments in the field of art experience a basic violation when standards of aesthetics are abused. Others view this approach as overly judgmental and feel it restricts the entire flow of communication. 'Standard' sounds very close to 'conformity,' which has been the stimulus for a long-standing rebellion. Distance from such a personalized point of view on the part of all concerned is needed. Everything expressive is not always beautiful and deserving of praise. For the therapist to help patients harness, cope, and crystallize their feelings and imagery through a cohesive representation of art may offer a new feeling of mastery. On the other hand, those trainees who insist on certain preconceived standards at the cost of freedom and spontaneity may well look to the areas of power and control filtering into their therapeutic attitudes.

Exhibitionism in the arts, when truly expressive and integrated, can be a positive avenue of self-affirmation. However, this impulse may be dissociatively acted out with patients and materials. Often, too, the art therapist plays the game of show and tell with her patient's art products. A therapist's power cannot arise from the display of her patient's paintings as a means of covering some of her own inner sense of impotence.

Another caution for artistic expression lies in the area of touch and sensuality. Art therapists often express unsatisfied needs for touch and intimacy that are not sublimated through normal interpersonal experiences. This delicate balance can be upset easily as patients and materials interact, causing a good deal of tactile excitement. For many, this is a positive experience. For others, however, erotic stimulation can overpower both participants in the dialogue, causing a flooding of the student's ego. The understanding of the principles of timing and rhythm is difficult to apply judiciously when the therapist's need for contact interferes with good judgment.

Many young trainees are both fascinated and trapped by their patients' unconscious communications. Not all symbolic communications connect with a quest for identity. Some material is discursive in nature and meant to

be an avoidance of the reality problems of existence. Art therapists, if they themselves are lost in fantasy, may be unable to make this distinction.

Art therapists are constantly flooded by induced reactions ignited by the patient and the art process. Rage, intense eroticism, and anxiety of panic proportions are but a few of the internal vibrations that resonate in a therapeutic relationship. In the past, the art work of the artist has been a safe insulation and shock absorber from difficult affects that must now be dealt with in a more direct manner. The art therapist must constantly be aware of subtle maneuvers to avoid direct expression, which requires the development of an observing ego that listens and discriminates among many levels of communication. This observing ego aids the therapist in taking a more objective view of a subjective experience. Also involved in this process is the development of a concerned empathy, to be differentiated from sympathy. Placating patients by inundating them with gifts or approval may be one way to deaden or avoid rage, while hostility and curtness, as well as the use of certain aggressive materials, may cover the warm, sensitive parts of an interaction.

Art therapists need to be encouraged to accept a wide range of feelings as part of a normal therapeutic engagement. Difficulties in dealing with certain affects can be observed through a tendency to repress, dissociate or overemphasize certain aspects of communication. Discriminations between rage, vindictiveness, sadism, spite, and indignation can all be jumbled and lack specificity when one is under fire. Ultimately, all these feelings can be used as positive means to effect change. Thus, for example, the therapist's perception of her own indignation can be used as an important learning tool, particularly with patients who have lost their will to fight back.

A central issue for the art therapist is the distinction among separation, loneliness, and solitude. Occasionally the artist has been lonely as well as alone during major parts of her life. Art has been a companion and has partially allayed a sense of emptiness. Often there are deep scars in these areas which become stirred up as her or she faces his or her patients' feelings of loss and abandonment. His or her identification with the lost child in the patient makes the drawing of clear boundaries between therapist and patient a difficult task. Under the guise of being humanitarian, a therapist can lose his or her sense of self and become hopelessly lost in over-identification with the patient's grief and loneliness. A significant jump in learning is made by the student who realizes that he or she does not necessarily desert a patient when he or she goes home at night.

Separation, abandonment, and helplessness constantly surround the budding art therapist. Not to push the patient while experiencing his or her

extreme pain will take a lot of discipline. To feel the desperate rage of a depression without attempting to manipulate superficial change virtually puts one through a wringer. Some depressed patients do need concrete help; others simply require the presence of the therapist. The art therapist diagnostically discerns these differences and use materials, as well as feelings, in response to this discrimination. Those therapists who have unresolved problems regarding mothering will find it a difficult task to distinguish in the patient feelings of emptiness that arise from fears of intrusion, as contrasted to emotional impoverishment. Feeding and caring cannot be the magic solution to all of life's problems.

Involved in all the issues regarding growth is gradual transition from simultaneous helplessness and seeming omnipotence to a professional autonomy that is purposeful, free, and yet controlled; the cognitive part of the therapist is integrated into a real sense of knowing. The omnipotence utilized as part of the creative process now rests more comfortably with a more authentic sense of power. Grandiosity is now used as a constructive therapeutic force which allows the therapist to take chances, reach into the unknown, and breech new frontiers. At the same time he or she can laugh at him- or herself, forgive his or her errors, and recognize that his or her wish to play God must exist side by side with his or her own frail humanity. This degree of self-confidence and ease comes with years of struggle and only after a good deal of stumbling.

The every essence of the artistic experience negates authority. The negation is both the strength and the weakness of the artist. Many interns become threatened when faced with the need to set boundaries and limitations. Gradually they recognize an inner sense of authority comes from competence and knowledge rather that power. Some find this a rather difficult transition and tend to subtly stimulate the patient's own rebellion and loss of inner structure. A few may become power-oriented in their approach to patients. In spite of these problems, the individualistic nature of an artist may be the very answer to a patient's hungry need for identification with a model who refuses to submit to society's madness. If anything, the artist may be uniquely qualified to comprehend the sanity of a 'disturbed' patient.

The art therapist brings with him or her the child who has found beauty, exploration and the wonder of discovery. Play, when used in the service of creativity, is an inherent part of the art therapy process. It is also a unique talent of the artist who, hopefully, will not forget this strength when he or she attempts to grow and mature in other areas of life. The art therapist who moves from the adult to the child and back again may be able to make that

unique synthesis of discipline, freedom, and excitement and apply it to his or her therapeutic relationships. In technical terms, an observing ego, free and autonomous, allows the unconscious room to explore, discover and mold new solutions to old problems.

Becoming an art therapist is a rigorous and demanding course of self-development. There is room along this path for regression, depression and reevaluation. So-called mistakes, as in any art- or life-endeavor, can be transformed into new solutions and learning experiences. With this in mind, an art therapist may slowly begin to meet the complex challenges of his or her professional assignments and to experience the joy and satisfaction of growth in the therapeutic relationship.

An important postscript needs to be added to the above paragraphs. As the student approaches graduation, the security and protection of a structured two-year graduate program now seems to be drawing to a close. There are big problems ahead as the student now has a much more sophisticated sense of some of the pressing issues in function and learning a living in the mental health field. Approximately twenty years ago, when the institutional field first opened its door to the art therapist, well-paying jobs were few and far between. The pioneering art therapy students of the first generation of graduates have forged their way into the institutional structure. In many states, civil service lines have been created for art therapists, and we have witnessed in the eastern part of the country the development of jobs that have been on the par of other master's level professionals. In other parts of the country, graduate programs have been developed only more recently and students must now establish inroads in an institutional structure that is more often than not resistant to change. Yet the fact remains that jobs are being developed and the field is expanding. The graduating student then must face where to put his or her roots down. Do you become a pioneer and go to a part of the country that has not established lines for the art therapist, or do you gravitate to places where positions already exist? This second choice will usually require living in a metropolitan center.

There is a complicating factor to this situation in that the overwhelming number of art therapists are women. The socio-political problems that are so prevalent in this society certainly bear noting when it comes to understanding the future possibilities of functioning as a female art therapist. Other master's degree professionals see private practice as a viable alternative to institutional work. They feel entitled to the compensations of private practice, and take some very direct steps towards independent functioning by getting advanced training. Art therapists are only beginning to see private practice as an alternative or conjunctive activity to institutional work. They

want a good living and do not intend to accept a lower-rung status, be it in institutional work or private practice. The notion of being solely an adjunctive therapist is anathema to their self-respect and the quality and training of their background and skills. The subtle depreciation of their skills, as well as the need to address the mental health profession regarding the complexity of their training and understanding then becomes a very pressing challenge for the new as well as the established art therapy professional. The view of art therapy as something 'soft' second rate is now being challenged by women who desire equality both in their personal as well as in their work life.

The unfairness of third-party reimbursement needs to be exposed for what it is. To be true, it is more difficult to start a practice without this alternative for reimbursement. However, there are so many instances of art therapy professionals who are now in full-time private practice that we must face squarely that the problems of third-party reimbursement can be used as a rationalization to avoid the anxiety of taking steps that will enhance one's sense of competency and power.

Alongside the above, there are a number of minority issues that need addressing. The society has built up enormous prejudice and barriers that affect any number of different groups. It is the subtle prejudice rather than the overt kind that often filters into the curriculums, as well as the thinking of middle-class white professionals. What is normal, and what is a family are big issues that are being challenged in all quarters. There are many art therapy professionals who are dedicated to working with disadvantaged groups and have very little interest in fitting into the established stereotypes of what makes one successful. Working with a variety of different groups and sub-cultures and understanding their language as well as mores should be part of anybody's training, regardless of their future goals and ambitions. The identity crisis that many art therapists face when placed in an institutional setting that is so unlike their background can be most disturbing. Finding a patient group that both stretches the student's potential as well as fits the student's own value system and style of life is both important and difficult in terms of occupational choice and professional development.

For many students the rigors of a graduate art therapy training program have left little energy for their own personal artistic development. Upon graduation, they face a difficult question: now that they have more available energy, can they once again establish a place in their lives for their own art work, as well as the professional practice of art therapy? Trying to maintain one's identification in both worlds is like having a love affair with two lovers. Whether it is possible to be a part-time artist as well as a part-time art

therapist can be a most difficult balance to strike. Many students relegate their own art to a secondary position. For some, the conflict is of such a painful nature, that they leave the field of art therapy to become full-time artists. Their are a few professionals who equally work in both areas. To go in this direction takes an extraordinary amount of discipline and self-awareness.

Over the past twenty years, the polarizations among different factions of art therapists have now receded. The new professional entering the field has little patience for these professional battles. He or she is interested in developing and growing, and will take and learn from many different quarters and directions. The new students entering this field seem to know what they are about and are very interested in acquiring the credentials to become fully-fledged professionals. In some ways, this development has been a good one, although I do miss the excitement, contentment and even the confusion which characterized this new field in the early 1970s.

Reference

Robbins, A. (1976) *Creative Art Therapy*. New York: Brunner/Mazel.

Creativity Development[1]

Arthur Robbins

A solid theoretical foundation in creativity development is critical for the aspiring art therapy student. This knowledge, combined with skills in therapeutic change, places the practitioner in a unique position in the field of mental health.

The purpose of this chapter is an attempt at synthesizing psychoanalytic knowledge with techniques and functions that stimulate creativity development. There are some crucial studies in analytic literature that provide an appropriate point of departure.

Ernst Kris (1952) views the study of art as part of the study of communication. Within this context, the process of artistic creation is broken down into three distinct spheres: there is a sender, a receiver, and a message. The message, or the work of art, is in part similar to a dream. One sees a multi-faceted integration on a variety of psychic levels and structures, manifested through an interplay of visual imagery. This message is an invitation to a common experience in the mind, to an experience between artist and audience as they discover new depths of meaning to the world.

Kris draws our attention to the ego of the artist. The expression of regression in the service of the ego, with the concomitant implications of allowing fantasies to flood one's being in order to regain master, brings a crucial aspect of artistic creation into focus. The essence of his thesis is the regulation of the ego and the individual's ability to bind, neutralize and channel energy toward creative work. Yet this description often leaves much to be desired. Perhaps more accurately, we are dealing with a different orientation of life, with attitudes, values, and responses divergent from a

1 This chapter appeared in its original form in *The Arts in Psychotherapy 1*, 2 (1973).

Western point of view. Central to a creative orientation, therefore, may be a shift to a nonrational, paradoxical, ambiguous state of experience rather than a rational, goal-oriented approach. Associated with this shift, the individual seems to be gripped by introjects that have confluent ego functions and energies. These intra-psychic forces can shake the essence of a human being (Roland 1969). If these energies are neutralized, they have the ability to stimulate and intensify communication on a primary level.

Any study of creative ability must include the whole area of nonverbal communication. Renee Spitz (1965), a psychoanalytic researcher in child development, refers to this primary relationship as *co-anesthetic organization.* To quote Spitz, 'Here sensing is extensive, primarily visceral, centered in the automatic nervous system and manifests itself in the form of emotions.' Adults, he states, who have retained the capacity to make use of one or several of these categories of perception and communication, belong to the exceptionally gifted. But, as Noyd, another psychoanalytic theoretician points out, primary communication is mutual. Hence the specific pattern, he states, of communication characteristic of early mother–child dyads is modeled on a combination of two factors: those contributed by the mother and those inherent in the infant. Thus, the primary mode of communication between mother and child can be one of looking, touching, and/or cooing. This behavior can be observed in a wide variety of relationships. The capacity, however, to relate to these very subliminal cues both from within and without may be the source of the artist's ability to see, hear, and experience the world with a sense of freshness and originality. A highly developed sense of nonverbal communication enhances his ability to break though the often stereotyped barriers of verbal communication.

Essential to this primary mode of communication is the artist's belief and trust in his work. These qualities can be found in friendship, marriage and therapy relationships.

The psychological research in the area of creativity has been growing. Some of the most important work emanates from the University of California where Barron has spent a considerable amount of time studying various groups of artists. The conclusions called from his studies point to three major factors connected with creativity: First, the artist seems concerned with complexity rather than simplicity; second, the artist seems to be more open perceptually and resistant to premature closure; and third, the artist often relies on his or her intuitive abilities. The implications of this research are provoking. Hopefully, the well trained art therapist will avoid the pitfalls of seeking simple solutions for complex problems. He or she will also need the courage to wait and listen and avoid inappropriate solutions. The creative

therapist must also address him- or herself to the uncomfortable issue of premature closure with its concomitant feelings of anxiety and ambiguity. Finally, he or she must employ his or her creativity to create environments conducive to the enhancements of intuitive and/or nonverbal communication. This environment or atmosphere would allow the therapist to replicate, for therapeutic purposes, a multitude of mother–child dyads, and relate to the specific imagery this relationship brings forth. As a specialist in nonverbal communication, he or she develops the capacity to empathize and to resonate with the patient. He or she mirrors, responds pictorially, and communicates graphically a whole range of textural messages. The art therapist has an empathetic ability to ebb and flow with the many waves of psychic expression generic to this process. At times, he or she may function as an ego support in order to set the stage for the release of neutralized energy. This energy is associated with primary introjects which have been externalized through the power of the creative relationship.

An art therapy relationship may seem strangely close to a love affair. This love affair may have some of the ingredients of a touching sweetness, or a sublime blissfulness. It contains all the trusting qualities of an early mother–child relationship where the basic mode of communication is one of a soft touch or perhaps a sweet sound. The therapist's response may be a reflection or a partial glimmer that is rarely verbally recognized. The words used would be graphic if not poetic. Object relatedness is often secondary. Premature emphasis on object relatedness is often secondary. Premature emphasis on object relatedness may often interfere with the creation of this generative partnership. The art therapist watches closely in order to respect the delicate movement along the closeness–distance continuum. Thus, as the creative dialogue charters itself in the most primitive layers of psychic organization, the early fears of being swallowed, abandoned, or annihilated can be mobilized easily. On the instinctual layer of a creative operation, strong cannibalistic urges are sometimes neutralized. The patient often needs the space to constructively use this energy to capture and to swallow his world, if only to send it forth with new meaning. For many, too great a closeness overwhelms the ego in its struggle for mastery or control. Yet, somewhere in the background, with this undercurrent of relatedness he or she may have the courage to brave the isolation of being with him- or herself and work towards creating an authentic statement.

As the art therapy relationship is fostered, a touching adoration can develop. On other occasions, the narcissistic investment and omnipotence remains largely within the patient as his or her work becomes literally a highly cathected appendage of him- or herself.

Likewise, the therapist ultimately may become an appendage. To determine the locus of the narcissistic investment is of prime importance in assessing the appropriate form of relatedness. On the level where the therapist is but an appendage, his or her ability to accept this role with minimal interference may be a condition in the determination of his or her effectiveness. Many a therapist cannot bear such an insignificant position and experiences a degree of narcissistic injury.

Where the investment is within the relationship rather than the work, the omnipotence of a therapist, as manifested by a glowing adoration by the patient, must be accepted with a minimum of counter-defensive maneuvers. For some, this can be experienced as a great burden. However, the art therapist can effectively use this relationship as a source of stimulation and encouragement. The identification process, which may be introjective, is in and of itself not necessarily destructive. The determining factor will be the quality of the identification. Does it function as a bridge to further autonomy or does it lead to a sterile imitation of the therapist?

The creative process contains magical and omnipotent forces that both serve as a basis for keenly accurate perceptions as well as a source of primitive fear and retaliation. The patient may need a good deal of support in his challenge to the world as he or she occasionally displays a grandiose flourish and abandon in his or her work. Yet, as he or she encounters approbation rather than punishment, the release of tension may well serve as the basis for motivation to delve deeper in exploration and discovery.

Security is not always possible when there is a bombardment of stimuli on a patient's ego which is already fragmented and disconnected. At times, a subtle restriction of stimuli may well give him the require protection. In contrast, others who are overly tight and rigid may need a certain degree of freedom and stimulation to loosen up the controls. Occasionally, the background of musical stimulation seems to break through the defenses and allow the connection to be made in the pre-conscious. On other occasions, the use of surprise or shock can have a catalytic effect.

The vulnerability to narcissistic injury can never be underestimated when one deals with the creative process. As a patient displays to the world part of his or her most primitive naked self, direct and frontal confrontation can be experienced as an assault that does nothing but raise defenses and lower the communication on the creative dialogue. One may wonder, therefore, how the whole process of working through an integration takes place, if one cannot criticize. To point out various avenues of exploration rather than to deal with the limitations of a work is a notion that every good teacher has in his or her professional equipment. To build rather than to tear down seems

too obvious even to mention. Yet, all too often, one hears the mutilated accounts of aspiring artist, shattered from their learning experience rather than reinforced in their conviction that they dare to be what they are.

Basically, the art therapist must be as in tune with an individual's ego resources as with the underlaying layer of preconscious fantasy. To assess when a person's ego integrative capacity has received maximum taxation, or when he or she needs encouragement to remain in the field of battle, is not always an easy chore.

The act of forcing more control may increase resistance to the flow of pre-conscious materials. To learn how not to push, to let things grow, to be able to know when to walk away, to be able – once you have the inspiration – to build rather than jump from one thing to another, are all parts of the ego techniques that the art therapist must have at his disposal. At times, there is too early a closure. Perhaps the accompanied anxiety to this lack of closure pushes the individual towards oversimplification. Together, through a mutual identification, patient and therapist face the paradoxes and inconsistencies and allow them to germinate until a more complete unity occurs.

Involved in the authentic relationship is the ability of the art therapist to distinguish what is truly artistic and creative. To discern the work that can stand alone as contrasted to material that is in the service of exhibitionism or rebellion is another important task of the therapist. As the therapist responds according to what is truly authentic, he or she may also help the patient perceive what is honest and direct.

On occasion, the patient may have difficulty in going on and challenging new and different areas of exploration. It is up to the art therapist to observe and deal with this occurrence, for often there is a fear of letting go and dipping once again into the pre-conscious layer.

The sense of touch pervades all areas of artistic integration. One of the most sensitive issues, however, is the actual physical 'layering of hands' on the piece of work. For a few, the actual touching of the work also imbued can be experienced as a form of release. One can also be sensitized to a heightened degree of preciousness in the art work. Breaking this spell also permits the patient to boldly strike out in new directions and not be a party to his or her own internal narcissistic restrictions. However, when the narcissistic investment is in the work of art, the patient may be psychically wounded or debilitated if the therapist physically touches it. A patient's perfectionism may well force him or her to come to a self-destructive position. The work becomes his or her prison where he or she feels cut off and unrelated to his or her inner self. A therapist may well protect the patient from this position by helping him or her to walk away from his or her work

in order to approach it on another occasion with fresh eyes. Again, it is the art therapist who must be in tune with the real rhythm of the energy so he or she can combat the self-destructive introjects mobilized in the patient.

Thus, the alliance with the good mother is made, fighting off fears of retaliation that, at times, are manifested though perfectionism. The good mother in the art therapist encourages, protects, but also knows when to let go so that the person can capture his or her own sense of power. The development of autonomy is not only of importance between the patient and the creative product, but also between the patient and the therapist. A therapist in tune with his or her patient will discern easily the process of individualization. As a person develops, he or she will need less and less psychic nourishment until ultimately he or she is ready to explore new and different environments. Separation can be very painful for both parties. The beautiful sweetness, the intimacy, the power must be relinquished. The patient makes a more realistic assessment of the therapist's strengths and weaknesses. Possibly, both patient and therapist will want to continue a contract that no longer services their individual growth needs. Recognition of these feelings by the therapist demands a good deal of depth and maturity. The patient in this developmental stage will become angry at him- or herself for his or her own unwillingness to acknowledge separateness. Unless protected from him- or herself, he or she may become caught up in another introjective battle that can only contaminate if not destroy his or her work. In this instance, one sees literally a wrenching apart that may be the ultimate requirement for gaining freedom.

An art therapist has a highly sophisticated understanding of introjective processes. As was mentioned earlier in this paper, enormous untapped energies are bound up with introjects that are stored deep within the recesses of the unconscious. As these introjects emerge either within the relationship or in the artistic product, there usually is a release of enormous energy that functions as an inspiration for the creative act. These introjects can be experienced by the therapist as literally possessing him or her in the form of demons. The induced feelings associated with these introjects can encompass such affects as rage, despair, hopelessness, etc. These emotions, which are originally part of a parental or child self, must be integrated and understood by the therapist in order to maintain the continual flow and release of energies. To act out these externalized introjects could well cause a reintrojection and a re-creation of the original trauma. The art therapist maintains the strength of his or her own identity and still fosters a primitive union. This is especially true when his is working with people who have extreme pathology.

The therapist combats these introjects in him- or herself and acts as a model for the patient to face some of his or her own primitive terror. As these conflicts originate in an early stage of development, a nonverbal, feeling experience is implied in the curative act rather than an intellectual or verbal response. Nevertheless, a theoretical conceptualization of this complex process contributes significantly to a resolution within the art therapist. Many of these notions have been intuitively incorporated by experienced art teachers and therapists. (A theoretical understanding may prove helpful to the art therapist who finds him- or herself on a plateau with a patient.) Creativity is an area that requires breadth and depth of psychological perspective. Many of these analytic concepts cannot be fully assimilated, but personal emotional growth accompanies a cognitive education.

Today our society appears to have produced increasing numbers of technicians with a high degree of information and competence. Of equal importance, however, is to develop the talent that can deal creatively with complex problems that are part of a very complex society. Research seems to indicate that with more schooling and education, creativity in children is either cut off or destroyed. This may be a consequence of both the kind of teachers we have as well as the institutions that demand conformity and a particular kind of adjustment on the part of both teacher and pupil. Thus, the area that may ultimately prove most challenging, if not most fruitful for art therapy, may be in normal settings such as schools and settlement houses where child and adult can rediscover a lost part of themselves. In the interim, the art therapist will continue to make a valuable contribution to creativity development in hospitals and other mental health care settings. The depth and strength of his or her work in this area will be determined by a sophisticated knowledge of nonverbal communication, intrapsychic process, and ego development.

References

Barron, F. (1968) The Dream of Art and poetry. *Psychology Today, 2,* 7, pp.23–26.

Kris, E. (1952) *Psychoanalytic Explorations in Art.* New York: International University Press.

Noyd, P. (1968) The Development of Music Ability. *The Psychoanalytic Study of the Child.* Vol.23, 332–347.

Roland, A. (1969) Paper presented at the 1st Theodor Reik Center Conference, May 1969, New York City

Spitz, R. A. (1965) *The First Year of Life.* New York: International University Press.

The Use of Imagery[1]

Arthur Robbins

Picture if you will a group of art therapy students sitting in a small seminar. They are meeting in my living room. The room is small and we are aware of one another in spite of ourselves. Some are sitting on chairs, others are sitting of the floor. At first there is a tense expectant air in the room. No one speaks. I look, I wait and wonder what is going to happen. I feel somewhat tense myself. I feel myself to be pushy and controlling. The students in the group have been aware of this, and have reacted in the past in kind. Now this image of my past, this dominating, controlling figure lies somewhat subdued as a stronger sense of me loosens up and springs toward freedom. This is our last session for the year and reports are due. Then quietly and poignantly one of the students states that he has something to read. Slowly a volley of poetic images and perceptions flow forth as he describes his work with a young boy. I will read you part of this report by Pierre Boenig. But first a few comments. Pierre works in a school for the emotionally disturbed children and his report describes the inner life experience of his work with a particular child. I will not attempt to give any of the history but offer to you two paragraphs of his report which so much describes what we have been working towards.

> 'Mark goes with me to get my coffee, pours the coffee and then spits in the cup. Exploring the hallway further and further, visiting the class across the hall for a few minutes, hiding when stranger come into our room or trying to kick them out, cursing anyone inside or outside, demanding to be carried. Now I am walking, protecting, stopping, holding, comforting, an ally; fighting, killing and being killed; also I

1 This chapter first appeared in *The Arts in Psychotherapy 1*, 3/4.

am the strength, the power where frustration, anger, fear, cries and
tears mix, and melt through my acceptance of him. How much is it
me, how much is it him? I give my resources, he gives his will to fight
the suffocation, the rigidity, the conformity, and all of a sudden he is
by himself, with himself, and his face is dry.

'Two days ago I told Mark that his mother would be coming to visit.
For two days he worries what she will do to his position in the school.
Now I tell him that when she comes I will be on his side, by his side.
When mother came into the room Mark was on my lap, on the floor.
He, his face on me, and I held him. He cried and screamed at her to
get out, to leave. She told him not to cry, to be a good boy and if he
would stop crying she would leave. She threw him kisses and looked
paler than I had remembered her. Mark hid in my lap crying so he
could not hear what she had to say, wanting, her out, away, out of the
confusion, the fusion.'

After hearing the report, the students are moved and deeply touched. I am
particularly pleased as it graphically summarizes the course. Sometimes all
of us wondered whether we were participants in a group therapy seminar.
This didactic, somewhat overbearing imago in me would often put a stop to
the flow of material and once again place us more certainly in a classroom
atmosphere. However nebulous our subject, whatever the anxieties and
tensions that accrued between us, all of us realized that we had shared an
experience.

As I review the course, one thing seemed to stand out. Art was play and
all of us started to relearn how to play. Our orientation was not on a
conscious, goal-directed level. Indeed we sought and drifted to a different
level of existence. A shift in ego state, if you will, where we were able to
tolerate the paradoxes and ambiguities of our thoughts. We encountered
demons of our past, images of lost days and nights that seemed to contain
untapped reservoirs or energy. I would like to talk briefly about these demons
or introjects and relate them to what goes on in the creative dialogue.

All of us at one time or another appear to be captured by an introject.
Often they creep up on us and literally transpose us so that we lose ourselves
completely. These figures are like foreign islands within the deep reaches of
our unconscious and represent the figurative embodiment of our personal
lost battles and traumas. They have their own independent existence with a
whole set of concomitant values, perceptions and notions. These island
figures are not integrated into a unified image of self, but emerge from time
to time and completely dominate our thinking and behavior.

The prescription for growth often calls upon us to face crises. Through various developmental conflicts and encounters, key individuals in our past who are associated with these crises are incorporated fully into ourselves, for they are the result of an inability to separate and experience loss. For others, the feeling of being overwhelmed by either hostile or sexual impulses is too much for the child's self to cope with. He or she submits to the larger force and becomes one with it, losing his or her true self while his or her quest for identity is crippled. For many, these introjects have damaged the entire ego of the individual and we experience in our relationship with him or her a conglomeration of disintegrated imagos that has no central force or direction. Fortunately, there exists a reparative need to challenge these past devils and demons by externalizing them on a welter of different relationships. Sadly enough, the uncanny power of these introjects pushes the individual to recreate not only the same conflict of his or her past, but also the same result. Thus, for some, human relationships are all too dangerous and fantasy and unconscious processes become the focus of emotional investment. For a fortunate few, the world of creativity becomes a major source of externalization. Here in the safety and confines of a sphere when they are completely in charge, the individual dares to bring forth and concretize the early representations of past conflicts.

Perhaps if I start this description of a journey into the unconscious with the very disturbed and distraught, it will provide a frame of reference that can be easily transferred to a wide range of patients. As I approach this patient immersed in his or her own world where there has been damage in many areas of perception, affects and integration, I search for the right melody to tune in to. For some, I can be but an extension and impose little of my own self or existence. I stand on the outside and observe. As I lose some of my own conscious control, I constantly seek ways of blending into this totality. Gradually I discover the various nonverbal roots that can establish this very early form or relatedness. I attempt to pick up on the most sensitive level of the patient's primary sense of rhythm and touch. Indeed, hopefully I may be to the patient a sensitive mother who approaches a young child that has been brutalized.

In many respects I witness and feel the beginning of a love relationship. Yet as the patient dares to explore on this primary journey that is mediated through graphic play, I observe that something strange is taking hold of me. Seemingly, from out of nowhere, the terror and hell of the patient's infant self is felt within me.

I experience the parental forces that existed in the patient's past. The long felt contempt, disdain, or ambivalence, possesses me like a demon. I now

know, on a feeling level, what this patient has gone through in his or her early life. To have the courage not to act out this externalized introject with the patient, to be able to maintain my sense of self and at the same time allow myself to be engulfed by these feelings puts a tremendous burden on me. Yet hopefully, if I can show him or her that I will not be overwhelmed or lose myself to these devils, perhaps then the patient will learn from me and internalize my strength. Perhaps I too would try to harness this force through my own personal art work. I will have to decide whether the patient is ready and willing to see what I experience with him or her. Maybe all that is necessary is to feel deeply what is going on in the patient. This, in and of itself, is a communication. For where there is a deep sense of injury, part of the reparative work is to feel what the patient has felt in the past. Together we experience pain, rage, and a welter of affects. Involved in this curative as well as creative process, there is a release of energy needed. As one introject subsides, another looms up for both of us to encounter and experience. Over and over again I creatively attempt to access the distance and closeness of our relationship and determine the dosage that the patient can take of what I have to offer. At the same time, I am very much aware of my own personal battles and demons and try to separate them out from the art therapy relationship. What I do relate to has much more to do with what is induced by the patient and his work.

I encounter some difficulty in determining the kind and amount of images I choose to share with a patient. Some patients experience a sense of intrusion if there is any mutuality. In these instances, I wait until enough time has passed so he or she can test out his or her terrors within the more protective confines of his or her art work. I wait for an invitation. If none is forthcoming, I wonder if there are feelings inside of me that are interfering in our relationship. On the other hand, there are some who will only enter into an art therapy dialogue when and if I make the first overture. For a few, a self portrait may be the invitation required of me so that the overture can begin. Others might be intrigued or touched by a graphic gift. Each has his or her own starting point and demands all the consideration and thought that goes on in good child rearing.

In graphically expressing my own imagery, I am careful not to overwhelm the patient by my skill. Indeed, I show my past errors and ask for help. Yet at the same time, it is important that I am not a phony, for he or she will sense this immediately.

I deal with art imagery in myself differently, depending on the particular problem or issue at hand. I think of the very deprived child. The child that has minimal identification and a vacuum inside of him or her speaks of an

empty breast. Though he or she seems depressed, more accurately he or she is empty. My imagery and fantasies are used as a source of stimulation and engagement and at the same time supply the raw food for ego building. I can think of no better way of developing a sense of self then through sharing my imagery with the child. In contrast to the child who has been over-whelmed by a parent, this one will selectively take from me the images and fantasies that will enhance his or her own sense of genetic destiny.

A patient may make contact with him- or herself and learn through a mirror reflection of his or her own psychic processes. The direct confronta-tion and verbal dialogue is experienced as wounding. I think in particular of character disorders who fend off anything that is distonic or foreign. In these instances, I may outdo the patient's imagery and exaggerate his or her defenses, but give him or her distance and control.

One of the areas that lends itself very well to the use of mutual imagery sharing is work with children. Together we enter a world of fantasy and play. We exchange roles, models, and imagos. Together we loosen up, allow our fantasies to travel, and join in the art work. Sometimes I cannot do this. I must wait for consolidation of the ego that occurs through the art work before I can go on.

Yet play therapy should not be confined to children. Playing with fantasies and images is what art is all about. Adults may need a chance to act out in the safe confines of a therapeutic relationship where there is a joint living out of imagos and roles. There can be some release of inhibition and constraint.

As I view the art therapy relationship and its dialogue, the horizons that both patient and therapist can cross appear boundless. The limitation of this journey may well be the therapist's capacity to experience a whole range of difficult and complex feelings that may accrue either from the patient or from him- or herself.

I view the art therapist of the future essentially as a specialist in the creative process. Images and symbols are the everyday language of creativity. The art therapist understands the power of the symbol and utilizes this tool as a very special way of communicating. He or she recognizes that the image pulls together many levels of the psyche and can make a more accurate and complex statement of cognition than any verbal interpretation.

A Creative Arts Approach to Art Therapy

Arthur Robbins[1]

All of us are surrounded by the mirrors of our environment that reflect our perceptions of inner and outer reality. These mirrors first reveal themselves to us in our earliest infancy and continue to be reinforced, contradicted, and modified throughout our lives. What we ultimately possess from this dialogue between inner and outer reality is a frame of reference, a sense of ourselves in the world that becomes our basis of thought, viewing, or contemplation.

Sometimes when we see a particular movie, observe a dance, or hear the rhythms of a song, we catch a sudden glimpse of ourselves encapsulated in the unique expression of a particular medium. This phenomenon becomes important to us as an expressive therapist because it is our job to help patients construct or modify these mirrors which frame, organize, and contain the externalizations of elusive inner worlds. This task takes time as it is necessary to work through the reflections seen and to gain some degree of mastery and integration. The challenge for the therapist comes from the fact that just as a different song, dance, or piece of art will touch each of us, so too different media tap different layers of psychic expression. The part any given medium plays in relation to any given psyche varies with each patient.

Inherent in what I have said is the belief that art therapists can develop flexibility and range in the use of different expressive modalities. The reader should not, however, conclude that I am suggesting that all therapists must be all things to all people at all times. Therapists have individual limitations and a variety of sensitivities to different levels of nonverbal communication.

1 Part II of this paper can be found in *The Artist as Therapist.* (Robbins 1987), or in *The Arts in Psychotherapy 11*, pp. 7–14, 1984.

There are, however, some principles of nonverbal communication that form a common denominator regardless of the medium employed.

In considering the issue of choice of medium, a question that soon becomes apparent is what diagnostic considerations govern the change from one modality to another within a given treatment session. More specifically, are there particular organizing properties or qualities in any given ego state that might be enhanced by a particular modality? Traditionally, art has often been viewed as tapping more cognitive layers within a personality, while movement makes available kinesthetic or bodily experiences, and music evokes the more primitive affective layer reminiscent of the mother–infant dyad. Unfortunately, these neat therapeutic recipes often break down in actual practice, as art can be quite kinesthetic, while movement or music can stimulate visual images that are of a high intellectual order. For any one individual, a particular modality may produce a high degree of defensiveness, while another may encourage a sense of mastery or self-esteem. Ideally, a modality should frame and organize a particular therapeutic experience to control the degree of stimulation. The patient should be neither so under-stimulated as to lose his or her engagement in the process, nor so overstimu-lated as to become overwhelmed. Choosing a particular modality can be viewed within the context of the patient's ego state in the following terms:

1. The fluidity or rigidity of the defensive apparatus of a patient to a particular kind of stimulation, i.e., are the boundaries either overly permeable or so rigid as to block all incoming stimulation, and will the inherent properties of a particular medium reinforce or undermine this particular condition? One example is the use of finger paints with a borderline patient. In this case, use of the medium can reinforce a regressive pull towards fusion.

2. The level of object relatedness associated with any given patient's ego state. Care must be taken here in that this can shift quickly.

3. The inherent properties of a modality such as form, movement, affect stimulation, use of space, and cognitive involvement lend differing structures to the therapist–patient interaction.

4. The patient's unique response to properties such as those listed in 3.

5. The therapist's skill in offering a holding environment using any given medium.

The core issue in choosing any given modality for a patient is determined by the internalizations of early nonverbal, sensory experiences that he or she laid down as memory traces during formative years. Some examples that

might shape a patient's responses to various modalities are the rocking of a child in a parent's arms, the singing or cooing of a mother and child to one another, or the playful roughhousing of a father and child. Thus, the introduction of a modality may not only affect the ego resources of a patient, like the availability of conflict-free energy or the malleability and adaptiveness of defenses, but also may touch deep internalizations.

The therapist clearly must weigh several complicated factors in formulating a decision. As different pathological introjects are externalized and seek expression, a given medium may stimulate or cool down the therapeutic process. In the face of the tremendous amount of unneutralized affect being released, the ability of the medium to help the patient link up, or integrate various parts of the self must be considered, as well as the degree to which the medium will promote enough security to allow the patient to feel mastery and self-esteem.

The clinical case material that further clarifies this point of view can be found in either *The Artist as Therapist*, (Robbins 1987), or in the article 'A Creative Arts Approach To Art Therapy' (Robbins 1984).[2]

References

Robbins, A. (1987) *The Artist as Therapist*. New York: Human Science Press.

Robbins, A. (1984) A Creative Approach to Art Therapy. *The Arts in Psychotherapy 11*, pp. 7–14.

2 This chapter can be found in *The Artist as Therapist* (Robbins 1987), or in *The Arts in Psychotherapy 11*, pp. 7–14, 1984.

The Play of Psychotherapeutic Artistry and Psychoaesthetics[1]

Arthur Robbins

The Challenge

The institutionalization of art therapy began in the early 1970s, fulfilling our dream that the merger of art and psychology could play a meaningful role in the mental health field. In very short order, we art therapists promulgated standards, addressed ourselves to the entry requirements of our profession and argued about the scope and definition of art therapy practice. A good deal of our theory was adapted from other professions and resulted in a patchwork quilt of the psychology of creative expression, psychodynamics, and a broad sampling of the available therapeutic orientations. As was previously described in the preface, two main crosscurrents became prominent in art therapy education. Those professionals with a strong psychological background gravitated towards the notion that art was a bridge to the verbal dialogue that traditionally constituted 'therapy'. The artist/professional, on the other hand, became more involved in the healing power of the artwork itself, as an adjunctive contribution to the therapeutic team effort. At times, these two orientations pushed each group into an extreme position, with neither party able to see the overlap or similarities they shared with the other. Each orientation seemed to lack an organic synthesis that spoke to the sensibilities of the artist while at the same time incorporating important dimensions of psychotherapeutic theory. The challenge of our profession remains a formidable one: to develop a theory that truly reflects the complex dimensions of psychotherapy without betraying the artistic

1 Published in *The Arts in Psychotherapy 19*, pp.177–186, 1992

sensibility central to our work. This chapter will attempt to meet this challenge by drawing from the broad subject matter of aesthetics and integrating some of the basic notions of this subject within the context of object relations theory.

Then, a theory of treatment will be discussed that is largely psychoanalytic in nature and drawn from object relations theory. We will pay particular attention to the aesthetics of the transitional space, and give examples of creative psychoaesthetic dialogue. Here is the central idea of psychoaesthetics: therapeutic contact is an artistic process that evolves through psychotherapeutic play.

The Aesthetic Perspective

First, a definition of aesthetics seems in order. Traditionally, aesthetics is the study of beauty and its psychological effects, but more needs to be said about this, the word 'beauty' having become associated with mere 'prettiness'. Indeed, what interests us in art therapy is often not at all pretty. In a previous text (Robbins 1987), I referred to the art experience as one of transforming the inanimate into the the animate. So, what is 'beautiful' is what comes alive, whether in the artwork itself or in the transitional space between patient and therapist. If we are to include a concept of beauty in this framework, our focus will be on an inner beauty that touches the very depths of our understanding and responsiveness. Beauty then becomes associated with the transformational process in which the core of the patient sends a very alive and communicative message to the outside. In this transformational process, the plastic form of art becomes the medium of the art message, taking on a life of its own, and offering meaning and psychic existence to the viewer.

Ernest Kris' text *Psychoanalytic Explorations of Art* (1952),makes an enormous contribution to our understanding of the place of aesthetics in treatment. Kris views the work of art as an invitation to the mind of the viewer to reaccompany the artist in the creative process that was originally associated with the artwork. In this process, the viewer also contributes his or her unique creativity. The art form becomes a joint communication, indeed a very deep and meaningful communication, characterized by a merger of the artist's creative process with that of the viewer.

Within this aesthetic perspective, the creative arts therapist approaches the therapeutic work of treatment with a psychological orientation and with an understanding of the underlying influences and conflicts that affect the aesthetic process. This understanding includes a diagnostic sensitivity to the problems of the creative process; further, it includes a notion of the conditions that are necessary to heal the creative process of the patient. Thus, working

with a variety of art forms and offering patients a variety of creative holding environments, therapist and patient enter the playground of what I term the psychoaesthetic experience.

Resources and Sensory Flow

The creative arts therapist brings to the treatment process a familiarity with the language of art, which contributes to a perceptiveness and sensibility in responding to the aesthetics of the treatment dialogue. This language relates to the structure of art works. It is the sensitivity of the art therapist to such issues as form, color, space, texture and the inherent organization of these qualities, that will contribute a unique and penetrating perspective to the psychotherapeutic process. During this patient–therapist communication, sensory channels become potential organizers of images which offer us clues and guidance in the process of shaping and reshaping transference and countertransference material. For instance, the images formed in the thera-pist's mind during the treatment process may mirror significant affect states experienced in the past by the patient. When this occurs, the therapist can consider that the tone, inflection and cadence of his or her voice may have enormous bearing on the ability of the patient to process the transference/ countertransference relationship.

For creative arts therapists, the use of the eyes becomes an important diagnostic indicator that offers guideposts for therapeutic contact and responsiveness. We can use our eye movements to map out the patient's psychic territory of self and other. Our eyes tell us if the patient feels swallowed up or lost as we focus on the center. At times we cannot find the center as our eyes bounce to the outside of the art form. Sometimes our eyes get lost in the pieces and fragments. We can also experience the complex relationship of form and color. Colors can capture the essence of affect states. At times form chokes off color, or at other times, color can completely distort the art form. We can see the surface of the art expression and its relationship to the inside. We can ask ourselves whether the skin of the art piece is glossy and hard and makes access to the insides of our patients difficult. Similar analogies can be made with other art media. What happens to our kinesthetic sensitivity when we encounter our patient's movements and what do we hear as we listen to the music and sound of our patients?

A sensitization to nonverbal cues appears to be a prime requisite in understanding the flow and shape of therapeutic material. Hearing the sounds behind the words, sensing the visions that erupt out of communica-tion patterns, feeling the body tensions that stem from the transference/ countertransference relationship are all part of the psychoaesthetic experi-

ence. This sensory flow has its own rhythm, and our ability to immerse ourselves in this space becomes a personal and artistic challenge. If nothing else, we must use our gut feeling for what is going on between our patients and ourselves. Pertaining to the felt experience of the transitional space, we must ask ourselves: Is it heavy or light? Does it have color? Is there a musical tone to it? Does it feel like three-dimensional material? Does it organize itself into an image? The task, then, is one of knowing and apprehending through the senses. Once we immerse ourselves in the transitional material, sensing its pliability and texture, we must slowly let the material speak for itself. In so doing, a shape emerges for us that takes its form in interpretive intervention.

Finally, the choice of art medium or modality, by the very nature and composition of the material (rigid or fluid) contributes as well to defining the holding environment.

Primary Creativity and Transitional Space

The work of psychoanalytic theorists such as Winnicott (1971), Rose (1987) and Ehrenzweig (1967) contributes to the ideas behind this paper, but it is Winnicott's notion of primary creativity that is the central organizing force: the idea that the 'space' which the mother forms with her child is not an inside or outside space but something in between. This is a place where two minds meet in a shared reality, but it is more than a cognitive resonance, for it is kinesthetic in character, highly fluid in motion, and charged with a variety of affective states. Originating within this space, mother and child establish a bi-polar relationship of oneness and separateness, oscillating back and forth, feeling and being in a state of formlessness and union and then emerging into form and differentiation. Feeling and being in this ego rhythm then becomes the basis of an atttunement between mother and child. This ego rhythm also becomes the source of a life-force, making connection between the child and the 'other'. We will see or hear this rhythm, this action of oscillation, again and again in our discussion of several bi-polarities, including being/meaning, gratifying/frustrating, mirroring/interpreting and so on.

This life-force, characterized by a process of taking in and assimilating experiences, being shaped and reshaped by developmental crisis, represents a potentiality for relatedness and creativity. It has all the characteristics of primary creativity but now becomes a built-in potentiality of our character structure that can be stimulated or stifled by the vagaries of our life destinies. This place becomes the meeting ground that can best be approached through play and where imagination stemming from our deep source of symbolism

and images becomes shaped and reshaped as vital links to the outside. This space (originating in primary creativity) I will refer to as 'transitional space,' which ultimately must be developed in treatment.

The art form becomes an important meeting ground of patient and therapist and also serves as an organizer of this space. Again, I wish to emphasize that transitional space can be viewed as multi-level and interrelated by different ego rhythms that are shaped and formed from modality to modality. The therapist, on the other hand, facilitates the flow of contact between these various levels and moves from one level of expression to another. Consequently, the ego rhythm of a therapeutic relationship that is largely verbal in nature may be quite different when experienced through a nonverbal modality.

As so aptly stated by Ehrenzweig (1967), pathology occurs when primary creativity has gone wrong. In treatment, our therapeutic task is rediscovering primary creativity through therapeutic play. As we work with our imaginative resources and the fears, resistances and problems of the patient, transitional space becomes the therapeutic workspace of treatment. Here we jointly struggle with getting in and getting out of this transitional space, with the aid of the symbolic resources of both patient and therapist. In Winnicottian terms, when patients cannot play, we help them learn how to play.

Being and Meaning

We struggle together with our patients to establish a deep sense of mutual oneness reminiscent of both the experience of the artist merging with his or her medium in one phase of creation as well as the primary creativity of mother and child. We also learn how to work with our patients in giving shape and form as well as differentiation to this state of oneness so that we are constantly fluctuating between the two ego states of being and meaning, going from one to the other according to the rhythm of our patients. The state of being is often expressed through intonations of voice, postural and facial expressions, and kinesthetic responses. This quality of nonverbal relatedness is a manifestation of the primary process that appears to fuel the whole movement of treatment. This state of being is a state of oneness with another.

We also work with imparting structure and form as well as differentiation to this state of being. This form can be facilitated by the structure of a therapeutic relationship or the variety of parameters inherent in a particular art medium. Structure and differentiation then become the other pole: a state of meaning which connects the inside life of the patient with the outside world.

Being one with the patient, then separate, then one again, becomes a challenge that demands openness, fluidity, and sensory attunement. Often, the particular type of resistance manifested by our patients will make it difficult to create one or the other state. Characteristic of profound pathology are toxic communications which are dysrhythmic, unpredictable, and dissociated. These communications are difficult for the therapist to contain and organize. Most often, the therapist is thrown off center, losing the connection between mind and body that provides a personal sense of balance. Often the therapist finds him- or herself unable to move out of a closed, restricted space, shared by the patient, which can be characterized by over-identification, remoteness, or some combination of the two. This stance makes reaching an attunement virtually impossible. The therapist who develops a variety of techniques for processing toxic communications will be able to regain his or her own therapeutic center. An elaboration of this topic will be discussed later in the paper.

Form/Formlessness

As we move towards the experience of oneness, the stress of meeting the demands of outside reality recedes and there moves into its place a deep sense of healing and restoration of the self. Most artists will report that dipping deep inside one's self is often a deeply gratifying process. If creation of mutual oneness acts as a source of gratification, it stands to reason then that frustration may arise when this state is disrupted by the form of interpretive intervention which creates separateness. Structure and interventions help patients challenge reality. Yet there are always balances to be met that oscillate between the healing of the self and the meeting of the challenges associated with reality. In an ongoing treatment process, we are constantly creating new interpretive forms that emerge out of this place of oneness. Providing structure becomes an extremely important part of psychotherapeutic artistry. How, when, and in what way are we to shape the material? Change becomes intrinsically related to the creative process as we provide a climate for the patient to dip into a state of formlessness and then move into form; sensations merge towards internal structure, creating action that becomes part of a creative, aesthetic, therapeutic communication. This oscillation between form and formlessness becomes a mutually creative process of treatment. At first, the therapist is in charge of this joint artistic endeavor. Later, patients take over the process and determine their own movement from inside to outside. Consequently, therapeutic technique must not be taught as a series of maneuvers, or learned technical procedures, but must originate in the authenticity of the therapist. I define 'authenticity' as

an experience in the patient of an inner availability on the part of the therapist, co-existing with respect for the boundaries of treatment. Authenticity is thus bi-polar also. It 'resides' in the therapist, but is experienced by the patient.

Within the therapeutic workspace, the art form of the patient is expressed through the transference. The transference may be expressed within the interpersonal relationship, often through words, or within the nonverbal modality, or more often, through interaction on both levels. Here, the patient's attempt to master trauma creates an artistic expression of his or her developmental conflicts (Rose 1987). By contrast, the art form of the therapist is far more mobile and fluid, constantly adjusting to the developmental resistances and fears that emerge in the treatment process. It is the role of the therapist to present new possibilities so the patient can discover his or her authentic rhythm. I define this as the patient's constitutional thrust for creating new patterns of oneness and separateness with his or her environment. Art and the treatment process have in common that each offers an opportunity to project disparate elements of the self into a container, be it an art medium or therapeutic relationship. Then, through a process of scanning, as well as the organization and reorganization of these projected elements, an art form emerges. As the artist/patient moves from an inside state of oneness with his or her material to an outside state of giving form to formlessness, we also observe a movement from a state of being to one of knowing. By doing so, both therapist and patient become one yet separate, each sharing the creative process of the other. On occasion, one or both parties will build up defenses and barriers against sharing this joint message. In most instances, the therapist joins the patient in giving shape to the creative message if by only offering consistency, structure, understanding, acceptance and concern as basic ingredients in the holding/healing container of therapy. This interaction between therapist and patient has all the elements of an aesthetic process that moves from form to formlessness, oneness to separateness, and is experienced on a number of complex and interrelated levels of consciousness.

Bad art superimposes a form on material. This usually occurs in therapy when there are countertransference resistances that interfere with the therapist's artistic rhythm. When this happens, the therapist superimposes an alien form upon a patient's material, thereby introducing a toxicity that prevents the authentic patient/therapist alliance from producing its own true form. We can use the analogy of stone sculpture: the artist never fights the stone, but highlights and emphasizes what is already there. When an attempt is made to force the stone into an alien image, the resulting sculpture never

materializes its own organic form. To make another artistic analogy, in our work we observe resonance and shape being amplified through different rhythmic compositions. We might shape the resonance we experience through offering a metaphor, or through presenting a linear interpretation. In one or a series of sessions, a theme might be amplified until it runs its course, while another theme slowly emerges. Along the same line of thinking, we might play with positive and negative valences; for example, some themes need expansion, or a repetition of the material through different empathic resonances. Polar opposites of affect, idea, or sensory input might evolve into a dynamic interplay of forces, creating a gestalt to which the therapist can respond. Depending on the nature of this gestalt, a decision is made as to the needed mix of empathy and confrontation. Of course, each patient/therapist dyad has its own toleration level for conflict, contrast and empathic resonance. If there is too much balance, there is no therapeutic tension to set the stage for change. On the other hand, when the communicative material is too much out of balance, both therapeutic parties will have a difficult time moving towards homeostasis. Treatment interventions are then directed toward bringing about a better balance or realignment of the communicative gestalt. That the therapist's basic artistic thrust is toward offering interventions that feed the life and dynamism of communicated material is the underlying premise of this therapeutic approach.

We refer back to the sensibility of the art therapist as being defined by his or her ability to respond to both the nonverbal and verbal elements of the therapeutic relationship, both within and outside the modality. This responsiveness is both artistic and aesthetic in character and directly responds to the creative process of the patient with all its deficiencies and strengths as well as its different levels of organization. In short, the art therapist constantly responds to the structure of the therapeutic art form, the interplay of form and formlessness or the differentiation and nondifferentiation of fragments of the self that are projected into the transitional space, and into the artwork. In this oscillation we can observe a deep unconscious expression of the core of the self that goes beyond words and images, indeed beyond a conscious sense of knowing. In this expression the patient touches and feels colors, fragments, and sensations. This is the province of the pre-symbolic self, the part of the personality that approaches a state of formlessness where energy, light and color connect the patient to a universal stream of consciousness. When the deepest level of the core self is touched through the art expression, there are connections to universal archetypes and levels of meaning that go far beyond one's individual existence. This is the province of the artist that is potentially found in every patient: a place where aesthetic

expression offers a sense of knowing that goes beyond words and joins us all together.

Empathy/Interpretation

I have placed a good deal of emphasis on the mix of empathic resonance and form. By so doing, I have also described the subtle interplay between gratification and frustration. The precise dosage of gratification and frustration promotes the identification process of the patient with the therapist (Behrends and Blatt 1985). The patient retains a memory trace of a previous gratifying experience while he or she experiences separation and loss through the introduction of interpretations. The internalization of the therapist's creative process then becomes the fulcrum of growth for the patient. As this new self-object takes hold, the patient is finally able to experience life creatively and therapeutically. He or she is also able to search out new mirrors to reflect this different experience and finally leave behind the previous, stereotypical manifestations of repetition compulsion.

Pathologies and Aesthetics

I will cite a few examples so that we can better understand how character formation, developmental conflicts and defenses can profoundly impact the art forms produced by patients. In the case of the extremely disturbed patient, such as the schizophrenic, fragments of the personality may be projected on to the art form but the result has little to do with the creative process. In these cases the projections provide a screen or a defensive barrier against the flow of contact from inside to outside. In other terms, primary process expression becomes a defense against secondary process expression. Projected elements, when expressed in the art form, lack the vital order and centrality of self-organization. The question still remains: Why is the patient unable to use these elements as part of his or her creative expression? Most often, these patients have enormous difficulties in experiencing a state of oneness, as this state is associated with fears of annihilation and death. The invitation to experience a state of oneness does not open up creative communication. Indeed, when we are too vigorous in our attempts to be one with these patients, we may observe further fragmentation and disorganization of the personality. Paradoxically, these patients have enormous thirst for symbiotic relatedness, but also require a firm and clear structure that offers distance and protection from fears of being engulfed or destroyed.

The problem of oscillating between the ego states of oneness and separateness then becomes the focus of therapeutic interventions. For in-

stance, some patients are highly defended in their ability to move from one state to another. Thus some will be lost in a state of oneness (more aptly called fusion) and unable to gain the appropriate balance in moving to and from a state of differentiation. Fusion creates a loss of the self whereas in the state of oneness the self expands even as we feel also a sense of unity. Patients with problems of impulse control, object constancy and narcissistic injury may both crave the state of fusion and have enormous fears of being separate. Other patients have difficulties in scanning and reorganization. While some are frightened of being in the state of oneness, others are only too happy to be lost in a fusion state. In each case, the creative arts therapist offers a structure or holding environment that presents the necessary aesthetic ingredients to balance the flow of energy.

Each manifestation of pathology represents an example of primary creativity gone wrong. Some further examples come to mind regarding disturbances of patients' ego rhythms. With the borderline patient, we observe that the form level breaks down as they move towards the state of form and differentiation. As the patient approaches the anxiety of separateness, we can see the form level deteriorating and a movement back into a state of pre-differentiation. Some clarification may be needed regarding form level. The form represents a permeable boundary going from two different states of existence, for example, the inside and the outside. When the form level becomes excessively rigid or blurred so that the creative flow is interfered with or stops, we then observe a break in the form level.

We can also observe narcissistic patients presenting enormous preoccupation with the inside even though they are at a loss and at times frightened of exploring the interiors of the self. As these patients struggle to comprehend the meaning of the self, and require an aesthetic mirror, this comes at the cost of being involved with the flow of movement from an inside space to an outside other.

By contrast, we can observe obsessional patients becoming lost in an enmeshment of form that protects the patient from experiencing formlessness. Indeed, the preoccupation with the formal details of expression often cuts off any spontaneous expression or creative rhythm of the self.

Colors can serve as a shallow defense muddying up the flow from inside to outside. We observe this in hysterical character styles that utilize affect states as false offerings as 'red herrings', defending against any real encounter with the therapeutic process. Thus, each particular character formation creates its own problems of flow that demand a very creative form of therapeutic interaction. Perhaps, in the near future, creative arts therapists will develop a diagnostic framework that could match with some accuracy

the range of disturbances in aesthetic form and ego rhythm with implications for treatment.

We can also apply the principles of aesthetic form as a means of exploring countertransference issues. I refer to a previous publication, Expressive Therapy, (Robbins 1981), which illustrates the principles of therapist self-exploration. In this example, the therapist explores her feelings regarding a particular patient through an artistic clay experience. The aesthetic form that was associated with her work opened up the issues of countertransference conflicts and disturbances. In the text, The Artist as Therapist (Robbins 1987), disturbances in art forms provide a key to the therapist's management of a short-term group therapy experience.

The Aesthetics of Transitional Space

In many respects, I have described an ideal therapeutic situation as moving with relative ease between states of oneness and separateness. More often than not, however, therapists are out of rhythm with patients, feeling confused, perplexed, overwhelmed, and certainly not always available to just 'be' with them. Within this situation lies the potential for a transitional space to be transformed into a creative work space. The projective affects are the projective bits and pieces that lie within our patient that are neither assimilated nor integrated into a form over which the patient has any degree of mastery. Then the creative process of the therapist is called into play. How do we assimilate and hold on to these pieces? How do we give them order and shape in our unconscious so that they merge into an image? How do we mirror and reflect back these pieces so that the patient is neither frightened nor ashamed nor made anxious by these pieces, but learns to accept them as parts of him- or herself? Our approach to the questions becomes part of the transformational process. To the degree that our own creative process is called upon to move deeply and assimilate these pieces without projecting them back to our patients, we may model for them an internal order. We offer a loving mirror to our patients either through our very presence or by working with them in a particular modality. The transitional space is no longer just a meeting of the minds but a place where creativity is rediscovered by both patient and therapist working very deeply and closely with one another.

Evaluating and ascertaining the most easily assessible level of consciousness of each patient becomes possible. For instance, some patients are more effectively contacted through a meditative, spiritual approach that is less conflict-laden than a more direct verbal encounter. Discovering the level of therapeutic contact which can be most productive is based in large part upon our aesthetic appreciation of the patient's psychic organization. The thera-

pist's sensitivity to a particular artistic language may also play an important role in this determination. In all instances, however, the therapist attempts to provide a link between multiple ego rhythms and levels of consciousness, sensing where there is greater flow, moving in and away from conflictual material and making multiple determinations as to how and when to process the developmental conflicts that are seen to affect aesthetic form.

Crucial to this entire theoretical position is the issue of therapeutic flow. Transitional space moves in and out of positive and negative valences. Besides the flow from form to formlessness, there are whole dimensions of the use of space, color and texture that provide a movement from one level of expression to another. The creative arts therapist, sensitive to areas that are repetitive, frozen or dead, creates a frame for the regeneration of life and energy as well as movement.

What are the specific issues that the therapist encounters in dealing with frozen, dead or noncreative transitional space? At times we must call upon our understanding of ego psychology, object relations theory and self psychology to help us find some guidelines. Rigidity of form, depth of impoverishment, and hunger for an attachment are all important therapeutic considerations. However, our cognitive theoretical guidelines cannot be separated from a nonverbal attunement to transitional space. By this I refer to our feeling of being one with our patients, accompanying them in the act of becoming as well as sensing their individual quest for meaning. We also go through a process of assimilating and experiencing our patient's imbalances, encountering their creative blocks and resistances and allowing these forces to live inside of us. To the extent that we take in the pain, resistances and fears of our patients, and avoid the inevitable countertransference resistance of projecting toxic material back to our patients, we will then be able to provide a more accurate mirror for our patients. I refer the reader to the chapter dealing with transformational process in The Psychoaesthetic Experience (Robbins 1989) which elaborates this further.

In each therapeutic encounter, we create a holding structure that either mirrors, resonates or balances the flow of aesthetic material from our patients. For some, we offer a quiet sense of our presence as they gradually assimilate our centeredness even though we may both be living in chaos. We feel and experience their disorganization but still maintain centeredness. Some of our patients may require a much more lively engagement as stillness may be associated with complete absence of another being. Other patients lock enormous energy and conflict in their bodies while the art form on a visual level expresses deadness and stereotyping. In these instances, the therapist may focus upon the patient's body, assimilating and digesting the body

representation of the patient. The creative challenge then becomes one of mirroring back this assimilated representation in order for a dialogue to begin between the body self and the psyche.

Mirroring takes in a variety of forms. We mirror body postures as well as emotional tones and resistances. Our mirrors may tap deep hidden shadows of the patient that hunger for expression and dialogue; for some, the mirror may be a simple reflection with a slight modification of the reflective image that sparks the flow of inside to outside. This an important part of therapeutic artistry. The depth of our reflected mirrors becomes an artistic challenge that is constantly modified and changed as the patient grows. We are creating a variety of holding environments which facilitate mirroring. Thus, how closely we hold, how much space we offer, how deeply we mirror, are all part of an intuitive cognitive decision.

In each therapeutic interaction we observe the results of our interventions. Often in hindsight, we assess the impact of our work and observe either a deterioration of form level or further movement towards differentiation. In each case we must ask: on what part of the creative process do we place our focus? The overriding thrust of treatment remains clear even though from time to time we become lost or confused in our therapy. In this psychoaesthetic approach to treatment the division between words and images becomes an artificial one. In each instance we are assessing how the aesthetic expression furthers the development and regeneration of ego rhythm. Consequently, for some patients words are an intrusion while with others they are an important structure to rely on to access the boundary between the inside and the outside. Images help, though it is easy to get lost in images if they do not have ready attachments to the outside world.

Examples

Two examples are offered illustrating the flow of aesthetic expression in the art form playing within the context of the therapeutic relationship. These sketches are thumbnail at best and are presented only to illustrate and clarify what the author means by the play of aesthetics in the art therapy relationship.

A fifty-one-year-old woman has been in therapy for approximately three years on a twice a week basis. She came to treatment because of feelings of inadequacy as a theatre director. She expresses an enormous sense of disappointment in herself regarding a childless marriage and a style of life that has made her a wanderer in the world with few roots or deep lasting friendships. Her early family mirrors these issues. She had a rather retiring mother, who spent her life furthering the narcissim of a self-centered actor

father. This patient spent much time in private schools and has an early history of much family movement and a series of substitiute mothers.

The patient expresses feelings of being lonely, lost and disconnected. Yet, she does not produce empathy in me but a mild sense of irritation and being controlled. The patient has recently returned to New York City after a series of out-of-town engagements. She is experiencing a dread of the city, which she likens to a feeling of returning to a dark hole. The patient from time to time has painted in water color and drawn in pastels and I encourage her to explore her feelings when she is at home. During the subsequent weekend she finds an old drawing pad and fills up the pages with paintings. She comes in and says nothing but offers the notebook to me. I return the book and encourage her to share her material and find her own voice that expresses the sentiments of the art form.

(a)

(b)

Figure 4 (a) Art without the blob (b) Art with the blob

As she goes from page to page, the patient laments that invariably she introduces a blob of paint that overdoes the simplicity of the expression and destroys its essence. I playfully wonder out loud why she can't let go of the blob. 'As in my work,' she states, 'I am so frightened of criticism and judgement that I can't leave well enough alone.' Memories of her father's criticisms and attacks soon follow and she comments that she invariably gets attacked even today if she comes on too strong. I point out many instances where her directness and forthrightness have simplicity and power in her life, just as they do in her art form. She is pleased by this but wonders whether it is really possible to be out there so alone and naked. I reflect back and state that her art work is like a haiku poem, the power of which lies in its brevity and poignancy. In these brief moments, we meet in the art form and the transitional space that arises in our mutual understanding of the pain of being there, making her statement to the world and being so open and vulnerable. The session ends with my appreciation of her art expression and the meaningfulness of the exchange. Our words have a touch of poetry reflecting the art form and a shared subjective reality. The patient this time leaves her father out of our space and goes home with a quiet sense of pleasure. The space between us gains a sense of aliveness and authenticity and the blob recedes in the distance.

In the second illustration, a forty-two-year-old architect comes to treatment with feelings of depression and isolation. Now, five years after our initial contact, he has made remarkable gains in the professional world but is still terrified of intimacy with women. He is a workaholic and seeks prestige and professional recognition as proof that he is somebody and is worth something. Yet, he is terribly frightened of being vulnerable and opening himself up to possible scorn and derision. He comes from a large family of eight children where both parents were busy with their professional lives. As the youngest child he was often mocked by his brothers as the cry baby who couldn't hold his own.

I mirror, support and occasionally challenge him regarding his defenses of detachment, criticalness and the defensive derisiveness he turns on anyone who gets too close to him.

In a recent session he has little to say and feels bogged down in his despair and his inability to get close to women. I encourage him to pick up a pastel crayon and let his hand express his inner voice. 'Don't think what you're going to do. Don't judge it. Let your hand just follow its own course and when you see an image arising give it some shape and form.' He gets intently involved in the drawing and tells me about it after it's completed. 'The man in the circle,' he says, 'is both myself and my father locked in a circle trying

to get on the top of the heap. I know I should get out of this circle but have no way of finding any way out.'

Figure 5

My eyes are drawn to the two circles; the crossed-out one may represent the emergence of a self that is trying to escape but has no counterforce to give it balance or meaning. It is something that is simply crossed-out, as I believe the authentic self is in this patient. I point this out and wonder whether he could really find some use for the crossed-out circle. 'There must be some use to this,' I comment, 'Perhaps he could fill this in with the real missing pieces of his life.' 'I know,' he says, 'that the woman I want will be loving and there for me. At times I think I really know who she is, but then it eludes me.' I point out to him that in the few instances when love is offered to him he devalues and depreciates the relationship. Those crossed-off lines represent his fears of really filling in the circle with love and care. He reflects about this and agrees and then says 'I'm so scared of opening up and knowing what it's all about.' I respond that that is true for many of us. In a shared transitional space, we engage his vulnerability one inch at a time, my

becoming his self-object, and he becomes more capable of internalizing a good object that permits him to be seen, heard and to become alive. Though never mentioned, the heap that he describes seems like a massive bird coming out of an egg and I wonder if something will be 'hatched' in him that will give him power to fly. Right now it looks like a mysterious presence emerging out of a smoking mass. It is the biggest object on the page. You cannot take your eyes away from it and yet I do not believe that there is enough of a dialogue with it, in aesthetic or psychological terms. This may well be the mythical powerful mother that the psychic traveler must conquer, and yet I believe it represents both an aesthetic and psychological trap. The figure of himself and his father sits there unable to move out of its enclosed circle. Our eyes are drawn inward to the mouth of the hidden bird and the only thing that has space is the discarded circle floating above the two.

Conclusion

In each of the illustrations there are varying levels of aesthetic engagement where two minds join and work together. The problems that we face when we are no longer emotionally present with our patients in the art form, and the therapeutic play that arises out of this experience, create the aesthetic challenge for both patient and therapist. Reconnecting in the therapeutic workspace, then, becomes aesthetic play, while the art created in this interaction becomes regenerated messages of the self, which take on new meaning as they meet the outside world.

For many creative arts therapists, responsiveness to the content of a therapeutic communication rather than to its aesthetic structure will have far more meaning and impact. For some, starting with the content may offer a more intuitive connection to the patient's problems. Ideally, structure enhances content, while content may help us understand some of the underlying issues regarding the structure of art. As creative arts therapists, it is important that we value and enhance our psychoaesthetic sensitivity to our patient's communications. This is our unique contribution to the mental health field. I refer to our sensitivity to aesthetic form and its inherent meanings as well as our ability to play with these forces. Within this theoretical framework, the definition of practice is not determined by our use of one modality or another or our reliance on words. It is the language of the artist and our sensitivity to the aesthetics of the art form that may well define the level and scope of our work.

For many creative arts therapists, the language of movement and the language of visual art are interrelated and they can move from one level of consciousness to another. Others will be more comfortable with and sensitive

to one particular language of art, though other forms of aesthetic expression may offer at least some conversant value. In terms of this paper, our engagement with aesthetic process and its inherent psychodynamic meaning becomes the organic definition of therapeutic practice. The merger of the language of art and the language of psychodynamic expressions can speak to the very soul of the creative arts therapist. In this paper, I have attempted to illustrate how the aesthetics of therapeutic play interface with the aesthetics of the therapeutic message. Our artistry is our strength and contribution to the therapeutic scene.

References

Behrends, R.S. and Blatt, S.N. (1985) Internalization and Psychological Development Throughout the Life Cycle. In A.J. Solnit, R.S. Eissler and P.B. Newbauer (eds) *The Psychoanalytic Study of the Child*, 40, 11–39. New Haven: Yale University Press.

Ehrenzweig, A. (1967) *The Hidden Order Of Art*. University of California Press: Berkeley and Los Angeles.

Kris, E. (1952) *Psychoanalytic Explorations of Art*. New York: International University Press.

Robbins, A. (1981) *Expressive Therapy: A Creative Arts Approach to Depth-Oriented Treatment*. New York: Human Science Press.

Robbins, A. (1987) *The Artist as Therapist*. New York: Human Science Press.

Robbins, A. (1988) *Between Therapists: The Processing of Transference–Countertransference Material*. New York: Human Sciences Press.

Robbins, A. (1989) *The Psychoaeshetic Experience: An Approach to Depth-Oriented Treatment*. New York: Human Sciences Press.

Rose, G. (1987) *Trauma and Mastery In Life And Art*. New Haven: Yale.

Winnicott, D.W. (1971) *Playing and Reality*. New York: Basic Books.

Further Reading

Bollas, C. (1987) *The Shadow of the Object, Psychoanalysis of the Unthought Known*. New York: Columbia University Press.

Confer, W. (1987) *Intuitive Psychotherapy*. New York: Human Science Press.

Freud, S. (1928) Dostoevsky and Parricide. Standard Edition 21, 177–99. London: Hogarth Press.

Grunes, M. (1984) The Therapeutic Object Relationship. *Psychoanalytic Review Sp 71,(1) 123, 143.*

Resistance in Art Therapy
A Multi-Modal Approach To Treatment[1]

Arthur Robbins and Barbara Cooper

Introduction

Therapeutic models of treatment roughly fall into four major categories: Drive Psychology, Ego Psychology, Object Relations, and Self Psychology. Each theory attempts to organize therapeutic data under a central organizing principle that not only helps us understand each case but offers, from this understanding, a methodology, of interaction with our patients. Regardless of this understanding, therapeutic communications may either flow or stall into a period of stagnation that is characterized by stereotypy or repetition. When the latter occurs interventions are required to improve therapeutic flow and processing. Each model offers us clues and guidelines that may help us remove these resistances. The organization of patient art along with transference and countertransference phenomena lend themselves to a particular model of treatment. This paper will attempt to clarify the variety of differentiations that lead us to adapt different therapeutic models and the variety of therapeutic interventions that are associated with this understanding.

The Multi-Modal Approach

The multi-model approach to treatment has been extensively elaborated by Pine (1990), who roughly divides models of treatment into drive theory, ego psychology, object relations, and self psychology. Lazarus (1976) also uses the term 'multi-model', but his orientation is heavily behavioral and cognitive. The authors of this paper recognize that different models of treatment

1 Originally published in *Art Therapy*, vol 10, pp. 208–218, 1993.

and their particular languages may speak more or less eloquently to each therapist, depending on his or her particular personality. Yet regardless of the therapeutic orientation of the therapist, all patients resist therapeutic process. The intent of this paper is to present a broad framework for resistance work that is not imbedded in one particular therapeutic school or another.

Four Models of Resistance

Resistance can be viewed as any psychic obstacle that interferes with therapeutic process. The concept of resistance was originally developed in drive psychology, and remains fairly central in each psychoanalytic framework, having taken on new meanings in the contexts of object relations theory, self psychology, and ego psychology.

1) Drive Psychology

Drives are energetic expressions of sexual and aggressive tensions. Patient communications are funneled towards the expression, organization, and mastery of drives and/or their equivalents. Affects of guilt, shame and anxiety that are associated with defensive operations lead to resistances and are lowered through therapeutic interventions. Integration of drives in one's functioning becomes the central theme of this treatment model.

From a drive psychology perspective, the therapist works with the patient to make resistance ego-alien, and thus lessens the obstacles to the treatment process (Fenichel 1934). Within a drive psychology framework, the focus is upon the patient's integration of drive material into his or her everyday functioning. Resistance occurs when the patient feels overwhelmed and frightened by drives and becomes defensive. But the pioneers of treatment did not foresee that resistance work could, on occasion, be experienced by the patient as critical and unacceptable. Direct confrontative resistance work can cause even more pronounced resistance. Perhaps in reaction to the limited classical appreciation of resistance, Moustakas (1974) reframes resistance as the psychological protection developed by a patient to preserve an inner sense of ego integrity. Consequently a respect for the adaptive importance of resistance enters the treatment process.

2) Object Relations

Therapeutic work is organized around issues of internalized relationships (objects) that are associated with fears, longings or conflicts around attachment, loss, and the process of separation and individuation. Interventions are focused in the area of abandonment and loss. The constancy of the real

relationship and the structure of art making becomes an important piece of the reparative process.

From an object relations perspective, resistance calls for a variety of holding environments which, it is hoped, will increase the patient's ability to tolerate the vagaries of object attachment and loss (Kernberg 1976). Personality is organized by a series of early relationships that are internalized, both unconsciously and consciously. These relationships are constantly repeated in the present, and therapeutic challenges to these embedded patterns create fears of abandonment. In an object relations framework, the therapist creates a 'good enough' holding environment, within which the patient can internalize both the strength and perspective of the therapist, thus becoming more able to withstand the problems of change. Defensive patterns of resistance to treatment are resorted to when fears of abandonment become overwhelming.

3) Self Psychology

Under the psychic construct of the self that represents our interests, values and attitudes, interventions are directed towards affirming self-cohesion. Anxiety represents a threat to the self and interpretations are organized around mirroring and supporting the self.

From a self psychology perspective, appropriate mirroring or empathy reduces resistance and facilitates treatment (Kohut 1971). By mirroring, we reflect back to the patient the dissociated parts of the patient's self. This mirroring is both cognitive and affective. It is expected that the patient may go through an idealization process, perhaps creating a transference/ countertransference relationship marked by 'twinship'. ('Only you and I understand each other.') When treatment bogs down, the problems can often be traced to a lack of empathy on the part of the therapist. Resistance is ameliorated when the therapist responds to the patient's communications with appropriate empathy or mirroring.

4) Ego Psychology

The therapeutic focus is placed on reinforcing the adaptive abilities of the patient that are consistent with their developmental maturation. Interventions are directed towards enhancing the patient's ego resources that are intimately related to self-esteem issues. The ego represents a series of functions that integrate for the patient inner and outer reality demands.

Ego psychology can encompass both behavioral therapy and cognitive therapy, and offers as well a developmental perspective on the patient's ego

adaptational conflicts with reality. Treatment centers around the management of reality and the reinforcement of more effective ego-based coping mechanisms. Included in this orientation are such techniques as offering therapeutic contracts, supporting and improving ego skills, and creating models of identification which improve social effectiveness. In working with art, the specific skills necessary to make meaningful art are reinforced and supported by the therapist. Within the context of ego psychology, resistance occurs when the therapist demands behavior or relatedness that is inappropriate to the patient's developmental level (Hartmann 1939). In these instances, the patient's competent functioning and self-esteem are considered pivotal in treatment. Supplying appropriate developmental tasks and emotional support becomes the therapist's goal. Resistance occurs when the patient feels overwhelmed by developmental tasks that are inappropriate to his or her skills or cognitive and emotional integrative ability.

Art Diagnosis

The challenge for the art therapist within a multi-model approach is manifold. First, an assessment of the artwork in terms of its developmental level and defensive organization will be necessary. Second, we must take into account the meaning of this organization within the context of the transference/countertransference relationship. Third, we must develop a series of interventions that lessens the patient's resistance and increases his or her ability to be therapeutically present in the treatment relationship. Psychoaesthetic organization in artwork informs a diagnostic perspective with therapeutic implications.

The artwork of patients who respond most readily to an ego therapy model often presents material that seems to 'float off the page' (see Figure 8). The artwork lacks grounding, and does not seem connected to the outside. We see problems in creating a gestalt and a tendency towards fragmentation. Such skills as judgement, planning, and the capacity for symbolic abstraction are not apparent in the artwork. The material seems obvious and at times, stereotyped. This visual organization parallels such a patient's behavior. These patients are overwhelmed by reality and present to the therapist feelings of inadequacy and low self-esteem.

An object relations framework will prove useful when we see artwork in which the structure of the artform shows enmeshment of two forces 'fighting' one another. Our eyes move to the center and then are bound or trapped by an outside force. The usual oscillation of the eyes' movement from inside to outside and back is inhibited. In contrast, when there is true object constancy, we observe a fairly clear flow of in and out in the artwork. From an art

structural perspective, the flow of energy toward the center is thought to represent the self, while the horizontal and vertical axes represent the object. The flow of energy in the artwork, horizontally, vertically, and from inside to outside and back, will be be organized in a way that tells the story of the patient's internal object relations.

When a patient's artwork pulls our eyes toward the center, or when there is no pull at all toward the center, the self psychology model is also relevant. Sometimes there is relatively little movement back and forth from the inside to the outside, nor any great enmeshment of self and object. Our eyes move toward the inside of the artwork and remain there. Often the material is shallow and expansive, or at times small and minuscule. The experience of viewing this artwork is one of being enmeshed in the center, or of not being able to find the center.

When a patient has worked through the basic issues of object constancy, he or she may produce artwork featuring a relatively stabilized organization of movement from inside to outside. Now a drive psychology framework is useful. We may see evidence of strong defenses around drive material, with the flow of energy being stopped either on the horizontal or longitudinal axis. For instance, we may see a heavy overbalance of horizontal art activity that stops the flow of energy upward, or tight obsessional forms that interfere with the movement or flow of the artwork as a whole. Our attention is then directed to where the flow stops. Do we see strong, emotional, affective colors being overly contained with strong lines either in a horizontal or vertical direction? Sometimes the artwork will tend to be overly elaborated, overly structured, as a way of muffling or restricting strong emotional engagement with the viewer. We may also observe the opposite, presented with a chaotic display of emotional coloration, primitively organized. Here our therapeutic interventions will be directed at creating a flexible structure that facilitates our patients' affective connection with us, without overwhelming or overly restricting them.

Transference and Countertransference

The scope of this paper precludes extensive discussion of transference and countertransference as understood within each model of treatment. What we wish to emphasize is that different models of treatment offer different means of processing the communications of patients. At the same time, different models of treatment tend to create different transference and countertransference reactions. For instance, working from an ego psychology perspective, the therapist will be very active and structuring, creating a very powerful authority transference. Within an object relations framework, the therapist

adheres to firm boundaries, while the patient is constantly struggling against 'falling into a dark pit', and may go through any number of provocative maneuvers. The art form can play an important part in the therapeutic relationship. Art serves as a transitional object and holds the patient in spite of the transference and countertransference machinations that may go on between therapist and patient. When we approach cases from a self psychology viewpoint, however, the experience is one of being present for and with the patient. The patient enters into either an idealizing or self object transference relationship with the therapist. Building the patient's sense of self through mirroring and empathy is the main thrust of treatment. Finally, the therapist working from a drive psychology perspective will attempt to maintain a fairly neutral and separate therapeutic stance with the patient. A variety of drives and fears may be projected on to the therapist which ultimately are either interpreted or confronted. As there is less use of the therapist's personal resources as a holding or healing agent, countertransference responses are associated with the traditional notions of countertransference: past conflicts of the therapist getting in the way of treatment process.

Treatment Interventions

We have already discussed in some detail the interventions that are typically indicated by our four models of therapy. In an ego psychology model, structure, support and reinforcement are basic underpinnings of treatment intervention. In self psychology we have emphasized mirroring and empathy as basic tools in working with resistance. In an object relations framework, the art form becomes the transitional object that deals with object loss and a need for holding. Finally, in drive psychology terms, we are constantly encouraging as well as interpreting and/or confronting the defenses we see manifested in the art form, so that there can be a greater synthesis and ego integration. The implementation of these four models of therapy can flow from one to another. They often overlap and become central from one phase of treatment to another. The artwork itself usually offers the diagnostic clue as to how the therapeutic material may best be understood and treated. Following are four clinical sketches that are offered as illustrations of how the four models of treatment can be applied to different clinical problems and manifestations of resistance. Cases 3 and 4 are by Barbara Cooper.

Case 1

Joan, a married woman of forty, without children, enters treatment with complaints of loneliness and depression. In her capacity as a theatre director,

she views herself as unsuccessful and frustrated, in spite of the fact that from time to time she has directed important pieces that have received good reviews. Her husband, a busy professional in the medical field, works long hours and is not always available, either physically or emotionally. On the surface, he is supportive, but he feels uncomfortable in any intimate dialogue. With their busy professional schedules, they rarely spend time with one another except on vacations. Joan's parents were also busy professionals, leaving the children to surrogate caretakers. Private school beginning at age eight afforded Joan some structure in which she felt cared for and secure. Joan describes an overly anxious and infantile mother, who, out of her own sense of insecurity (rather than concern), was both overprotective and neglectful. Now in her third year of treatment, Joan has moved from a very distant and unrelated connection to the therapist to one in which she feels far more connected and emotionally grounded. Mirroring, empathy, and reflection have been important modes of intervention. Joan brings her loneliness and sadness to the session, and she can be very elusive and difficult to reach. At times we refer to her relationship to her mother as being repeated in the transference, though the focus has been basically on her self. Joan rarely refers to the father, who was largely absent and emotionally unengaged with his daughter.

In a recent session, Joan speaks about her dissatisfaction with her job. She feels unappreciated and unrecognized and despairingly complains about her inability to do much about her situation. She admits that her colleagues view her as competent, but she gets no gratification or pleasure from this. Joan speaks of a secret place inside of her that even she does not know very well. This juncture in our dialogue seems to be an excellent place to move into a nonverbal mode. I ask her if she can draw this place, and she says she will try. She chooses a soft pink pastel that she says represents some vague far-off place in herself. She asks me if I will accompany her in her drawing, and I agree. The closeness and intimacy are consistent with the self psychology approach. I would be far more hesitant to accompany my patient if there were issues around boundaries or regression. In the following interaction there is a mutual mirroring process. This technique seems most applicable in cases where the object attachment needs firming up. Mirroring occurs on conscious and unconscious levels, in both participants. The relationship has a symbiotic quality. Out of this rhythm of give and take, the patient develops a new perspective on the self.

Joan draws a half-circle and I complete the other half with sharp angular lines (see Figure 6). This intervention comes fairly spontaneously, though I am subliminally aware that I want to offer her a framework in which she can

Figure 6

feel held and yet have something to bounce up against. I am also trying to mirror the masculine and feminine elements of the self so that she has a frame for exploration. She chooses brown and orange pastels and transforms my harsh lines into something more flowing and soft. We both recognize that she would like me to hold and recognize the soft flowing part of her. I then draw a box, as my representation of the missing object, and then she fills it with a pink color. She proceeds to draw a green outline inside the box, and I fill it in with green. I say to myself that her emptiness can be filled, even though I hear somewhere, her green envy. Once again, I mirror her wish to be filled, and at the same time suggest perhaps that envy is something that can be accepted without judgement. Perhaps this secret place may be the envy and hunger in my patient, but I do not feel it necessary to verbally articulate these impressions. The simple nonverbal mirroring is all that seems required. I then draw a circle and she shades half of it with green pastels. I outline one part of it with red, and she softens it with a red flow. She comments on the empty spaces and wonders if that's what's really inside of her. I comment that perhaps the empty space feels too enclosing and she needs to express the flowing part of her without being entrapped. She smiles

to herself as she observes that her flow of brown lines have their own entrapment. 'I guess,' she says, 'I'm a woman of the nineties; I want softness, I want to be held, I want to feel strength, and I want freedom.' Here, in visual dialogue, the soft parts of the patient's self encounter the firm straight line of the therapist, and the sense of flow that resonates with the soft flowing part of the patient. In this mirroring dialogue, I mirror her need for closeness and intimacy, as well as her desire to make her own art structure. This complicated mirroring we both participate in, share, and observe. The paradoxical nature of the self becomes highlighted in this mirroring. The wish for freedom interposes and interfaces with the need for softness and holding. In this session the patient takes some risk in being close while at the same time expressing her need for freedom.

The therapeutic engagement is directed at the patient's sense of self. To be sure, she wants freedom from encroachment, but most important, she wants to be seen. There are many sessions of this nature. Gradually the patient evolves into a more defined and definitive woman who addresses her needs both in work and with her husband. There are of course many regressions, particularly when the therapist takes his vacation. However, slowly the patient has become more organized and clear, as well as related to an I-thou therapeutic dialogue. The mirroring techniques of self psychology have been especially helpful to this patient.

Case 2

Mary, a married woman of thirty-five, mother of two young children, a girl of four and a boy of six months, has been in intensive psychotherapy for approximately six years. During one three-year period, Mary was seen three times a week. She is currently worked with once a week. Initially the patient was a very lost and confused woman, but slowly she discovered herself, fell in love and married a very supportive husband, and prepared herself for the profession of medicine. A good deal of therapeutic emphasis has been placed on the self and object loss during the main part of treatment. Mother, viewed as infantile and immature, and Father, all too busy with his business, left much of the parenting to a live-in nanny. The mother was fairly warm and caring when the patient was pre-adolescent, but the teen years created for the patient a good deal of alienation and estrangement from the family. The mother was seen as a very poor role model, and as a woman whose interest in sexual matters was minimal. Currently, Mary has little to do with her mother. Mary's father died two years ago from a sudden heart attack. During the most recent stage of treatment, Mary has grown very articulate in addressing her problems. Treatment is basically verbal in nature though the

patient on occasion works with art to clarify a particular issue. She also works with collages in an art class and often shares her newest creation with the therapist. Her sexual life has improved, but now, after the birth of her latest child, she once again wants little or nothing to do with sex. This has caused problems between her and her husband. Mary is visibly upset over her inability to deal with her sexual problems. She considers her body ugly and unappealing. She hates her round hips and hairy body. (Most people, I believe, would view her as very pretty.) In this reported session she states that she wants to take a breather from talking about sex. She is concerned about her daughter, Donna, who hates wearing pretty clothing and prefers the torn jeans that adolescents commonly wear. Donna hates bathing and is generally oppositional toward any suggestions that Mary makes about her clothing. The mother laments that her daughter is turning out to be like herself. While Donna exhibits oppositional behavior, she is also very concerned about showing favoritism to either parent: after spending time with her father, she reassures her mother that she really cares about her, and

Figure 7

in turn, when she spends time with her mother, she then reassures her father that she cares about him as well. The patient laughs and comments that it looks like her daughter is in the middle of the oedipal phase. 'What does this have to do with you?' I ask. The patient shrugs her shoulders and I suspect that we are ready to move to another level of expression. I ask her if she would like to draw her mother, her father, and herself. She readily agrees, but draws a small box-like figure for her mother, a long straight line for herself, and an even longer line for the father (Figure 7). I comment that she could at least add some meat and substance to her representations. I feel, however, that any more interpretation would not be useful at this point. She calls her mother 'the fecal baby' and says there is nothing she can add to it. What she really wants to do is rip and tear.

I encourage her to do so and she takes the side of the paper with the fecal mother and tears it in pieces. She complains that she does not have brown paper, which would be far more appropriate to accompany her affect. I proceed to give her some brown paper and she proceeds to make a pile of pieces of paper. 'What would you like to do now?' I say, and she comments that she would like to burn the pieces. 'Shall we?' I say, and she breaks into tears and says, 'My poor mother. She has been mean to me in many instances, but I can't hold it against her that she is so inadequate.' I reflect back, 'It is very hard to be furious at such an inadequate mother, for she was such a pushover and does not know how to fight back. Do you really think that your anger can be so destructive to your mother?' 'Well, if this is what's holding me back, I'm going to do something about it,' she says. I remind her that her most creative work in a recent art class dealt with collages. The patient decides to take the pieces home and bring back a creative work of the cut-up pieces of her mother. 'Maybe,' I say to myself, 'the patient can find some transformational qualities in her rage that can truly lead to a separation from her mother and a more adequate notion of the female image.' Though there are issues around separation from the mother, the overwhelming thrust of the material deals with defenses against rage and guilt, and the reintegration of these impulses into a more organized picture of the female self. In this therapeutic instance the toleration of rage, as well as a creative reorganization of this drive material, becomes the focus of treatment. Subsequently, the patient entered a rather protracted period of loss and depression that seemed to be precipitated by problems with her child. However, it also became apparent that after the period of rage toward her mother, the object of her mother was able to be externalized, which set the stage for feelings of loss and abandonment. So, at this particular juncture of therapy, the therapist moves from a drive psychology framework of process-

ing to an object relations model that is more appropriate to work through object loss.

Case 3

Rose, a thirty-year-old woman, came into the Harlem-based clinic for help. She claimed to feel angry and depressed much of the time and the precipitating factor was a fight with her mother. Rose is a welfare recipient, has a seventh grade education, and has been employed once in her life for six weeks. Rose has a thirteen year old daughter who lives with her mother. When Rose was five she witnessed her father stab her mother. She was assaulted as well, and was hospitalized briefly for a concussion. Rose is married to Joseph, now serving a prison sentence for drug selling. They met through a friend of Rose while Joseph was in prison for assault. They married while Joseph was still in prison. They lived together for a year before Joseph was re-incarcerated. During that year, Joseph was physically abusive with Rose. She was hospitalized for a head wound after she was thrown against the refrigerator. When I met Rose she was both abrasive and tearful, pleading for help. She attached to me in a positive way immediately, almost too quickly, it seemed. Her case history, coupled with her immediate attachment led me to believe that Rose was a borderline personality. A few months passed, and Rose continued to become more attached to our sessions. She identified with me in a profound way. During this time I asked her to do a drawing. She complied, though reluctantly. The art therapy is sporadic at ebst and as the process progresses, the patient moves much more in the direction of dealing with her social world. In this instance however, the drawings give a crucial indication as to the direction of treatment. In Figure 8 we observe that her drawings are childlike, exhibiting a floating, empty, simple quality of expression. The emptiness had a more organic quality than is usually associated with the borderline personality. (The organic factor was later ruled out by psychological tests.) I tended to be confrontative, addressing any acting out and encouraging a search for the self, assuming that this self, when emerging early in life had been treated harshly, negatively and/or with abivalence by the mother. I was working with Rose assuming that she was a borderline patient. But Rose's responses to my interventions were uncharacteristic of the borderline patient. My confrontation of her acting out was not met with rage, but with appreciation, a deepening of trust, insight and change. Rose took in my interventions and used them to the best of her ability. A search for the 'underground self' discovered emptiness and a need for Rose to take in the self of another. I recommended vocational training for Rose, as well as a group that met at the clinic once weekly. In addition,

Figure 8

I scheduled a brief second weekly session with me. She responded by brightening up and feeling energized. She came to the next session wearing glasses (that I had never seen her wear) claiming, 'I'm going to be going to school soon, and I need to see!'. She received much encouragement and support for this. Unfortunately, I went away for two weeks shortly thereafter. I hoped Rose would attend the group to keep some continuity with the clinic. When I returned, I found that Rose hadn't attended the group. She missed our first session as well. When she called to say she was ill and couldn't come in, I suggested we have our session over the phone. We talked for forty five minutes – apparently, Rose hadn't left her apartment since I had gone away. She was extremely depressed. She cried that when I went away she realized that she had nobody. She threatened not to keep her appointment with the Office of Vocational Rehabilitation that week because of her depression. I gave her a 'pep' talk about getting out and being with people. I asked her to picture myself on her shoulder saying, 'Go for it!'. She laughed at this and promised to go.

Up until now, my countertransference reactions to Rose varied from anger at her ability to love the husband who abuses her, to compassion for her, to admiration for her strength and fearlessness in seeking treatment, having come from a street culture that views therapy in a negative light. Now, my countertransference response was overwhelming to me. I detested being needed in this way, knowing that without me she couldn't function. I understood my response and where it came from in my life, but felt paralyzed in my role as therapist for Rose. I presented this case to my weekly supervision group to gain some insight and clarity, and to rid myself of this oppressive feeling of responsibility. My supervisor diagnosed Rose as an inadequate personality. Of course, treatment will differ from that recommended for the borderline personality.

I had been approaching Rose from an ego psychology viewpoint, becoming quite involved in her life, structuring her time, etc., yet I had believed this to be erroneous, nonpsychoanalytic, a crossing of boundaries that ought not be crossed. Through presenting this case, I could see that my approach with her was actually on target. I came to see through this presentation that I needed to set Rose up with more structure, perhaps in a day hospital. The feelings of dread subsided as I began to feel hopeful about Rose's treatment once again. The image that emerged for me during this presentation was one of using three dimensional materials that would create a dialogue between formlessness and form, and would enable her to gain ego skills. I thought of modeling clay with cookie cutters. The group suggested actually making cookie dough with her and sending her home to use the

cutters herself, bake the cookies and bring them back to share. This would enable her to feed as well as to be fed. The balance between giving and enabling her to give helped me to feel less awesomely responsible for her.

When Rose came in for our next meeting, she arrived uncharacteristically early. I heard her speaking in a loud rapid voice in Spanish to the receptionist and to another caseworker. (She knows that I don't speak Spanish.) The therapist told me that she was 'badmouthing' me, claiming that I expect so much from her (groups, vocational training, etc.) that she felt like killing herself. When Rose came into my office, she wept and talked about how glad she was to see me, how much she missed me. I asked about her anger. First she denied being angry. I told her that the other therapist had told me what she said. Coupled with her missing her first session back with me last week, I said, her behaviour amounted to this: and I held up my middle finger. She laughed, and poured out her anger at me for leaving her. Her 'heavy' affect changed to a brighter, more energetic self. We talked about what is now going on with her and what our immediate goals are. As treatment progresses, within an ego psychology framework, the patient feels increasingly grounded and effective in handling reality demands.

Case 4

Betty, a forty-three-year-old woman, was admitted to the inpatient unit of a private psychiatric hospital after a very serious suicide attempt. She had sent her husband and two teenage sons off to the movies and taken an overdose behind her locked bedroom door. During the movie, the older son 'had a funny feeling,' left the theatre, rushed home and found his mother near-dead. She recovered in a medical hospital for about a week. Reportedly, upon regaining consciousness, she spotted a plastic knife on a food tray near the bed, grabbed it, and tried to stab herself. When she was admitted to the inpatient unit, she spent a few days in her room with constant twenty-four hour 'suicide watch'. Her first group as a patient in the unit was in my 'Visual Journal' group, in which the whole unit (fifteen patients) participates.

Betty is a high-functioning, somewhat intelligent counselor. She works at a crisis center for Vietnam veterans and deals with suicidal behavior in her work. After hearing the story of her attempt, I was surprised to meet a very attractive, sharp woman, dressed as if she were going to work (amongst sweat-suited inpatients).

Her first drawing is of a tree with a black hole with blood dripping out of the hole. She shared with the group her ambivalence as expressed in the tree: is it shedding leaves for fall, (to bloom again in spring), or is it dying? She admitted to feeling suicidal, although not as violently as before.

The patient had a flair for drama and was impressed by my being an art therapist. When she presented that first drawing to me she was well aware of the effect of the black hole with the blood running out of it (See Figure 9). She sought my attention outside of the group and asked for individual

Figure 9

sessions. I declined her request because I did not do individual sessions at the clinic. However, I would have refused in any case, so as not to feed her desperate need for specialness. Also, she was already seeing a primary therapist. Betty agreed to continue with the group treatment that I felt was appropriate for her.

In the first art therapy group that she attended, I spoke about the tree she had drawn and asked her if she could crawl into the hole and experience the blackness there. She was quite willing to do this. (She constantly gave

the impression of wanting to please and be 'the good patient,' yet there was a concurrent feeling of rage, hostility and devaluation about her as well.) She closed her eyes. I sat with her and talked her through the experience and then asked her to draw what came clear as her eyes adjusted to the darkness. The second drawing is her image of the rage in the darkness (See Figure 10)

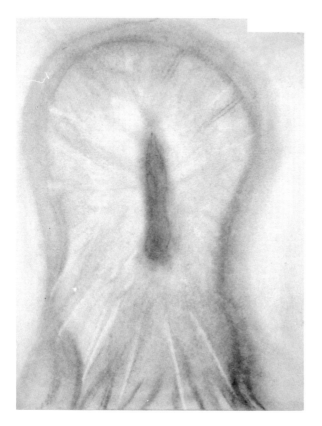

Figure 10

She then told her story: she had been having an affair with another counselor at work, and he had left her. She believed that without him, there truly was no air for her to breathe in this world, so she attempted suicide. After this session, she began bringing me poetry from her journal which exhaustively described her symbiotic attachment with this man and her rage and despair at the abandonment. Her next drawing is a further exploration of the black

hole which takes more form than the first and again describes ambivalence: the death-mask and the rage. (See Figure 11). This drawing also brings to light her delight in shocking the group. I think she believed she was shocking me as well.

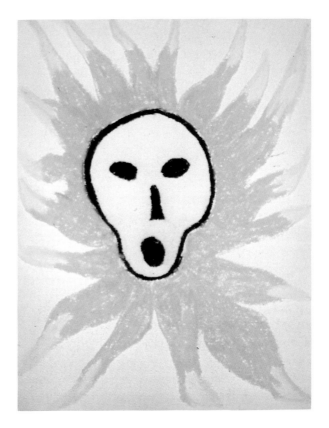

Figure 11

The next drawing is a further exploration of her rage, also disguised as a question mark (See Figure 12).

Her work may seem quite contained as a statement of rage, but these were as 'wild' as she was prepared to get. Betty is a model of control and perfection in her personal habits, appearance, poetry, and artwork.

She brought me a clay piece she had done on her own and of which she was very proud. A woman in the fetal position is unsure if she is going to

stay curled up and die, or unwind and give birth to herself. Betty's choice of pink (flesh) for the glaze was, she reported, a clue that this figure would give birth. This 'psychologizing' of her own work was, I believe, part of her continuing campaign to impress me.

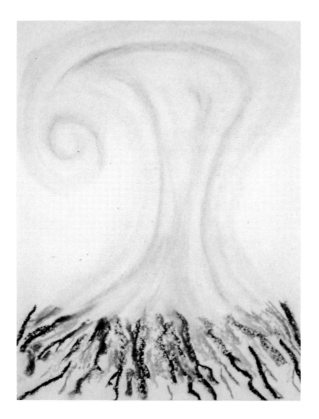

Figure 12

The next drawing (see Figure 13) is one which she had done in her journal, again on her own, and exemplifies her drawing style when in control. Again, the theme of life or death is apparent. Also, there is seductiveness here – the beautiful flowers detract from the horror of their being uprooted. Are they going to be repotted and live, or starved and left for dead? Betty wouldn't say.

The next drawing was done during group time when the assignment was to 'take a picture from inside you and put it outside of you to look at.' As

Figure 13

she finished drawing this she gasped and jumped out of her seat. She hadn't intended the red mass of blood that dripped from the wound to be a figure and had just noticed its shape (see Figure 14). This truly frightened her and prevented her from talking about the picture in any detail. She did say that it accurately described how she felt. She responded with anger when I made a comment about 'the good breast and the bad.' This was followed up by the next drawing of a black door with blood running out from underneath it. She sobbed as she talked about her relationship with her father and how there was always a wall between them. The only way he would validate or notice her, would be if she cut herself and let the blood run out under the door. Maybe then he would see her pain and take notice. She was enraged at him. At this point I gave her clay and suggested she 'wedge the hell out of it' as she shouted resentments at him. For all her drama, I felt that this

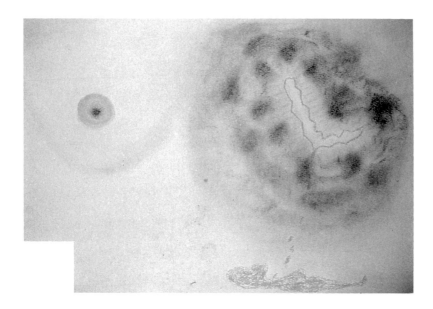

Figure 14

Figure 15

was one of our genuine times, when she truly felt and her feelings were truly processed. The next drawing was produced the next morning in Journal group: a peaceful, calming drawing. The last drawing came a few weeks later, and represents her moods and feelings as she got ready for discharge (Figure 15). Her last artwork was a drawing of herself, looking out into the future.

In this series of artworks, we see the outside object choking off the inside self of the patient. In her life Betty acts this out with her former lover. She cannot leave this object and is constantly hounded by its presence, yet she dances around this conflict, not really getting into the pain of loss, for she cannot face feelings of abandonment. On brief occasions, however, she does move into a very authentic place and starts to deal with her problems. Art is being used to impress others and to present a false self. This manipulative controlling behavior is commonly part of the borderline. There is obviously a good deal of splitting in her searching for the good object while at the same time subtly acting out the introject, and ultimately repeating her abandonment anxiety.

My countertransference toward Betty ran the gamut. I liked her; she was seductive. I withheld at times in response to her feelings of entitlement. Her artwork was quite seductive – an art therapist's dream. She knew this. The times that real growth took place, I believe, occurred when I consistently confronted her entitlement and grandiose/false self for a few sessions. She would then be enraged at me and withholding. I would validate her angry stance and provide materials for the expression of this. She was then able to use the materials for authentic expression. Clay and pastels proved to be the best media for her. (They both defied control to the extent that would challenge her without over-frustrating.) At these times she allowed her clothing to become soiled with the materials; she 'played' with them. She let herself cry, thus letting her makeup run off. This was quite uncharacteristic of her style. Unfortunately, time wasn't available to work through a synthesis of the bad/good beast within Betty. I felt that my role with her was to stand back, and yet be firm in setting boundaries; to be the voice of truth confronting a false self; to provide the means for her to ground herself and through this, to discover herself. I believed she had a rich, creative, intelligent, very funny, wonderful self somewhere deep inside. I let her know this in many ways – most importantly in the way I confronted her phoniness.

Summary

Patients can and do resist therapeutic process. Treatment is concerned with the problems of patients being out-of-process, and the variety of interventions necessary to help patients regain therapeutic process. Indeed, when

patients are in charge of their process and have acquired the ability to regain their process upon losing it, they are very close to the terminal phase of treatment.

As with any creative endeavor, our problems are often intensified when we have only one way of seeing our patients' communications. In all the above cases, it is the structure of the art form that gives us diagnostic clues as to the treatment intervention. Yet art diagnosis must always be viewed within the context of the transference/countertransference relationship. In our first case, the mirroring became very complex and symbolic. Here, mirroring involves the play of hidden shadows and nuances within the patient's personality that the therapist represents and which become reflections for the patient to feel, touch and reintegrate. Attachment issues, as well as mirroring, are illustrated in the therapeutic dialogue.

In the second case under discussion, Mary's three brief lines were not truly a representation of her inner world but an acting out of her contempt for her parents. The resistance that was manifested in the art form did not prevent the patient from processing her therapeutic material. On a very profound level, albeit in a very simple and direct form, she informed the therapist that they were not worth that much involvement. However, the direct expression of her rage became the pivotal point in the shift toward a new level of painful therapeutic engagement: that of depression and loss.

In the case of the third patient, we observe how a knowledge of a therapeutic model of treatment helps the therapist to understand what is needed in treatment. On the surface the patient acts like a borderline, yet her art work offers a true representation of her condition. The structure and reinforcement works with this patient. Trying to be a holding agent and reflect the self simply would not be enough to contain this patient in treatment. In short, survival and functioning were far more important at this stage in treatment than going through the various stages of mirroring.

In the fourth case, the variations in ego states that are so prevalent in the borderline condition are reflected in the art work. We observe in Figure 15 the sublime fused quality of her representation as she retreats from any real struggle of self–object differentiation. Figures 9 and 10 represent the inner black self trapped in the surrounding object while Figure 14 demonstrates the split of good object and bad object. We also see in this drawing the patient's passive self being hooked up with a very frightening introject. The artwork seems to have contained this very difficult representation of a bad object, and perhaps gave the patient some room for a reorganization before she left the hospital. On other occasions, her art work seemed too pretty and false. Thus, the slippery and fast moving ego states often move in and out of

the patient's art work. Yet her language is rarely connected to the symbol except in Figure 14.

Questions may be raised concerning the subjective appraisal of the patients' art representations. Yet, we believe that there is no such thing as one truth in art or in therapy. The mutually interacting personalities of patient and therapist will determine many subjective/objective realities. The therapist's evaluation of the resistance will set the course of the therapy. Interventions arise out of a given diagnostic appraisal and are shaped by a therapeutic model. With a multi-model approach, we can evaluate whether in fact our model is working for the patient.

Verbal dialogue can be elusive, and the same can be said for representations in artwork. Both types of expression offer an important means of understanding the composition and organization of the patient's personality. From this understanding, a way of working with patients can be derived that may be of help to therapists who are lost in the quagmire of therapeutic resistance. Obviously, therapists will be drawn to one therapeutic model or another, but in stormy times, when the resistance is high, a multi-modal approach will offer an additional compass to navigate through muddy therapeutic waters. Each therapeutic model offers a mode of intervention for coping with resistance. Each can become an indispensable tool for organizing therapist–patient communications.

References

Fenichel, O. (1934) *Outline of Clinical Psychoanalysis.* New York: Norton.

Hartmann, H. (1939) *Ego Psychology and the Problem of Adaptation.* New York: International University Press.

Kernberg, O. (1976) *Object Relations Theory and Clinical Psychoanalysis.* New York: Aronson.

Lazarus, A. (1976) *Multi-Model Behavior Therapy.* New York: Springer.

Moustakas, C.E. (ed) (1974) *The Self: Explorations in Personal Growth.* New York: Harper and Row.

Pine, F. (1990) *Drive, Ego, Object, and Self.* New York: Basic Books.

Further Reading

Kohut, H. (1977) *The Restoration of the Self.* New York: International University Press.

Robbins, A. (1989) *The Psychoaesthetic Experience.* New York: Human Science Press.

Art Therapist and Psychic Healer
Description of a Joint Workshop

Arthur Robbins and Sandra Robbins

Exploring the symbolic and plumbing the depths of meaning are corner-stones of depth-oriented therapy. We encounter the symbolic in dreams, fantasies and art, and feel its texture and depth on different levels of consciousness. Therapists utilizing different orientations approach their patients with different tools for discovering and exploring these symbolic images. Psychoanalysts bring a sensitivity to the dream world, while art therapists offer a visual creative frame in which patients search out the meaning of the symbolic. Psychic healers provide their patients the possi-bilities of seeing and being in an altered state of consciousness. What are some of the parallels and differences between these therapeutic approaches to the exploration of the symbolic? Will patients encounter different types of symbolism even though they are approaching the same subject matter, because of the nature of a particular therapeutic frame? The authors investi-gated these questions in a two-hour workshop, and will discuss the implica-tions of exploring this area in this paper.

The issue of symbolic meaning will also be a focus of discussion. The authors are interested in exploring the interpersonal context that influences symbolic meaning. Also, as part of the above issues, the inevitable fears and resistances to acquiring meaning must also be accounted for.

This subject will be approached through the study of a single patient who is in analytic treatment with one of the authors. As part of his treatment a joint workshop has been introduced as an ancillary therapeutic experience. By contrast we will briefly discuss the experiences of two graduate art therapy students who have participated in this workshop and whose interest

centers about acquiring further knowledge in the area of symbolic expression.

Methodology cannot be separated from the belief system and artistry of the therapist. The complicated interrelationship between the personality structure of the therapist and the therapeutic style is beyond the scope of this paper. However, the backgrounds and theoretical positions of both leaders will be briefly described to orient the reader.

The background of one of the leaders, Arthur Robbins, has been described in previous chapters. The other leader, a psychic healer, works with her patients often inducing them into an altered state of consciousness. Her background, aside from psychic healing, is in movement and drama. All three disciplines have been combined into an integrated system of working with the body's energy. As a healer she works from a disciplined grounded position from which she frequently moves into altered states of consciousness. In these states, the boundaries between self and other are temporarily suspended as she focuses on the problem at hand. Being grounded, open and focused are prerequisites of this system. Through this process, colors, images, sounds and kinesthetic and emotional feelings become uniquely accessible to the healer and often more available to the consciousness of the patient as well. She works from the theoretical assumption that we are all governed by energy systems that are both personal and universal, have light, color and motion, and contain imagery that cannot easily be understood in linear terms. These energy systems have different fields that are intertwined and interrelated. The healer utilizes her energy system to join with the patient's, so that fields that are out of harmony, blocked or chaotic can be moved or changed. Problems in the energy fields manifest themselves by being disruptive, dysythmic, vertical or horizontal rather than circular and peaceful in motion. This level of consciousness has been described in such terms as spiritual, religious, timeless, spaceless, and trance like. All these terms somewhat limit the experience because they structure our understanding through certain terminologies. We are on safe ground if we say that we move into the sphere of the unchartered, and deal with time and space on a different level than the here and now.

We have described how we bring different backgrounds of experience to our patients, and how our differing methodologies stimulate exploration of different levels of consciousness. The workshop that we will describe was an attempt to highlight the differences in working both in manner and methodology, and the various types of symbolic explorations that arise from the two different approaches.

What we attempted to demonstrate in this workshop was the relationship between symbolic meaning and different levels of consciousness. Some of our inner symbolic conflicts can best be processed through a healing approach, in which the here and now experience of the transference and countertransference is mitigated and the patient experiences the healer as a 'channel' from a universal level. This does not mean that there will not be transferences that arise between a healer and a patient. However, by the very nature of his or her approach, a healer will usually reinforce a very positive and loving transference, while an analyst will be more open to both positive and negative projections and will work with them in the here and now situation. In our workshop we attempted to demonstrate to the participants that there are indeed levels of consciousness other than unconscious, pre-conscious and conscious. We refer to symbolic expression that relates to the broad meaning of one's place in the universe. Individuals, of course, may be more receptive to one level of consciousness than another. Also, intrapsychic and universal symbols can and do overlap. Concerning the material that emerged in the workshop, one can take the position that ultimately every-thing can be traced to an intrapsychic issue. Artists and many analysts will dispute this. In the final analysis it is the meaning that each of us give these symbols that will be the final indicator of their import and importance, both as regards ourselves and as they may bear on the broader issues of what life is all about.

The psychic healer worked with the participants leading them into an active meditative state. The other leader invited the participants to express images in a here and now context.

Twenty-four participants attended this workshop exploring four images, namely the tree, flower, animal and bird. These images were introduced as symbols that potentially live in all of us on one level of consciousness or another.

First, the participants were requested by the psychotherapeutic leader to draw with either pastels or crayons each of these symbols. They were encouraged to let their hands become their inner voice. The intent of the art exercise was to create a mind/body experience with a minimum of intellec-tualization, and to create in the participants a willingness to put aside their preconceived interpretations of these symbols.

Next, the psychic healer conducted an active kinesthetic meditation accompanied by music. First, a 'grounding' exercise was offered, utilizing rhythmic breathing and large body stretches, using the metaphor of reaching to the sky and then touching the earth. The purpose of this exercise was to help the participants come in contact with their bodies and breath, moving

them into a centered place of meditation. As part of this grounding exercise, the participants were invited to imagine a tap-root dropping from the base of the spine going straight down deep into the center of the earth. Having created this sense of being grounded and this meditative state of consciousness, the leader then led the participants through guided imagery exploring each of the four symbols. All four of the symbols were explored from the meditative state kinesthetically; participants were invited to feel the essence of each one of the symbols in their bodies, sensing their colors, shapes, rhythms and forms. The participants were then asked to draw the experience of exploring these symbols using the same media as in the previous exercise.

The members of the workshop then processed their material in pairs and with the group as a whole. In most instances, the drawings as well as the internal experience was sharply different depending on who was leading and on what level of consciousness the particular symbol was encountered. The following descriptions concern three participants, one a psychotherapy patient currently in treatment with the psychotherapeutic leader, the other two graduate students who are currently enrolled in the art therapy program at Pratt Institute.

The patient, John, a forty-two-year-old research investment specialist, has been in treatment twice a week for approximately five years. Unhappy in his profession and discontent with the quality and scope of his relationships with women, he is perplexed as to why he cannot find and develop an intimate relationship. When he is attracted to a woman, she does not respond and he in turn has little interest in the women who are available. His work is lucrative but highly demanding and rarely satisfying. He feels frazzled but is trapped by his need to get ahead and win prestige and status through success in his profession. He would like to leave this work but has few ideas as to where to turn as far as his next vocational move. In the past, he was a computer consultant and much earlier worked for the Department of Human Resources as an investigator.

John looked forward to the workshop as he has been very attracted to the practice of yoga and has an interest in 'spiritual' experience. He loves music and is an avid sports enthusiast. However, most of his time is taken up in work. In the session following the workshop, John's first question to the therapist is whether the therapist's wife (the other leader) tints her hair. The therapist does not reply and then the patient confides that he sees her as a very beautiful woman though he can't quite believe that she doesn't do something to her hair. 'I suppose,' he says, 'you want to talk about the workshop, but I first want to tell you about a dream I had last night. In the dream, a good friend of mine, George, is going to kill me in my place of

work, Joe, another junior analyst, tells me that this is not so and tries to reassure me, but I know I must run for my life.' Joe, in actuality, comes under John's direct supervision and is someone whom John has sometimes 'given a hard time'. George, on the other hand, is perceived by the patient as a creative person with wide interests. John looks up to George. George, however, has made his peace with the work world and is basically invested in getting ahead and being a success.

John then shows the therapist the pictures from last night's workshop. He states that the only image that he was truly involved with was that of the tree in the first phase of the workshop. He drew a tall tree and placed a sun in the picture though none was requested (Figure 16). The animal and the

Figure 16

plant were scribbled in as an afterthought with no room at all for the bird (Figure 17). He had no particular associations to any of these representations

Figure 17

but immediately showed the therapist the second series of drawings from the meditative exercise. He commented that a good deal of the material was influenced by the music and wonders what would happen if there were no music at all while the leader conducted the meditative work. Once again, only one image really became invested as a major symbol in his exploration. This time it was the flower, a golden yellow flower, that was flowing in the air (Figure 18). He enjoyed the sensation of flow but once again had few associations to the material. The therapist wondered out loud whether the tall tree striving upward represented the powerful male world that so much governed his personal history and life. Of note, the patient's father was extraordinarily important in the child-rearing of this patient, while the

Figure 18

mother often receded into the background. The father, grandiose and narcissistic, projected many of his own frustrated aspirations on to his son. The son in turn spent a good deal of his life searching for men who would love and respect him. Paradoxically, he feels trapped by his need for the approval which he purchases at the cost of his own personal autonomy. In treatment, the patient often seeks direction and approval from the therapist. The therapist encourages him to find his own voice but invariably there is some entrapment in the transference/countertransference relationship. As happened on this occasion, the therapist leads in the exploration of the art material. The patient agrees with the therapist that the tree and the striving upward movement represents the male side of him while the flowing flower

may be the source of his creativity which does not have enough room to live. Near the end of the dialogue the patient mocks the therapist and gratuitously thanks him for all this information. Though this material regarding the male and female parts of him may all be true, he reminds the therapist that there was not enough room for his own voice to be heard in today's session. The therapist concurs and agrees that John's father has once again visited their session. With this recognition, the patient smiles broadly, pleased that his complaints have been heard, and leaves the office. In this context, the symbolic material becomes intrinsically bound up with the transference/countertransference relationship. Thus a very complicated exchange occurs in this very brief description of a session. In the session, the patient strives to have a separate voice in the interaction. Though there is scant reference to the patient's animal self, he does forcibly at the end make his point: 'Give me room for the other parts of myself to be heard and perhaps in my own way I will put the various symbols and levels of my consciousness together at my speed and time.'

The illustration above offers an interesting and powerful insight into internal symbolic experiences and their potential usefulness in the therapeutic interaction. The patient, preoccupied with the outside as validating the self, listens only briefly to his inner symbolic material, though at the following session he goes back to the dream, for he is quite disturbed that his friend George is out to kill him. Why does someone he admires become the killer while the man under him tries to seduce him into staying at work? The therapist notes that George, though creative, has limited his expression and places much of his energy into work. The therapist asks, 'Is this the solution that will lead to the murdering of the creative flow of his flower?' The person under George has no such conflict but must put his nose to the grindstone if he is to succeed. The dream and the drawings mirror one another in their representation of John's dilemma. The exploration of these issues is invariably limited by the patient's quest for outside approval, and his low tolerance for listening to that interior self that wants to blossom and grow. So, although important symbolism was tapped in this workshop, it cannot fully be explored or utilized by the patient because of the transferential issues.

Some note seems to be in order regarding the patient's comments in this session about the therapist's wife. The patient seems somewhat taken and involved in her beauty though he can scarcely talk further on the subject. Does she represent the female part of his life which receives such short shrift in his development and strives for some greater enlargement and involvement? Is it the beauty and the flow of the flower he drew that is touched

upon in his initial comments regarding her presence as a workshop leader? His disbelief that, considering her age, her hair color can be her own may reflect his disbelief that female/creative beauty can really have some authentic expression without being 'touched up'. Also, he is expressing attraction to the therapist's wife and subtly seeking approval for his interest.

By contrast, the two students with previous personal therapy behind them become very invested in the workshop material, but utilize this information on very different levels. Both process this material together in a private conference with the psychotherapy leader who is also their teacher. The first student talks of her initial drawing as representing the flowing maternal part of herself (Figure 19). She is surprised by the pointed tree that is stiff and

Figure 19

upright, standing tall in the ground. The latter image, stimulated by the meditative state, was in contrast to the flowing tree which was far more comfortable for the student to discuss (Figure 20). She is aware of the

Figure 20

beautiful eagle flowing on top of her first picture, and the cat and the reaching-out plant that are important guideposts to her conscious representations of self. The predatory bird, a pterodactyl, stimulated from her experience in the meditative state, was both awesome and unsettling. The dog emerging out of the wire mesh also seemed strange and peculiar. She reports, 'I could hardly move when we explored this animal.' She is shocked and surprised by these images, but her fellow student smiles and points out that *she* sees these images even though she is very much aware of the flowing nurturing part of her friend and peer. The student responds that though these images may be present, they upset her and she does not like to think of herself in such terms. In fact, she would much rather leave well enough alone, as she is satisfied with who and what she is.

By comparison, the other student reports that the experience was so powerful that she felt nauseated and sick from the sheer impact of the images and symbols. This reaction arose from the exploration of the images coming from the meditative exercise. She felt her whole body shake and experienced an enormous release of energy. She felt excited and challenged by the entire workshop and wanted more of this type of exploration.

As she reviews her first drawings, she describes herself in somewhat mocking terms as a 'tweety bird' of a woman who is friendly, sweet and nice. The first drawings were abstractions of the various images (Figure 21). They

Figure 21

were not very specific. Then, she immediately went to her second drawing and commented on the tulips that made such a profound rich statement about the flowering part of herself (Figure 22). The animal was the friendly lion which she could get close to while the bird was a black hawk with fierce-looking eyes piercing out. This seemed to come from the dark side of her self, tapping on the male energy. The student describes both images as the predatory animal that lives inside of her. She then amplifies some of her

Figure 22

reactions regarding these images. 'The images of the lion and the black hawk make me feel that I am part of the jungle. The bird in my first drawing was light and feminine but this bird in the second picture was a positive use of male energy, for the male inside of me has always been something that I have been frightened of. The father in me, a good man whom I love, has always scared me in some very unsettling way. The bulbs of the tulips are the heart part of me that I want to tap, while the oak tree is solid, huge and powerful. In this tree I see an old wise woman who is timeless. She reassures me and supports me. She is very different from my own mother who is passive and rather retiring.'

Let us now review these drawings from an art diagnosis perspective and compare the organization of the art for each of the three participants. The patient John invests a good deal of energy in the tree symbol. The longitudinal lines are very strong while the plant and animal, placed on another sheet of paper, are somewhat more delicate and less rooted. There is no place

at all for the bird. The colors in the tree are rich greens and brown. There is a deep orange sun that is also added. The total impact is one of strength and power. When we review John's second drawing, the material seems fragmented and ungrounded. Though the flowing flower takes central prominence on the page, it bears little connection or relationship to the other images. Here we see that the art work is much less connected, almost piecemeal, and very far away from the patient's ability to make a creative statement about this experience. This parallels his ability to talk about the experience in any emotionally connected way. The art work mirrors the patient's distance and disconnection from the feminine self. However, the dream work following the workshop becomes a very profound source of symbolism that engages the patient deeply. The dream, rather than the workshop material, becomes the medium to the interior of the patient, though the latter still has a potential power to create therapeutic movement.

There are sharp contrasts as well between the two sets of artwork created by the other two students. The artwork of the first student has a pastoral and peaceful quality. The lines are soft and flowing. By comparison, her second drawing makes far more use of straight pointed lines and illustrates archaic symbolic material. The image of the dog emerging from the mesh of wire begs for meaning and exploration. The pointed tree sticking prominently in the ground also carries a very important symbolic message. Both students recognize the aesthetic truth of the first student's drawings. Of note, the interrelationships of the four symbolic forms are far more prominent in her second drawing. When we compare drawings one and two, we see a clear demarcation of space and form mirroring the student's defined grasp of her own boundaries, and indicating the limits of what she is prepared to deal with in terms of new challenges. Yet, we really don't know what the future holds for her in terms of realizing the latent power of these symbolic forms.

The second student's drawings are notable for their density and high impact of color, form and symbolic expression. Though there is use of strong lines, the symbols and images need more space and room to breathe. This parallels the student's report of the high intensity and impact of the experience. The drawings are rich in color and have a wide range of symbolic expression. In drawing two, which depicts her experience in the meditative state, vertical lines become more prominent, perhaps indicating a craving for power and release. The centerpiece of the first drawing, the black image that looks like an animal, has been converted in the second drawing with richer colors and movement, projecting a predatory and fierce impact on the viewer. The rich sun of drawing one now moves towards the center tulip that seems

to rise out of the ground. All this requires a good deal of exploration that is limited by the scope and boundaries of the workshop.

In these three examples we observe the relationship of symbolic expressions which reflect experiences on different levels of consciousness. In each example, defenses are organized around the individual expressions and symbols. These defenses must be taken into account in our understanding of their relatedness to the participants' self-awareness through the various levels of consciousness. In the example of the patient, transference and countertransference considerations become intimately enmeshed in working through the meaning of symbolic expression. Yet, there is clear indication that even in this instance, imagery from the altered state of consciousness offers a different kind of symbolic experience that can potentially have a powerful influence on the processing of therapeutic material. Verbal processing offers us important clues as to the participants' emotional availability in making these connections. On the other hand, the art material illustrates important psychic dimensions of the symbol which often go far beyond words. The complicated intermeshing of these levels reflects the potentially rich source of psychic material that can be tapped when therapists employ a meditative state that can work in conjunction with more traditional types of therapy. The second student, in fact, reports a shift in energy that is very typical of someone who has received a very profound and meaningful therapeutic experience. This was equally true for some of the other members of the workshop.

The complicated interrelationship between symbolic experience and the meaning needs further clarification The patient by and large minimizes the importance of the workshop and pays much more attention to his dream. One possible understanding of this reaction can be traced to his instant transference to his therapist's wife. The tinge of erotic attraction and his wariness of permitting himself to become interiorly involved with the workshop may well be related to his generalized fears of women. Getting too close to some of his erotic interest and the underlying fears of competition as well as loss of his therapist's love and acceptance may have some impact on his conscious minimizing of the workshop experience. By contrast, both students, less encumbered by the complexities of the transference/countertransference relationship, must still face their own particular resistances in digesting powerful images and their emotional implications. In spite of their lack of therapeutic processing, the second student has informally reported to the author the workshop's profound and long lasting effect.

What are the implications of this workshop for therapists who work together and have different therapeutic orientations? First, transference and resistance are part of any experience, regardless of the level of consciousness that is explored. The resistance or openness to any particular experience must be taken into account, at least in terms of the patient's conscious use of the experience. A healer may tap levels of power and symbolic organization even though there may be more conscious resistance to the experience. This aspect will need further investigation to understand the implications of resistance to one kind of therapy or another. What is safe to say is that the two therapeutic methodologies stimulate different symbolic experiences. Both may well be equally valuable and important for a patient to explore. For some patients, because the active working-through of transference is minimized, the healing approach may provide a more accessible inroad to exploring profound conflicts. For others, the here and now aspect of psychotherapy may have a much more tangible quality, and may be the more meaningful vehicle for self-exploration. The results of this workshop point to the merits of a joint therapeutic relationship that may prove quite productive for some patients, in spite of the increased complexity and multiple determinations that are created by such an endeavor.

Clinical Considerations[1]

Arthur Robbins

A diagnostic hypothesis will be informed by the clinician's understanding of developmental psychology, the ego and its defensive and adaptive functions, and transference and countertransference. From an initial evaluation, a theoretical model of treatment can be drawn that leads to a particular technique or intervention. Art therapists cannot separate diagnostic thinking from treatment process, for they are constantly changing and influencing one another. Treatment techniques, then, arise out of this process and become a concrete implementation of treatment theory.

The beauty of artistic expression and the excitement of fantasy play may lead the student to think that there is nothing more important than offering patients 'creative experiences' with the goal of releasing them from personal emotional prisons. Slowly, however, this goal is perceived as inadequate and naïve. When some patients do no grow, and others misuse or abuse therapeutic overtures, it will be seen that something more is needed than a belief in nonverbal communication. A hard look into the specific therapeutic issues presented by various patient groups is in order.

This chapter cannot substitute for extensive readings in developmental theory, personality dynamics and clinical diagnosis. The following material assumes that the student has some beginning notions of a clinical framework. The intent of this chapter is to provide a broad synthesis of treatment theory as applied specifically to the nonverbal and verbal problems of different patient populations.

1 A major portion of this chapter was printed in *Creative Art Therapy*, by Arthur Robbins EdD, ATR and Linda Beth Sibley MPS, ATR. New York 1976.

Some initial statements are needed as a frame for this chapter. When I refer to a patient's ego, I am describing a series of functions that mediate the inside world of the patient with outside reality pressures. Such abilities as thinking, motility, perception and integration are but a few of these functions that help us adapt to reality. Defenses are part of our ego organization and may either be conscious or unconscious. These defenses help us survive and live with ourselves as well as others, and most important, facilitate a state of homeostasis where we are not overwhelmed by the disturbing affects of guilt, shame or anxiety. Defenses run the gamut from extreme rigidity to inappropriate fluidity and porousness. Our assessment of a given patient's defenses will tell us a good deal about the level of accessibility that is available to work with our patients.

Art therapy students may find it useful to create a visual image to understand complicated concepts of ego organization. I've requested students to draw their personal shield that will act not only as a calling card, but also as a means of illustrating what they use to take care of themselves in the world. Involved in this image is an understanding that our defenses constitute our personal style in meeting life's problems. We may ask ourselves after we draw the picture. We may also ask the question: 'Is it too heavy to be adaptable, or can it be used in any number of different situations?' 'Is it rigid, like a tightly bound fortress? Could it crumble like a sand castle if you apply extra pressure?' The therapist in the last instance would go slowly in the depth and directness of the therapeutic interventions. In the former instance, a head-on collision with a rigid armor does not make any sense, and so we would attempt to find a way to make contact with the patient in a therapeutic ground that is not so highly defended.

The student may consult *The Artist as Therapist* (Robbins 1987) to become familiar with the variety of art exercises that are available to understand object relations phenomena that exist in the day to day communications of our patients. Developmental issues are not necessarily confined to the first five years of life as critical problems with families and other significant relationships make their imprint throughout the course of our existence. Object relations theory describes the varieties of internalized relationships that we carry within us, and which ultimately influence our present day connections to others. Assessing this developmental level is important in making a diagnostic assessment.

Between the ages of twelve and eighteen months, the child develops an inner feeling of self under the influence of environmental and familial factors. To the degree that the patient's history has 'a good enough' maternal environment in which significant figures were both attuned and mirrored

the patient's sensory, affective and cognitive experiential state, the foundations of a self becomes solidified and crystallized. Self psychology addresses itself to the variety of problems in development that arise out of a lack of such attunement.

All the above factors are re-experienced in the transference/countertransference relationship. We may ask ourselves: Does the patient let you exist as a separate entity, or does he or she distort and mold you into an extension of his or her narcissistic self? Do you feel penetrated or wounded or annihilated? Each of these affect states between therapist and patient provide valuable clues as to how early developmental problems are being relived in the current therapeutic relationship. These issues of transference/countertransference, defensive organization and developmental considerations enter into the nonverbal communication of the patient. Our understanding of these issues will determine our therapeutic stance and manner of intervention.

Each broad grouping of patient behavior presents characteristic issues for the art therapist. The following diagnostic positions can be helpful in formulating a treatment plan. However, the author cannot emphasize enough that the following descriptions are merely guidelines. No on patient ever falls clearly into any one diagnostic category. Each patient is a unique entity with a multitude of characterological styles, and must be seen as an 'original'. These guidelines are not intended to restrict the vision of the student, but to help him or her more easily understand the singular reality of each individual patient. Clinical references that offer more complete discussions of individual diagnostic groupings appear at the end of this chapter.

Neurological Disorders

The broad spectrum of neurological disabilities offers a good starting point. The patient with a neurological disorder tends to be hyperactive, excitable, emotionally labile, and distractible; his or her thinking processes tend toward concretism. He presents such perceptual difficulties as perseveration and a diminished capacity to distinguish figure from ground. This characterization has certain implications for an educational–therapeutic point of view and approach. Presented material should be concrete, structured and defined. Stimulation should be minimized and psychomotor coordination demands kept fairly simple. While bright, alive and multivariegated colors are at first avoided, poster paints rather than oils or finger paints seem more suitable. Clay, if introduced, should be presented in small amounts. The therapist provides patients with instructions from the rudimentary gradually to the more complex.

Educational and rehabilitative approaches often stop at this juncture, with the entire emphasis on perceptual training and organization (Evan 1969). By implication, all that is needed is retraining. Self-exploration, fantasy play, and creative expression are often seen as interferences to this learning process. Yet, this myopic view deceives. On closer inspection this patient is confused as to his or her body image and has all the attending developmental living problems. If anything, his or her emotional life is further complicated by perceptual difficulties that cannot be solved simply by conditioning, structure, and retraining. The art therapist, cognizant of the perceptual needs and limitations of his or her patients, gradually enlarges the neurologically handicapped person's capacity to handle expressive communication. Dosage and timing go hand in hand with a slow building of release techniques.

Try to picture yourself as an art therapist with a group of brain-damaged children. The room is booming and buzzing like a beehive, crackling with impulses and energy. Clearly functioning as a role model, you gradually introduce simple, structured activities that capture this energy. Later, working with an individual child, you might offer more expressive art materials for the child to explore and investigate. You build, increase and reinforce frustration tolerance. Within the security of a safe and clear world, the child takes a chance and begins to confront some of his or her inner life material. He or she experiences the joy of mastery as well as the thrill of creation. Imagination and fantasy are no longer bottled up or overlooked but given an outlet through the artwork.

Once the mode for creative expression has been established there are many areas to explore. The body image is investigated through tracing techniques and clay work, while perceptual diffusion and feelings of social inadequacy and impotency are brought forth through a host of play techniques. Feelings of perplexity and impotence may be conceptualized through nonverbal media. In more serious neurological cases, the patient may not have the verbal tools to describe the sense of chaos and confusion. The clear and concrete representations of feeling states may be one way of making this situation somewhat easier to handle (Birch 1964 and Evan 1969).

Ego psychology techniques that are structured, concrete and sensory-oriented apply to this population. The student may refer to the 'Techniques' section that emphasizes these qualities.

Autism

A neurological group that requires particular emphasis are the autistic children often encountered in a school situation. Walking into a classroom of autistic children can be a most disconcerting experience for the uninitiated. The children often seem to be bouncing off the walls unless the teacher has held tightly the reins of classroom activity. Hyperactive, distractible and very inside themselves, these children are locked into a prison of unrelatedness. This disorder, which is neurologically based in its origin, demands the utmost patience and perseverance on the part of the art therapist. Structure and clarity is vital, with a good deal of control on the input of stimulation. A wide open approach to these children is definitely not indicated, for their ego apparatus is primitive and undeveloped. As the art therapist becomes more focused and related to each child, their individual personality emerges. Positive reinforcement of coping abilities seems very useful in these situations. Offering a structure that demands limited abstraction, and where the emphasis is on concrete sensory and structured expression appear to be the most useful course of action with these patients. Articles in the *Pratt Creative Therapy Review*, Volume 10 (1992) on the topic of autism describe the variety of materials and activities relevant to working with this population. Along with reinforcing adaptive skills, interventions that facilitate a primary attachment are very relevant for this patient group. The section on sensory techniques may also have some usefulness to the fledgling student who is introduced to this patient population.

Mental Retardation

Art therapy makes a unique contribution to mentally retarded children and adults. The world of fantasy and creative play is a vista not often crossed by these patients when placed in the ordinary institutional settings. Mental retardation does not necessarily imply an equal retardation in the capacity for creative and imaginative work. Yet, retarded patients may be shunted into back wards with minimal stimulation and communication. Art therapy offers an opportunity to open up a whole new life of images, sensations and feelings, potentially making the difference between stagnation and vitality.

With the mentally retarded patient the practitioner starts on the sensory level in order to acquaint patients with feelings and sensations that establish the pattern for an inner life. Expression should not be restricted to one sense modality. Music, dance, and drama, along with art, are necessary ingredients to lay the groundwork for translations into imaginative experiences.

This patient literally hungers for attention and care. Once the art therapist gives this attention, his or her creativity is constantly challenged to explore the appropriate sensory level that moves this patient into imaginative spaces. The therapist introduces each activity slowly so that the experience becomes familiar and concrete. For instance, touching of the various parts of the body of one another as well as the therapist can be constantly repeated before progressing to body tracing exercises. Concurrently, one might also use mirrors, polaroid cameras or videotape to enhance the visual feedback. Music or dance helps facilitate the assimilation process by furthering the exploration of the rhythm and movement of one's body.

A wide range of encounter touch techniques are integrated with educational, ego building and reinforcement theory. Lack of stimulation certainly may regress the intellectual functioning of mentally retarded patients. This group deserves the opportunity not only to feel and be touched, but also to learn how to play and feel alive (Saunders 1967).

Geriatrics

Working with the elderly can be a meaningful experience for the art therapist. Expressionless faces on immobile bodies cry, 'Listen and respect me; value what I have to offer. Do not discard me for there is worth in what I have to contribute.' Often this message is not heard or responded to. The older person can be found sitting alone, having minimal interaction with his world. Institutions reinforce this dysphoric experience, by caring for patients with marginal enthusiasm and even less understanding of their needs.

At the very least, an art therapist can be open and available for an involved and feeling relationship. In many instances, the elderly need much more. A strong developmental need may exist to put life in order, to reflect and to make a statement about the individual life experience. Art therapy may offer an opportunity for a pictorial overview, capturing feelings of loss, separation and disconnection as well as those of joy, love and accomplishment. Images and traces long since without words float together through the art experience. At times, the visualization of a life cycle produces a good deal of discussion and introspection. But for many, the picture may say it all, requiring no explication.

The elderly person may find it difficult to deal with abstractions or material without something concrete and familiar to hold on to. At first, he or she may need to relate on an arts and crafts level so his or her products become gifts that function as a connection to friends and relatives. These products ultimately may be a transition point for more imaginative work. Another patient, however, may need to maintain ties to his or her neighbor-

hood or community. In these instances, the art therapist moves past the limitations imposed by an art room and evolves into a creative social facilitator. For example, children and young adults need the wisdom and love of the elderly; likewise, some older adults need to share the joy and exuberance of the young. The art therapist finds ways to set up activities such as exhibits, fairs and workshops. When the therapist creates a meeting ground for elders to find respect and meaning within the total community, the end of life becomes more of a fluid extension of a changing identity. Old age does not necessarily mean the end of growing. The creative sphere, characterized by a timeless quality, may give new meaning to those faced with death and separation. The imaginative and creative world can at least help make the transition to a state of cosmic unity (Levin and Kabana 1967).

Schizophrenia

The world of Picasso's Guernica is upon you as you encounter the reality of schizophrenia. Ravaged and pained forms, distorted phantoms and ghosts, confusion and panic float in and obscure your vision. The art therapist's very being is rocked as the power of unconscious symbols of the patient's faraway past are reactivated. The gloom and ache of lost battles and the piercing deadness of something empty and gone become present. Schizophrenia takes on many shapes and forms. However, all schizophrenics have in common a sense of defeat and retreat from external reality. For some, this loss virtually began at birth so that not even a glimmer of a self to be rediscovered or reborn is provided. There are chronic and acute patients, non-differentiated patients, as well as more encapsulated patients with crystallized versions of pain and terror; their diagnoses read catatonic, paranoid, and hebephrenic. Each patient hopefully has a distillation of a self to be rediscovered, an ego to be regenerated, and a reality that needs reintroduction. The self within awaits contact. Perhaps art may be a way to find courage and hope by putting the various pieces of a fragmented self into a new whole.

In working with this group of patients, words often take on peculiar meanings. At times, they are experienced as an intrusion or an assault; they give little room to breathe. The picture or the nonverbal act gives a more open and less threatening space to explore. Life problems are on a preverbal level where the very textural quality of the art work promotes and encourages a form of symbiotic relatedness. Of primary importance is the art therapist's capacity to capture the rhythm and tempo of his or her patients. Art materials enhance the relationship, stimulating the externalization of introjects crucial in bringing about a reintegration. Slowly, the art therapist can tune into the pace and quality of the patient's life process. By engaging the unconscious

and converting vague fears and affects into distinct images and pictures, the therapist and patient build an ego to harness, mediate and synthesize these energies into something comprehensible and communicable. The therapist lends his or her resources to make this journey less frightening for the patient, being careful to avoid stimulating a regression to fusion and nothingness.

Today an increasing number of hospital programs address themselves to the adaptive resources of the patient. The well-trained therapist combines resocialization techniques with his or her knowledge of unconscious symbolism and creates a flow in his or her work going from the unconscious to the conscious self, constantly encouraging an emerging identity. Thus the art therapist aids in organizing and synthesizing imagos and introjects and reinforces the emerging capacity of the patient to mold this material into a creative statement about him- or herself.

Art therapists can also understand how and when expressive materials are used as a massive defense instead of a release for regeneration. Not all delusional or hallucinatory material is connected with the self. Much, in fact, protects and hides the self from emergence. The art therapist needs to understand when fantasy is a connection rather than a separation from the self. The art therapist feelings provide a most important guide in making this distinction. Indeed, his or her feelings may be the only criterion that has any validity. Is he or she bored? Is he or she disconnected? Does the material feel stereotyped and flat? Or does he or she feel engaged and related to affects that either the material or the relationship induce? Thus, the art therapist can creatively us him- or herself and materials with a very sophisticated understanding of ego and unconscious dynamics. In many institutional settings, the art therapist may find him- or herself increasingly preoccupied with the development of the ego functions of his or her patients. Art then becomes a safe testing ground where the patient tries out various alternative solutions for problem situations that are illuminated by the art therapist. The ego functions of time, space and judgment, to name but a few, are closely scrutinized. This approach is particularly useful with chronic and pre-symbiotic patients who need constant building, reinforcing, and channeling of an adaptive ego.

An example of the above process is the execution of a clay model. The therapist helps the patient conceptualize and plan the work. He or she creates an opportunity to verbalize the patient's ideas as well as lay out, step-by-step the means of carrying his or her plan into action. The model is constantly molded and remolded till the inner representation and the outer embodiment have some real meaning and communicative value. The therapist constantly reinforces the execution of the art work so that it makes sense not only to

the patient but to others. At some point the schizophrenic must be able not only to depict his or her symbols and affects in the art work, but somewhere find a road that makes contact with others rather than being a path to autistic withdrawal (Scarles 1965).

Patients who are in the throes of an acute breakdown often do best in a quiet, centering environment where ample room is offered for healing and integration. Work with mandalas is often useful. Uncovering techniques should be avoided, as the patient's ego capacities to integrate anxiety-arousing material is already broken down and requires mending rather than stress and confrontation.

On the other hand, patients who have already accommodated themselves to their schizophrenia require structures that help them differentiate between what is inside and outside. The paradox of working with this patient group is a challenging one. Techniques that on the one hand expose the patient to making contact with the outside, and yet offer opportunities to maintain a sense of self-protection are very much in order. For instance, we may ask a patient to draw a mural of their particular form of a hiding place, and offer opportunities to make their hiding place as formidable as required. Fears of intrusion and invasion are important areas to be respected and assessed. Likewise, the therapist may also experience feelings of being invaded or annihilated. Techniques, therefore, that are non-exposing, and have a minimal personal threat can be very useful. Creating such nondescript activities as drawing pumpkins during the holiday season can offer such a safe expression.

Psychosis

Psychotic patients may well be affected with disorders of the central nervous system. Various addictions can precipitate a break that has all the trappings of a functional disorder. However, when the etiological factors are brought to light, the central nervous system disorder becomes a paramount factor. Again, the many elements that relate to brain damage require the attention of the art therapist – structure, concretization and a carefully paced building of ego functions are needed.

Another common psychotic state can be found with patients suffering with manic-depressive psychosis. In these cases, the therapist avoids allowing patients to consume art material voraciously. She or he attends the underlying depression and communicates through the art and through a close, supportive relationship. Art materials are consciously used to reach an underlying fear of loss and sense of blackness (Burton 1961).

Neurosis

The neurotic is often all too aware of the world around him or her and handles it with at least a modicum of adaption. His or her defenses, to some degree, work. This sometimes comes at the cost of self-expression and an inner vitality. An art therapist brings a range of expressive techniques that are directed at emotional release. With neurotic patients therapy emphasizes emotional reaction, fantasy and play, focusing on the ability to respond. Feelings should not only be expressed but worked through so that there is a connection between the cognitive and emotional worlds.

An excellent contrast can be made between the obsessive and hysterical style of neurotic adaption. The former is characterized by an isolation of affect, a predilection for power and control, and a belief in the magic of words and rationalizations. Art is an excellent vehicle to break through these intellectual controls. Think of the fastidious patient who is confronted with the dirt and mess of clay or the gushiness of finger paints, or perhaps the entanglement of armature wire. He or she cannot hide behind the word. The material demands a response. The work focuses upon synthesizing thinking and feeling functions. By contrast, patients with an hysterical emphasis rely on action and dramatization. There is emotional lability and an intolerance for anxiety; repression seems to be a major defence. The therapist helps patients connect words with affects. The approach then recognizes the cognitive problems of these patients by utilizing art as a stimulus for associations and insights.

With all neurotic patients, the art therapist needs to assess the character style that protects the intrapsychic conflict. Equally important, the cooperative aspects of the treatment relationship must be utilized. By the very nature of neurosis, as contrasted to psychosis, a cooperative ego exists. The therapist forms an alliance with the healthy part of the patient and works towards wholeness. At times, there may be more talk than play. In other instances, art may break through resistances where more orthodox techniques have failed. The art therapist need not feel out of his or her element if the patient only wants to talk. Art experiences do not need to be contrived or forced; a creative experience can come through words as well as acts (Fenichel 1945 and Kubie 1961).

The section on uncovering techniques often has a good deal of relevance to this patient population. Although it is rare that these patients do not need some work regarding object relations, the overall thrust and direction of treatment can be much more directed towards the integration of drives. Here, a mind–body integration becomes a central focus of treatment, as the uncovering of defenses permits a more energized expression of selfhood.

Transference phenomena are of a much more benign nature, and are processed within the context of a therapeutic alliance between patient and therapist.

Depression

The art therapist will see a wide range of depressives in any number of different settings. She or her should keep in mind that not all patients who present a despairing, depressed, dysphoric mode of adjustment come from the same genesis. Depression has different meanings for different people. For some it represented a lack of internalization and loss of meaning, a hunger for direction and mothering on a very basic pre-symbiotic level. They need to touch, feel, and sense a caring, understanding therapist. The utilization of a range of sensory materials is a beginning requirement to any work in this area. Essentially, the art therapist builds the world of imagination and feeling. She or he likewise connects the body with material and experiences and offers a whole range of development tasks to aid in the construction of a new being, a new self, and an ego that relates to both the inside and outside. There is also an emphasis on emotional feeding and giving as the art therapist acts as a very primary maternal agent. Not all depression stems from this genesis. Some depressives are caught in a symbiotic bind of dependency, hate, distrust, and need for autonomy. These depressives are tied within an introjective battle that gives them no peace or freedom. Hate and love fuse while separation anxiety causes an inability to reach out to the present. These patients engage the art therapist in a symbiotic relationship where it is necessary to avoid being induced into the role of the introject. The therapist aids separation and individuation by being with the patient and withstanding fits of rage, anxiety and loss. Materials solidify this encounter by making minimal verbal demands on the patient. Techniques are introduced with an attitude of acceptance and understanding. An implicit statement is constantly made: 'I am available, I am with you, I will listen but not take over.' There are still other forms of depression. Some represent a feeling of helplessness when defenses have decompensated with accompanying feelings of impotency. Here the art therapist uses her or his materials to externalize conflicts and provide a field for alternative solutions. As patients test out conflicts in a safe atmosphere, a sense of mastery grows and the depression abates.

Depression can be seen in the whole range of neurotic, characterological, borderline, and psychotic formations. Patients who functions near the schizoid level need distance rather than feeding. Their emptiness arises from a sense of being eaten up by life. The world is perceived as invading. Art offers distance and opportunities to discover oneself. Materials and stimu-

lants, in these instances, should not be very demanding. The schizoid patient, emptied by forces within and without, needs room to find his or her own space, as contrasted to others who require constant space. Superficially, these depressed patients may look the same, but the internal dynamics, as well as the application of the art therapy technique, are different. The art therapist can often make the distinction by being very pragmatic in her or his work. For example, she or he might ask if feeding brings about a flowing or produces further regression.

Patient, then, whose depression stems from a pre-symbiotic impoverishment often do well within an ego psychology framework. Techniques that are structured and support effectiveness often fill in the wide empty spaces that are so prominent in these patients' lives.

On the other hand, in instances where the depression stems from object loss, techniques that facilitate a searching and investigation into the me and you of life become of paramount importance in the treatment relationship. Object loss, fears of abandonment, and identification with lost objects are part of the treatment material that is presented in the patient–therapist dialogue. The structure of the treatment relationship regarding time and place my be an important area of investigation, for invariably, absences and vacations by the therapist, as well as lateness or missed sessions by the patient, all indicate some disruption of connection that is typically the tip of an emotional iceberg that covers many experiences of loss and abandonment. Art can create a place to redevelop a relationship with a lost object that is safe and within the patient's control. Through these nonverbal confines of art expression with the lost object, the unheard affects of rage, grief and pain can be reintegrated within the patient's psychic life. Treatment then, is directed at developing a separation from a highly charged and confining object that the patient can neither live with or without.

Character Disorders

A patient with a character disorder typically has an orientation of manipulation, contempt, and a preoccupation with power. The world is perceived as a battleground for action and self-aggrandizement. Character formations take different forms. They range from the explosive acting-out to the passive-aggressive, placative and self-abnegative. The therapeutic problem, however, remains the same – breaking through the character armor, engaging the patient in a real confrontation and overcoming game playing. Thus, there is a need to be very direct as well as knowledgeable of what is happening on a dynamic level in the relationship. All too often art therapists have been 'had'; art supplies have been squandered and exploited; the art therapist has

been sucked in and used in the service of manipulation which only aids and abets the self-contempt of the patient and reinforces the fantasy of control and power. Thus, the practitioner must use materials judiciously and deal with action and counteraction. Media and techniques that particularly highlight action are very important. What better way is there to confront an acting-out patient than through tape, video, or film? The evidence cannot be denied or dissociated; his behavior is recorded for a return observation. Art and dramatization can help to break through defenses.

At times, this is not enough. Behind these chronic disturbances are deep wells of emptiness and loneliness that are the hallmark of a lack of primary identification and internalization. The therapist must not only be able to present structure and firmness in the relationship, but also care and concern, which facilitate the identification process. As a consequence, the art therapist must be a very touchable and available professional. The authenticity of the therapeutic engagement is an intrinsic part of this process.

Borderline States

As this particular group of patients offers special issues regarding diagnosis and treatment methodology, I have devoted a separate chapter regarding the identification of this group of patients and the treatment issues. The reader is referred to Chapter 13 which deals with the transference and counter-transference issues in working with borderline conditions.

Narcissistic Disorders

The reader is once again referred to the chapter regarding the diagnosis and treatment of these disorders. Issues around the self in which the patient moves in a bi-polar transference from idealization to grandiosity are quite typical for this group. The section that deals with the self psychology models of treatment under the general chapter of resistance (Chapter 7) may prove most revelant to this topic.

Summary

As we have reviewed the major diagnostic categories, an important qualification needs constant reiteration: treatment cannot be approached by thumbing through a diagnostic manual. Dynamics and defenses flow from one level to another. No one patient falls strictly into any one group. A patient who at first seemed a dull plodding obsessive can suddenly develop hysterical symptomatology or perhaps regress to a schizoid solution. The best one can do is to be completely present for a patient, feeling the impact of the

relationship, and discovering the uniqueness of each individual's style of life. As the art therapist accrues a clinical frame of experience, he or she shifts from level to level, integrating the analytic and creative spheres of perception and perspective. Thus, the art therapist loses control, lets something happen, feels the impact of the experience, and slowly puts everything together within a clinical framework. Involved in each contact is the expansion of each individual's creative sphere so that a flow of energy from the cosmic to the adaptational breathes new life in therapeutic endeavors (Redl and Wineman 1952, Reich 1949).

References

Birch, H. (1964) *Brain Damage in Children.* Baltimore: Williams and Wilkins.

Burton, W. (1961) *Psychotherapy of the Psychosis.* New York: Basic Books.

Evan, T.W. (1969) *Brain Injured Children.* Springfield, Ill: Charles C. Thomas.

Fenichel. D. (1945) *The Psychodynamic Theory of Neurosis.* New York: W.W. Norton.

Greenacre, P. (1953) *Affective Disorders.* New York: International Universities Press.

Kubie, L.S. (1961) *Neurotic Distortion of the Creative Process.* New York: Noonday Press.

Levin, S. and Kabana, R. (1967) *Psychodynamic Studies on Aging-Creativity, Reminiscing and Dying.* New York: International Universities Press.

Redl, F. and Wineman, D. (1952) *Controls from Within.* Glencoe, Ill: Free Press.

Reich, W. (1949) *Character Analysis.* New York: Orgone Institute Press.

Robbins, A. (1987) *The Artist as Therapist.* New York: Human Science Press.

Saunders, R. J. (1967) *Art for the Mentally Retarded in Connecticut.* Hartford, CT: Connecticut State Department of Education.

Scarles, H. (1965) *Collected Papers on Schizophrenia.* New York: International Universities Press.

Art Diagnosis

Arthur Robbins

Approaching my patients' art, I often ask myself these questions: How does it feel to live in the picture? What happens to my body? Do I feel tight, or restricted, or free with plenty of space around me to move? Would I like to live in this picture? Does it feel lonely or crowded? Can I enter the picture, or does the artist keep me outside of his or her artistic endeavor? I try to note the movements of my eyes. Do my eyes move into the picture, do they bounce to many different scattered places, or do I get lost in one particular area or another of the picture? In art diagnosis we attempt to translate the story that is told by the structure of the patient's pictorial expression, as well as the content. The theoretical assumptions underlying this approach are elaborated in Chapter 3.

Looking more closely at the art work, we can observe the story of self and object and their relationship to one another. Does the structure box in the energy so the very essence of the self is squeezed and smothered? By contrast, preoccupation with the center (more or less ignoring the outside) betrays very little internalization of the other. The structure of horizontal and vertical lines may mirror, hold, or contain the center. On the other hand, the structure may impair, invade, or overpower the center. In either case, analysis of this relationship will tell us much about the patient's developmental issues. For those readers whose sensibilities may be more kinesthetic than visual, take a particular picture into your body and attempt to feel the movements of the various parts of the pictorial expression. Can you feel the rhythm of the picture? By rhythm, we refer to the organization of energy that moves back and forth from inside and outside. Is it fast or slow, chaotic or harmonious? Does the energy in your body move from a deep central place inside, or are their various body parts moving in discordant directions?

Can you feel in the work of a borderline patient the struggle between the inside and the outside? Can you spot the body being bound and completely out of tune with the center?

Art work can offer tactile sensations. These sensations can have a whole range of qualities such as softness, hardness, grittiness, wateriness, etc. Experiencing these sensations in the body can give therapists another way of entering the patient's experience. Colors often communicate affect states. How does it feel to move like the color purple or red? Of course there are qualitative differences to each of these colors, and our ability to shape or give them boundaries offers added meaning.

Horizontal lines reach out for contact, while vertical lines strive for assertion and autonomy. At times, an art work can feel heavy and weighted down. Once again, experiencing my body as heavy may give me a better sense of what the patient is telling me. Is the picture ungrounded or floating off, or so heavy with its burdens that it has little awareness of the space around it? Indeed, an art work can seem to take up an enormous amount of space, or shrink smaller than its 'actual' size, which again sends a very telling message. We are constantly experiencing both on a visual and kinesthetic level the force and flow of our energy. Are we reaching out, or being weighted down? Are the reds inside of us angry or warm, and to what extent are they bound or unbound? The self, then, lays out all of its particular developmental landmarks in giving organization to the art form.

We see also how defenses appear in the art work. Where does the energy stop, and of course, how is it stopped? Do we see stereotyping or perseveration in the art form that diminishes the authenticity of the expression? Is the art form punctuated or inundated with tight obsessive islands? We can also observe a split in the art form in which there is very little integration between two forces juxtaposed against one another. For instance, the center may be boxed in with a harmonious flow of form while the outside surrounds the center with a chaotic and disconnected art structure. When the art is overformed and rigidified, or without structure, we see how intellectual controls have influenced the personality organization.

We are also aware of the dimensionality of the work of art. Is the art work flat and monodimensional? That is often part of the expression of an impoverished personality structure. The very center of the self was long ago unseen and unresponded to. Thus, the richness of the images, the organization of their expression, and the flow from inside to outside all relate to the personality organization and sense of inner cohesion of the artist.

We can observe the integration (or lack thereof) of the soft round shapes of archetypal femininity with the clear straight lines that are archetypally

masculine. 'Masculine' expressions also include sharp dagger lines that represent our sadism. The nurturing, nebulous softness of the feminine may invite a fuzzy retreat from the world.

How the white relates to the black is another indicator of personal and aesthetic integration. Is the white like a flat shroud that tells us of the patient's emptiness or flatness? Or, do we see the emergence of light that can come from the transformation of blackness into a living and breathing expression of the self? Whiteness can express emptiness, or the negative space can be an important connecting force between the various images of the art piece. At times all the whiteness of the art piece can be absorbed into color, offering either a dense or rich experience.

Feeling in our bodies the various dimensions of visual expression gives us another way of knowing and being with our patients. Movement gives us an additional avenue of nonverbal expression that cannot easily be reduced to words.

At best, the above descriptions are approximations of inner experiences of art which in the end defy verbal articulation. Each one of us brings our own subjectivity to the art form. Yet as artists, we know that there is truth to our subjective experience, for we know that no one interpretation or meaning can say everything there is to say about a particular aesthetic experience. This understanding of the possible meanings of aesthetic expression places the creative arts therapist in a unique position. The structure of the art form can act as a telling x-ray of the patient's experience.

The following examples are presented as a further elaboration of this approach to art diagnosis. No attempt will be made to go into the histories or treatment of these patients. Some, however, have been reported in other texts or articles to which the reader may refer to to follow their treatment. Two of the cases are described in *The Artist as Therapist* (Robbins 1987) under the chapter heading 'Transference and Countertransference Within the Schizoid Phenomena'.

In Figure 23 our eyes are immediately drawn to the harsh red lines. They are brutal and fierce, and on first impression seem to start and stop rather abruptly. On closer inspection our eyes move towards a fragmented center that is pierced by a nail and small red globs of paint. The patient's object reinforces and mirrors the pained, fragmented center of the artist. There is much space around this drawing, demonstrating perhaps, that for this patient all that exists is brutality and pain. By contrast, to return to Chapter 7, describing a multiple-model approach to art therapy, Figure 15 of the borderline patient presents that soft, blue, murky quality that tells us the artist is walking through a haze of clouds. There is no inside or outside for this

Figure 23

patient, for he retreats to a fused state of sublime bliss that covers over and masks a good deal of anxiety.

Figure 14 (drawn by the same patient), presents the dance of self and other that is scarred and marred by deep red droplets of blood. On one side there is that round, soft, breast-like image; the other side has jagged lines in the interior which have the quality of paramecium. Our eyes immediately go to the bottom of the page where the figure lies passively on the floor. The connection is through blood, and the object lies passively, unable to offer any real holding energy to the patient's center. Thus, we see a forced connection as a defense against no connection. The breast-like figure on the left side may well represent the patient's search for the good object, though the object seems a distant fantasy, without any organic connection to the rest of the artwork.

Finally, Figure 11 offers another dimension of this patient's core self. The center is enshrouded in whiteness. It is both dramatic and provocative, and perhaps a little contrived. Our eyes travel to the center and we are trapped in the stark white space that is surrounded by flaming blackness. The blackness entraps the white space and holds it stationary and our eyes cannot easily pull away from the stark white center. Perhaps the patient projects

blackness to the outside and as a consequence lives in a vacant black blank space. The two forces seem to be locked into one another but at the same time do not have an easy flow from one to another. Are we then articulating the story of self and object for this patient?

The work of another patient tells another object relations story. The clinical material can be found in the text *The Artist as Therapist* (Robbins 1986). The image of Figure 24 is stark and dramatic. The patient places his family on his back. The object lies precariously on the back, creating a

Figure 24

distortion of the entire art form. The heaviness of the piece, all pointing downward, tells us the story of the patient's burden within the family. The small center that moves from the patient's head inward toward his chest seems locked in and unrelated to the object. The object (the family) is a heavy burden that has no end or beginning. There are soft lines in this patient, indicating a keen sensitivity to the subtle nuances of life, but at times the mind for detail becomes obsessive and burdensome. The hands are not proportional to the body, for they could not possibly help support this man's burden. The picture is one of pain and remorse, for the patient pictures

himself as a beast of burden. This patient has intense back pains and is under medication to reduce some of the muscular stress.

Figure 25

Figure 25 describes an angry self placed in circular form. The image has a stubborn but fragile quality as it floats directly into the eyes of the viewer. The outer circle seems to give it some kind of boundary, but the emphasis is on the center. The center almost looks like Humpty Dumpty, ready to fall, as we see the artist, demanding from the viewer: Hold me, don't leave me, for I need your sustenance and nurturance.

Figure 26

Figure 26 has also been part of a clinical presentation in the book *The Artist as Therapist* (Robbins 1986). The image of the mother floats in without a ground to give it connection to the earth. The lines are harsh and sadistic. If we look closer, we see the mother barely touching the child. In the left-hand corner, there is a small puppy dog that could well be saying to the viewer, 'Hold me, and touch the warm, cuddly part of me.' The face of the witch is marred by jagged lines, offering but a poor mirror reflection to the child. Within these straight lines there is much unbound energy that seems barely contained. The structure of the art form tells the story: there is an absence of soft lines; a lack of relatedness; unbound energy that is barely contained and a fear that this woman can easily float, for she has no real relationship to the ground.

All of the above pictures tell a story of object relations, ego organization, and experiences of the self. We see the interplay of defenses, adaptations, and character style, all making their telling mark in the art form. We are either invited in, or left out of the picture, encouraged to relate or to disconnect. We may feel the artist's passions, or be buried alive in the psychic debris of the patient's past. Art diagnosis can identify underlying problems and indicate strategies for intervention. Expand this paragraph. Wax poetic. In the story of the art, we learn how the patient feels about him- or herself and others. We also see where the energy stops flowing, offering possible indicators for the locus of a conflict. If we understand how it feels to live in the patient's art, we can also ascertain the hidden message of artist to therapist. Look carefully at the picture and we can tell how the picture is out of balance. Problems in composition all mirror therapeutic issues that demand aesthetic reorganization along with the parallel psychodynamic response. Art diagnosis can be penetrating and profound. Here lies an important tool of the art therapist. The knowledge and the sensitivity to the structure of art defines a very central difference among the many therapists who utilize art in their treatment. This skill and ability of the art therapist requires nurturance and support. The over-reliance on content analysis is a restriction of the art therapist's most vital capacity to contribute to the mental health team.

References

Robbins, A. (1987) *The Artist as Therapist.* New York: Human Sciences Press.

Diagnostic Indicators in the Artwork of Borderline and Dissociative Patients

Mary D. Cole and Arthur Robbins

This paper represents an exploration of the ways in which art therapy – as a primary psychotherapeutic modality – can be used to differentiate the borderline from the dissociative client. The treatment discussed involved observing and working with eating disorder patients in an inpatient, critical care milieu.

Among eating disorder populations, there is a statistically significant proportion of patients who are characterologically disturbed; of the various Axis II diagnoses, borderline personality disorder appears most frequently (Gartner, Marcus, Halmi and Loranger 1989). As well, the increasing emergence of dissociatively disordered clients is noteworthy, as was indicated in the telling workshop title, 'Eating Disorders and Multiple Personalities: A Hidden Epidemic,' at a 1991 conference.[1] As do other clinicians, we struggle with the issue of accurate diagnostic differentiation between these two disorders, which often appear to effectively mimic each other. An *American Journal of Psychiatry* article on 'Discriminating Borderline Personality Disorder from other Axis II Disorders' (Zanarini, Gundererson, Frankenburg and Chauncey 1990) outlined the following features, stating that they 'were found to be somewhat specific to borderline personality disorder: quasi-psychotic thought, self-mutilation, manipulative suicide efforts, abandonment/engulfment/annihilation concerns, demandingness/entitlement, treatment regressions, and countertransference difficulties.' In our experience, all these features also apply to the more severely dissociated clients we

1 Workshop presented by Bob Grant PhD, and John Lovern, PhD, CEDT, at the Fourth Annual IAEDP Eating Disorder Conference, Falmouth, Mass., August 1991.

have seen. It is no wonder that the dissociative client who has not yet revealed the existence of alter states is often regarded as a borderline client. Definitive diagnosis of MPD cannot be made in the absence of alter personalities (Ross 1989; Putnam 1989). Psychological testing is unlikely to be helpful, and indeed Putnam (1989) refers to studies done on the MMPI revealing that 'MPD patients appeared polysymptomatic on the MMPI and many exhibited profiles commonly regarded as indicative of borderline personality disorder.' Descriptive evaluations, such as the S.C.I.D. or the D.E.S., may be helpful, but are not commonly a part of an eating disorder evaluation; indeed, they are unknown to many clinicians for whom the treatment of dissociative disorders is yet unfamiliar. Also, the more florid behaviors associated with MPD may or may not emerge during an average six to eight week stay, making it difficult if not impossible for an accurate diagnosis to be made.

Treatment style and emphasis for the inpatient borderline client differs from that typically offered to the dissociative client; the highly structured, limit-setting, confrontational therapeutic style typical of borderline treatment may be overwhelming and disorganizing for the client who is dissociative but displays borderline traits. Moreover, while in the hospital, both types of clients may respond positively to the specific interventions that treat anorexia or bulimia, but the prognosis for follow-up treatment is extremely poor for the undiagnosed dissociative client, for whom the eating disorder is a secondary symptom (Torem 1986). Consequently, correct diagnosis of these patients is perhaps even more crucial for their long-term care than for the shorter-term eating disorder treatment.

In our experience, the dissociative patient who presents for eating disorder treatment has often had a long history of eating disorder pathology, and enters treatment at a somewhat later age than the average inpatient. At this point, characteristically, neither the patient nor the staff know that dissociative mechanisms are strongly at play. Any patient may be docile and superficially agreeable, or manifest a typical reaction of panicky desire to flee treatment. Commonly, all patients escalate pathological behaviors as the coping mechanism of the eating disorder is taken away from them. The behavior modification milieu restricts access to bathroom facilities, and provides a strictly reinforced eating schedule, individually tailored to meet the patient's caloric and nutritional needs. The anorexic cannot restrict intake for long, and the bulimic cannot purge. Under these circumstances, sub-merged and denied feelings arise, anxiety is heightened, and acting out is expected. Depression is common; vague, or sometimes more than vague suicidal ideation will be present; self-inflicted injury may become part of the treatment picture, and the staff will often have conflicting and strong

countertransferential issues surrounding the care of the patient. The doctor will hear one thing, the clinician another. The patient may show signs of gender identity disturbance, and emotional lability. Under the duress of being away from his or her outpatient therapist and/or friends or family members, and without the seduction and comfort of the eating disorder to numb affect, the patient may begin to panic and express fears of being abandoned. The need for attention, reassurance, and connectedness intensifies and yet fears of intrusion and suffocation surface with equal power. Within a week or so this patient may be given a diagnosis of borderline personality disorder, and the staff's acceptance of this diagnosis will strengthen the perception of the patient as a 'borderline.' If the clinician works especially well with this patient and objects to the diagnosis because it doesn't 'feel right,' the team will often accuse him or her of being over-involved and subjective. At this point the treatment plan will stress firm boundaries, active intervention in limit setting, limited clinical time, group therapy emphasis, and a calibrated but firm insistance on rules and regulations. The patient may adjust, and become compliant with the program. He or she may even gain the needed weight under duress or withstand the anxiety of not purging. But he or she will surely fail the moment he or she leaves the unit, because this experience will be compartmentalized and become completely irrelevant to his or her struggles in the outside world.

The diagnostic problem that occurs for the eating disorder specialist is: how does one differentiate the dissociative patient from the borderline patient before there is any outward and visible sign of multiplicity? This issue is complicated by the fact that eating disorders seem to be dissociative by their very nature. Patients easily respond to an exercise that asks them to 'draw your eating disorder' with disembodied, fully characterized, 'evil' entities that they describe routinely as 'something outside themselves.' Surely not all these patients are dissociatively disordered. It is a danger, on one hand, to miss this diagnosis by confusing it with the borderline; on the other hand, it is problematical, to say the least, to think that every person who paints a satanic face to represent his or her eating disorder is a multiple. The reluctance of many mental health professionals to recognize the diagnosis of MPD at all is yet another hindrance to the process of providing relevant, efficient, effective treatment for these patients.

One of the ways in which these patients can be identified is through a careful exploration of the artwork that they do within the first art therapy sessions. If a patient has a psychosocial history that reveals or suggests childhood abuse, particularly sexual abuse, or if he or she cannot recall significant periods of his or her past during his or her intakes, particular

attention is paid to the images produced. Yet even without those indicators, there are certain visual patterns that give the art therapist clues to the personality make-up of the patient.

Art therapy, as we are using the term here, is to be distinguished from projective testing, or art-making as an activity therapy. We are describing here a modality through which the therapist is an active participant in the art-making process of the client. That participation is not in the creation of the art itself, but rather in the provision of the therapeutic space in which the client can express him- or herself, and in the ensuing interpretations and/or interventions.

We believe that all therapy exists in relationships, and that the process of image-making – regardless of the artistic skill or lack thereof of the client – is analogous to and representative of the process of self-creation or healing that is the goal of therapy. Too often, the act of making art is regarded by the treatment team as a pleasant distraction for the artistically talented. One of the authors recently visited a dissociative disorders program which relegated the 'nontalented client' to making collages out of magazine pictures. That client is being cheated out of an opportunity to nonverbally communicate, explore, and integrate important material.

When a client offers us his or her picture, regardless of the 'aesthetic value' of that picture, he or she is offering a view of him- or herself. By asking ourselves the following questions, we can arrive at a destination which closely mirrors the inside state of our client, both affectively and developmentally: How would it feel to exist inside this picture? Is there an organization to it that enables the viewer to enter the picture, or does the artist keep you out? Is this a chaotic and inaccessible image? Is the artist trying to communicate with you or hide from you, in repetitive, trite images? Is there depth and dimension in this picture? Color? How does the artist use color? Is there rhythm and movement in this picture, or is there dead space? By rhythm, we refer to the movement created by the artist wherein the viewer's eye follows a picture to its center, and then moves outward; the eye moves in and out according to how the flow of form goes from less structure to more structure. When the eye stops and there is no movement, we have encountered dead space (Robbins 1992).

How are boundaries used? Have the images no border? Does the material flow outside the paper, unable to be contained even by the outer boundaries of the page? Is this client trying to tell you a story? Is there a conscious attempt to communicate something she may not be able to speak, or is she offering an image that has embedded meaning not yet available to her conscious mind? (Schaverien 1992)

Intrinsic to this exploration is the notion of energy, and the play of form and energy. 'Energy' here is defined as the movement of our eyes from one part of the paper to another, as there is a gradual change from form to formlessness. Does the artwork have a center? Do the eyes move towards a deep inside place within the picture, which we assume is the very heart of the patient's self-organization?

The shaping of our internal resolutions to developmental problems will necessarily be experienced in the art form through some type of symbolic or image activity. The existence of 'talent' has nothing to do with this central fact. Just as a person's handwriting, no matter how legible, decorous, or attractive it is or is not, is a characteristic and definitive expression of the individual self, so is each image put out in clay, or across a piece of drawing paper equally reflective of the inner workings of the 'artist.' We can observe chaos – unbound energy – lacking rhythm, dimension, or form; we can observe bound and overformed artwork in which no life exists.

Upon closer surveillance of the art form we can also observe the story of self and object and their relationship to one another. Does the form and structure box in the energy, or compartmentalize it? By contrast, we can observe very little internalization of the other with an enormous preoccupation with the center. Or, differently, we can see that there is no center to the picture, no central organizing principle and little relationship between isolated elements on the page. Can we feel, in a particular borderline client, the struggle between inside and outside, or spot the body being bound and completely 'out of tune' with the center?

In Figure 27, painted by a borderline client, the picture represents this young woman's long-standing relationship with her mother. She is the tiny figure in the bottom right-hand corner of the page, barely taking up space; the threatening black cloud above her 'exists at all times,' and 'will never go away.' This bulimic patient, a twenty-two year old college student, has little relationship to her real mother, and has clearly not internalized any of the menacing power her mother holds over her in her mind. The self remains powerless and without definition; the figure painted appears to be like a fetus, suspended in space, vulnerable to impending engulfment and annihilation. Neither does the mother-symbol have definition; it remains a formless and impersonal threat to existence. It is difficult to either assimilate, identify with, or leave this very powerful, yet unformed and ill-defined blackness. Its shape almost suggests a huge paw, or fist. This patient experiences a constant state of dysthymia, and occasional bouts with suicidal gestures; she is also a self-cutter, which, along with her bulimia, provides welcome relief from the dread of engulfment and annihilation that she feels on one hand, and her

Figure 27

Figure 28

often-voiced desperate longing for a relationship with her mother, on the other.

An interesting contrast to this picture is that in Figure 28; painted by a woman in her late twenties, married and the mother of two young children, this picture is also about concepts of self and other, from a memory of her childhood. Again, the self-portrayal in this picture is fetus-like, but here it is enclosed in a safe container through which there is a window to another world, and a sun, which the woman describes as 'hope.' This compartmentalized sun image, we believe, represents the potential health of this patient. In Figure 27, there is complete engulfment, fear, and awe of the threatening object; in Figure 28, there is a protected self. It exists in the same space as the symbol of the sun; although separate still, this sun represents the existence of a good object, in spite of the outer threat of impending darkness. The blackness surrounding this protected self represents the father, who sexually abused this patient during early childhood, but whom she also loved. It is significant, here, that the figure of the fetal self is painted in the blackness of the father's threat. She has internalized the voice that tells her she must be silent, and she has no self-worth except as his object. The picture is also not grounded on the page, but exists, suspended in space, suggestive of the dissociated place in which this woman guards these memories. This patient, like the first, presents as depressed, with suicidal ideation and an occasional desire to harm herself. She struggles to feel worthy of her children's love, and equally struggles to feel deserving of the staff's attention, which she also craves. She had a pattern of opening up in group to reveal parts of her inner self, only to close down and run away from the attempt at contact she made. As she worked through beginning memories of her father's abuse, the borderline qualities we saw in her behavior gave way, in importance, to a clearer picture of her as dissociative. At this point, one can conceptualize the eating disorder as a means of keeping memories at bay; the removal of the defense has the power, for many dissociative patients, to produce the first fragments of memory.

One of the striking differences between these patients was that a therapeutic alliance was not only possible with this second young woman, but able to be somewhat consistently maintained. With the first client, any connection at all took on a kind of intense struggling quality that would then fade into feelings of great distance and emptiness. Close contact often created anxiety so high that self-cutting, or burning herself with a cigarette lighter would follow. This was a way in which she could release the tension produced. By contrast, we have found that when dissociative clients begin to access memories associated with the early engagement of their defense,

therapeutic alliances with significant staff members deepen. In the dialogues that ensue around the act of making art, the art therapist has the opportunity to mirror the client's work affectively, and structurally. In the case of the above client, this dialogue began to build a bridge between that frightened, cut-off, infantile self, and the therapist, as the therapist mirrored the child's wish to be enclosed in a safe place where she could see hope. Even when the art-making itself is difficult, because it is self-revealing and makes the client feel exposed, it is possible through the dialogue to create a space for that client where it is safe to be seen. Issues of shame and worthlessness come up, as they speak of being ashamed of not being able to draw well, and disparage their attempts. The impulse to discard their work is revelatory of a deeper wish to discard the shameful self, housed in a body they consider 'damaged goods.' Yet later, when they have worked through these feelings, they will often verbalize being grateful for nonverbal ways in which to work, for being able to access feelings and speak about them, without long-held and sophisticated verbal defenses to get in the way.

Borderline clients rarely keep their artwork; the product of the self is also seen as 'bad' and must be discarded. Unlike the dissociative client, the borderline disparages and dismisses any connectedness felt in the therapeutic process. The artwork destroyed may become the symbolic chance to cut or harm the self, lest it be annihilated by the therapist. Dissociative clients will

Figure 29

be more likely to keep the work themselves or offer it to the therapist, as a symbol of hope that the therapist will keep this piece of them safe, or as a way of remaining in the therapist's presence.

Figure 29 is a painting done by a young client with borderline traits, which expresses the sadness and isolation she feels at the loss of a peer relationship on the unit. 'I am all enclosed in black,' she said, 'I made the heart red but realized it was black, too. I feel isolated and alone but I want it that way because it's hard to get to know people and have them leave me.'

When asked about the 'fe' she said she had lost half of her 'life' when her friend left, and felt 'confused.' This young woman's intense merging with her peer, in a very short amount of time, created for her a situation on the unit wherein she would not work on her issues with her family, nor relate to the peer group as a whole. Without this one friend there, she expressed overwhelming feelings of abandonment and loss of her self. In the picture, the concrete signs – as opposed to symbols – have no relationship to one another. The borderline client does not symbolize, and remains two-dimensional; the images tend to be repetitive and indicative of resistance rather than revelation. One would not want to live on this page. The space is dead, and the colors dull. There is no movement, no rhythm, because there is no real relationship between self and other to portray. The other person is used as a way to pretend to feel whole; and in fact, when the 'friends' were together, they were destructive to each other's recovery. They literally took the other half of 'life.'

Figure 30

Figure 30 is another picture by a borderline client whose fear and anger are portrayed in a very concrete depiction of her eating disorder experience; her anorexic fear of the scale, fear of her body becoming a fat blimp 'out of control', and terror of her sexual self, central to the page, all comprise another space that the observer would not want to enter. The sharp, dagger-like outlines suggest this woman's preoccupation with self-mutilation as a way to release tension and prove to herself that she is, indeed, there. The images appear to be artificial mirrors of the self, perhaps mutilated, giving her some kind of self-definition that is otherwise lacking. There is no suggestion of relationship on the page, outside of her relationship to her disorder, which has preoccupied her time and attention for several years including multiple hospitalizations. Indeed, she has often voiced the thought that without her eating disorder there would be nothing there.

There is a feeling of tremendous rage imploding in a random and chaotic fashion, which gives this energy no release and no resolution. The observer can imagine being hurled from one treacherous point to the next in this picture, with no relief. This client demands massive amounts of attention when she is on the floor, both from staff and peers, but is unable to internalize that caring. She will lash out in hatred as a means of connecting in the same way she will look for attention by literally asking to 'sit in your lap.' The experience of being with her is very much akin to the experience of being with her artwork.

Figure 31

Figure 31 is a drawing made by an older client who had been diagnosed borderline throughout her first stay with us. This drawing is typical of many that she made, but more colorful than most. Much of her work in the artroom was quite spare in both use of space and imagination; she often drew well formed figures of the people in her family without including herself; her husband and children would be drawn suspended in air without background. She was always dismissive of her work, but seemed pleased to hand it over to the therapist, with a wry grin and a disparaging comment. It seemed worth noting that she did not, however, discard her work. The painting in Figure 31 was one that puzzled her. She repeated several times that she 'didn't know what this was about.' On the unit she was very difficult to manage. She was argumentative, constantly threatened to leave, and often would not eat. The staff became split between her fans and critics; the general consensus was that she was 'exhausting' whether you liked her or not. After discharge, she was home for three weeks and became severely depressed. Re-hospitalized, she brought one of the authors the pastel painting in Figure 32 that she had done at home. This picture was absolutely nothing like anything she had

Figure 32

completed in the previous hospitalization. Its attention to detail, use of materials, subtlety of forms, use of symbols, and expression of energy were all striking. The one common element the two paintings had (Figures 31 and 32) was the existence of six symbols or separate areas that were connected by a black line in Figure 31, and by a flowing river in the other picture. Her comment about the picture was the same. 'I don't have any idea what this is about.' We 'went for a walk' into the picture together. When she first presented it, the grass of what she called her 'meadow' was filled in in one section, and missing in another. We walked to the edge of this space; when asked what was in the empty place, she said she couldn't 'see what was in there,' but because she wanted to finish the picture, she filled it in with the same 'meadow.' She liked the energy of the rushing stream, and the peacefulness of the sky. She expressed fear of the mountain on the left, and indeed, later in that hospitalization, drew a picture of 'an unerupted volcano' which looked somewhat similar to this mountain (Figure 32). The volcano image is arrestingly sexual, with an enclosed phallus rising out of the angry,

Figure 33

pent-up base. The patient stated that if she allowed this to erupt, then she would explode in rage and be unable to be contained.

Like many of our patients in eating disorders, this woman had been egregiously abused as a child, sexually, emotionally, and physically. Shortly after she walked through the spaces of this picture with me, she began to have the flashbacks that allowed us to see her more clearly, not as a borderline client but as a dissociated client. Indeed, she later emerged as a poly-fragmented multiple personality. Her artwork, in its expressive, but compartmentalized way, reflects an early attempt to reveal, not only to the therapist, but to the patient herself, the presence of the very separate ego states which comprise her personality. The boundaries between these states are powerful and protective of the child selves who contain the memories too painful to face. The flowing water represents, to these observers, the incredible energy this woman needs to keep herself going, to be a part of an intact marriage, to be a mother to her three teenage children, and to keep her internal boundaries intact. She left our unit eventually for more specific treatment for MPD and is now home, struggling, but at a healthy weight. Her eating disorder functioned for years to block out feeling and thus keep intrusive memories locked up.

The existence of geometric shapes and abtract symbols is far more likely to show up in the art of dissociative clients, and can be contrasted with the more concrete and pictorial images the borderline client may draw.

Figure 34

Figure 34 is one of more than a hundred pictures drawn by a multiple client who had been hospitalized for anorexia and major depression. While this woman, who was also a highly functioning wife and mother prior to this episode of her illness, at no point presented interpersonal behaviors suggestive of a borderline diagnosis, nevertheless she was the subject of much controversy within the confines of the team. She exhibited occasional behaviors that were initially questioned as quasi-psychotic, and had transient episodes of suicidal ideation that became problematic for an open eating disorder unit to manage. An artist, she was adept in the use of materials, and might be expected to use design elements effectively and cohesively. Nevertheless, commonalities with the artwork of previous MPD clients began to emerge, despite her superior skills. The experience, for the observer, of being inside her artwork was energizing and compartmentalized at once; there was a flow between spaces in her art and connecting lines between symbols that provided both connection and boundaries against intrusion at the same time. The picture in Figure 34 represents a clear split between two ego states who drew on different sides of the paper. She was later able to describe this process, as she remembered the experience of having 'someone else' take over mid-way and finish the picture.

Figure 35

Finally, as a companion picture to Figure 34, the drawing in Figure 35, by a different client, another older anorexic wife and mother, has some similarities. The energy of this picture is more contained but nevertheless balanced and geometric; the picture represents an expression of this woman's anger at her doctor, whom she depicts with the orderly plaid lines. She sees herself as a whirling but contained wheel of anger, which, if allowed to be loosened, would 'destroy everything in sight.' Images of contained anger are common in dissociative clients; 'unerupted volcanoes,' wheels that seem to be pulsing mandalas of energy, rushing water, or compartmentalized spaces in which other symbols rest, like the dead log in Figure 32. These compartments exist either by themselves or in relationship to other images on the page. These pictures tend to use spaces in conscious ways. The observer's eye can follow without him or her feeling as though he or she will drop through space or encounter either deadness or unbound chaos.

The dissociative client will often relate quickly to questions like 'What is it like to enter this picture?' Even if the client cannot tell you, because of fear or uncertainty, we find that the dissociative comprehends the question, easily relating to the concept of leaving one space to enter another, or leaving one reality to take part in another. Borderline clients will often find it difficult to relate to the concept of entering a space, finding the idea terrifying and an invitation to annihilation. They can more easily describe their pictures to you, using more predictable and universal signs like broken hearts and black clouds. They benefit from an attentive and respectful willingness on the part of the art therapist to accept what they offer without either embracing or dismissing the gift, but discussing it, mirroring back the need for concrete boundaries and safety between the warring self and other.

The ability to detect the possible dissociative client, early on in a patient's stay, is an invaluable addition to the work of the treatment team, whose mandate it is to provide discerning and individualized care. The art therapist's ability to discern significant differences in the overall structure, tone, and feeling of the patient's artwork is uniquely relevant to the diagnostic task. Art-making is of its very nature somewhat dissociative; the artist is familiar with alternate ways to perceive 'reality' and acquainted with the feeling of disassembling the ordinary in order to create the new. An understanding of the movement between observer and painting, artist and artwork, observer and artist, prepares us well for a compassionate response to the creative process which engenders multiplicity as a defense.

One enters these intrapsychic spaces to experience with their creators the waiting memories, often terrifying and grotesque. Within these spaces awaits also the discarded body-self, unhappy container of the memories kept at bay

through starvation or purging. To aid the dissociated client in the difficult task of reclaiming this body, re-experiencing the contained memories, and undergoing the catharsis needed in order to discharge them of their power, is not possible unless the client has been diagnosed correctly in the first place.

What do we look for? The ability to create symbolic material, no matter how crudely expressed, often arises in the early part of treatment. Compartmentalization of the psyche is often expressed in the artwork through boxes within boxes, as seen in Figure 8; it is also revealed in the sectioning off of images or groups of images, and in the use of geometric shapes that are drawn in relationship to one another on a page. Many of the drawings produced by dissociative clients have borders around the outside of the paper, as though to insure that each piece will be contained in a manageable space. While not shown in this article, we have experienced as well a phenomenon where the client with MPD will sometimes even unknowingly reveal a specific number of alters who may be present by presenting that exact number of images on a page. Figure 31 may well be an example of this, although when it was drawn we did not yet know the client had MPD or was even dissociative, for that matter. The personality system may present clues in the artwork well in advance of presenting itself in other, more clinically observable ways. In contrast to the borderline client, these patients' art in general is more colorful, and more often than not has a sense of inner organization and cohesiveness that may also contain richness of ideation and many layers of meaning. There is seldom anything trite or banal; to the contrary, images will emerge that are enigmatic, to creator and observer alike. An image that has recurred in the artroom of one of the authors is that of a dead log; three different patients, two anorexics diagnosed borderline, and a bulimic with no Axis II diagnosis, (none of them patients during the same period), each made an almost identical image of a dead log (one of them appears in Figure 32). Further, each professed herself unable to relate to this image. All three patients later emerged, either in our hospital or in aftercare elsewhere, as MPD clients. Our interpretation of this symbol is that it may stand for the deadened piece of the abused self which houses memories too grotesque to imagine. Just as the archetypal tree has long stood as an inner symbol for the self, so may this deadened log lie as silent witness to the past for which these clients have no words.

In conclusion, our experience suggests that the overlapping characteristics of the borderline and dissociative patient populations require the clinician of whatever discipline to pay particular attention to the limitation of a quick diagnosis. While it must be recognized that borderline patients may share dissociative defenses, and dissociative patients may experience borderline

states, we believe that art therapy can assist in discerning these differences, recognizing that the intrapsychic structure of the borderline differs from that of the dissociative patient. The art productions of these patients, studied over the span of their treatment, may provide potent clues for a differential diagnosis. Correct diagnosis then leads to appropriate treatment planning, which is the ultimate determinant for a positive treatment outcome.

References

Gartner, A.F., Marcus, R.N., Halmi, K. and Loranger. A.W. (1989) 'DSM-III-R Personality Disorders in Patients with Eating Disorders.' *American Journal of Psychiatry 146*, 12, pp. 1585–1591, December.

Putnam, F. (1989) *Diagnosis and Treatment of Multiple Personality Disorder.* New York: Guilford Press.

Robbins, A. (1992) 'The Play of Psychotherapeutic Artistry and Psychoaesthetics'. *The Arts in Psychotherapy 19*, pp. 177–186.

Ross, C. A. (1989) *Multiple Personality Disorder: Diagnosis, Clinical Features, and Treatment.* New York: John Wiley & Sons

Schaverien, J. (1992) *The Revealing Image: Analytical Art Psychotherapy in Theory and Practice.* London: Tavistock/Routledge.

Torem, M. (1986) 'Dissociative States Presenting as an Eating Disorder'. *American Journal of Clinical Hypnosis 29*, 2, pp.137–142, October.

Zanarini, M.C., J.G. Gunderson, F.R. Frankenburg, and D.L. Chauncey. (1990) Discriminating Borderline Personality Disorder from Other Axis II Disorders. *American Journal of Psychiatry 147*, 2, pp161–167, February.

Further Reading

Demitrack, M.A., F.W. Putnam, T.D. Brewerton, H.A. Brandt, and P.W. Gold. (1990) Relations of Clinical Variables & Dissociative Phenomena in Eating Disorders. *American Journal of Psychiatry 147*, 9, pp.1184–1275, Sept.

Steinberg, M., B. Rounsaville, and D. Cicchetti. (1991) Detection of Dissociative Disorders in Psychiatric Patients By a Screening Instrument and a Structured Diagnostic Interview. *American Journal of Psychiatry 148*, 8, pp.1050–1054, August.

Developing Therapeutic Artistry
A Joint Countertransference Supervisory Seminar/Stone Sculpting Workshop[1]

Arthur Robbins and Marc Erismann

Introduction

This paper will demonstrate how a clinical case presentation seminar, facilitated through nonverbal processing and a stone sculpting workshop, guided by a psychotherapist/artist, can provide a needed alternative supervision technique for psychotherapists from all mental health disciplines. In describing this joint workshop, we will explore countertransference issues and pay particular attention to the development of those emotional and cognitive resources that contribute to psychotherapeutic artistry. Central to this exploration will be the group processing of conflicts that arise in the transitional space as therapists work with patients. The authors hope to provide a penetrating glimpse of the countertransference conflicts that are inevitable in the therapist–patient relationship and to share with the reader the rationale behind their particular approach to supervision.

Historically, the training of a psychotherapist includes study of such areas as psychodynamics, transference and resistance, psychopathology, diagnosis, and personality development. Rarely does the traditional curriculum relate to the subject of therapeutic artistry. More specifically, there is very little attention focused upon the therapist's integration of the creative and therapeutic processes. For the most part, personal therapy is assumed to be sufficient to free the therapist in his or her work as a psychotherapist. (We will return to this topic at a later point in the paper.) At times, supervision

1 Published in *The Arts in Psychotherapy*, Vol. 19, pp. 367–377, 1992.

addresses the issues of psychotherapeutic artistry, although there are strict lines drawn between the discussion of such emotional material as is thought to belong in personal treatment, and the teaching of therapeutic technique. We are, of course, referring to any psychodynamic supervision regardless of the background and discipline of the particular therapist. Supervising therapists as well as therapists under supervision must be willing to take emotional risks. They must have made sufficient progress in personal therapy to be able to move from an emotional subjective position to a didactic and cognitive approach. Traditional supervision focuses upon the patient and the techniques that are required and the theory that is applicable to do the therapeutic processing. The authors of this paper work from the assumption that the traditional format of personal therapy, supervision, and coursework does not make room for the kind of integration that encompasses the creative process of the therapist, their particular characterological defenses and style as well as the variety of emotional inductions that are part of countertransference.

We have stated the following in an earlier text: a good therapy session contains many of the characteristics of a work of art. Both share a multiplicity of psychic levels and a release of energy that radiates along the axis of form and content.

Therapeutic communication, like art, has both sender and receiver and is defined by psychic dimensions that parallel the formal parameters for which art is expressed. In any one session, we can detect in patient–therapist communication both verbal and nonverbal cues that can be examined within the artistic parameters of sight, sound, and motion; that is, in rhythm, pitch and timbre; in color, texture, and form; and in muscular tension, energy and spatial relations. These elements of therapeutic composition have their own principles and require the utmost skill in therapeutic management (Robbins 1981).

Thus, from our perspective, the typical verbal articulation of a therapy session has many limitations. If there are so many nonverbal parameters to a session, then we must adopt a language that can describe them. The language of art accurately and tellingly describes some of the important dimensions of the therapist–patient interaction. Our workshop also provided a format in which to do nonverbal processing and thus fulfill a need we consider very important in therapeutic education.

We return to a description of a patient–therapist interaction. Ideally, there is a meeting of two minds in which there is an experience of both separateness and oneness. Making this space alive and meaningful becomes the work of treatment. This space can also be referred to as transitional in

nature as it is constantly moving and changing. During this patient–therapist communication, sensory channels become potential organizers of images, which in turn offer us clues and guidance in the process of shaping and re-shaping transference and countertransference material. The complexity of this material often leads to decisions as to use of therapeutic technique. For instance, the images formed in the therapist's mind during the treatment process may mirror significant affect states experienced in the past by the patient. The clinical use of these affect states then becomes part of the treatment process. More often than not, these inductions are toxic in nature, ranging in affect from rage to despair, from dissociation to intrusion, and from powerlessness to grandiosity. The creative challenge for the therapist becomes an imposing one: on the one hand we must be open enough to take in these very complex emotional states of being; on the other, we must be able to separate ourselves from these inductions and creatively transform them into positive mirrors in which patients can view themselves. In short, we take in their pathology and offer them back health. Our sensitivity and vulnerability to these various inductions and projections will vary from therapist to therapist. These inductions and projections are the raw meat of treatment and commonly fall under the category of transference. Furthermore, our ability to transform these projections will be contingent on our ability to identify with the patient and at the same time be free enough of these identifications to discover the positive constructive force that lies buried in these transferences. In many respects, transference becomes the art form of the patient, though the art form may well be rigid and sterile as a result of the patient's attempts to mask personal trauma (Rose 1987). The therapist's art form, on the other hand, may be his or her creative use of the countertransference to mirror back health rather than pathology.

In view of this subtle and complex interplay between the personalities of patient and therapist, therapeutic technique cannot be separated from the personality of the therapist. Indeed, how we navigate as therapists in this gray area of therapeutic communication will demand a high degree of artistry. The verbal description of therapeutic communication leaves much to be desired. Rarely can it capture the textural and nonverbal elements of treatment. The nonverbal frame then becomes a place to externalize the image as well as a means to explore the depths of its meaning.

For a review of the literature on transference and countertransference as they bear on this process, we refer the reader to two main sources *Expressive Therapy* (Robbins 1981), and *Countertransference* (Epstein and Feiner 1983). There are two main perspectives on the subject of countertransference. The more traditional perspective holds that countertransference interferes with

the processing of therapeutic material and should be attended to in one's personal therapy. The concept of countertransference has more recently come to be used in a general sense to describe the whole of the therapist's feelings and attitudes towards the patient. The authors of this paper take the latter position and work with therapists utilizing both their character problems and defenses, as well as inductions, as important issues that can facilitate or impede the flow of treatment process. One further issue needs to be addressed in this paper. Creative art therapists differ widely as to how and where to work with both the transference and countertransference. Many believe that material of this nature should be addressed mainly by work in the nonverbal modality. Others believe that this is an undue restriction and prefer to work both within the relationship as well as within the modality to process transference/countertransference material. For a review of this area, we refer the reader to the *American Journal of Art Therapy*, Vol. 21, No. 1. However, there is nothing in the literature that directly relates to the use of stone carving and other non-verbal media as a means of processing transference and countertransference material.

The Theoretical Structure of a Countertransference Training Group

The format for a countertransference group has been discussed in detail in one of the author's texts, *Between Therapists: The Processing of Transference/Countertransference Material* (Robbins 1988). In brief, the format of these particular training groups typically involves a case which is presented in an open-ended fashion at the onset of the group. This creates a climate which encourages free association, fantasy, and the processing of spontaneous feelings. The group tends to take on a life of its own; there is no fixed order as to whom is presenting. Often, cases reflect a particular group theme. Sometimes the sessions take on the atmosphere of group therapy in their openness and non-judgemental nature; at the same time, firm boundaries are maintained between the presenting of material that is too far afield from the case at hand, or could possibly turn the group into a more personal therapy experience. We maintain a policy that transference issues among group members, or with the leader, are not processed unless not doing so interferes with the total learning experience. All members have enough personal treatment behind them to enable them to move back and forth from deeply emotional forms of communication to a more cognitive learning position. Out of this mix evolves a structure for learning that is affectively 'loaded' but generally supportive. This atmosphere can only take place in a climate which encourages trust and rapport between members and leader. Given the

usual political problems in an institute, this model is more suited to a private practice setting.

As the interplay of group dynamics evolves, a splitting process can arise in which parts of the patient in question are projected on to various members of the group, or the leader. The ensuing dynamic is handled in a variety of traditional and nontraditional forms, through confrontation, mirroring, fantasy, or dramatic dialogue, all of which contribute to an alive and charged atmosphere. Talking like our patients, sitting and moving like them, drawing our patients and their parents, as well as our own parents – these activities create a rhythm of nonverbal organization that becomes projected into the room. As it does, we take turns in organizing and shaping the space, each one of us developing his or her own unique style and manner. In short, we learn how to be close to our patients, be one with our patients, and yet at the same time understand how to remain enough outside of the transitional space so that we can play with it, giving it shape and form. Playing, in this sense, requires a capacity to work on dual levels of consciousness.

The Theory of the Stone Carving Workshop

In addition to the above learning experiences, there is no substitute for a hands-on experience with one of the studio arts. Many therapists have developed artistic skills with an art teacher. Rarely, however, are students provided opportunities to attend a studio workshop conducted by a therapist skilled in both therapeutic and artistic processes. We know of only Robert Wolf and Elaine Rapp, who have utilized this technique with therapists. However, the theory and scope of our workshop was conceived independently of these two professionals and developed along different lines. In the studio experience which we facilitated, students confront personal issues regarding the interplay of space and resonance, feeling first hand how personal conflict interferes with the total composition of the artwork. In this setting, psychoaesthetics becomes alive: space, color, form and rhythm are revealed as components of personality when they appear as aspects of the process of artistic creation. Such personal issues as perfectionism, fear of judgement and attack, and reluctance to deal with accidents emerge. This last issue can become a catalyst for an entire creative exercise: errors in artwork, like errors in psychotherapy, demand creative and therapeutic attention. It is rare that our unconscious does not spill out, in spite of our wishes to be careful and thoughtful regarding either our patient's space or the integrity of our artwork. Accepting our vulnerability to error and accident, and openly investigating it with our patients, becomes a curative experience. Now there are two people grappling with humanness, frailty and

vulnerability. In a similar way, the examination of the implications of resistance in art has enormous value in the context of treatment. Especially in stone, the art form has a mind of its own and must be worked with. Accidents cannot always be repaired and demand an innovative approach. The stone experience often helps participants circumvent the difficulty of words or the limitation of language by providing a concrete experience of the interrelationship between space, form and energy. Nonverbal mastery, as well as defeat, gives one the chance to think and see as well as feel in a new modality, creating the possibility of carrying these new insights into one's clinical work.

Description of the Workshop

A five-day workshop was offered to clinical therapists, including psychiatrists, psychologists, and art therapists. In the mornings, participants focused on countertransference within a verbal case presentation format. In the afternoons, the participants worked in an art studio setting under the guidance of a co-leader whose training is in artwork as well as in clinical dynamics. The art medium was limestone or marble, and the participants were directed to focus on the figurative motif of the human body. Throughout the day, the co-leaders attempted to relate issues that emerged in the case presentations to the students' work in stone. In the afternoon art studio sessions, an important issue for discussion was the students' relatedness with the stone as both material object and interpersonal object, drawing analogies between working with sculpture and working with clients. Specific topics included the interpersonal implications of the use of space, light, lines and planes, surface and volume; the interpretation of the students' relative comfort with the tools and technique, and the students' responses to incompleteness or deficiency in the portrayal of aspects of the human body. The crucial point was that a student create a pictorial image and sensorially explore it, rather than prematurely interpret in words its manifest and latent significance. In the particular material chosen for a sculpture lie potentialities for certain kinds of physical interactions, and not others. Thus the physical responses of a particular material tend to lead to certain effectual expressions, as well, and not to others. Because of this, selecting their stone becomes a passionate process for the participants. Conscious planning as well as unconscious and pre-conscious projections and identifications can lead to love at first sight, but can also lead to doubting and helplessness. 'Do I choose a stone that's very hard to maneuver? Do I want one that's big and tall? Or flat and light? Can I trust its structure and cohesiveness? How do I place it on my work table? Does it have firm footing, or can it be easily pushed?'

The Processing of the Workshop

On first meeting the stone, as in meeting our patient, we must open up our senses to hear its powerful but silent language. We approach it, engage ourselves physically with it by touching it, handling it, feeling its textures, its weight, its volume. As one feels the stone, there occurs the unique reciprocal of the tactile experience: the 'touching' emotional experience of being touched. We are led to associations which are often the memory traces of our earliest, most intimate experiences. Perhaps these may be traces of our early states of self-object differentiation, experiences in which through physical touch we knew our mothers, and began to know ourselves. Or, our associations may lead us to memories of the act of sexual intercourse, in which we define ourselves through the desire of and for the other. Next, through the language of the hammer and chisel, we begin to learn the rhythm and music of this particular stone. And we soon become enmeshed in the dance between the stone and ourselves, a dance which oscillates between intimate closeness to the stone, and cooler observation of it from a distance. We can touch the stone directly, with our hands; or we can indirectly touch it through the intermediary of the hammer and chisel; or we can touch it only with our eyes, from an observing distance.

As we work on our stones, at times we feel an almost irresistible temptation, a deep need to touch the sculpture. Drawn to the surface of the stone, some of us proceed to grind and even polish its surface to a smooth, shining 'skin.' When we do this, we learn to know the electrifying, sensuous, and sensual feeling that the new touching of it could evoke. We learn that, on the one hand, smoothing a surface effects a sort of closure of the form, imparting to it autonomy, otherness. And, on the other hand, retaining roughness in the surface preserves a feeling of openness and access into the material; roughness can preserve a kind of umbilical cord to the creator.

For many therapists, work on the stone will at first be a welcome relief from the challenges of emotional containment and responsiveness to patients. For with the stone, the therapist can freely allow vivid expression of emotion concerning the patient. Another satisfying aspect of working with the stone and not the patient is that with the stone there is a constant pictorial presence, a constant image of the transitional space, an image which does not fade away in the flow of dialogue as happens with patients. This pictorial presence is not only intellectually reassuring to the therapist; it also offers a degree of object permanence which is not possible with the patient or any living being. And so, emotional relief and the reassurance of object constancy can offer positive satisfactions while beginning work on the stone.

But as the therapists continue working on their stone, they soon discover that a stone has a character and life of its own with which the artist must negotiate even while feeling some semblance of mastery and control. The physical resistances and anomalies of that particular stone thus become quite analogous to the emotional resistances of a patient. However, unlike the situation in therapy, the artist can simply walk away from the stone when work on the stone's resistance becomes too frustrating and difficult. The artist–therapist may even express his or her frustration and fury by hammering away at the stone, without fear of retaliation. However, if the participant directly confronts the stone's resistance in this way, he or she risks penetrating the stone or injuring its skin, perhaps even splitting apart its physical integrity. And thus one risks injuring the matrix of one's imagination, the field of expression itself. Perhaps by becoming aware of the stone's physical vulnerability, we face our own vulnerability to narcissistic injury. It seems also that with a stone, we can experience directly a sense of our power to damage or injure, a power which has its analogue in therapy.

Thus, recognizing the nature of the stone's resistance is quite similar to respecting the nature of a patient's resistance: if we superimpose our own rhythm on the stone, or conversely treat it as too fragile, we will never really meet the stone itself at all, never feel its unique resonance, nor hear its mysteries. Some participants came to realize that they could not do what they wanted to do with their stones: they had to face up to the inherent limitations of the stone itself, as well as face their own limitations of bodily strength, and the constraints of time and place. Each participant had to find some kind of compromise for each of these issues. So too must we face limitations in our clinical work. We cannot always do what we want to do for our patients; our patients themselves have limitations, as do we, in mind and body; and in therapy as in the art studio, we face constraints of time and place.

Problems with tools and their use were a particular focus in the discussion of limitations. Some people found that their instruments were not appropriate for the task at hand. Could they give up one tool and decide to choose another? Some became particularly attached to a hammer, even though it was too big or too small for their hand or the stone. Finding the right tool that expresses the needs of both stone and artist thus became an immediate encounter in creating a living transitional space, one that is alive on both sides. In some cases, the choice of an inappropriate tool turned out to reflect a resistance against involving themselves in the process. In other cases, whether the tool chosen was appropriate or not, participants would only scratch the surface of the stone, as the stone seemed either too big or too

ominous or too fragile to treat more aggressively. Some participants had difficulty in changing the stone at all, even scratching its surface. They were more comfortable in treating their stones as 'found objects' or 'ready-made,' treating the stones as not needing change at all. The new participants, those who were taking this workshop for the first time, were particularly tentative about moving into the heart of the work: 'Is my stone too much for me? Should I choose another?' Fears about hurting one's back or arm were often voiced, as well as doubts of bodily effectiveness: 'Could I really be so in charge of my body as to really express the inner part of me outwardly, through and with the stone?' Thus projections into the stone began. For some, fragility soon became evident; for others, omnipotence. Some feared the stone would break. Others projected 'Will I be destroyed if I use too much force?'

The Experience of One Participant: Marc

The therapist, Marc, complains that he is out of sync with his patient. Nothing seems to flow, interpretations are deflected, empathic resonance falls dead or is not heard. There is a feeling of disconnection and of being out of tune with the patient. The therapist feels exasperated trying to work with this case. Marc draws a picture of his client. (Figure 36)

There are sharp, cutting, penetrating lines as well as soft undulations. Yet, he can't find a way of responding to either. He can't seem to connect with the patient. His hands feel tied. He cannot be one with the patient, and feels uncomfortable being separate from the patient, for then he feels alone and disconnected.

As we look at the picture, we see repetitive horizontal elements which are broken through by bundles of vertical and oblique lines. These lines form dysrhythmic convergences and divergences, creating tensions and blockings. Although there are circular elements resembling a head at the top of the drawing, there is no connection between this circular 'head' and the straight lines on the bottom of the drawing. Further, one is struck by the fact that the cut-off hands on the portrait unintentionally give the form a deeper meaning, a meaning that is applicable to both the supervision and the sculpting. We want to remind the reader regarding our position with respect to interpretation of any art form, be it verbal or nonverbal: therapists may offer any number of subjective or objective meanings, and all can be appropriate and helpful. The ultimate test is not one of finding an absolute truth but of ascertaining the effectiveness of our interventions in facilitating treatment process.

Figure 36

We then moved into role-playing to get a better sense of the relationship between Marc and the patient. In the dialogue, the 'patient' played by the presenting therapist interjects a volley of questions. The 'therapist' played by one of the leaders feels inclined to respond to these tempting tidbits. Upon which the patient throws his arms open wide and says: 'Come into me and fill me up!' Yet when the therapist attempts to respond to the question, the patient tersely responds: 'No. That's not it,' and the volley of questions continues. 'Should I stay with my wife, or go with my girlfriend?' His girlfriend, of course, satisfies him sexually, but on the other hand, he feels loyal to his wife, etc., etc. What should he do? What should he do? And he states that the therapist has no answers for him. He oscillates back and forth, requesting engagement, and then turning it down so that there is no

engagement. The patient's questions are obviously not the real ones, yet the patient's perplexity hides something very real.

Let's translate this dialogue into pictorial metaphor. The patient draws sharp lines defining his space. The therapist responds, speaking in soft, resonant tones, the equivalent of circular, undulating lines. And nothing seems to happen; there is no contact or play between the linear and the round part of the dialogue. Then again, if the therapist responds with a confrontational straight-edge by stating what is actually happening in this questioning dialogue, the patient, as it were, dissolves and floats away. The therapist is tied up in knots: confrontation does not help, and empathy appears to be wasted. Soon the therapist feels impotence and rage. The patient is sending out nonverbal communications replete with the tones of sadism and impotency. The therapist, in response to this material, becomes enmeshed, and loses his therapeutic distance. The challenge, then, is to be very present in the same space with the patient; to neither dissociate nor act out in the therapeutic dialogue. These observations are shared with the group, yet what becomes very clear is that the group recedes in the background and the focus becomes centered on the leader and the presenter. In this format, the countertransference of the leader also becomes an important factor. The leader not only experiences the role of the patient played out by the presenter but also some of the significant issues of the presenter that are presented into this dramatic space. The leader feels playful and fatherly as some of the images of his own father–son relationship seem to filter through his consciousness. He feels protective and playful as well as somewhat provocative and challenging, and he decides to use these affects in the further processing of the material.

We go back to role-playing: the leader plays the therapist, and the therapist plays the patient. The patient asks a question. And then, with a provocative, almost evil smile, he says: 'But I know therapists are not supposed to answer questions.' We explore different ways of responding to this communication. Finally, the leader offers the following response: 'It's your hard luck,' he says, 'that you have such an impotent therapist, who isn't wise enough to answer these questions. Maybe I should consult my supervisor so I can be more adequate to field such questions.' The 'patient' smiles genuinely, and the tension visibly relaxes between them. In fact, a sense of alignment, of at-oneness, palpably arises in the shared space.

In this dialogue, the 'therapist' did not fight the induced role of impotence, but instead used it playfully to show his 'patient' that even impotence may have its uses in a relationship. In short, the leader accepts the role offered by the 'patient.'

The impotent role of the son that may be lodged in both the patient and the presenter now finds a voice and speaks back to the father that appears in the patient. In this dramatic play we discover opportunities to process some of the unmet dialogue of father and son. Much of this processing could easily fit into an object relations framework. However, therapists whose personality and character structure resonates with a self psychology perspective might relate to the hidden self of the patient that was not adequately mirrored. Again from a drive psychology position there might be a mirroring and a playing with hostility as the central feature of the interchange. From this perspective therefore, our theoretical position and interventions may well be an outgrowth of both the interchange of patient and therapist, as well as our characterological predisposition to be attracted to one type of intervention or another.

We return now to the patient–therapist dialogue. We observe that by accepting and playing with failure and impotence, rather than becoming identified and fused with it, the therapeutic workshop opens up. The surface masochistic role of the therapist no longer locks him in to the fear of being pushed into a sadistic role. Indeed, sadism here becomes playful, converted into therapeutic self-assertion. Aggression itself thus becomes neither fearful nor harmful, but a form of play that has warm, accepting overtones. This mirroring of aggression becomes the healthy reflection of father and son becoming playful as well as aggressive.

Marc's Plan For The Stone: The Picture Of A Hand

Marc introduces his plan for the stone: it is a drawing of a hand (Figure 37). Speaking as the hand, Marc says: 'Let me be. I don't want to be pushed one way or another. I am just simply there.' And now Marc must face his dilemma: the sculpture of the hand must successfully integrate the lines of softness and aggression (Figure 38). The hand must mirror the hidden potential of the patient, must show that even though it is open and ready to receive, it also is capable of movement and aggression. The patient must therefore not be too frightened of feelings of impotence and failure. If we attempt to overcompensate for our feelings of failure or impotence by demonstrating to the patient the adequacy of our interventions, then we become the sculptor who imposes a false form on the work of art. The presenting therapist then reflects upon his experience with his son. The son challenges him and fights with him, wanting to feel the loving experience of his aggression. His aggression is playful but real, angry but loving, protective but free. The paradoxical father–son relationship searches for the loving experience of aggression. And the therapist feels secure enough to participate in this kind

Figure 37

Figure 38

of relationship with his son. However, he wonders if there is in him an authoritative and explosive father that may get out of control with his patient. As he considers further, he wonders if in his drawing of the patient, the denial of the body as expressed in the representation of the cut-off hand might not illustrate the patient's fear of an authoritarian father breaking into consciousness. And also that in a deeper sense it may also represent the cutting-off of mind from body symbolized by castration anxiety. The presenter now becomes visibly centered and in touch with his patient. His own fears of castration are no longer dreaded or defended against but become a road to understanding what is going on with the patient.

In treatment, we are reminded that there is a continuous oscillation between an experiential (perceptual/feeling) and a conceptual (knowing) position. This patient may need sufficient time and room for the father/therapist to play with him. Only then will the patient have had the experience upon which to form useful verbal conceptions. For if we move too fast into the cognitive field, the loss of the father/son exchange becomes painful, and the communication is likely to be maintained on the sadomasochistic level. Thus the experience of playful interaction with a person who is strong enough not to be afraid of his aggression, must precede any attempt at conceptual interpretation.

As we reviewed the possibilities of this therapeutic exchange, the theory of working with highly defended and characterologically resistant patients moved into the foreground of discussion. A direct attack on firmly entrenched characterological defenses seems comparable to fighting the rhythms of the stone.

The Experience of a Second Presenter

The second presenter states that her patient is dying of cancer. The patient's mother and father had very little to do with each other. The mother was self-absorbed and masochistic, all too involved in her complaints and problems. She gave an implicit message to her daughter: 'Care for me, reach out to me, mother me, or you don't exist.' The daughter, as a means of protecting herself from both parents, developed a removed and dissociated personality. She moves in and out of relationships, not letting anyone get too close to her. The therapist feared that few present in the group would understand the very special space that a therapist shares with a dying patient. The shared space is paradoxical: 'The patient is dying, and searches for life. I represent life, and she is dying. How can one leave an empty space when it needs to be filled by taking cognizance of the patient's lost dreams and wishes, if only in our office?' The therapist states her own problem to the

group: she does not know how to bring the patient to a deeper level of therapeutic involvement. She says that she does not really feel the presence of the patient. As the therapist speaks, anger soon appears on her face, as if a wall stood behind her eyes. She blurts out that she feels a sense of isolation and despair. She visibly struggles with the tears and pain that are breaking through her wall. The group becomes hushed. A tense dialogue ensues between the leader and the presenter: she wants to communicate something which she believes the leader does not want to hear. She wants to be listened to. Perhaps this sheds some light as well upon the parallel process between the therapist and patient. Could the patient be communicating: 'Do you know what I really feel? How can you? You are living, and I am dying. Just listen to me, and be with me.'

The discussion now shifts to one of the patient's drawings from her first therapy sessions. It features two large, concentric circles. Straight, sharp lines shoot out from one side. The picture is ominous, frightening, with its jagged toothlike lines. It may be that in this visual metaphor we are being introduced to a powerful, disturbing introject. The therapist then speaks of missing the presence of the patient's female body in the picture. The therapist says she cannot get into these issues with the patient, partly because the patient offers only brief glimpses of her daily life. She is a runner, and her verbal expressions are likewise quick and fleeting. She seems to say: 'See me, hear me, but you can never control or possess me, for my body and soul belong only to me.' We are aware of the harsh lines in the patient's drawings. Can we mirror the hidden softness in this woman, and still offer her safety and strength? We see a progression in the patient's drawings over time: in the first drawings, there are only harsh, straight lines. In later drawings, the patient struggles to express roundness and softness, yet is constantly pulled back to the harsh lines. Her drawings often show evidence of her trying to fill something into her circles. Yet it is also evident that she destroys these attempts. It seems that there is too much dread of this soft vulnerability. In still later drawings, soft pastel colors begin to emerge. The therapist says that she wishes the patient would explore the soft, pastel areas of her life, as well. But formidable barriers seem to prohibit this direction of work, even though the therapist offers clear, firm boundaries, hoping to open a space in which the patient could express softness. The evolution of lines and forms continues in the patient's drawings: she moves into sensual forms, and the images become more figurative and concrete, less abstract. The play of form and energy becomes more alive.

In this patient's drawings, we see in the jabbing straight lines the possibility of introjects emerging with toxic effect. Yet we see, in the later

artwork, that as the therapist offered a clear, firm structure, the material evolved into a more cohesive whole. In fact, in some of her more recent drawings, the patient even attempts to draw the female form, although she soon obliterates it. She cannot stay in the realm of the female without experiencing great anxiety.

From the outset, the presenter works with two somehow corresponding stones. While being sculpted, the two stones are constantly in juxtaposition, defining a space that is very much alive, a space that vibrates in and out between the polarities of the two different images. Indeed, we know a version of this phenomenon from the figure–ground relationship in drawings. This in-between, empty, 'negative' space introduces itself to the sculptress as itself an actual sculpture: the most alive, though fragile, part of the artwork. The sculptress constantly encounters and faces the problem of how to preserve

Figure 39

this transitional space without destroying either side of the walls of her two stones. She knows that for this space to become a living, moving experience, she must allow a certain ambiguity to exist between the two boundaries of the stones, and yet she cannot. For some deep, mysterious reason, she overdefines the space between the two stones: it has become very important and meaningful to her. At the same time she feels trapped by her need for structure and clarity.

Figure 40

The therapist then confides to us that she has had a number of important losses this year. It has almost been too much for her to bear. Definition of the transitional space between her sculptures, she says, denies another upcoming loss, the separation between her and her patient. Work then, with

a dying cancer patient, requires that one be a helpmate from the state of the animate to the state of the inanimate, from life to death, from one form of energy to another. All this requires a delicate attunement to the rhythms of separation, loss and regeneration. Yet, if we are overrun by too many losses and too much pain, we often need a period of just being as we are, unchanging, before we can return to the natural rhythms oscillating between oneness and separateness. Transitional space is a moving, dynamic phenomenon. It is thus, because we tend to constantly fill up the 'empty spaces' with representations. And as soon as we find a representation, the space fades under our hands.

Conclusions

In both the case presentations above, the encounters with transitional space in the studio are quite parallel to those we experience in the consulting room. The stone work leads one to new perceptions of the transitional space, and thus to new verbal conceptions of it in interpersonal spaces as well. Through stone work, we feel and encounter in concrete form our particular conflicts that we bring to the interpersonal transitional space. Countertransference is often elusive, and therefore difficult to verbalize. Yet through a medium such as stone work, we can actually touch, look upon, and examine with others a concrete example of our conflicts within the transitional space in which countertransference is activated and expressed. Although the creation of such an enduring sensory image cannot replace our own personal verbal therapy, such an observable image offers irreplaceable knowledge of ourselves, a penetrating glimpse of our countertransferential conflicts.

In conclusion, we view the processing of countertransference material as a lifelong professional challenge. An intensive workshop of this nature cannot substitute for continuous scrutiny and investigation of countertransference phenomena, but it can offer something special that individual supervision or personal treatment cannot provide. We see in bold relief the nonverbal dimensions of transitional space taking on a very real and dramatic form. To take advantage of this unique structure, participants require neither skill nor experience in the arts. All that is asked is a willingness to take a chance and dip into the unknown.

References

Epstein, L. and Feiner, A. (1979) *Countertransference.* New York: Jason Aronson.
Robbins, A. (1981) *Expressive Therapy.* New York: Human Science Press.

Robbins, A. (1988) *Between Therapists: The Processing of Transference\Countertransference Material.* New York: Human Science Press.

Rose, G. (1987) *Trauma Mastery In Life And Art.* New Haven: Yale University Press.

Further Reading

Boehm, G. (1985) Zu einer Hermeneutik des Bildes. In Gadamer/Boehm, *Die Hermeneutik und die Wissenschaften.*

Erismann, M. (1989) Die dynamische Ästhetik des Selbstportraits. *Forum für Kunsttherapie II,* 2, October.

Merleau-Ponty, M. (1964) *Le Visible et L'Invisible.* Gallimard, Paris.

Robbins, A. (1987) *The Artist as Therapist.* New York: Human Science Press.

Robbins, A. (1989) *The Psychoaesthetic Experience.* New York: Human Science Press.

Countertransference and the Art Therapeutic Process with Borderline Patients

Arthur Robbins

Your patient makes you feel impotent, furious, and depressed. Thoughts of discharging this patient have often crossed into your consciousness. At times, you secretly wonder about transferring this patient to your worst professional enemy. You're embarrassed and ashamed of these thoughts, but cannot let go of them. These thoughts intrude into consciousness when you are seeing another patient, or before you go to sleep. The reactions are well known and have been recorded extensively in the literature (Leboit and Capponi 1979). We are in the land of the borderline: psychic no-man's land, where the effects of love and hate, devaluation and idealization, as well as such mechanisms as projective identification and splitting become important landmarks of the patient's interpersonal territory. If these reactions are not enough, art therapists, because of the particular modality and the psychic power inherent in their tools, encounter additional problems that must be faced in order to maintain their therapeutic center in the treatment process. This chapter will attempt to elaborate the particular problems generic to art therapy treatment that arise out of work with the borderline patient.

Words differentiate and communicate a sense of separateness between patient and therapist. Interpretive interventions, and especially confrontations, emphasize that we cannot think for our patients or be distracted by provocative or explosive expressions of a fragile and frightened sense of self. The movement, therefore, mediating nonverbal and verbal flow can be extraordinarily deep and profound as the art material opens up penetrating

symbolic expressions of the self that often shock, surprise and overwhelm the borderline patient's capacity to tolerate the anxiety of the unknown.

Let me be more specific regarding these issues, particularly in instances with patients who have borderline conditions. These patients plunge into a muddied state of fusion when they become threatened by too much autonomy or separateness. Paradoxically, they experience a state of anxiety when they feel too close and intimate. Yet both states are important in the act of creation, and art therapy constantly creates a state of confrontation for the borderline patient, impelling him or her to integrate these two levels of relatedness. In order to move back and forth in the creative state of expression, he or she must master such ego functions as frustration tolerance, judgment, discipline, and loss of control, all of which are parts of an emerging ego that can integrate self and other. Indeed, it is the developmental state of rapprochement that has been disturbed in these patients, who are lacking in the development of these ego-adaptive resources. The child develops a sense of effectiveness through trial and error, knowing when to come back for security, holding and emotional support, before returning to the task of mastering the world. This basic developmental state, which occurs between eighteen months and three years of age, is played out over and over again in the patient's adult life. Thus, when the patient is exposed to art therapeutic activity, the work puts him or her into the very heart of the trials and tribulations of the rapprochement period.

The control and regulation of symbolic processing is a very important and delicate matter for therapists to face. Too much enmeshment in heavy symbolic material creates more anxiety then the patient can handle, but it is difficult to anticipate when too much exploration will overstimulate borderline patients. The telltale sign of overstimulation is increased resistance, but the expressions of resistance can come without warning, and we as therapists can easily feel overwhelmed and shocked by the suddenness of the eruptions. At times, verbal exploration of this material can obscure rather than clarify. Often the verbal dialogue has a facile superficial quality, dancing around the image without real cathexis.

Often art therapists are very aware of the false nature of these communications. The very nature of the art creative process promotes a certain respect for integrity and authenticity. Thus, when the patient is fooling himself, a cornerstone of the art therapist's value system is being attacked, and there is a very strong wish on the therapist's part to expose the falseness of the communication. We believe in authenticity and cannot tolerate the false nature of the material. This can equally be true of the phony quality of the art expression. It is all too tempting to push for authenticity when the patient

needs to hide, for he or she cannot tolerate so much exposure. There is a fear of really grappling with the true depths of what one is saying about oneself. There is also another dance in which the patient touches upon things that are truly meaningful, and then quickly disappears before he gets lost in the material. The therapist feels teased or irritated. There is a feeling that the patient is dilly-dallying and not getting down to the real therapeutic task. The art therapist may try to bring the patient back to the material so that the patient can finally process what he or she is concerned about. Sometimes we try to tie things up for the patient, even if it is too early for closure, as we cannot tolerate so many pieces of the patient's psyche floating around with so little cohesion. We find ourselves being overly structured or interpretive in order to hold the patient on the so-called appropriate road to individuation. As many therapists will report, this can only lead to a combative enmeshment where both parties feel exasperated and angry. We now feel impotent and may become overly controlling, unaware that we have not given the patient enough space to regress or hide, and that we have demanded too much separateness and autonomy.

There is another conundrum that is associated with nonverbal material. The sharing of such depth communication can bring about an empathic relatedness that ironically can be experienced by the patient as an invitation for fusion. Once again, we can easily spot the signs of our countertransference reactions, for the borderline can be an expert in communicating devaluation and contempt if distance and separateness are required.

Many experienced therapists are aware of these problems, but constantly find themselves in this countertransference bind. The patient filters into the therapist's unconscious in spite of all our resolutions to the contrary. They touch our own unresolved needs for closeness and separateness, and we are faced over and over again with a therapeutic dysrhythmia that is the hallmark of the treatment of the borderline patient. The nonverbal character of art therapy intensifies this conflict, creates problems regarding authenticity, and highlights and intensifies the problems of separateness and oneness. As art therapists we pride ourselves in creativity and are constantly encountering our therapeutic endeavors being disrupted by the transference/countertransference phenomenon.

The following is a short account of a patient–therapist interaction in which the borderline condition becomes the central organizing problem of the treatment process. This case has been reported in the chapter dealing with resistance. In the following example, the therapist, in a workshop, takes the role of the patient. Another art therapist from the audience volunteers to become the therapist and work in a simulated role-playing. The patient's

dialogue, as played by the therapist, is a replay of some of the actual sessions. The therapist's responses highlight an extremely important issue that becomes a focal point for case management discussion.

A brief reading of the patient's case record follows: C., a forty-three year old woman, was admitted to the inpatient unit of a private psychiatric hospital after a very serious suicide attempt. She had sent her husband and two teenage sons off to the movies and taken an overdose behind her locked bedroom door. During the movie, the older son 'had a funny feeling', left the movie, rushed home and found his mother nearly dead. She recovered in a medical hospital for about a week. Upon regaining consciousness, she spotted a plastic knife on a food tray near the bed, grabbed it, and tried to stab herself. When she was admitted to the inpatient unit, she spent a few days in her room with a constant 24 hour 'suicide' watch. Her first group as a patient in the unit was a 'Creative Journal' group in which the whole unit (15 patients) participated. C. is a high-functioning, somewhat intelligent counselor. She works at a crisis center for Vietnam veterans and deals with suicidal behavior in her work. After hearing the story of her attempt, I was surprised: she is a very attractive, sharp woman. The report mentions that she is also dresses attractively, as if she were going to work (among sweat-suited inpatients).

Upon their first meeting, the therapist introduces herself and talks briefly about what they are going to do. The patient expresses enthusiasm about doing work in art therapy and confides to her therapist that she is a therapist herself. The therapist offers her magic markers to work with, and the patient requests that she be given cray-pas (oil pastels) instead. There are no cray-pas available, and the patient complains that her insurance company is paying so much money that the very least the institution could do is to provide cray-pas. With some reluctance she gets down to work, and the therapist starts the session by saying that she can draw anything that she feels that will express herself. Figure 14 (p.83) represents her first drawing. The patient talks about getting more training and becoming an art therapist while doing the drawing. The patient then returns to complaining about the materials, and the therapist attempts to point out to the patient that she is angry. The patient immediately ducks away from this interpretation and says that the images she has in her mind are soft, and magic markers do not do the job. The patient says that she wants to be soothed and feel better, and maintains a lamenting pitter-patter regarding a lack of cray-pas. She then says that the picture reminds her of her father. She tried every way to get him to notice her, but to no avail. 'He would only notice me when I would hurt myself, and then he would be concerned. There was nothing I could do; I certainly

couldn't be myself. I then met this man who really did notice me, and I really got into it. And then when he left, and wanted nothing to do with me, he took my lungs, and I had no more heart. He took everything from me and that's why I didn't live; I was dead.' All this is said very dramatically, and yet there is something hollow about the patient's words. 'I never thought,' she says, 'about the connection between my father and this lover.' These connections seem to roll right off the top of the patient's consciousness. 'My father was always on the opposite side of the door,' she says, 'and I could never open the door.' 'If you did open the door,' the therapist asks, 'what would you say?' 'Look at me, look at me!' the patient shouts. 'Can't you see me?' The therapist asks, 'Do you think I see you?' Here the therapist intrudes her presence into the dialogue. This may express her wish for closeness to the patient as well as her wish to get into a more authentic dialogue. The patient shrugs her shoulders and says, 'I don't know.' The patient then changes the subject and talks about the courses she will take to become an art therapist when she leaves the hospital. The therapist then makes a further interpretation and states that the patient wants to destroy the closeness that has just occurred in their dialogue. The therapist states that she is being devalued by the patient's claiming that she can be like the therapist by taking a few courses. The patient then feels blamed and criticized, and becomes combative.

The patient dispenses with all interpretations, and says that this is exactly what she is going to do: become an art therapist. She defensively claims, 'I am not trying to devalue you, I'm trying to be like you. You don't understand me.' There is, in this last interaction, an inference by the patient that she and the therapist can become friends on the outside, and would share a good deal in common.

In this short example of patient–therapist interaction, we see a number of problems that occur one way or another with the borderline. Although the patient refers to her problems and losses with her lover, the drawing tells its own story. We see two prominent images that clearly look like breasts. We see the tear in one, and the connection of this patient to one of the breasts as she lies passively on the ground. Notably, the patient rarely talks about her mother, although we do know from previous sessions that she was experienced by the patient as cold and unavailable. The father imago then becomes the more conscious screen for the patient to vent both her rage and despair. Yet, even talking about her lover, there is an over-dramatic quality to her verbal communications that makes an impression on the entire ward. She cannot, however, talk about her pain to her cold blue mother, nor of her passive wishes to regain union with the female imago through death. The

drawing is so rich with symbolism, and yet we really cannot touch it. There is the good breast and the bad breast, as well as the tearing connection with mother through pain. On some level, both therapeutic parties know that the therapeutic gold lies in this material, yet the patient must be allowed her defenses and must also dance away from the material. She hides in her pseudo-identification with the therapist, while the therapist, on the other hand, attempts to pull her into a more authentic communication. The therapist also wants more intimate communication with her patient than that which is therapeutically tolerable. If anything, the patient needs not to have her defenses challenged, but space enough to recoup her resources so that she can once again take a peek at what is bothering her. Moving away from the material, not tying things together, is part of the borderline dance. Patients stop, they leave, they come back, for there is much anxiety about separation. Sometimes we really do not know where they are going with the material, but this is part of both therapeutic parties facing their separateness, for real separateness requires tolerance for the many unintegrated pieces of our psychic makeup. It also requires trust that they will come together with enough support and security. Patients with this condition require their masks, as well as their distance, along with appropriate dosages of empathy and support. Yet our pain as art therapists often becomes exacerbated as we function for the most part in short-term treatment centers. We want to give our patients something to hold on to before they leave, yet ironically, what we have most to offer is our ability to tolerate their incompleteness and confusion, and to respect the importance and meaningfulness of their defenses.

In treatment of the borderline, the therapist is constantly being knocked off his or her emotional center. The mind and body are split and he or she often feels ungrounded and lost. First and foremost, the art therapist must recognize the signs of uncenteredness as they lose their therapeutic rhythm and become overcontrolling through interpretations or interventions. Art therapists must do their own processing of their experience with the patient. Drawing the patient in the safe confines of their studio helps. Processing the symbolic infusions of affects and primitive material so that we as therapists can use art as a container becomes a very important safeguard in work with these patients. We have reported in the literature a number of different techniques for accomplishing this task. As we develop our own resources to process this material, on some deep undercurrent level of relatedness we bring back to our patients the capacity to hear, see and contain the dual dance of being and meaning that is the art therapeutic process.

Reference

Leboit, J. and Capponi, A. (1979) *Advances in Psychotherapy of the Borderline Patient.* New York; Jason Aronson.

Technique

Arthur Robbins

This chapter was originally published in *Creative Art Therapy*. The breakdown of the various categories already point to a multi-model approach. No attempt will be made to update the listing of these techniques. The author takes the position that techniques must be constantly recreated on the spot with a given patient and cannot easily be applied in a cookbook fashion. It is to be hoped that the listing that follows will stimulate the reader to build and create their own particular methodology for each individual patient. However, the following are questions that may prove helpful for the reader who is at the beginning stages of art therapy practice: 'What is art therapy?' 'What do you do?' 'How do you do that?' 'What skills and techniques are involved?'

We have all been asked these questions and all felt uncomfortable or somehow unable to answer then satisfactorily. At times, as practicing art therapists, we have all reached for a technique either to help a patient towards a therapeutic goal, to relieve our own anxiety, or both. While we have dealt with the specific problems of theoretical and professional definitions elsewhere, here we would like to offer a catalogue of techniques presented within a theoretical framework relevant to the therapeutic relationship.

To begin defining 'art therapy technique', let us separate the component words of the term. **Art** speaks of originality, individuality, a creative process; graphic materials, colors, textures; spontaneity, risk, alternatives and imagination. **Therapy** implies taking care of, waiting, listening, healing, moving towards wholeness, provoking growth, medicine, human exchange, sympathetic and empathetic understanding. **Technique** connotes structure, rationality, mechanical, unfeeling, industrial, calculating; a skill acquired by repetition and familiarity. The meanings of the individual words combine

and rest on a sound definition. The individual definitions seem to cancel each other out. Perhaps it explains why art therapists in the past have encountered difficulty in communicating exactly how they practice. Nevertheless, there is little question that students and professionals need to have a framework that can be tested, communicated and shared as an orderly basis for future growth (Kandinsky 1970, Plaut 1970, Wolberg 1967, Menninger 1958).

An art therapy technique is a concrete implementation of theory introduced by the art therapist at the appropriate time to *facilitate creative and therapeutic change*. Some patients need very little in terms of technique from the art therapist. They are self-motivated, self-actualizing people, who, when given the proper atmosphere, interact with the the therapist. At times, this atmosphere is referred to as technique. We prefer, however, to relegate the atmosphere to the axiomatic given that should be a part of *any* educational, therapeutic and growth situation: the respect and regard for the individual worth of the patient; a definite contract for uninterrupted space and time; the establishment of care and trust in the relationship; the presence of a therapist who is emotionally available and connected to his or her patient, and who has the capacity for an empathetic relatedness that is neither identified with nor too distant from the patient.

For many others, however, the process of creative self-development needs much more. The process gets stuck and bogged down. There is a deadening, vapid aura that surrounds the interchange; the artwork becomes sterile and repetitious. Somewhere the patient is frightened of moving forward and retreats into a welter of defenses. He may be frightened of letting go, opening up or just daring to take a peek at some of what is going on inside himself through an expressive act. The mere presence of available materials and a good trusting relationship is not always enough. The questions then arise: How do we move? How do we begin the dialogue? At this point the therapist may make a creative statement to the patient to break through and reach the patient's hidden self. This creative communication cannot be contrived but must be discovered and extended with a dynamic sense of aliveness and authenticity. This communication is what we call technique: it recognizes the patient's fear of growing as well as his opposing wish to change. It is our understanding of how to respond to these forces that will jar the energy balance and result in a release of self-actualizing material.

To a point, the collected material reveals where we are as a profession regarding art therapy technique. Towards self-development, we often adapt psychotherapeutic techniques; towards creative growth we often adapt art education techniques. The survey that follows includes techniques developed

also from happy accidents, as well as creative solutions to therapeutic problems. Many of the art projects presented were not new or extraordinary. Their appropriate utilization and underlying rationale make them useful and exciting. The specifics of implementation – why, how, when and what – are all too often determined by chance or solely by the intuition of the therapist. This chapter is in no way meant to be a gourmet guide of recipes intended to remedy that situation. To simply extract an idea (i.e., puppets because you just watched *Sesame Street*), without making the related considerations, is not only anti-therapeutic, but may be destructive. Technique is only one element of a network of component parts comprising the therapeutic situation. This can be no substitute for a sensitivity to the specific patient population, relevant issues, goals, atmosphere and setting.

In essence, cognitive understanding must accompany feelings and intuitions for effective implication. All of the above factors contribute to the therapist's response to a patient via an art therapy technique that will facilitate the ongoing process. We realize this task requires years of education, practice in the field and, most of all, continuing personal growth on the part of the therapist.

Information for this survey comes from four main sources:

(1) personal interviews conducted at the 1973 convention of the American Art Therapy Association in Columbus, Ohio

(2) a questionnaire distributed to students in the Pratt Institute Graduate Art Therapy Program

(3) telephone interviews with members of the New York Art Therapy Association

(4) perusal of the complete works of the *Bulletin of Art Therapy* and the *American Journal of Art Therapy*.

The collected information from interviews and written responses has been correlated and presented within the following format:

• **Technique:** the title or descriptive name of the activity

• **Materials:** the kinds of preparation and things needed before starting a therapy session

• **Directions:** how to use the materials; how the script may unfold

• **Population:** age and general physical or psychic condition of patients' technique was used and may be adapted

• **Issues:** probable and possible topics raised as a result of introducing this technique

- **Therapist:** the specific individual who contributed this concept. Often, ideas were reported by several therapists. Where possible, the original source has been indicated. Inclusion of the therapist's name will hopefully give credit where due for originality, but does not imply exclusive use or patent rights. Often, therapists shared experiences and feelings that would make these sparse descriptions come alive. Unfortunately, the way the collection grew and developed does not allow for a prose description of individual applications. Most therapists listed here are members of the American Art Therapy Association. On their behalf we extend an invitation to contact them should you desire further information. To all contributing students and therapists we offer our sincere appreciation for sharing their experiences. We hope they have been interpreted accurately and that others are aware enough to adapt these specific implementations to their own needs.

The techniques are divided into three large categories according to their *function*: toward what goal does the therapist aim to use the energy released through the activity? The term *focus* indicates the specific area of development the technique intends to facilitate. Depending on the particular individual or patient group, the current life problems being experienced and/or under discussion, the therapist may wish to focus awareness through the introduction of one of these techniques. It is hoped that the original poems preceding each focus will communicate a sense of the patient's subjective feeling experience.

The first function category we have called *building out* from the core of a person's identity; communication and perceptual skills; understanding self in a relationship to others, etc. The second function category may developmentally follow the first *revealing and discovering* the self: how is energy used to bring together existing parts of the self and understand them further? An awareness of the inner world is emphasized here. *Integrating* techniques comprise the third function category. Here energy is used to pull together the inner and outer worlds of the personality in an attempt at further individuation. Adequately understood and creatively employed, some techniques can be used for all three functions. We are less concerned with a doctrinaire system than with providing material for innovation and application.

Building Out (Ego Psychology)

Building out translates as structuring and constructing the patient's image of himself in relation to the world around him. While image and ideation

come first, in this area the therapist also helps the patient experience, comprehend and integrate his interpersonal interactions within his environment. Developmentally, art therapists may originally find themselves focusing on an awareness of the patient's sense perception, body schema, visual–motor activity and cognitive skills. If one is to explore the outside world, a point of reference is essential. This group is labeled *Me, the Patient*.

Me, the Patient

Who am I? My self, my voice, my body, my name. This feeling of me, not you. Uniquely me-in-this-world, in my room alone. How do I see, hear, touch, feel? What's my history? My herstory? Where have I come from, have I been, am I going? My dreams. I am learning to do – I can't do this but I can do that. My freedoms and limitations. Stretching myself always to make me, me!

FUNCTION: Building Out FOCUS: Me, the Patient

Technique:	*Paste Up Autobiography*
Materials:	Paper, old magazines, glue, scissors
Directions:	Find images from magazines and photographs that represent your life
Population:	Adolescent, adult
Issues:	Reinforcing physical reality
Therapist:	James Denny (Denny 1972)

Technique:	*Shoebox Camera*
Materials:	Shoebox, scissors, markers
Directions:	Cut a hole in the box for a lens and take imaginary pictures. What is significant in this room? Objects? People?
Population:	Adolescent, adult, neurotic
Issues:	Focus on what I find meaningful in the environment
Therapist:	Elaine Rapp

Technique:	*Simon Says*
Materials:	A wide open space to move
Directions:	Children follow the leader game; change leaders
Population:	Children up to 8 years
Issues:	Building body awareness
Therapist:	David Tavin

Technique: *Felt Board*

Materials: Masonite board, felt background, scissors, cut-out felt, figures, letters, house, window, car, face with features, etc

Directions: Use in conjunction with crayons and paper, written word and touching relevant part of body or toy or thing

Population: Child, autistic

Issues: Perceptual training, spelling, patterning

Therapist: Pam Glick

Technique: *Stringboard*

Materials: Homosote board, hammer, nails, colored string or thread

Directions: Draw a circular pattern in pencil, hammer nails on outline, one inch apart, wind thread around and around to create an image

Population: Child, autistic

Issues: Centering, release of tension in hammering, eye–hand coordination, pressure, concepts of around and back and forth

Therapist: Pam Glick

Technique: *Smells*

Materials: Perfume, spices, soaps, flowers

Directions: Always combine texture and smell with visual image

Population: Child, mentally retarded

Issues: Alternate ways of learning

Therapist: Rosalind Seldigs

Technique: *Setting the Table, Household Chores*

Materials: Various.

Directions: Involve parents in therapy by consultation and communication of goals; chores can provide practice area

Population: Child

Issues: Perceptual training: left–right; top–bottom; sweeping broom towards or away from you

Therapist: David Tavin

Stepping beyond the entirely egocentric stage, the therapist will find ways to initiate the therapeutic dialogue. Establishment of a flowing communication between patient and therapist is, of course, necessary for further development of the process. These techniques fall under the heading *Me and One Other.*

Me and One Other (Object Relations Model)

Me and you. Separate. Hard to hide. You care, why? Do I trust? Or run? You are here, intensely here for me. I need no help. I want no help. Can you hear me? Stay away! Stay, maybe we can share. Do it together; share and trust. Don't talk but share an ocean walk.

FUNCTION: Building Out FOCUS: Me, the Patient

Technique:	*Face Painting*
Materials:	Acrylic paint, soft brushes
Directions:	Using the face as a canvas, paint an abstract design or expressive mask. Uninterrupted time; one-to-one
Population:	Child, adolescent, adult
Issues:	How do I see you? How will you paint me? Trust and perception
Therapist:	Janet Adler

Technique:	*Sharing the Drawing Space*
Materials:	Paper and markers, pencil, crayons or pastels
Directions:	Have a nonverbal dialogue in images; create an environment for the two of us to exist in; exchange color or medium after a while
Population:	Child, adolescent, adult, withdrawn
Issues:	Safe means of stimulating involvement introduction through images.
Therapist:	Joel Barg

Technique:	*Sharing a Constructive Activity, Just the Two of Us.*
Materials:	None
Directions:	Yardwork, shopping outside the hospital and then role-playing the activity afterward
Population:	Adult, psychiatric hospital
Issues:	Trust, appropriate behavior, comprehension
Therapist:	Robert Ault

Technique:	*Portrait Impressions of a Partner*
Materials:	Paper and crayons or cray-pas or markers
Directions:	Create a portrait of your partner only in colors and shapes, non-figurative
Population:	Adolescent, adult
Issues:	Sensory perception
Therapist:	Linda Brown

Technique:	*Role-Reversal: P teaches T a skill*
Materials:	Open
Directions:	Allow P to teach you a craft or skill, i.e., needlework or origami
Population:	Child, adolescent, adult
Issues:	Statement of belief in worth of P; role-playing of authority; I'll only ask you to do what I'm willing to do also
Therapist:	Jil Lustgarten

Technique:	*Therapist as Secretary*
Materials:	Paper and pen, quiet
Directions:	T takes dictation and types letters, poetry, stories
Population:	Child; adolescent; adult, particularly geriatrics
Issues:	Role reversal; respect for thoughts and power of communicating them; teach mail system; encourage contact outside the institution
Therapists:	Ann Watson, Helen Landgarten

Technique:	*P and T Draw and Exchange Paper to Work Further*
Materials:	Paper and markers or crayons
Directions:	Draw for specified amount of time, either free or theme-oriented
Population:	Adolescent, adult
Issues:	How do I regard your creation? What's the message? Differences and similarities in color, mood, tension, etc
Therapist:	Michael Edwards

Technique:	*Problem–Solution Diptych*
Materials:	Paper and markers
Directions:	Fold paper in half. P and T each draw a problem on the left exchange paper, and draw the solution on the right
Population:	Adult, psychiatric
Issues:	Problem-solving, reality testing
Therapist:	Shellie David

Once the relationship gets going, patients may need their world expanded further; connections must be made. Perceptions of the family may be vague and diffuse and seem unrelated to the therapeutic encounter. Incorporation of the self-image and interpersonal environment can be explored and horizons widened through techniques under the headings of *Me and the Family* and *Me and the Peer Group*.

Me and the Family (Object Relations Model)

Who am I to them? They to me? Sometimes we, then again me. Separate from them. We/me/they. Love, how? Manipulate and want to kill, give a kiss, make a present, compete, separate. Parents and power. A need to be loved, feeling ignored, important for survival and must outgrow and the constellation changes for a lifetime.

FUNCTION: Building Out FOCUS: Me, the Patient

Technique:	*Houseplan*
Materials:	Newsprint and crayons
Directions:	T draws house plan and asks P to indicate members and describe activity
Population:	Child
Issues:	Awareness of roles; relatedness to family; environment
Therapist:	Harriet Cheney

Technique:	*Paper Dolls and Animal Zoo*
Materials:	Paper, scissors, pen
Directions:	Fold and cut animal families and paper dolls; evolve a story with the P as you proceed
Population:	Child, withdrawn and mentally retarded
Issues:	Assessment of growth and development; relatedness and feelings about family
Therapist:	Emery Gondor

Technique:	*Sociogram*
Materials:	Paper and pastels, markers
Directions:	Graphically illustrate yourself as the center of a wheel and your family around you; closeness to center indicates importance of tie, time spent with family, emotions invested in them
Population:	Adolescent, adult
Issues:	Taking an objective look at interrelatedness of members
Therapist:	Elaine Rapp

Technique:	*Family Tree*
Materials:	Paper and markers
Directions:	Make a tree and assign a part to each family member; list age and relationship and feelings towards
Population:	Child, where there is no access to records

Issues: Who's left out? Power struggles, favorite parent, etc

Therapist: Linda Beth Sibley

Technique: *Family Mobile*

Materials: Cardboard, coat hanger and string

Directions: Construct a three-dimensional sociogram of members representional or abstract

Population: Child

Issues: Can child see family as a unit with stable and moving forces?

Therapist: Pat Newell-Hall

Technique: *Paper Sculpture*

Materials: One piece of construction paper, glue and scissors

Directions: Quickly make something

Population: Family art therapy group

Issues: Individual and family focus, projective technique

Therapist: Helen Landgarten

Me and the Peer Group (Self Psychology)

Equals. Sameness. Difference. Ages alike and worlds apart. Consciousness begins and oh, what pain, partners, groups. A new family – only different, equal. More freedom and more responsibility. Best friends, yet reluctantly respectful of friend's other friends, possessive, jealous, competitive, devoted, depressed, excited. Teamwork, cooperation; changing insides all the time.

FUNCTION: Building Out FOCUS: Me, the Patient

Technique: *Cooking a Meal Together*

Materials: Kitchen, food and serving area

Directions: Plan, shop, prepare, serve and enjoy a meal. Alternate roles if done on a weekly basis, i.e. host, guest and chef

Population: Adolescent, hospitalized

Issues: Teamwork, allocation of responsibility, planning, handling money, manners, reading recipes, cleaning up

Therapist: Leslie Abrams

Technique: *Puppet Show Videotaped*
Materials: Fabric, socks, paper cups, styrofoam, buttons, cardboard, etc., paper plates yarn
Directions: Suggest story line analogous to recent experience of group. More directly, act out upsetting occurrence
Population: Adolescents, hospitalized
Issues: Feedback, useful for other staff, sublimation and integration
Therapist: Nancy Bagel

Technique: *Newsletter or Magazine*
Materials: Stories, poems, drawings, cartoons, riddles, puzzles and a printer or photocopying machine
Directions: Collect, design, print, distribute all contributions from group; ongoing project
Population: Adolescent, adult
Issues: Task-oriented, ventilation, creativity respected, communication to other staff regarding patient feelings
Therapist: Joel Barg, Mary Steele

Technique: *Round Robin Drawing*
Materials: Paper and markers, crayons
Directions: With group sitting in a circle, draw for 1–2 minutes and pass your drawing to the right until it completes the circle
Population: Adult
Issues: Group unity, drawings as indicator of group identity
Therapist: Linda Brown, Julia Housekeeper

Technique: *Group tied together with string*
Materials: Several balls of colored string
Directions: Tie yourselves together as a unit; move, dance, get a cup of coffee
Population: Adult
Issues: Cooperation
Therapist: Cliff Joseph's Group Art Therapy class

Technique: *Feeling Charades*
Materials: Paper, pencil and a hat
Directions: Each member writes an expression of feeling on paper and puts it into a hat; feelings acted out in turn for identification
Population: Adults, psychiatric hospital

Issues: Experiencing feeling levels nonverbally
Therapist: Sonia Moscowitz

Technique: *Group Sociogram*
Materials: Mural paper on the floor, markers
Directions: Graphically illustrate community relationships
Population: Adolescent; adult, residence
Issues: Interrelationships, decision-making, cooperation
Therapist: Leslie Abrams

Technique: *Mime and Drama*
Materials: Stories, plays
Directions: Choose work analogous to life situation, i.e., *The Lottery* by
 Shirley Jackson.
Population: Adolescents, deaf and mute
Issues: Nonverbal communication, body awareness, comprehend-
 ing material
Therapist: Linc Reinhart

Technique: *Mural with Moveable Cut-Out Figures*
Materials: Mural paper, drawing paper, scissors, color crayons, pastels
 or markers, masking tape
Directions: Ask each group member to draw a full figure self portrait;
 cut it out and tape it to the mural paper in the place the
 patient finds most suitable for himself. Each person may
 change his own placement or others' to best describe how
 he sees the group. Allow the group to come to a consen-
 sus on the final placement of the figures and then create
 an environment for them on the mural
Population: Adult, psychiatric hospital
Issues: Group identity, interpersonal relationships, leadership size
 and placement of figures
Therapist: Mickie Rosen

Technique: *Theme Mural with Interchangeable*
 Cut-Out Figures
Materials: Mural paper, drawing paper, scissors, color crayons, pastels
 or markers, masking tape
Directions: Place cut-out figures on to a group mural depicting a
 fantasy theme, i.e., 'The group has been stranded on a de-
 sert island. We've made a life for ourselves, now a rescue

ship is in sight, but it does not have room for all (another ship will be along in the future). Who will go? Who will stay?' 'We are in school. The teacher is absent and there is a substitute. How will the class behave?' or 'We have gone on a picnic. What will we do? What will it be like?'

Population:	Adult, psychiatric hospital
Issues:	Separation, frustration, tolerance, cooperation, peer relationships, authority, etc., depending upon the fantasy situation offered by either the therapist or the group
Therapist:	Mickie Rosen

Technique:	*Solar System*
Materials:	Styrofoam, wire, string and paint
Directions:	Three-dimensional sociogram using planets as people
Population:	Child; adolescent, school
Issues:	Interrelatedness from general science interest
Therapist:	Wendy Wulbrandt

Technique:	*Wooden Dolls*
Materials:	Flat wooden doll family, tree, car, house, 8–10 inches tall
Directions:	Trace and compose a picture
Population:	Adult, psychotic
Issues:	Reality testing, projection, body awareness
Therapist:	Maxine Whiteman

Technique:	*Group Sequential Drawing*
Materials:	Large paper and markers
Directions:	Draw and pass to create a story
Population:	Adult, psychiatric hospital
Issues:	Collective statement of focus
Therapist	Shellie David

Technique:	*Silhouette Mural*
Materials:	Mural paper, markers, scissors, slide projector or spotlight
Directions:	Silhouette body parts, cut out, arrange on mural
Population:	Adolescent
Issues:	Introductory group experience, body awareness
Therapist:	Cynthia Wolf

Technique: *Film-making with Street Gangs*
Materials: Super 8 film equipment
Directions: Film your world, print, edit
Population: Adolescent street gangs
Issues: Identity, respect for equipment, body image
Therapist: Barbara Maciag

Technique: *Filming Group Process*
Materials: Super equipment, masks
Directions: Short film describing activity of growth of the group
allegorically in mime and dance
Population: Art therapy students
Issues: Learning equipment, cognition of emotional process
integration
Therapist: Cliff Joseph Group Art Therapy

As awareness-of-self grows outward and becomes awareness-of-self-within-an-environment, a patient begins to see social and political groupings beyond the level of family and friends. Art provides ways for safely exploring the outside world through practice in fantasy. Increasingly, art therapists see themselves working with patients outside the consulting room or art studio and opening up direct communication with and in the environment.

Me and the Community (Self Psychology)

Who's in this with me? A hamlet, a town, a city, a country – the global village via TV – how many of us are there? What are the rules? Where can I go? How to relate to bus-drivers, cashiers, police and teachers? Kids – younger and older than me. Grandparents; dogs and cats; others' property; signs that say 'No Trespassing' and 'Welcome!' What's a museum? an aquarium? a bodega? a community day? How do you pay? Who does the work? Let's do it together.

FUNCTION: Building Out FOCUS: Me, the Patient

Technique: *Fantasy Community*
Materials: Mural paper and markers
Directions: Discussion and drawing. Who will we admit? Where shall
it be? laws? leaders? recreation? schools? housing?
Population: Adult, psychiatric hospital
Issues: Freedom and responsibility in all areas of life
Therapist: Jessie Bighach

Technique: *Miniature Village*
Materials: Cardboard, plaster, papier mâché and construction paper
Directions: Create a three-dimensional town in miniature, changing the appearance to suit occasions and seasons; semi-permanent in the art room
Population: Adults, psychiatric hospital
Issues: Outside life versus inside hospital; awareness of seasons and cyclical processes; vehicle for storytelling
Therapist: Toby Gross

Technique: *Take a Walk, Play Basketball, Visit a Museum.*
Materials: Free time
Directions: Spontaneity in response to need
Population: Adolescent, one-to-one
Issues: Courage to move from safe therapeutic space and relate to a large environment
Therapist: Leslie Thompson

Technique: *Telephone*
Materials: Old telephone or play phone
Directions: Keep available for use anytime for fantasy conversations
Population: Child; adolescent
Issues: Teaching skill in using; practicing communicating and reaching out
Therapist: Bob Wolf

Technique: *Role-playing with Hats*
Materials: A collection of hats, i.e. police, fire, detective, nurse
Directions: Choose a hat and speak for that person in your town; what does he do, feel, touch, how does he relate?
Population: Child, schools and hospitals
Issues: Awareness of how I and others function in community; what I would like to be or do; why did I choose to be that person?
Therapist: Linda Beth Sibley

Technique: *Map-making*
Materials: Paper and markers
Directions: Draw my bus or walking routes from home to school; school to Scouts, etc.
Population: Child, dyslexic

Issues: Patterning, following directions, awareness of environment, left and right

Therapist: David Tavin

Technique: *Refrigerator Box Houses*
Materials: Huge box, paint and mat knife
Directions: Create your own house or several to make a neighborhood
Population: Child
Issues: Personal environmental statement; openings, doors, windows, number of rooms, color, space, etc.
Therapist: Ann Watson

Technique: *Theme-Centered Collage*
Materials: Magazines, paper, scissors and glue
Directions: T chooses relevant issue and Ps respond by selecting pictures that convey a feeling response in collage form
Population: Adolescent; adult
Issues: Open
Therapist: Susan Mann

Technique: *Matchbox Car Mural*
Materials: Collection of miniature cars and mural paper
Directions: Create a road system, road signs, territory, towns, schools. Detour, yield, slow down…and play!
Population: Child
Issues: Response to environment and directions, movement for active kids; stimulus for fantasy
Therapist: Madeline Tisch

Technique: *Ragdolls*
Materials: Old sheets, scissors, thread and needle, pattern, fabric scraps, cotton for stuffing, yarn for hair
Directions: Cut, sew and stuff happy and sad soft dolls to be used for pre-operative teaching for surgery
Population: Parents of children in hospital
Issues: Occupies parents during operative wait, provides kids with a better understanding of procedures
Therapist: Madeleine Petrillo

A patient needs various ego skills to survive and deal with the world around him. A mastery of materials not only provides the tools for creative expression

but can accurately parallel personality development. Art educators bring special strength to this area including perceptual judgment, patterning, and synthetic and organizational abilities. Included below you will find materials that stimulate growth on several levels simultaneously.

Materials (Ego Psychology)

Look, mom!, I can build! I can bend and fold and sew and form and dance. I can make a mess. I can write a story, make a movie, be a robot, ride a rocket. Look at what I can do! (But I can't draw a straight line.) Here's a present. It's like magic. Want to learn how? I'll show you!

FUNCTION: Building Out **FOCUS: Me, the Patient**

Technique:	*Tissue Paper Sculpture*
Materials:	Colored tissue paper, armature wire, glue and music
Directions:	Pick a color you resonate with, throw, catch, swirl it to the music, move your body freely; then stop and combine the wire and paper to make a sculpture capturing that feeling
Population:	Adolescent; adult, neurotic
Issues:	Integration of sound, space and color movement and feeling
Therapist:	Elaine Rapp

Technique:	*Carpentry*
Materials:	Wood, hammer, nails and saws
Directions:	Make an abstract wood sculpture
Population:	Child, autistic
Issues:	Concrete structured activity that releases tension
Therapist:	Pam Glick

Technique:	*Needlecrafts – Weaving, Needlepoint, Macramé*
Materials:	Loom, yarn, canvas, markers, cord, pins, and scissors
Directions:	Individual projects or group with wall hangings; don't ignore boys and men!
Population:	Adolescent
Issues:	Sensory-motor coordination, follow-through, frustration tolerance
Therapist:	Olive Galdston

Technique: *Scratchboard, and Magic Pictures*
Materials: Crayons, indian ink, stylus, cardboard
Directions: 1. Paint a picture with colored inks, cover with black
 crayon and scratch away a design with stylus.
 2. Crayon a picture, paint it with black indian ink and
 colors show through.
Population: Child; adolescent; adult
Issues: Sure success and neat trick to capture imagination with
 combination of materials; concepts of addition and sub-
 traction
Therapist: Deborah Oberfest

Technique: *Junk Sculpture*
Materials: Lollipop sticks, bottle caps, foil, broken game pieces and
 glue
Directions: Create a sculpture, mobile, collage with found objects
Population: Adolescent
Issues: Acceptability of non-formal materials for making art; ability
 of student to make a creative statement of value from oth-
 ers' garbage
Therapist: Leslie Thompson

Technique: *Butterfly Painting and Potato Printing*
Materials: Paper, paint, potatoes
Directions: 1. Drip paint on center of page and fold in half.
 2. Cut potato in half, carve design and dip in paint to
 print
Population: Child; adult
Issues: Sure success of these and other art education projects
 provides atmosphere for development of trust and willing-
 ness to relate
Therapist: Randy Faerber

Revealing (Self Psychology/Drive Psychology)

All of the above techniques have something to do with the building of the
patient and his relations to his outside world. But what of his inner world?
The inside part is composed of lost images, disorganized and conflicting
affects, fantasies and myths. How does the art therapist relate to this world,
particularly when avenues of entry are protected by road blocks which only
serve to further embed and alienate the patient from himself?

Revealing translates in our terms as conscious discovery of more unconscious, less obvious aspects of the self – gathering information and recognizing ways of perceiving. This process is more analytic in approach than building out. Identifying and understanding these characteristics of being fall into four main areas: *feelings, sensations, thought,* and *intuitions.* These techniques are applicable to patients who are already functioning on fairly mature levels of integration and who seek more self-awareness. At times one finds these techniques demonstrated in workshops or in settings with fairly normal populations, perhaps college students.

The expression of much repressed feeling is a central road to travel if we want to become aware of unconscious forces affecting our perceptions, judgments and behavior.

Feelings

Am I hot, cold? Comfortable. That's good, no good? Feeling rejected, accepted, ignored, loving, close, distant, left out. Angry, *furious, scared, admired and envied. Hate, passion, stiff and awkward, very tired, well welcomed, blue, green and yellow success. Where does it come from – this continual flow of feelings, MY feelings???*

FUNCTION: Building Out **FOCUS: Me, the Patient**

Technique:	*Drawing Emotions*
Materials:	Paper and markers or crayons
Directions:	Ps execute quick abstract drawings in response to T's spoken word, i.e., love, hate, anger, depression
Population:	Adolescent, adult
Issues:	Identification of emotion in relation to color, shape, pressure
Therapist:	Mala Betensky

Technique:	*Masks of Affects*
Materials:	Papier mâché, paint, found junk and egg cartons
Directions:	Choose an emotion and make a mask that expresses it
Population:	Child, adolescents
Issues:	Follow-through on an important feeling
Therapist:	Janet Adler

Technique:	*Clay Monsters*
Materials:	Ceramic clay, glaze and kiln

Directions: Create a three-dimensional monster, fire and glaze, from either fantasy or dreams

Population: Adolescent

Issues: Concretization and assimilation of scary feelings

Therapists: Leslie Abrams, Robert Ault

Technique: *Finger Painting to Transactional Analysis Statements*

Materials: Finger paint, special paper and a nearby sink

Directions: T makes child, parent and adult statements, i.e., 'Let's play', 'Go to your room', 'I appreciate your opinion'.

Population: Adolescent, adult

Issues: Connection to feeling role states

Therapist: Elaine Kirson

Technique: *Group Mural*

Materials: Mural paper and pastels

Directions: Discussion of theme followed by each P's response by individually going to mural and drawing; discussion

Population: Adult, hospitalized

Issues: Leadership within group, relevance of theme, connection or dissociation from topic

Therapist: Cliff Joseph

Technique: *Angry People Collage*

Materials: Construction paper, glue and magazines

Directions: Cut out pictures clearly expressing emotion and paste into a collage; write a dialogue for each character

Population: Adolescent, adult

Issues: Ventilation, acceptance and assimilation of strong negative emotion

Therapist: Helen Landgarten

Technique: *Draw Situation Depicting Feelings*

Materials: *Paper and crayons*

Directions: Draw yourself in a stressful, joyful, helpless, controlling, etc. situation

Population: Adult, hospitalized

Issues: Observing ego defense mechanisms and/or responses to a specific situation

Therapist: Myra Levick

Technique: *Draw your Earliest Recollection*
Materials: Paper and markers
Directions: Draw earliest and next earliest recollection and relate to present situation via discussion
Population: Adolescent, adult
Issues: Influential memories, beliefs, continuing themes through life
Therapist: Susan Mann

Technique: *Draw Your Mother Criticizing You*
Materials: Paper and markers
Directions: Change family member and action to suit each patient
Population: Adolescent, adult
Issues: Observing ego in a feeling interaction
Therapist: Susan Mann

Technique: *Gesture Drawings*
Materials: Large pad of paper and charcoal
Directions: Make a gesture that communicates an inner feeling and further articulate gesture into drawing that you find most clear
Population: Adult
Issues: Combination of feeling, movement and visual represent-ation; releaase of energy
Therapist: Ben Ploger

Technique: *'I am a window and…'*
Materials: Storytelling poster or large blown-up photo
Directions: Select a part of the photo and become it and speak for it
Population: Adolescent, adult
Issues: Gestalt exercise in projection of feeling and identification
Therapist: Elaine Rapp

Technique: *Exploring Holiday Symbols*
Materials: Paper, markers and scissors
Directions: On appropriate seasonal holidays, ask for feeling assoc-iations to be drawn and discussed, i.e., hearts, crucifix, flag
Population: Adult, psychiatric hospital
Issues: Personal versus cultural meanings of symbols
Therapist: Bernard Stone

Technique:	*Feeling Judgments*
Materials:	Paper and pastels
Directions:	Draw the person I hate, admire, love, envy the most
Population:	Adult, psychiatric hospital
Issues:	Awareness of feeling projections; acceptability of a wide range of emotion
Therapist:	Bernard Stone

Technique:	*Exchanging Self-Portraits*
Materials:	Paper and cray-pas
Directions:	Draw a self-portrait and exchange for further additions; draw your partner and exchange
Population:	Married couples
Issues:	How I see you and perceive you; where we differ in opinion
Therapist:	Harriet Wadeson

Technique:	*Physical Release of Anger*
Materials:	Beanbag chair and tennis racquet
Directions:	Breathe deeply, allow sound to come out, and beat beanbag chair with tennis racquet
Population:	Child, adolescent, adult
Issues:	Release of anger, rage, physically to complement emotional art experience
Therapist:	Elaine Rapp

There is a natural flow from the feeling to the sensation world; before some patients can feel they must learn how to touch and become re-acquainted with their sensorium. The art therapist should be particularly at home in this world, as it is an intrinsic part of her sense of creative identification.

Sensation
Stimulation to my eyes and hands and imagination. Colors flowing – red, orange, magenta; now the silk touch of plaster warm and liquid against the rocky roughness of a hard and cold cast. Cold reception from a roomful of classmates or cold aching in my gut? Now. Textures of stone, metal, yarn and steel wool. How do they make me feel? What images meet and flow with sensations to tell me more about me and being alive?

FUNCTION: Building Out FOCUS: Me, the Patient

Technique:	*Meditative Drawing*
Materials:	Paper and markers
Directions:	Close your eyes, relax and concentrate on bodily sensations. Stay with body awareness until you have clear images; draw abstractly to communicate your experience
Population:	Adolescent, adult
Issues:	Ability to quiet outer world and listen to inner world; sensitivity to sensorium
Therapist:	Efrem Weitzman

Technique:	*Swallow a pea...*
Materials:	None
Directions:	Pretend to swallow a pea (or a Polaroid or a submarine) and verbally report where it is going and what it experiences within your body. Please exercise with caution
Population:	Child, adolescent, adult
Issues:	Body sensation, anatomy, imagination
Therapists:	Helen Landgarten, Paulette Floyd

Technique:	*Photo Landscapes*
Materials:	A collection of photos of various landscapes, i.e., desert, snowy mountains, tropical island, village, arctic, city
Directions:	Choose a locale and spin a fantasy of what appeals to you: what you do there, how life would be, etc.
Population:	Open
Issues:	Environmental effects on emotions, temperatures, activities patient feels comfortable with
Therapist:	Ginna Cottrell

Technique:	*Drawing to Music*
Materials:	Records or tapes, paper and markers
Directions:	Listen for images, movement, colors, and draw what you see with eyes closed; abstract, loose, playful, serious. Bach, Beatles. Tibetan Bells
Population:	Open
Issues:	Coordination of rhythms, movement and auditory stimulus
Therapist:	Deborah Knable

Technique: *Moving Through Peanut Butter*
Materials: Paper and markers
Directions: Imagine you are moving through peanut butter, jello, bubble gum, a roomful of pins, marbles, jungle, feathers, etc. Act out and draw sensations
Population: Child
Therapist: Cynthia Smith

Technique: *Ceramics*
Materials: Clay, clay tools, perhaps a wheel
Directions: Handbuilding and throwing simple pots
Population: Child, adolescent, adult
Issues: Sensitivity to earthen clay and its various forms and states. Patience, being centered; an original product
Therapist: Deborah Green

Technique: *Play Dough*
Materials: Flour, salt, food coloring, water, plastic bag
Directions: One part salt mixed with two parts flour and colored water will give usable play clay. Good for play food. Can be baked in the oven to dry
Population: Child, school or hospital
Issues: Fun to mix from scratch, different feel of ingredients. Soft, coarse, wet, gushy, dry granular; measuring; stimulates fantasy
Therapist: Joan Ellis

Technique: *Sand Casting with Plaster*
Materials: Sand in cardboard box, plaster of Paris, shells, junk
Directions: Design in sand and pour in plaster
Population: Child
Issues: Contrasting textures, immediacy of product, i.e., wall hanging, mirror frame, abstract sculpture; messy but washes off
Therapist: Deborah Green

Technique: *Finger Exercises*
Materials: A partner
Directions: Sitting cross-legged facing each other, eyes closed, join hands and stroke, push, pull, caress, lift, clap
Population: Adolescent, adult

Issues:	How much can you learn about another person only through the way he or she touches?
Therapist:	Ilana Rubenfeld

Technique:	*Touch Boxes*
Materials:	Shoe box, feathers, wire, fur, jello, gum, foil, etc.
Directions:	Create a mini-environment within a shoe box that describes you personality. Share it with others, their eyes closed. Get the message?
Population:	Adult
Issues:	Sense perception connected to emotional awareness
Therapist:	Pratt Group Art Therapy class

Technique:	*Cracker Collage*
Materials:	Half-dozen different kinds of crackers, i.e., graham, Triskit, pretzel, Ritz, rye; cardboard and glue
Directions:	Make a collage, either representational or abstract
Population:	Child
Issues:	Textures and, undoubtedly, tastes
Therapist:	Linda Beth Sibley

As was pointed out earlier, some patients need to order and logically think through their self-discovery process. Feeling and sensing are not enough; they must know and understand. A cognitive orientation to the often seemingly irregular evolution of growth can be facilitated through some of the following techniques.

Thinking

Logic dictate: I began with A and followed it with B and C; Why? Explaining me to myself; I began here and was influenced by and got caught and then moved on. Why? This is my story. I can record my growth and therefore understand it more fully. Neat. Orderly. Rational. Explicable. Please clarify and describe that better, for I need all the facts.

FUNCTION: Building Out FOCUS: Me, the Patient

Technique:	*Self Winnicott Scribble* (Winnicott 1971)
Materials:	Paper and markers
Directions:	Close your eyes, scribble for one minute, open and find an image and develop it within the scribble

Population: Adolescent, adult
Issues: What image means to you, relevance to your life. What does it tell you about conscious conflicts?
Therapist: Lynne Flexner Berger

Technique: *Cartoon Mural*
Materials: Mural paper, markers and cray-pas
Directions: Divide mural into eight boxes of eight patients and ask them to draw within their own space a response to a given theme
Population: Adult, psychotic
Issues: Need for structure and safety within limited area
Therapist: Linda Brown

Technique: *Mythology*
Materials: Drawing materials and clay
Directions: Define identifications with personal heroes and villains: Snoopy, Batman, the Hulk. Draw, sculpt and act out a scenario.
Population: Children
Issues: Fantasy becoming real and experiential
Therapist: Joan Columbus

Technique: *Journal of Thoughts, Dreams or Perceptions*
Materials: Blank book, drawing utensils and collage materials
Directions: Keep a record of your personal growth via daily, weekly entries, written and visual stories
Population: Adult
Issues: Respect for inner world; define patterns, continuity
Therapist: Janie Rhyne (Rhyne 1973)

Technique: *My Necessities and Luxuries*
Materials: Mural paper and markers
Directions: Draw all the things you need – then all the things you want
Population: Adult, neurotic
Issues: Separation of fantasy and reality; are necessities people, space, things, travel, food, attention?
Therapist: Elaine Rapp

Technique:	*Lifeline*
Materials:	Shelf paper, or adding machine rolls and markers
Directions:	Draw your life in images from birth until now and, perhaps, beyond. Time limit, i.e., half an hour or an hour
Population:	Adolescent; adult, neurotic
Issues:	Space attributed to what events or emotions? What was omitted? Cause and effect clearer? Patterns evident?
Therapist:	Janie Rhyne (Rhyne 1973)

Some patients need to be able to listen to themselves and trust their unconscious. They must first get in touch with a whole reservoir of images, fantasies and myths that lie somewhere in the pre-conscious recesses of the psyche. To learn how to listen to inner thoughts and phantoms and not be threatened by the strangeness of primary process thinking is extremely important. At times this falls into the nebulous category of intuition. There are a number of developmental tasks and exercises that highlight this area.

Intuition

I can read A and B and already know Y and Z, being able to use imagination and follow it wherever it may go. Trusting my hunches, clues that seem irrational (no one would believe I knew it before it happened!). Possibilities and probabilities. Hard to decide even the smallest thing. Ways of relying on answers that come up from inside without explanations and logic. What if...? Fantasies, you call them, but my realities. Implicit. Maybe mystical. Invisible but real.

FUNCTION: Building Out FOCUS: Me, the Patient

Technique:	*Guided Image Trips*
Materials:	Uninterrupted space, quiet, paper and markers
Directions:	T tells a story consisting mainly of images; P listens, responds and finally draws what he saw in his mind's eye. Example: meditation and visualization aiding in achieving a remission in cancer patients
Population:	Child; adolescent; adult, hospital
Issues:	Healing power of images
Therapists:	Dr. Carl Simonton, Michael Bova

Technique: *Magic Shop*
Materials: Space, quiet, paper and markers
Directions: 'You are lying on a beach in the hot sun, you go for a walk
 and find an old village. A small charming shop catches
 your eye. It's a magic shop and wonderful things are in-
 side. Let your imagination wander and see what you find.'
Population: Adult, neurotic
Issues: What did you find? Temperature? Anything recognizable?
Therapist: Ilana Rubenfeld

Technique: *Magic Body/Magic Eyes*
Materials: Space, quiet, paper and markers
Directions: Be the $6,000,000 man (kid) and make your body do any-
 thing you want. Where? What? How? What do you see?
Population: Child, hyperactive
Issues: Identifying fantasies and wishes
Therapists: David Davis, Susan Mann

Technique: *Original Plays and Masks*
Materials: Paper bags and paint
Directions: Responses to a House *Tree–Person test became a play; characters
 come alive with the use of paper bag masks*
Population: Child
Issues: Need to assimilate material brough up in testing through
 imaginative acting-out
Therapist: Linda Beth Sibley

Technique: *Change Your Dream*
Materials: Recent dream, paper, markers and clay
Directions: Verbally and visually create a more satisfactory ending to
 an unhappy dream
Population: Adolescent, adult
Issues: Freedom and responsibility to create your own reality
Therapist: Elaine Kirson

Technique: *Storytelling*
Materials: Popular story, myth, fable (i.e. *The Ant and the Grasshopper*)
Directions: Read the story and ask P to change the ending; read until
 the climax and ask for an original ending
Population: Child

Issues: Trusting one's own originality, power, foresight
Therapists: Richard Gardner, Katherine Cripps (Gardner 1971)

Technique: *Free Association Drawings*
Materials: Paper and markers, pastels
Directions: Draw anything and verbalize any thoughts and feelings
Population: Child, adolescent, adult
Issues: Comfort anxiety or inability to draw and verbalize
 impulses, fantasies, associations; willingness to open up;
 demonstrate trust
Therapist: Myra Levick

All four of the above foci are aimed at learning to experience and know oneself better, trusting one's strengths and becoming wary of weaker and underdeveloped functions.

Integration (Ego Psychology)

Integration of the self describes the third major category. These techniques are characterized neither by their emphasis on survival tools nor on analytic insights; they highlight all four areas of perception and judgment. Perhaps we could say these techniques are aimed at realizations about to become conscious within the patient. In each of the following techniques the processes within and without are strikingly parallel. The bridge connecting within and without is very short; the tension of energy crossing and recrossing this bridge is alive and vital. This is true for all kinds of patients – autistic children, acting-out adolescents and mature analysands. Immediacy, relevance and painfully obvious parallels seem to be the most distinguishing qualities of the following techniques. The focus here differentiates between techniques applied more successfully to either an individual patient or a group of patients.

FUNCTION: Building Out FOCUS: Me, the Patient

Technique: *Body Outline*
Materials: Mural paper or sheet and markers
Directions: 1. Lie down on paper on floor and trace body for
 another
 2. Name body parts as traced, label after for children
 3. Color in or fill with collage materials
Population: Open

Issues: Inner and outer image of physical self

Therapist: Joan Ellis

Technique: *Draw Your Breath*

Materials: Paper and pencils

Directions: T marks a dot on paper and asks P to start by drawing his breath

Population: Adult, psychotic

Issues: Encouragement for small energy expense, on paper and in relationship with T; a beginning

Therapist: Joel Barg

Technique: *Pinch Pot*

Materials: Clay

Directions: Form clay ball the size of your fist, push thumb down the center, pinch thumb against fingers while rotating ball. Try to stay centered so pot becomes balanced

Population: Child, adolescent, adult

Issues: Centering inside and out

Therapist: Paulus Berensohn (Berensohn 1968).

Technique: *Poetry's Images*

Materials: Original poetry, or Whitman, Sandburg, Gibran; paper and inks

Directions: Read poetry aloud and illustrate

Population: Adult, geriatric

Issues: Feelings translated into words and images

Therapist: Gloria Martin

Technique: *Ragdolls*

Materials: Old sheets, scissors, yarn, doll pattern, scrap fabric, cotton stuffing

Directions: Trace pattern, cut out, sew edges, turn and stuff. Add yarn hair and doll clothes

Population: Adolescent, pregnant

Issues: Manifestation of invisible body process

Therapists: Nan Tesser, Ginna Cottrell

Technique: *Mandala*
Material: Paper, cray-pas, paper plate and kaleidoscope
Directions: Trace circle from plate, start in center and draw a balanced, centered design. Close eyes and watch colors and images. Use kaleidoscope for Ps stuck for impetus
Population: Adult, psychiatric hospital
Issues: Centering, balancing, meaning of images
Therapist: Joan Kellogg

Technique: *Comic Book Cartoons, TV Pad*
Materials: Hardcover drawing book, pencils
Directions: P draws characters, T draws dialogue to create continuing story
Population: Child, mute
Issues: Messages from within become without
Therapist: Michael Filan

Technique: *Clay Marionettes*
Materials: Clay and wire
Directions: Movable clay marionette to resemble P, environment to scale
Population: Adolescent, amputee
Issues: Accepting physical reality through transitional object
Therapist: Paulette Floyd

Technique: *Ceramic Portraits*
Materials: Clay and a shoebox
Directions: Make a relief portrait inside the shoebox; allow to dry; paint
Population: Child, schizophrenic
Issues: Ability to see self reflected within a limited, focused, safe, confined space
Therapist: Deborah Green

Technique: *Doll House Series*
Materials: Cardboard, stones, plaster, paint
Directions: Make three-dimensional houses representing various stages of identification, i.e., grandparents, parents, foster parents, child's residence.
Population: Child, orphan

Issues: Foster parents, child's residence. House as interior structure
 of psyche
Therapist: Dinah Kahn

Technique: *Polaroid Photographs*
Materials: Polaroid camera
Directions: Take picture of child and let him take pictures of his env-
 ironment
Population: Child, autistic
Issues: Focusing and stabilizing self in immediate reality, physical
 and psychic
Therapist: Ellen Nelson-Gee

Technique: *Zen and Painting*
Materials: Paper and paints
Directions: Select an object (i.e., flower, chair) and imagine yourself be-
 coming the essence of that object; draw during or after
Population: Adolescent, adult
Issues: Centering, focusing within and without
Therapist: Gloria Martin

Technique: *Stonecarving*
Materials: Stone, eyeshield, water bucket, pick and hammer
Directions: Follow the flow of the stone and evolve sculpture
Population: Adolescent, adult
Issues: Internal dialogue, resistance, flexibility
Therapist: Elaine Rapp

Technique: *Cakebox*
Materials: Bakery cakebox, scissors, and markers
Directions: Illustrate child self/adult self on the inside and outside of
 the box; inner world and outer world; how you are and
 how you would like to be, etc. Fashion into a paper sculp-
 ture
Population: Adult, neurotic
Issues: Polarities and integration
Therapist: Elaine Rapp

Technique: *Survey of Past Work*
Materials: All art work drawn at a specific period of therapy
Directions: At appropriate time, review art work

Population:	Adult, psychiatric hospital; private practice
Issues:	Cognition and integration of process
Therapist:	Myra Levick (Fink, Levick and Vaccaro)

Technique:	*Stencils*
Materials:	Tempera, paper, and scissors
Directions:	Cut stencil for P to paint in eye or nose, etc., rather than paint for him
Population:	Child, mentally retarded
Issues:	Reaffirm worth of P, independence
Therapist:	Rosalind Seldigs

Groups

Art therapists more often than not work with groups and require a tremendous amount of grounding in group dynamics. There are various group projects that highlight the interpersonal world of the patient in a group and help facilitate dynamic interaction.

FUNCTION: Building Out FOCUS: Me, the Patient

Technique:	*Ethnic Music and Mural*
Materials:	Ethnic music, paper and pastels
Directions:	Listen, dance, share experiences of homeland and draw
Population:	Adult, psychiatric hospital
Issues:	Owning, appreciating and sharing one's heritage
Therapist:	Estelle Bellomo

Technique:	*Blind/Sound Floor Mural*
Materials:	Mural paper and pastels
Directions:	Place mural and pastels on floor; eyes closed, make a sound and draw to that sound for ten minutes. Open eyes and elaborate design
Population:	Adult, neurotic
Issues:	Primitive sound relatedness, vibrations, movement, space
Therapist:	Michael Edwards

Technique: *My Name*
Materials: Paper and markers
Directions: Dramatically enunciate your name; match syncopated sound
 with appropriate body movement. Do not use name tags;
 identify other group members by their sound and body
 language
Population: Adult, neurotic.
Issues: Clear statement of individual identity opens door for group
 identity formation
Therapist: Christopher Beck

Technique: *Clay Figures*
Materials: Clay
Directions: Model a figure of another group member in a posture that
 clearly communicates his feeling
Population: Adult, prison inmates
Issues: Body language as a reflection of one's inner world
Therapists: Jan Adler, Dina Rose

Technique: *Treasured Objects*
Materials: Personal belongings
Directions: Ask each P to bring his most precious possession; share its
 meaning and related experience
Population: Adult, geriatric
Issues: Self disclosure, past becoming present
Therapist: Gloria Martin

Combination Techniques

Several techniques can be used for *building out, revealing* and/or *integrating,*
depending on their utilization by the therapist and her view of a particular
patient. A few such versatile, 'open-ended' techniques are listed here.

FUNCTION: Building Out FOCUS: Me, the Patient

Technique: *Super 8 Films, Filmstrips, Slide Series*
Materials: Appropriate equipment
Directions: Write, animate, edit and show film as illustratration of folk
 song, fable or myth
Population: Adolescent, psychiatric hospital

Issues:	Planning, frustration tolerance, coordination of music and imagery, cooperation
Therapist:	Jeff Goshen

Technique:	*Videotape and Polaroid Camera*
Materials:	Appropriate equipment
Directions:	1. Tape a therapy encounter, use with psychodrama or write a story and act out for TV
	2. Photograph group interactions
Population:	Child, adolescent, adult
Issues:	Immediacy of self-image via objective ego of camera
Therapists:	Milton M. Berger (Berger 1970), Ellen Nelson-Gee

Technique:	*Poetry*
Materials:	Books of favorite poetry, paper and pencils
Directions:	1. Read a classic and illustrate, i.e., Blake, Cummings
	2. Read a poem and write a poetic response
	3. Choose a fantasy topic and write your own poem
Population:	Child, adolescent, adult
Issues:	Imagery's relation to feelings through works and/or pictures
Therapists:	Morris Morrison, Pierre Boenig

Technique:	*Collection of Objects*
Materials:	Miniature houses, matchbox cars, keys, hats – any group of similar but individually distinctive objects
Directions:	Choose a key and fantasize the door it opens; choose a house and fantasize who lives in it
Population:	Adolescent, adult
Issues:	Resonate with an image and own it; explore your fantasies
Therapist:	Elaine Rapp

Technique:	*Sequential Graphics*
Materials:	Shelf paper or notebook or small pads and markers
Directions:	Series of drawings that tells a story:
	1. P draws all
	2. P and T take turns drawing
	3. T draws problem and P draws solution
	4. Group shares in creating a story
Population:	Child; adolescent; adult, mute

Issues: Quick movement of story, minimum drawing skill required
Therapist: Bernard Stone

Technique: *Sandplay*
Materials: Sandbox and miniature figures of animals, people. Without
 sand, clay flattened into a pancake acts as a base
Directions: Make a picture and tell a story
Population: Child, adult
Issues: Safety within limits of the box, picture reflects intrapsychic
 forces
Therapist: Dora Kalff

Technique: *Family Art Therapy*
Materials: Easels, large pads, and pastels for each member
Directions: Draw and title:
 1. Free drawing
 2. Family portrait
 3. Abstract family portrait
 4. Eyes closed drawing
 5. Scribble
 6. Joint family scribble
 7. Free drawing
Issues: Families – therapist should observe art product, behavior
 and verbal interaction
Therapist: Hanna Kwiatkowska

Technique: *Psychodrama*
Materials: None
Directions: Role-play yourself and/or others in emotional situations
Population: Adolescent, adult
Issues: Open expression of feelings, problem solving
Therapist: Hanna Weiner

Technique: *Multimedia*
Materials: Non-destructive room, piano, tape recorder, telephone,
 music, junk, art materials, and total freedom
Directions: Explore possibilities offered here; no limits
Population: Adolescent, residence
Issues: Choice, freedom and responsibility
Therapist: Susan Swamm

Technique:	*Communicators*
Materials:	Telephone, tape recorder, walkie talkie (real, toy, or home-made)
Directions:	Imagine conversations or letters – telling people off or turning people on
Population:	Adolescent
Issues:	Practice in communicating, appeal of machines, audio reflection
Therapist:	Bob Wolf

We conclude our survey with four of the most commonly used projective techniques which comprise an art experience designed to divulge information not directly obtainable from the patient or case records.

Handled with care, the therapist cam emphasize the 'fantasy-play' aspect over that of the 'testing' element that so often seems anti-therapeutic (12).

FUNCTION: Building Out **FOCUS: Me, the Patient**

Technique:	*Scribble Drawings*
Materials:	Paper and crayons
Directions:	T scribbles and P makes an image; P scribbles and T makes an image
Population:	Child
Issues:	Rapport builder, fun; significant images surface; drawing becomes transitional object
Therapist:	D.W. Winnicott (Winnicott 1971)

Technique:	*Draw-A-Person Test*
Materials:	Typing paper and pencil
Directions:	1. Draw a person
	2. Draw a person of the opposite sex. T follows through with post-drawing questionnaire and evaluation
Population:	Child, adult
Issues:	Self-image, sexual identification
Therapist:	Karen Machover (Machover 1957).

Technique:	*House–Tree–Person Test*
Materials:	Typing paper and pencil
Directions:	1. Draw a house
	2. Draw a tree

3. Draw a person
T follows through with post-drawing questionnaire and evaluation

Population: Child, adult
Issues: Self-image, fantasy life
Therapist: John S. Buck (Buck 1966)

Technique: *Kinetic Family Drawing Test*
Materials: Typing paper and pencil
Directions: Draw a family doing something
Population: Child, adult
Issues: Interpersonal dynamics of P's family
Therapist: Robert Burns and S.H. Kaufman (Burns and Kaufman 1970)

No chapter on techniques would be complete if we did not mention that art is often used in conjunction with other modalities, i.e., music, dance, movement and even sports. To move with music while expressing oneself graphically allows the art therapist to broaden the range of how he or she touches sense and relates to people. There will be many art therapists who will be reluctant to broaden their horizons to integrate dance and music into their repertoire. But as pressure increases to unify the various expressive modalities and break through artificial restrictions, the therapist will be increasingly strong in her position if she does not restrict herself solely to graphic techniques. Music in the background, movement of colors, the rhythm of forms all imply that a patient cannot be compartmentalized or relegated to a dance, drama, art or music therapist.

Our underlying thesis is one of openness to the challenge of each situation and the inherent demands of the patient population, institution and specific talents of the individual therapist. Creativity is our stock in trade. Can we afford to be inflexible?

References

American Journal of Art Therapy, Vol. 1–13: October 1969-January 1974.

Berensohn, P. (1968) *Finding One's Way with Clay.* New York: Simon and Schuster.

Berger, M.M. (1970) *Videotape Techniques in Psychiatric Training and Treatment.* New York: Brunner/Mazel.

Buck, J.S. (1966) *The House–Tree–Person Techniques.* Los Angeles: Western Psychological Services.

Bulletin of Art Therapy. Fall 1961-July 1969.

Burns, R.C., and Kaufman, S.H. (1970) *Kinetic Family Drawings. (K-F-D): An Introduction to Understanding Children Through Kinetic Drawings.* New York: Brunner/Mazel.

Denny, J.M. (1972) Techniques for Individual and Group Art Therapy. *American Journal of Art Therapy 11,* 3 April.

Gardner, R. (1971) *Therapeutic Consultations With Children: The Mutual Story Telling Technique.* New York: Spence House.

Hammer, E.F. (1967) *The Clinical Application of Projective Drawings.* Springfield, Ill: Charles C Thomas.

Kandinsky, D. (1970) The Meaning of Technique. *Journal of Analytical Psychology 15,* 165–176.

Machover, K.A. (1957) *Personality Projection in the Drawing of the Human Figure: A Method of Personality Investigation.* Springfield, Ill: Charles C Thomas.

Menninger, K. (1958) *Theory of Psychoanalytic Technique.* New York: Basic Books.

Plaut, A. (1970) What Do You Actually Do? Problems in Communicating about Analytic Technique. *Journal of Analytical Psychology 15,* 13–22.

Rhyne, J. (1973) *The Gestalt Art Experience.* Monterey, CA: Brooks/Cole.

Winnicott, D.W. (1971) *Therapeutic Consultations in Child Psychiatry.* New York: Basic Books.

Wolberg, L. (1967) *The Technique of Psychotherapy.* 2 vols. New York: Grune & Stratton.

Materials[1]

Arthur Robbins

All too often art therapists restrict themselves to one or two basic materials. Different media, however, provoke different kinds of messages. Some address themselves to the ego organizing capacity of the patient. Others tap very deep libidinal levels; while other materials have an exploratory quality. Some challenge a sense of mastery; others provide just pure fun. It is to be hoped that an art therapist can work towards becoming an expert in the broad use of materials which supply the needed communicative links in everyday therapeutic situations.

Although we realize patients often have their choice of all available materials in an art room, their creative experience is ultimately the responsibility of the therapist. At other times he may present a specific activity. He may also offer a choice of materials that represent opposite qualities, allowing the patient to communicate his needs.

Materials can emphasize the various polarities of a patient's intrapsychic life. A patient who is drawn to hard, aggressive materials, for instance, may need a gradual introduction to round and soft experiences; armature wire can be molded into soft curvilinear shapes or made into sharp, spiky aggressive projections. A doll house can offer a cozy enclosed space. Patients benefit from exposure to these opposites: they need to experience material help to help them to let go as well as contain them; to be able to push in and insert as well as to receive. By highlighting and bringing together polarities, materials add richness to an individual's experience.

The art therapist must assess the stimulus potential of a medium as well as the ability of his patient to cope with and integrate excitation. For example,

1 This chapter originally appeared in Creative Art Therapy.

finger paint makes high demands on a patient's ability to control and manipulate fluidity, rhythm and texture. This can be too much of a challenge for an acting-out patient. On the other hand, a tightly restricted or depressed patient might find some release with this material as it opens the gates for a needed regression. Thus, the quantity of materials, textures, malleability, and chromatic stimulation are all parts of the assessment of stimulus impact.

First, however, the art therapist should look at the patient and the particular developmental stage requiring attention. Is the patient's need for comfort, organization, or mastery? Is regression a factor or does he need broadening and reflections of his inner life? Does the patient need – and can he tolerate – a challenge in the form of a new material? Will the material be too threatening to the adult self of, on the other hand, will it be a road to a thwarted infantile impulse?

Since the art therapist works, for the most part, with groups rather than individual patients, he should also be able to transpose some of these principles within a group dynamic approach. The group then is assessed as a unit and responded to in terms of its capacity to handle stimulation.

Touch and *texture* are important dimensions to consider in assessing a particular medium. Some materials have a soft quality, others feel harsh or brittle; a few are sticky, tight or touch. The art therapist who is truly resonant with his patient may be able to introduce material that corresponds appropriately to the patient's needs. Some patients have a void in the area of touch and sensorium while others, threatened by too close contact, need a slow and gradual introduction to texture stimulation. For example, a lonely removed child may slowly work his way from paper dolls to tempera, watercolor to clay, and finally to soft textured materials as parts of a collage. Involved in this kind of progression is an opportunity to begin with distance and control, gradually increasing exposure to stimulation and psychomotor release.

Jung (1968) states that <u>colors</u> may be attributed to the <u>four functions of perception and judgement</u>: <u>green</u> for <u>sensation</u>, <u>yellow</u> for <u>intuition</u>, <u>red</u> for <u>feeling</u>, and <u>blue</u> for <u>thinking</u>. Luscher (Scott 1969) also developed a well-known color theory. The art therapist may play with some of these notions and hypothesize an intrapsychic map based on the patient's reliance on or avoidance of certain colors. He may also give the patient the freedom to choose colors that express his current emotional state as well as set in motion a dialogue in contrasts and alternations. The individual who denies blackness and dysphoria with excessive use of white spaces may need a breakthrough via dark or chromatic materials. Likewise, a preoccupation with dark heavy affects may need exposure to the vitality of yellow and

Pfister, Max (1950) Color Pyramid Test

Luscher, Max (1948) Color Test

orange. The cold rationality of blues may require the spontaneous childlike expressions of pinks or reds.

The color inherent in any particular material has its expressive as well as defensive qualities that need the appropriate response and remedy. The therapist who assesses the energy locked into the color of a material can offer an additional experience that either harmonizes or contrasts with the cross-currents flowing from the patient. Color is more often a consideration when using two dimensional materials, i.e., paper and paint, markers or crayons. But think of the stimulus impact of terracotta clay as contrasted to white porcelain clay; the former is more basic and primitive, while the latter seems more controlled and pristine.

Specific media may also be broken down into various components. Clay has a range of textures and stimulation: rough and abrasive; wet and gushy; elastic and short. Ball clay will stretch and twist, while Plasticine is tighter and holds its molded shape better. Play dough offers smell and color as added ingredients for stimulation and direction but lacks the permanency of Plasticine. Paper also is a common material with a multitude of tactile messages. Think of the difference in feeling quality among the following papers: colored construction, foil, oak tag, corrugated, tissue, velour, kraft, magazine, newspaper, lace, wrapping and low-grade notebook. Even white drawing paper and manilla each have a distinct touch characteristic.

Materials also have their particular characteristics in terms of *movement* and *rhythm*. Some media are easily controllable while others demand a connection between inner and outer flow. Some media can be avoided in the early stages of a treatment relationship as they demand too much flexibility and freedom of movement. The patient who is struggling with mastery and dominance may find stone an excellent testing ground to explore these conflicts. Stone requires strength and a force of precision; it does not always respond predictably to pressure but must be respected for its own internal harmony and movement. Watercolor paint demands a willingness to be spontaneous; oil paint offers a more predetermined and exacting challenge. The latter takes weeks to set and dry and likewise demands a test of one's patience. Woodcarving has some of the same rhythm requirements as stone and gives a clearer map for a patient to follow because of the texture and movement of its grain. Clay, on the other hand, can be pushed and shoved in a multitude of directions and can offer a wider range of possible expressions. Metalwork dances and moves as it becomes hot and fluid. With the bubble and flow of hot metal there is a tremendous sense of excitement as something very basic and powerful starts to emerge. Armature wire helps the patient push and pull and express conflicting tensions, otherwise, if there

is a loss of control, he may end up in a tangled mess. Another example of contrasting rhythms is linoleum printing versus potato printing. The former entails a controlled but aggressive movement and involves more extensive planning and execution. The latter requires in a repetitive motion and gives quick, easy results. Thus, the determination of the more appropriate task includes an evaluation of the age and coping capacity of the patient.

Space is another component quality of a particular material. Some media have their own boundaries; others are flexible. Some activities are enclosed, as in a sandbox where the patient can feel safe and avoid the fears of a swallowing environment. The antithesis might be Elaine Rapp's technique (see p.183) in which music, tissue paper and movement are involved, and the patient is required to throw, catch, hit and swirl. As body, material and movement intertwine, feeling free and comfortable with movement in space is a necessity. Plaster may be experienced as inviting, threatening or releasing. A metamorphosis may happen before one's eyes as the wet amorphous flow becomes hard and brittle. Plaster also changes from warm to cold in temperature. Clay moves from soft to hard but takes days to accomplish this transition. The environment, objectified and contained through murals done on large expanses of paper, also requires body movement.

Movement in space implies different demands on one's musculature. A contrast might be between crocheting, weaving and making jewelry, as opposed to hammering, chopping or welding. Some people have a large, rough body movement orientation while others prefer small precise movements. Some patients need encouragement in dealing with more freedom in movement; others offer a wider range of choices and possibilities. One example of this dimension can be found in working with hospitalized children, who often experience their environment as manipulative and chaotic and feel an accompanying loss of control. These feelings can be counteracted by building with materials that have a structural quality, such as lollipop sticks, building blocks, Lincoln Logs or Tinker Toys. The child constructs a part of his own world and feels a sense of mastery. The repetitive safe quality of the activity is a way of dealing with the pervasive confusion and overwhelming change in his life. Children who have come to terms with the hospital experience can then move on to handle the more expressive experience of clay or paint. The transition from a safe repetitive structure to the more fluid changing material can be molded and remolded to fit a changing understanding of the environment.

Changing our perspectives, we can view material in the light of to its *concrete* or *abstract qualities*. Some media have prescribed courses or structures to follow; others demand a continual flow of abstractions and probably have

a more expressive quality associated with them. It is important to understand those patients who need something concrete and specific, where a crafts orientation provides a comfortable meeting ground between therapist and patient. The geriatric population offers a case in point. Often this group needs something tangible that produces concrete results. At times, an older person presents a rigidification of thought processes and a diminution in their ability for abstraction and expression. They may feel threatened by a request to paint or draw and may need a stimulus such as a poem or story to ignite images. Georgianna Jungels (personal communication) satisfied this need by collecting antiques, everyday objects common during the beginning of our century. When shared with a group of older people, these objects stimulate memories, dreams and images which act as connecting links between past and present among group members.

Risk-taking varies from material to material. Some patients, frightened of mistakes or errors, soon learn to capitalize on accidents as a rich new avenue for expression. The patient may learn this through stone as he increases his appealing result. By contrast, the use of oils entails considerable skill and control. It is all too easy to end up with a mess. Patients whose abilities are limited by skill or patience should stay away from this medium. In many instances, the philosophy of introducing an activity easily mastered at the beginning of a relationship may give the needed confidence to take greater challenges in the future.

Some materials more readily lend themselves to *fantasy play*. Miniature figures of people, animals and villages can stimulate dramatic play on a mural, clay base or road map and help the therapist and patient clarify important life themes. Other patients need to use material to express ill-defined symbols. Body tracing with markers and large mural paper can start building a symbol of the physical self. Dolls, puppets and masks can express through dramatization various part images and introjects. Cardboard boxes and construction paper often help to concretize the outside world when used, for example, to make spaceships, trains, doll houses or play country stores. With these representations, a child has the opportunity to take a fantasy journey through play and discover the various conflictual energies contained in his inner life.

Many individuals need an opportunity to conceptualize and contain a shattering and split-off world. The Polaroid camera gives a live reflection of this world and at the same time gives distance, space and containment to the experience. The camera works as a synthesizer as well as an observing ego. The immediacy of the picture captures the reality and makes it possible to digest in small parts what previously seemed overwhelming. In psychological

terms, the ego has an opportunity through this medium to become increasingly differentiated and autonomous. Movies and video have some of the same attributes and offer the added opportunity of capturing a series of movements in a more realistic, alive fashion. To play back and study behavior that has been dissociated and repressed can make an important therapeutic contribution.

Junk sculpture is an excellent means for helping a child evaluate and value his world; to let him know that things that seem lost may be rediscovered and once again become useful. Some patients who have been discarded by family or society need to experience this lesson. This sculpture expresses a particular kind of mastery: what others consider junk, not only has value but provides an avenue for expressing a new-found creative identity.

As we review the subject of materials, the range of considerations posed by each seems overwhelming. Ideally, a familiarity through the use will allow the therapist to be aware of touch, color, movement, rhythm, risk, and space considerations, as well as symbolic content. This information will be integrated with clinical and environmental demands so the therapist may offer the most appropriate activity or choice of activities.

Media can be used to build or uncover; they also connect as well as express outer and inner life experiences. Art therapists often rely on intuition with regard to the use of an appropriate medium. The conceptual and cognitive understanding of a psychology of materials will strengthen the therapist's ability to make a therapeutic impact. This knowledge of materials and the subtle and creative use of media to facilitate processes differentiates him from the psychotherapist who occasionally utilizes art materials to enhance therapeutic communication. From this vantage point, materials are very organic to theory, technique and the practice of creativity development and therapeutic change.

References

Jung, C.G. (1968) *Analytic Psychology: Its Theory and Practice.* New York: Pantheon.

Scott, I. (ed) (1969) *The Luscher Color Test.* New York: Pocket Books of America.

Institutional Issues[1]

Arthur Robbins

Art therapy cannot be taught in a vacuum. Becoming a professional entails a pragmatic exposure to the realities of practice. With fieldwork, the importance of the political nature of institutions and the impact it has on treatment become paramount issues for the art therapy intern. Theory, by necessity, is modified by the limitations of the agency structure. Complex problems are brought quickly into focus.

Health care institutions are flooded with patients. There are simply not enough staff, space, time or funds to adequately cope with the multitude of problems. A change soon occurs: the anxious, idealistic and enthusiastic student is transformed into a depressed, despairing and bewildering practitioner. She wonders if anything can be done, what functions she serves and what she can accomplish. The student recognizes slowly that she must understand the political realities of the institution in order to work with patients. One cannot function in isolation. The institution ultimately determines an atmosphere that has tremendous impact on the direction of treatment. If the setting is uncaring, concerned only with statistics and disconnected in its overall administrative procedures, then this tone undoubtably will effect the therapist–patient relationship. As a result the students' education must be broadened to include a psychological understanding of the institution as a political entity.

An institution can be approached like a patient. Some are restricted and tight; others are disorganized and even schizophrenic! At times they are disconnected, destructive, vague and fragmented. Occasionally, an institution works in coordinated teams with cohesiveness and unity. Unfortunately, this unity rarely happens. Professionals have grave difficulties in maintaining

1 Part of this chapter originally appeared in *Creative Art Therapy.*

sanity and identify when they find themselves in an essentially pathological settings. To withdraw, to be embittered or to be frustrated is understandable but does nothing to change the situation. To be uninvolved with institutional politics does not serve patients and destroys the student's personal and professional effectiveness. Art therapists simply cannot opt out and expect to survive in the field.

As with a patient, an institution brings distortions, inductions, projections, and 'double-bind' communications. These forces need to be recognized, attended and confronted. But as with a patient, the art therapist first develops rapport with her co-workers before anything can be done. For instance, the art therapist who starts out in an occupational therapy department can be requested to supervise patients in non-imaginative tasks. Art therapists resent this: they are threatened and sometimes react openly with anger. Routine, repetitive work seems antithetical to the whole concept of art therapy. Nevertheless, a therapist needs to understand that art has long been used for this purpose. Consequently, the student soon learns how to respond to the institution's notion of art therapy and introduces other concepts, such as problem-solving, that relate to other levels and goals of the agency. Thus, art can be used as a way to increase ego capacities, facilitate mastery over problem situations, and become the format to develop socialization skills. Again, as with a patient, the application of these concepts has to meet the institution on a comprehensible level. Conversely, if the student acts out with negativism or hostility, she will be unable to develop a mutual base of operations where the administrative perception of her role can change gradually. Large organizations take years to develop: personnel structures, communications systems, procedures and operational patterns, expecting overnight change any more than she would expect a chronic schizophrenic to deal effectively with reality after one semester of treatment. Organizations thrive on homoeostasis. They resent and fight change; people do not want their own position within the structure threatened. The art therapy student represents an unknown quality. Although she often begins at the bottom of the institutional hierarchy, because of her training talents and skills, she poses a potential threat to the security needs of others.

Agencies are expected to be mothering and caring agents. Often, however, settings are equally perceived as overwhelming, dominating, or engulfing. Pieces of the institutional reality are selectively chosen by the intern on which to hook countertransference problems, and which only serve to interfere with her effectiveness. The handling of induced reactions caused by institutional pressures is as sensitive and demanding a task as anything found in depth psychotherapy. Personal therapy and membership in peer discussion groups,

as well as other professional associations, are needed to maintain some degree of sanity and perspective.

Clarity and specify provide important guidelines to follow in dealing with organizations. For instance, training institutes should insist on very clear and concise affiliation contracts for their students. The clarification of obligations, responsibilities, and duties of the field and training institutions as well as the particular student help avoid potential obstacles. A definition of hours, working conditions, type of supervision, and the insistence on professional treatment can provide a working foundation from the beginning. Art therapists can be helped by an awareness of the institution's tendency to reinforce a sense of malaise and stagnation. Professionals grow all too comfortable in their roles causing a lack of inventiveness, risk-taking and growth. One remedy might be continued training outside the institutional settings. The therapist can also be constantly open to the exploration of new avenues and definitions for her work. Initiating help from professionals outside one's bailiwick can be the beginning of a rich cross-fertilization process. A concrete example would be the art therapist who functions in a primarily medical and surgical unit. Along with medicine, nursing, teaching and social work staff, she can form an interdisciplinary team geared to understanding patients from all perspectives.

The effectiveness of an art therapy trainee can be enhanced by a sensitive understanding of the institution's communication network. Administrative lines of responsibility, format for memos, and time lapses all form part of this knowledge. As well as facilitating effective communications, this network may impair it with red tape. Memos and requisitions are written, lost, ignored and filed; things become 'bogged down' at one level or another. Even more frustrating is the difficulty with which responsibility for any resistance encountered and reasons for institutional buck-passing are determined. Avoidance of decision-making is another phenomenon. An art therapist studying this network will learn to use it to her best advantage. Change necessitates knowledge of the 'ins' and 'outs' of an administrative structure. Patience and persistence sometimes stimulate this process and effect change. If the intern gives up easily, the institution will wear her down to a state of despair and stagnation.

Art therapy cannot be divorced from the economic problems that beset health care institutions. Each department has a vested interest in obtaining a share of limited space and funds. An administrator's main concern is getting the most productivity for his or her money. Art therapy may be considered a luxury in this respect. A good deal of education and clarification can change this perception: a patient's increased functioning can often be a direct result

of increased emotional health. For instance, art therapy on a pediatric unit may have a profound impact on preparation for surgery, remission and post-hospitalization adjustment. Creative play in educational settings may directly affect reading and achievement scores. The time for rehabilitation of psychiatric patients can be cut with the use of art therapy treatment. In these instances, there is not a clear an obvious relationship between art therapy and increased performance and, therefore, optimum use of funds. The most powerful way to establish causality and substantiate opinion is to examine the wealth of research, which brings objectivity and perspective to this problem.

Agencies rarely have a position or 'line' for an art therapist. Consequently, students are often assigned to the Occupational or Recreational Therapy department. On occasion, the intern is expected to function as a mother's helper who can keep the patients busy and only incidentally offer a therapeutic art experience. Rarely is there any sense of the training, perspective, philosophy and orientation of the art therapist; more often, a good deal of confusion between art and occupational therapy exists. The art therapist cannot immediately change these preconceived attitudes. Patience and a development of trust between the individual art therapist and other professionals is indispensable and can only be effected through constant communication and mutual sharing of experiences. Politically, art therapists need supportive friends and one hopes that they will search for staff sympathetic to change and innovation. Exhibitions, fairs and case presentations are some of the communicative skills of the intern. She can also learn the jargon or professional nomenclature of the organization and revitalize the words and labels so they take on a new meaning that is comprehensible and mutual. For example, instead of recounting a patient's play experience, one might invite other professionals at a staff meeting to become involved with art media.

Art therapists need not segregate themselves from other expressive therapists. All forms of expression can and should be used with any single patient or group of patients. Departmental divisions of dance, music and art seem artificial and at times politicized. The art therapist should be ready to share her skills with other expressive therapists and learn from them. It is to be hoped that she can communicate a degree of mutuality and cooperation in sharing and working with other closely aligned professions.

Art therapists who work in school systems are sometimes perceived as a threat to the territorial prerogatives of psychologists and guidance staff. The latter need to hear that art therapy presents an added dimension to children who do not have the verbal tools to work in the more standardized fashion.

Constant study and research is also needed here as a connecting link between creativity development and the mastery of basic skills. Art therapists who are unaware of or uninvolved with the goals of the educational institution may be thwarted in their attempts to initiate art therapy in schools. The trainee, therefore, must have a very clear theoretical model of the relationship between sensory awareness, imagery production, and conceptual thinking. The frontiers in the use of art therapy in schools are currently being explored. To go further, the student may need to incorporate adaptive and creative expression into an operational framework that makes sense to an educator, such as combining remedial reading with art therapy.

Similar principles should be maintained in other institutional settings. Art therapy can be combined with vocational guidance an rehabilitation procedures. Fantasy play, an exploration of the world of work, and setting up creative play situations to test out work skills can be one avenue for this approach. In day care centers, tactile, expressive and imaginative techniques can be employed to solve the problems of separation, growth and mastery. Old age and nursing homes need the artist as an ally to combat loneliness and boredom as well as to find a tool to help put residents' lives in order. In all these examples, the young professional must sense the aim of the institution and fit her particular skills into a facilitation and implementation of the agency's mission.

In some settings, the intern may encounter techniques employed by poorly trained staff that result in sadism, exploitation and the abuse of patients. If the art therapist chooses to work with groups, she can neither identify nor always prevent this but needs to constantly search for therapeutic models based on knowledge and sophistication. The student may well have to demonstrate the important difference between toughness or firmness and pure cruelty. Support from other staff members who are sympathetic to these values will help immeasurably in maintaining one's integrity.

An art therapist who can relate not only to the interpersonal dynamics of the setting, but, also to the ecological factors, will offer a unique asset to her agency. Enhancing the mood and rhythm of the institution can affect the well-being of patients as well as staff. To change the psychic, spatial and color world of patients may be a most challenging dimension of the art therapist's role. The somber walls of a ward can be transformed with colorful creative products for the benefit of both patient and staff. In addition, staff are also made aware of creative energies. Emotional growth and learning cannot be separated from the physical spatial attributes.

A wide variety of health care services utilize a behavior modification approach. Although a philosophical controversy surrounds the use of these

techniques, a lack of familiarity and understanding of this system may cause alienation from key members of a professional therapeutic team. An art therapist needs to assess where these techniques have been useful. Behavior modification procedures combined with creative modalities can increase the total effectiveness of a treatment program.

Art therapists may need to band together to form their own institutions as a viable alternative to the existing agency structure. These particular ventures, however idealistically based, are fraught with difficulties and pressures. Professionals who take this alternative approach should be prepared to work clearly through their purpose and function. Economic pressures will be immense and a familiarity with funding procedures is indispensable. A part-time affiliation with an institution may be essential if only to maintain a monetary flow for survival.

In summary, art therapy must include a sensitive understanding and educated response to the prevailing political realities of a particular agency setting. As a result, the intern may find herself fitting more into the model of social catalyst rather than therapist. She may also learn to flex and stretch her professional skills so that she can move out to settings that are somewhat atypical. Storefronts, parks and clubhouses are potential places for an art therapist to effect social change and facilitate creative movement through art. The art therapist, therefore, is not united to one image or notion of community involvement but is able to discover new and different settings where her work can be appreciated and her personal goals fulfilled.

Working in most institutions (with their attendant ills, problems, and peculiarities) will be a permanent feature of society. The creativity of the art therapist will – one hopes – stand her in good stead when she confronts the stagnation and oppression of agency work. In spite of all these obstacles, it is important to note that patients *do* get help; organizations *do* change; new professions *are* emerging and the art therapist is finding ever-increasing opportunities to become an effective professional. During the past five years, the opportunities for work as an art therapist in the New York area have increased dramatically.

Something seems to be happening and changing. We are often so submerged by the morass of obstacles and pressures, it is difficult to maintain perspective and observe the process of institutional change. Somehow the idealism of the new student faced with political realities can cope with her despair and confusion. Out of this experience she may create a pragmatic approach supported by hope, vision and flexibility and sustained by a large supply of energy.

I have addressed the variety of problems and issues which face an art therapist in adapting and living within an institutional setting. Art therapists will find it helpful to study their role in the institution within an art therapy framework. The following art exercise was presented to a group of students in an introductory course in art therapy. They were requested to draw their institutional setting and include the patients, their supervisor, and themselves. Some of them then proceeded to take their artwork home and created nonverbal associations in an art form that originated from their first drawing. Others were simply content to let their first drawing stand alone as a representation of their experience in the institution. The first student describes her experience in her setting as being a very positive one. In figure 41 she and her supervisor are walking together in the children's ward. The artwork appears dense and muddy. It is difficult to discern the two black dots of supervisor and supervisee as distinguishable from the rest of the artwork. Everything seems to be crowded in and lacks space. The student describes herself as someone who has issues around separateness and is drawn to intense, close attachments. She recognizes her own developmental issues, which will challenge her to work towards differentiating and giving distinctiveness to her patients as well as to her surroundings.

Figure 41

Figure 42

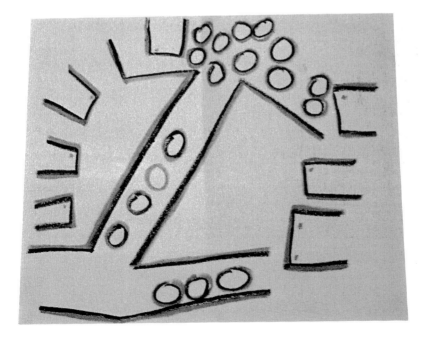

Figure 43

We contrast the above work with a student who offers two pieces of art (See Figures 42 and 43). She is both amazed and amused at herself upon reviewing her art work. Her artwork is usually colorful and intense. She describes her experience in a daycare center where she feels overwhelmed by too much stimulation. Her second drawing becomes a defensive expression and accommodation to these intense pressures. She simplifies the art piece and reduces it to a few basic structures of circles and lines. At this level, she is able to function and tolerate the noise and chaos of working in a setting of chronic psychotic and borderline patients.

The next student describes her experience in being assigned to a drug addiction center. The supervisor is absent and although the student claims that she has a good relationship with her, she is nowhere to be found in the art piece See Figure 44). The centerpiece represents a very imposing nurse who seems to have a powerful influence on the entire setting. The student notes that the nurse has no body nor any sexual characteristics. One of the arms of the nurse reaches out to a patient who is clutching his genital area. The student on the other hand touches the nurse with one arm and she too has no body. The problem for the student becomes immediately apparent. No one seems to be mirroring the patient's sexual issues and the supervisor gives her no help in confronting this matter. In fact, the dominant nurse seems to get in the way of the student making contact with her patient. There

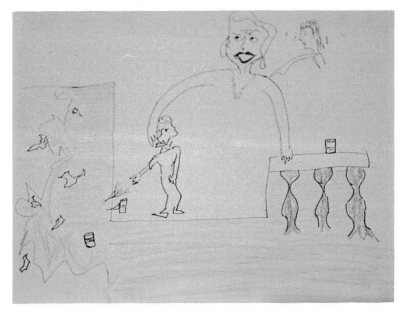

Figure 44

is a rigid, clear line separating the underlying chaos and the relationship of the three people involved in the picture. The chaos must be controlled, and apparently the student clutches ambivalently to the nurse and to the relationship so she will not float out of the picture.

In the final example, the student first draws a picture of all of the patients, herself, and her supervisor sitting around the table (Figure 45). In the second picture, she is alone with her patient and draws a separate box for the expression of the relationship between supervisor and supervisee (Figure 46). There are strong lines separating the two drawings and the student recognizes that she wants both control and autonomy in this situation. She recognizes that upon approaching something new, she tends to be cautious and controlled. The intense blackness is contained by vertical and horizontal lines and may need some further reintegration as she becomes more comfortable in her role as an art therapist.

Figure 45

Figure 46

Studying the subtle perceptions and nuances of one's relationship to the institution can uncover all kinds of transferences as well as characteristic styles in adapting to new and difficult situations. As art therapists, we have powerful tools to study these issues. The artwork can reveal important problem areas for students that can lay the groundwork for a meaningful supervisory dialogue.

Part Two

Case Studies

Clinical Applications

Arthur Robbins

The presentation of clinical case material becomes a fundamental tool in developing therapeutic competence in a graduate training program. Organizing our thoughts about a particular patient clarifies our diagnostic perspective and improves our ability to gain an overall understanding of therapeutic process. We also soon learn how much we know about a case and discover gaps in the organization of the case material. The following chapters represent internship experiences of second year students in the Pratt Graduate Art Therapy program. These chapters open up questions regarding theory and technique. In response, my comments are in boxed italics in contrast to the main body of the report. The first three chapters demonstrate the enormous breadth of possibilities in therapeutic style and art therapy technique in working with psychotic patients. With this patient group the real relationship becomes as important as the transference and countertransference relationship, for the deeply disturbed individual's sense of trust has been pathologically disrupted. At the same time, because they function on a primary process level, they penetrate right through defenses and make contact with the deepest part of the therapist's personal self. Consequently, the authenticity and genuiness of the therapist's personality becomes an overriding factor in determining the depth and breadth of the treatment dialogue.

In the first case study, Linda Joan Brown[1] examines a number of important aspects pertaining to the treatment of cases with profound attachment deprivation. As we observe the tremendous degree of impoverishment and lack of self-definition the therapist struggles with a very common problem

1 Author's article originally appeared in *Creative Art Therapy*

of what to do with this enormous void. What do we do with the emptiness and vacuousness of our patients who function on the pre-symbiotic level? Do we fill their emptiness and if so, with what? On the other hand, does their emptiness mask enormous rage? If we see the mother–child deficit as being very primary, do we attempt to form a very early symbiotic-like relationship with the patient. In Linda's case example the patient is a floating empty fortress making only the most marginal contact with the environment. The encapsulation and resistance to making contact becomes a formidable problem for both patient and therapist.1 Author's article originally appeared in *Creative Art Therapy*.

As Linda attempts to mirror and becomes related symbiotically to this patient, she recognizes her sense of futility in feeling or being fused with her. To be true, she must face her own feelings of disappointment in working with a patient who is of dull normal intelligence. However, as the therapist starts to take hold of the case and to structure and direct it, some movement and therapeutic process becomes evident. Thus, the long path of mothering and feeding this patient along with a wealth of stimulation and imagery has begun. This is essentially an ego-oriented approach where the object relations framework becomes very secondary. Reinforcing adaptive skills and working with concrete sensory experiences appear to meet the therapeutic issues that are presented by the patient.

Linda is wise enough not to start on a verbal level with the patient. Perhaps in no other area can the art therapist bring such a special resource to the treatment of a case like this. A verbal-oriented approach simply does not work with a patient with this type of disorder. The patient's ego resources and verbal tools are poorly developed and ill-defined. Imagery and nonverbal contact are much more accessible for therapeutic engagement.

Linda is able to recognize when art is used as a resistance. All too often, art therapists receive meaningless designs from their patients and cannot fathom the underlying message. These works are often an evasion of meaningful communication. Likewise, although the patient may be at first contacted on a primary process level, the goal is one of making this a bridge to the outside world.

Art therapists face the problems of barrenness and emptiness in any number of patient populations. If one assumes that this ego state covers rage, both parties often approach the underlying problem with a good deal of tentativeness. The explosive capacity will strain the holding recourses of even the best of therapists. We will see this as a particular problem in Ann Reilly's presentation. A common fear among beginning therapists who work with these patients is one of either infantilizing them or feeding their dependency.

More often then not, this problem applies to borderline conditions as the therapist discovers that giving only serves to force the regression. This is not the case with Linda's patient. Linda's patient responds positively to Linda's encouragement and interest which is usually an important indicator pointing to an ego-oriented approach to treatment.

By contrast Kristen Stonehouse and her patient fully plunge into a deep symbiotic relationship. The reader can literally sense their hunger for contact and fear of it. The symbiotic style of making contact is best illustrated by the 'squiggle' game. Mirroring appears to be less important as the patient's sense of self is at the most nascent level of existence. Because the patient plunges towards a very deep-fused-like state, the establishment of firm therapeutic boundaries becomes an important requirement for the processing of such a hot symbiosis. Unless there is a combination of a fairly straightforward structured approach that has its emphasis on activities, there is a potential for a good deal of explosion or withdrawal of the patient from therapeutic contact. Thus the therapist is very well versed in engaging the patient in a therapeutic dialogue. The working with three-dimensional material seems to facilitate the process, quite since this type of disorder in patients is concrete and non-symbolic. The issues of exploring loss for this patient may well be a resistance towards therapeutic process. Schizophrenic patients tend to be preoccupied with their insides at the cost of dealing with the outside. Here, then, lies the problem for patient and therapist. The patient recognizes that she has never had a healthy symbiotic union. Will her regression give her a second chance to rebuild the mother–child relationship and in the process develop ego skills in identifying her feelings about the past? The therapist moves in a direction of making art a transitional experience to repair object loss. Her approach may say as much about her own particular needs and conflicts in determining the methodology. Once again, the therapeutic process and either the lack of movement or progression will ultimately provide some answers to these issues.

In Anne Reilly's case illustration, the reader may experience a 'walking volcano' that requires plenty of space and containment. Fortunately the studio atmosphere is an ideal place that offers latitude for expression while at the same time creating possibilities for a frame to contain the raw output of rage. Creating a safe holding environment which is clear and firm but non-repressive becomes the paradoxical challenge of the treatment process. The patient requires the safety of firm boundaries so that the expression of fury does not spill over into dangerous acting-out behavior. Anne's creative talent as a therapist becomes mobilized in constantly developing a frame that gives the patient space and safety.

Issues regarding therapeutic regression are always prominent in working with psychotic patients. The patient expresses raw affect with minimal work in organizing them into an art form. The therapist takes the position that any pressure for artistic standards do not apply in this case. The patient does not seem ready to sublimate this volcano into a high-level expression of art. The underlying theoretical assumption behind this therapeutic stance believes in the value of regression as a reintegrating experience that will ultimately lead towards the rebirth of a self. This therapeutic position may well be largely contingent on the therapist's ability to trust the patient and not be thrown by the raw expression of rage. Most importantly, as we will see, the rage is contained in the studio and the patient does not become more anxious by this expression which would ultimately lead to more acting-out behavior. In spite of the conflicts and problems of the therapist, the patient does seem to feel safe with her, which may well be the most basic determinant in making regression a positive force in the treatment.

We see in the three cases differences in approach and processing of case material. They range from ego-oriented processing, attempting to make art as a transitional object to work through object loss, and making art and the relationship a safe container for the mastery of powerful id impulses.

Two case illustrations are presented demonstrating the combination of play therapy techniques within an art therapy framework. In Ellen Nelson-Gee's[2] report we see a very creative and artistic engagement of a very disturbed and provocative four-year-old girl. Therapists who work well with children are very much in touch with their own child and use this connection as a very important bridge in the treatment play of patient and therapist. My experience of Ellen in the class is that of a sad clown piercingly and poignantly carrying her message with a degree of lightness and love. Ellen utilizes her own child-self to make contact with her patient Terry as she sensitively understands how easily this child can be invaded, intruded upon, or used.[2] Author's article originally appeared in *Creative Art Therapy*.

Terry comes from a family where power is the medium of exchange. I suspect that there is a good deal of very early sexual trauma that has occurred with the excessive preoccupation and concern of the parents with the patient's bowel movements. At the same time Terry has employed helplessness and submission as part of her character structure and in so doing utilizes these traits as powerful tools to manipulate and control her environment. Ellen is wise to this and treats the very delicate line of protecting her from her own self-destructiveness while simultaneously giving her enough room

2 Author's article originally appeared in *Creative Art Therapy*

to develop ways of coping other than passive helplessness. Ellen attempts to avoid power fights with a child who is full of provocativeness and who induces the therapist to play the overwhelming role of the parent. Ellen side-steps, plays, charms, and lovingly offers tenderness and responsiveness as an alternative to willfulness. Through the medium of the sandbox, Terry plays out her deep fears of being intruded upon. Passive submissive feelings are expressed by this girl and Ellen gives her latitude for control and mastery over very difficult and humiliating feelings. Indeed, the entire therapeutic encounter is directed at giving her a sense of her own autonomy and power. She plays out the 'no' and enjoys the delicious sense of control over Ellen. She uses the therapist as an instrument to admonish her parents. With each step that Terry takes towards separateness, her fears about separation and abandonment are stimulated. Thus, a very complicated demand is made upon the therapist: let me be free, but show me you care. Ellen comes through this task with flying colors. She holds the child with care and tenderness rather than confinement and restriction.

We see in this case illustration a combination of treatment approaches. As with many sexual trauma patients, the reinforcement of power and mastery becomes an important therapeutic task. Also crucial is the working through of separation anxiety that develops as the patient develops her own core self. Ellen skillfully uses the tool of mirroring with the camera to rebuild this girl's body image. One suspects that Terry feels her body is a disgusting thing. They take pictures of one another, mirror one another, explore each other's bodies, and perform many of the basic functions of a good mother–child relationship. Ellen is essentially attempting to give this child a more positive feeling about her libidinal self and create a better integration of drives. Thus, as they touch various parts of one another there is a feeling of tenderness and engagement that underlies the contact. Here the child dares to confront parental disgust that is lodged within her. As the reader will see, Terry begins to enjoy her body rather than be repulsed by it.

As Terry has been the subject of a good deal of power and manipulation, she is no stranger to the world of sadism. This is a common pattern in disturbed children which creates a therapeutic challenge for the therapist. Thus, the therapist must contain the cruelty and be able to transform it back into a more digestible and soft form of contact. The therapist cannot be frightened of torture games, but must find ways of offering the possibilities of neutralizing and turning it into a more direct display of aggression in the interest of self-affirmation rather than power over others.

Sexual identification issues are also prominent in this case as femaleness and subjugation are already associated in this child's mind. As the patient is

still very much in the state of developing, there is still some question as to whether these profound areas of identification may one day need more work when she becomes an adult.

The next case presentation of play and art therapy opens up issues that have important theoretical and technical implications. We first meet Michèle Neuhaus and her withdrawn eight-year-old boy in a school setting. They are both wary of rejection and circle around each other sniffing out the therapeutic territory. Each is frightened of being vulnerable and the therapist struggles with these forces and slowly gets into the case. Monsters soon come into the art work and the patient dares to say through the metaphor: can you get behind my facade and see something that is so powerful and frightening in me that it could possibly blow both of us away? Both therapeutic parties persevere which ultimately leads them into the main therapeutic arena. The patient draws the *Phantom of the Opera*, and both parties immediately make contact through the image. No one can see behind the mask of the phantom, for it is too horrible for anyone to bare. Both patient and therapist embark on a drawing of the phantom which ironically becomes a form of unmasking the phantom. The drawing of the mask both reveals and hides the persona of the patient. When he is told that it is only a play, the patient cannot believe it. The phantom is his reality and he cannot tolerate the puncturing of his fantasy. The phantom becomes his bridge that makes contact from the deep recesses of his despair to the therapist. In the mask, the self of the patient is exposed even though he is protected by the mask. The therapist respects and plays with this communication and a reparative art therapy contact proceeds in the patient's search for meaning.

There are many side issues that gain importance in this therapeutic dialogue. The therapist leaves her storybook of the phantom in her car. She is rushed and wants to make her appointment and hopes that it will not be a big issue even though she has promised her patient that she will bring in this story in the next session. The patient is crestfallen but denies that he is hurt or disappointed. Instead of directly confronting the defenses of her patient, she comments how hurt she would have been if she were in her patient's boots. He is very good natured and the patient secretly smiles, for there is a glimmer of recognition that has gone on between them. On occasion, therapists do forget about appointments or inadvertently break promises. These so-called accidents are probably the result of countertrans-ferential inductions that are acted out by the therapist. However as with art, if the therapist can capitalize on these accidents, there are therapeutic gains to be made if one can explore the issues without being too guilt-ridden or

defensive. In Michèle's case, she handles the situation with the maturity of a seasoned therapist.

At times Michèle moves into the therapeutic dialogue, leaves her role as art therapist, and plays with her patient. He trounces her in a game of tic-tac-toe and will not let her win. The feeling of control and power is important to this child, as he has felt all too long a sense of powerlessness with adults. Thus, although there is a modification of the role of the art therapist, the process moves on and this becomes the ultimate criterion for therapeutic effectiveness.

In the next case presentation, Patricia Savage Williams works with a client who has been chronically sexually abused. Cases of this nature have been increasingly referred to art therapists who are able to work with images and feelings that are not readily accessible because of the highly defended nature of these cases. The focus of the presentation deals with the adaptive character style of both patient and therapist. Each has sexual abuse in their backgrounds and have similar family issues. Both became adults and parents while still children themselves, for there was no parent to protect or take care of them. In turn, they developed their intellectual defenses, rationalized, and intellectualized their conflicts, dissociated and cut off powerful emotions, and utilized their enormous need for control and order to become very professional in their particular occupational endeavors.

We meet Pat and her patient, each cautiously sensing out the other, and the need for control and power in the therapeutic dialogue becomes immediately evident. Neither party is going to let down her defenses very easily, for the unconscious fears of both patient and therapist subtlety enter the nonverbal dialogue. Pat takes refuge in a medical model and becomes a history taker. The patient in turn presents a façade of confidence for she has already dealt with her past trauma in past therapies. All she wants from Pat is to take a look at herself.

The artwork soon unfolds the problem. There are dark and oppressive forces in the patient similar to those of therapist. The therapist understands her patient's art as she describes it brilliantly, going from one picture to another. Alas, the therapist's character defenses become a formidable problem that interfere with the therapeutic processing. The patient describes her artwork but is affectively disconnected from the underlying emotional issues that the images represent. Art expression can indeed be a very intellectual process and the therapist must be constantly vigilant in discerning whether the communications of the patient have a mind–body coherence. If this is absent then it is up to the therapist to find creative ways of helping the patient to overcome this resistance. Finding the image in one's body by walking and

moving like the art piece – even speaking for it – all become important, possible avenues of affective expression. This kind of dialogue needs to be broadened in this report and the therapist is very much aware that this is the central issue for both of them.

The first picture of the therapist (Figure 70) may well give us some clues as to the transference/countertransference problems. The heavy black rock of the therapist looks so contained and enclosed. It requires mirroring and contact. There is much red energy around this black rock but it does not really make contact with the patient's depressive self. Perhaps the opening up of this area may help the therapist approach the patient's depression. At the same time the respect for these characterological defenses becomes an important dimension of therapeutic processing. These defenses have developed out of a response to master feelings of loss of control and trauma. They have served both the patient and therapist well and must be challenged with the utmost caution. The possibility for retraumatization is always a present danger in working with these cases. Art readily exposes the underlying problems and we must take our cues from the patient as to their readiness emotionally to engage the pain, the loss and the anguish.

I have included this case material as the final chapter for it presents a challenge for the future training of art therapists. All of us have complained about the dilemma of working on individual and group therapy in a society and community that does not support any of the therapeutic gains that are accomplished in the institutions. Barbara Maciag[3] goes out into the community and becomes what I call a 'community art therapist'. As I read the report, she becomes, for me, the jungle virgin-queen who walks into dangerous situations where others would fear to tread and commands respect and admiration: she is truly a pioneer bringing her skills as an art therapist to the community where she believes her patients can best be reached.[3] Authors article originally appeared in Creative Art Therapy.

There is a libidinal sense that one detects in this entire report. One becomes immediately aware of a raw, primitive aggression and sexuality that is tenuously harnessed by the mores of the street gang. Barbara becomes much more in touch with the forbidden sexual feelings that seemed to be dominant and that are directed towards her, and she is able to handle them with a sense of dignity and graciousness. She offers them a 'new woman' role model which may be as important a part of the treatment as her use of film with these men. Women for these men are put into very distinct categories. They are either possessions to be cloistered from a dangerous

3 Author's article originally appeared in Creative Art Therapy

outside world, or if they are women of the outside they are whores who are soiled and exploited. In the gang's mind, this vision exists and stems from their shadowy Oedipal past. If a woman is sexual, then she cannot be respected, for this means she can be had by everyone. The boys struggle with too close and sexual connections to their mothers which must be compartmentalized in order for them to maintain a sense of self-cohesion.

The use of film is a very important medium in working with a street gang. The tool can be mastered fairly quickly; there are tangible results, sometimes very gratifying ones. Though there are frustrations in getting some degree of technical competence, they are not so overwhelming as to cause a despairing withdrawal from involvement. Therapeutically, the gang members have a chance to see themselves in action and the film gives them a chance to act out in safety while having socially approved results. The gang then has a chance to see these actions and to evaluate what they are really saying about themselves in their lives.

Barbara understands the wide range of complexities that are involved in her work. She visits families and gets a very real picture of what her 'sons' must live with. With the agility of someone who knows her jungle, she attempts to manipulate the institutions to work for her rather than continually undermine any kind of sense of continuity. Art therapy in this context has a very broad base. The therapist works as much with society as with the individual dynamics of her patients.

Barbara is no fool when it comes to drugs. She recognizes that if she were to take a moralistic stand with these young men, she would be seen as absurd or foolish. Of importance is her view of drugs; a defense against real communication and relatedness.

The therapist who is afraid of violence will find this a very difficult assignment, perhaps in which one is impossible to be effective. What remains crucial here is to face one's own fears and loss of control and not to act out by triggering the group either covertly or overtly. Thus, the therapist in these situations struggles to avoid power fights and maintains an openness and acceptance of people who may have very different values and morals than the ones that he or she has been accustomed to.

As I review Barbara's work, I am very aware of her complete involvement in her role as a therapist. Technically, some may complain that she displays an overidentification with her men. Fortunately, these problems work to her advantage as the gang requires a person who is very committed to this kind of work. The description of Barbara's work gives us an excellent standard for future art therapists who might venture in this direction. Working with street gangs, or the homeless, may be one of the most effective places for an

art therapist to function as a creative individual. Art therapy is still a very young profession and we have much to learn as to how we can best contribute to this society. Barbara's case is an excellent transition from where we are now as art therapists to where we will one day develop.

Art Therapy with a Floating Fortress

Linda Joan Brown

The Case – Joanne

I have been working with Joanne for an hour a week for seven months. After four months of art therapy, she was discharged from the hospital after seven months as an inpatient; now she participates as an outpatient in the clinical, educational, and recreational activities of the adolescent program where I work as an art therapist.

Patient's History

Joanne is a 17-year-old black girl who has been treated since birth for cerebral palsy. She is not spastic and retains the potential for normal movement throughout her torso. The cerebral palsy is mainly manifested in her walk which is characterized by a pronounced limp. She walks without braces.

The hospital records indicate that she had an acute psychotic break with auditory and visual hallucinations, and that upon admission to the hospital she showed 'delusions of reference and control…verbalizing threatening paranoid ideation.' Her visual hallucinations are described as revolving around Moses, God, and the Devil, who wore black clothes and had red eyes. God would tell her not to eat and would call her names… People stared at her from her bathtub.

Little is known about the precipitating causes of her illness. Possible factors in her history include her having been 'dropped' by a boy whom she had been dating in high school around the same time that a female cousin departed from home, and a trauma experienced five months prior to her hospitalization when she was hit by a car and suffered minor leg injury and a blow to the head.

Little is known about Joanne's family history. Hospital records are incomplete and only minimal contact has been established with Joanne's family. What information is available, through records, family contact and Joanne herself, indicates that, except for the period of her hospitalization, Joanne has been residing with her 80-year-old maternal grandmother since her infancy. Joanne refers to her grandmother as 'mommy'. Joanne's mother, a diabetic, died of a heart seizure when Joanne was five years old. During Joanne's infancy and early years, the mother lived in a separate apartment with Joanne's father and two older children from a previous marriage. Joanne was looked after in the grandmother's home, primarily by the grandmother, by cousins and by her half-siblings. The mother, who worked days, would occasionally visit Joanne in the grandmother's apartment on weekday evenings, and she would take Joanne home to live with her on weekends. After her mother's death, Joanne rarely saw her father; she has told me that she sees him, on average, a couple of times a year.

Included in the hospital records are conflicting reports concerning retardation. Some reports state that Joanne has a history of retardation; others state that she shows no retardation but describe her as having low-average intelligence. Prior to her hospitalization, she was a junior in high school enrolled in a commercial course. Reports from the learning center at the hospital where she is now enrolled indicate that her reading and math skills are at the seventh-grade level.

Some Problems with Countertransference

From the outset of my work with Joanne, I was aware of the difference in our rhythms – my own quick, direct, somewhat impatient gestures and Joanne's sluggish heavy pace. Initially I felt somewhat intimidated by Joanne's remoteness and sullenness. Her intensely closed and rigidly defended manner made me feel hesitant and tentative about intruding into her world. The message I felt emanating from her was: 'Get away from me!' When we walked together I tried to slow my step to match hers and found it difficult to tolerate and to sustain. I tried to minimize what appeared to be the threatening effect of my presence by matching her rhythm and using a mirroring technique in the art work. Because of certain unresolved issues of my own, however, I slowed myself down to the extent that I became acutely self-conscious about the slightest movement or gesture I would make. I grew afraid to move, and as time went on, I became increasingly angry and frustrated by feeling so restricted and inhibited, so shut out and pushed out of her world. Through my own wish for merger and my denial of my own separateness, as well as hers, I had turned myself into a non-person.

> *The therapist is faced with a conundrum that will follow her through the whole course of treatment. The patient is very encapsulated and walled off, and attempts to form any kind of deep, mirroring relationship may result only in futility and frustration. Once the therapist asserts her presence and does not attempt to be so exquisitely attuned, things seem to go along much better.*

Slowly I began to assert myself, defensively and defiantly at first: 'I refuse to be a non-person.' As I introduced more structure into our session, I found myself growing pushy and impatient as Joanne persisted in her sparse monosyllabic replies to my questions, and as she retreated from what seemed to be the minuscule advances we sometimes made together in our sessions. Occasionally we would seem to establish closer contact, and at the next session she would come in as defended and closed as before. It seemed as if I had to start all over again each time. I became discouraged and depressed and grew passive. One day in frustration I decided to try to 'treat the resistance', and I stated that she was pushing me away. Her response ('You think I'm stupid!') indicated that she had picked up the accusation in my tone. As I got in touch with my anger after this session – how far short Joanne was of my expectations and my fantasy of the kind of patient I wanted to work with – I began to see my own massive denial of her. Joanne was not the bright, middle-class, verbal, intellectual patient I desired. At this point in her development, she was nonverbal, slow sluggish and dull. Therapy would be long and painfully slow.

> *In this genuine interchange, there are the beginnings of a good therapeutic relationship.*

Accepting these feelings – in a sense, seeing Joanne for the first time – brought about an important change in my feelings for her and for our relationship. I found myself more able to relax during our sessions, and at times, I felt very warm and protective towards her. My observation of her behavior sharpened as I watched for the slightest shifts in movement and expression as signs of changes in feeling and mood. I even began to watch Joanne's hairstyles as possible clues to her feelings at the beginning of our sessions. When her hair was pulled up severely into a knot or into a vertical braid (which reminded me of an Indian warrior), she seemed inclined to be more remote and defensive; when her hair was combed more loosely, she seemed happier and able to talk more freely.

As we continued to work and I began to connect with my own feelings and fantasies about her childhood experiences – of feeling isolated and stigmatized because of her handicap – sometimes I would feel overwhelmed with sadness and the wish to make total reparation for her pain. At other times our growing closeness and Joanne's increased willingness to share herself with me made me feel timid and doubtful of my own ability to handle what I fantasized would be a sudden unleashing of rage and grief as she began to experience her feelings about her disability. Lately, I have also felt burdened and resentful at times with the requirements of the work – helping Joanne means dealing with my own feelings about crippledness. Even as I write this I find myself painfully struggling with them – experiencing something of a 'wanting to and not being able to', a helplessness and a paralysis and, underneath somewhere, glimpses of humiliation, frustration, rage and self-hate. I know that I must deal with my own experience of 'I can't' before I can help her deal with hers, and it is becoming more urgent that I do so as Joanne continues to open up. In recent sessions we have talked at length about her surgical operations and about her childhood. We have been warm and close and sometimes it has been difficult for both of us to separate at the end of our sessions. She leans on me as we walk, shares with me the details of her daily routine: her involvement with food, her childlike fantasies of quick and agile trapeze artists and other circus performers. I see clearly her wish to be taken care of, for mothering – and her denial of her limitations, her longing to be the opposite of who she is. Joanne may be more ready than I to deal with these feelings, for I am still working on facing these feelings in myself and on gaining the courage to reflect back to her what she is expressing.

> *When the therapist accepts her role of being mother and does not attempt to therapize the relationship, both feel each other's presence and can make contact with each other.*

Technical Aspects: Use of Art

Of the materials I made available (cray-pas, pressed crayons, different sizes of drawing paper, watercolors, and pencils), Joanne consistently chose to work with the more controlled materials: pencil, pressed crayons, nine-inch by twelve-inch paper. During our early sessions, she would use the straight edges of the crayon boxes as rulers to guide the straight lines she drew in order to subdivide the page into geometric shapes. During the first several

weeks of our work together, I used the art as a nonverbal method of establishing contact. Joanne's remoteness, her closed and somewhat sullen manner and her reluctant monosyllabic replies discouraged my efforts at establishing a relationship by verbal means.

Mirroring

I began to draw replicas of her designs, imitating the composition and form, line quality, color selections, and the rhythm and pace with which she drew. I did this for a number of reasons – among them, to try and experience the feeling tone of what she was doing and to let her know that I accepted her productions (and therefore her) and found them valuable. Occasionally I would vary my choice of colors, selecting a lighter or darker hue than those she selected; and sometimes I varied the rhythm of my drawing, to see if she would pick up my rhythm and color changes so that we could begin a dialogue through art. From time to time, she did pick up my rhythm; at other times, she seemed stubbornly resistant to acknowledging my presence in any way. During these early sessions, she took her drawings with her.

> *The patient taking drawings home or to her room becomes a very difficult turn to call. On the one hand, the therapist does want to communicate that her art work is special and belongs in the therapeutic confines of the treatment room. On the other hand, at this point it is difficult to discern why the therapist lets the patient take her drawings with her.*

Soon Joanne began to share the crayons she was using with me, asking if I wished to use the colors she had just finished using. I commented on the difference between drawing fast and drawing slow… She said drawing fast was 'happier' and that drawing slow was 'lazy'. This comment seemed to confirm my impression that the slow pace and style with which she drew were partially a defense – that just as Joanne very slowly and carefully colored in the spaces formed by her geometric designs, she was also filling in the time she was obligated to spend with me, without revealing anything of herself to me or involving herself with me in the process. Her concern with reinforcing the lines that formed her geometric patterns, the weak intensity of her colors, the look of emptiness to the page, her somewhat compulsive drawing style, as well as her color choices, hinted to me of her need for structure and control, her lack of ego strength and ego boundaries, her depression and feelings of deprivation, and her ambivalence toward me.

Associating to the Drawings

At the beginning of our fourth session, I decided to stop the mirroring technique and introduce more structure into our sessions. I asked Joanne to draw me a person. She quickly agreed, then changed her mind, saying, 'I can't draw…I don't know how.' Despite my assurances and encouragement, she refused to try. Instead, she immediately began a design, using loose flowing lines instead of her usual geometric subdivisions of the page. When she finished, I asked her to tell me about these drawings, what images she saw in them. She spoke of certain letters of the alphabet, 'a flying ghost in the sky…a sunny day…railroad tracks…sliding ponds in the park…a slinky toy, and…when you do math with triangles and squares and round circles – a math design.' I was surprised by the contrast between the light childlike quality of the fantasies she had produced and her overtly depressed, heavy, burdened demeanor.

> *The patient allows the therapist to experience a piece of likeness and child-like fantasy that creeps through her very heavy burdened demeanor.*

At the end of this session, I asked her to sign her name to her drawings, add the session date, and to number them in the order in which she drew them: I wanted her to begin to acknowledge her work in our sessions as well as in our relationship; I wanted to start verbally communicating with her about her work. She readily signed, dated, and numbered her drawings, and, for the first time, she left them with me.

At the following session, Joanne spontaneously produced two drawings in which a small stick-figure stood alone in space. The drawings were chaotic and showed Joanne's feelings of helplessness in an overwhelming world she didn't understand and couldn't control. She drew these pictures in an extremely compulsive manner, writing her name several times on each drawing and obliterating her signature with Xs, a star-like symbol: a sign of the anger she turned in against herself and of her fear of revealing herself to me.

During the next sessions, we continued to play the 'word game' and I wrote down her imagery as she dictated it to me. Frequently her sparse associations had to do with playgrounds and childhood street games (hopscotch, the 'lode game') in which the rules of the game often involved staying within the lines. We talked a little about the wish to control and to make things perfect; as we continued to work and her productions became more figurative so that it was possible for me to see the infantile level of her

drawing, I began to relate her need for structure and control to the retardation factor mentioned in her record, a fact I had originally dismissed. I have since concluded, after twenty sessions with Joanne, that her retardation is probably not organic as much as it is a result of emotional factors connected with her and her family's manner of coping with her handicap: factors which have reinforced her infantile dependency needs and her withdrawal from social contact and which have minimized her opportunities for environmental learning.

Commenting about the patient's defenses does not usually help a patient with this type of disorder, i.e., her wish to control.

In the seventh session, in addition to Joanne's usual associations about playgrounds and active street games such as hopscotch, she introduced still another image that related to her disability: 'breaks in the knee in different-color pants…they need repair'. It was time to begin to deal with the issue of Joanne's disability, perhaps using the topic of the playground and childhood games as as opening. At the next session, she again mentioned the hopscotch game. Our discussion went as follows:

LINDA: Did you go to the playground with your mommy when you were little?

JOANNE: Yes.

LINDA: Besides hopscotch, what else was in the playground?

JOANNE: Monkey bars, the turtly, and the lodi game…

LINDA: Were there also swings and a sliding pond?

JOANNE: They weren't at that playground, but I've seen them at other playgrounds, like the playground near my house.

LINDA: What was it like for you at that playground when you were small?

JOANNE: Okay…

LINDA: Did you play with the other children?

JOANNE: I played with my friends.

LINDA: It must have been difficult for you…

JOANNE: *Silence. I sensed her attention sharpen.*

LINDA: *At this point, I shared with her my own experiences on a playground when I was a child at a time when I didn't know anyone and had no friends – how lonely and sad I'd felt watching the others play, not being part of it.*
 Did you ever feel that way?

JOANNE: No…it was okay…I played with my friends.

LINDA: And you mother…did she stay and watch?… Was she worried about you and concerned that you be careful?

JOANNE: No.

LINDA: Then your mother let you be free to play…

JOANNE: *Silence: a waiting.*

When it came time to end the session, Joanne did not wish to leave and found several reasons to delay her departure. As she left, she asked me for candy, and at subsequent sessions I made certain that sweets were available for her.

Although offering candy to a child borders on bribery, the fact is that is does positively reinforce the therapeutic relationship.

'Squiggles'

At the next session, Joanne asked, for the first time, with pleasure in her voice, 'What are we going to do today?' It was then that I introduced the 'squiggle' game. It seemed that by having addressed myself to some of the feelings connected with Joanne's disability, I was finally 'in the picture' for her.

From that point onward, the quality of the contact between Joanne became more interactive and personal. We did squiggles together and made up drawings together. With evident delight, she helped me paint a table for the new art room where we would continue our work together. Joanne began to greet me by taking my hand and would offer me candy that she sometimes brought to our session. She began to talk more freely, and she would occasionally say, 'I like coming here'.

Helping the therapist do concrete tasks, such as painting a table, are the kinds of activities that this patient needs in terms of acquiring feelings of effectiveness and competence.

Clay

After three months, I began to re-evaluate my goals in working with Joanne. Our relationship was established and it was time to formulate a specific direction for our work together. To the fourteenth session, I brought some play dough, and as we worked together on building a figure, it became

immediately clear how tremendously distorted was Joanne's body image. She seemed to have no conception of 'what comes after the head'. She would roll the clay into round balls and then become confused as to how to put them together. At this session I decided that working on body image was a primary goal – that through building clay figures, I could provide Joanne with a basic learning experience, and that this might be an avenue through which we could begin to deal more directly with Joanne's feelings about her handicap. Since that time, we have built a number of figures in Plasticine. All but one of the figures are female (her choice), and she has given them names and ages and made them into a family.

> *Concrete sensory experiences which relate to body image can also be of help to this patient. Once again, it cannot be emphasized enough that these patients do not do well with abstract symbolic material. Offering examples of how to mold the clay and build the body for her patient becomes a very concrete example of a very deep sensory relationship that is so needed between mother and child or patient and therapist.*

The first figure was that of a woman. For each part of the body, I asked her to touch and feel herself and to look in the mirror 'to see what's there'. When would then look at me as I touched myself in different places. We began with the head and named the parts as we went along. Through this process, Joanne's sexual blocking (hinted at in her earlier drawings) became strikingly apparent. I added a breast to the figure we were building and asked her to add the other. She added a piece of clay and very carefully proceeded to flatten it down. She 'forgot' the pelvis and was wondering how to add the legs to the chest. For the legs, she rolled the clay into a ball and placed it under the pelvis we had made. This reminded me of the stick-figure she had drawn in our seventh session where the female figure had only one leg, perhaps signifying Joanne's 'good leg'. I showed Joanne how to divide the sphere into two parts and roll the clay into legs. She still uses this procedure to make the limbs. The sphere for Joanne seems to be a primary symbol, perhaps representing breasts and nurturing as well as her preoccupation with childhood games. It is also reminiscent of the art work of very young children, in which the limbs are drawn as emanating from the head.

For six sessions, I continued to do mirror work with Joanne, encouraging her to see and touch the different parts of her body, to feel and compare which parts were smaller and larger, and to notice how the different parts of her body connected and moved. I also began to incorporate my skills in sensory awareness into our work. For a while, we would begin each session

with breathing and movement before proceeding to our work with clay. Working with our bodies – with breathing and touching one another – helped promote an increased closeness between us.

After the first two sessions with clay (in which we built the figures together and Joanne then traced on paper and colored in the figures we had made), she began doing most of the clay work on her own. The figures grew progressively smaller until she made a figure of a baby girl protected by a blanket in a crib (see Figure 25). As she was building the figure of the baby, we had the following discussion:

LINDA: Do you remember when you were a baby?

JOANNE: Yes…four months before I was born…

LINDA: What was it like?

JOANNE: Sleeping a lot and eating food and kicking…

 At this point, the sequence, as I remember it, is unclear. The fantasy seemed to change from the inside of the womb to outside, and I am unclear as to whether this change occurred through Joanne or through me. We continued, talking about the sounds that babies make.

JOANNE: Babies say 'Daddy', 'Mommy', 'milk', 'food', 'soda'…

 She was talking with obvious enjoyment about this.

LINDA: It seems that that was a happy time for you.

JOANNE: Yes.

LINDA: Sometimes I think it was happier to be a baby than to be grown up.

JOANNE: I know what you mean…

In this session (and through the progression from adult figures to child figures), Joanne seemed to be saying on one level that she could not deal with being a grown-up woman (with sexuality or being independent and taking care of herself in the world) and that she saw herself as a baby or would find it more comfortable to be a baby. Her fantasy about the womb indicated confusion and perhaps curiosity about women's bodies and where babies come from; perhaps it reflected some wish to have a baby. At the same time, her enjoyment of our breathing exercises and movement, which addressed themselves to her adult body, indicated to me that we must work simultaneously on both the child and adult levels.

> *Activities that she can identify with the therapist are all part of a generalized reinforcement treatment program.*

Since this session, through the creation of stories about the figures and drawings she has produced, I have continued to explore Joanne's fantasies as well as the reality of her childhood, we have talked at length about her leg operations during her childhood, and she has acknowledged some of the fear she experienced in this regard. I am slowly learning more about her family history and how she presently spends her time at home. As the opportunities present themselves, I may begin working with Joanne on sitting, standing and walking activities which will necessitate even more of an acknowledgment on her part of her feelings about her handicap. Gradually, I may want to get Joanne onto the floor (paper body-tracings or a childhood name like 'jacks' might be vehicles for doing this) for it is on the floor that the sensory awareness work becomes most effective in unblocking breathing, becoming aware of body boundaries, getting acquainted with the idea of the floor and ground as support, and, through the use of guided imagery, awakening and using the senses and becoming aware of the sensations and energy requirements of small and gross movements.

However, while the sensory work has both educative and therapeutic value, I view it as only one of a number of possible directions that my work with Joanne may take. Joanne is beginning to take the lead in our sessions (e.g., suggesting during our last session that we go outside for our meetings), and working with whatever feelings Joanne expresses during our meetings remains the primary goal.

> *The therapist might well entertain the possibility of offering concrete motor tasks for the patient to follow which will reinforce a sense of effectiveness and control.*

Merger and Separateness

Kristen Stonehouse

The placement where I am working is a community support services (CSS) program. It is a day treatment center for psychiatric adults, age 19 and up. There is a wide range of diagnoses, the main one being schizophrenia. Within this clinical setting, the main emphasis is on 'milieu' time and structured groups and activities. The creative arts therapies play an important part in this institution: art, movement, drama, music, and writing therapy groups are all included.

Let it be noted that the questions I pose throughout this paper were not communicated to the patient. The questions which I now bring to the surface are a way of processing the therapeutic material. In no way would I have expressed these thoughts verbally as they would have damaged the therapeutic alliance.

The first time I saw Daniella, I immediately felt drawn to her. Out of all the patients in the program I absolutely knew I wanted to work with this woman. As I try to concretize my reasons at to why, what comes to mind is that the term 'woman' does not exactly fit Daniella. 'Child' or 'girl' makes more sense when referring to this patient regardless of the fact that she is 24 years old. When I first met Daniella, she was standing against the side door to the program with her coat on. I do not remember every detail exactly, but an image which comes to mind is of a small, obese child wearing a little ruffled dress, knee-socks, buckled shoes, with her legs crossed, and holding a big colorful lollipop that she hesitantly licks.

In reality, Daniella's eyes are usually cast down towards the floor, yet timidly dart upwards, engaging the onlooker into her coyish and wide-eyed expression. I remember the feeling she gave me; I just wanted to sweep her up into my arms and cradle her to sleep. I wanted to take her home with me

an keep her as my pet. I wanted Daniella to be my baby, but when we actually started working together, I wanted to flee from her because I felt trapped.

> *The therapist refers to the the patient as her pet. Is Kristen fleeing from her own projections, wanting and fearing being a pet, or perhaps do the patient and the therapist make contact on this level of consciousness?*

I remember being nervous before our initial meeting. What if I blow it and she does not love me? What is if I need her more than she needs me? What if she takes me over and exposes my vulnerabilities? What if I let out my small, unprotected child and Daniella consumes her? Will she want to play with me? And if not, what does she want form me? A mother? A womb? A sister or a friend? My mind wandered on. Insecurities and doubts arose; I felt driven by the feeling that I needed to take care of this patient. The transference and countertransference were set into place for the time being.

> *Are we getting more accurately at the transference/countertransference problem? Is each therapeutic party expressing her need for closeness and fear of being consumed?*

When we had our first session, I felt like I was guiding a little child to come to mommy. Daniella's eyes were constantly fixed on me as I reassured her about the session. The first thing I discussed with her was the fact that I was a student and would be leaving after my school year was over. Upon talking with her primary therapist, I found out that separation anxiety and fear of abandonment were big issues in Daniella's life and that it would be most therapeutic for me to address these issues from the start. I also took the opportunity during the first session to discuss just what art therapy was. This was all fine, but I felt like I was filling up the session with this superficial talk in order to avoid the real relationship. Because Daniella was quite nonverbal, I felt I was not getting the response I needed. As the session dragged on, I became more anxious, and finally suggested we pull out some art materials, paper and pastels. I first asked her if she wanted to draw something. She only looked at me with hesitancy and sheepishly said, 'Umhum'. Before she had a chance to act, I jumped in to save her and suggested that we both draw on the same page. She responded in a firmer 'Yeah'.

> *The issue of whether we tell our patients from the very onset when we will be leaving presents a conundrum for the therapist. By so sharing with the patient that she will be leaving at the end of the term, the issues around abandonment are immediately brought to the surface. This certainly creates a focus for treatment but will it hide other issues from coming to the surface? The therapist also expresses her impatience in not getting the response she needed. Was this an expression of her own wish for oral merger? The patient and therapist embark on drawing on the same page. The creates a quality of symbiotic-like relatedness, and perhaps is the safest and easiest courses of action for the therapeutic process.*

As we drew, some of our anxieties seemed to diminish, and Daniella started telling me about herself as I initiated questions. At first she perseverated on the topic of her cousin's death and continuously asked me why it had happened. As she pleaded for an answer tears filled her eyes, and I felt the right thing to do was to acknowledge her pain. I told her I did not know why these things happened, but that it must be very sad to think about. Daniella seemed to respond to this. For a few moments I felt as if we were one; connected empathically through the affect. I believe she felt my genuineness. Daniella's past was filled with loss of attachments, but I was there making a connection with her. And if it was only for that second, it was a start.

> *The patient requests to be filled up, 'Give me something to fill my emptiness.'*

As the session went on, Daniella spoke to me mostly in the form of questions, such as: why her parents got divorced, why her mother had to go back to work leaving her alone all day, if I watched soap operas, or if I liked certain singers whom she liked as well. In addition, she constantly referred back to her cousin's traumatic death. I really felt Daniella was trying to identify with me, so I remained vague in many of my answers. Not knowing how Daniella would process my answers I simply reflected the questions back to her. I did not feel comfortable in sharing personal information because I thought she might use what I said against me at a later time. I think even more so, I wanted to keep my separateness and avoid merging with her.

> *What to share and when to share with a patient is often contingent on the regressive potential of the particular case in question. In this instance, sharing would only increase the fear and wish for merger. Sharing makes sense when it facilitates the processing of the material.*

It was that idea of merging that really raised my level of anxiety. Even as I write this paper, I am fighting against the feeling of being sucked into a merged state. The feelings are so intense with Daniella that I cannot escape. Even when I am far away form her, she is inside me. I realize this even more as I look at our initial art piece. Her choice of materials were pastels. I hate using pastels. They feel horrible; they are messy and uncontrollable. I need materials that have definition and boundaries; I went along with the pastels anyway. Maybe I experienced a weakness in my space and boundaries; a lapse in my defense system which allowed me to go inside Daniella and her to go inside me.

There was not much talk after our first drawing (Figure 47); however, after a few more sessions the drawing started to make sense to me. Daniella's person looks very unstable and unsupported, the chalk reinforced this idea.

Figure 47

The figure looks sad and lonely – in need of support and love. It gives me the feeling of impoverishment, not knowing how to extend its hands to form a relationship. Looking at my drawing, it is clear to me that I have drawn myself, pregnant with Daniella inside me. I am carrying her, protecting and supporting her. In this session we became one. We merged.

> *It takes a good deal of therapeutic courage on the part of the therapist to openly explore her relationship with the patient. She sees herself pregnant with the patient inside her womb. Is this a defense against relatedness or a covering of fears against abandonment?*

When I think of the transitional space between us, my head becomes cloudy and fuzzy. My thoughts are unfocused and as a defense, I become numb. In one moment I am pulled into Daniella's aura and in the next I am spat out. I ask myself, could this be how she feels in her world? Is Daniella always searching to merge, but rejected? Is Daniella's world hazy like a cloud. Could this also be a defense against feeling the pain of separateness? Does she become numb too? And, could I be feeling the ambivalence of the mother? What did I do wrong with this child? Why can I not fulfill her needs? She is always eating, shoving the world into her mouth but she is still not satisfied. Did I feed her poisoned milk? I feel like a failure. Did I try my best? Look what I am left with, a 24-year-old baby. I am angry. Grow up, snap out of it – just stop eating me.

> *The intensity of the orality continues and the the therapist feels compelled to meet this enormous pressure. Perhaps they are both frightened of rage that will explode if the therapeutic boundaries are maintained.*

I can feel the pain and frustration, the melting of my heart and the raging anger. How do I channel this energy? How do I move with Daniella? How can our bodies connect in synchrony? Where is that damned ego rhythm?

For our next session I entered with a planned idea based upon my own speculations and Daniella's history as it was written in her chart. She was diagnosed as having paranoid schizophrenia which resulted in her regression to a very primitive, pre-verbal level. Although she does communicate, it is often very limited and awkward. It is as if she has no impulse control in her verbal expression. She will just blurt something out and wait for a response. I feel her communication skills parallel our relationship. There is no syncopated rhythm. It is as if we try to connect, but our beats are off. The result is choppy dialogue verbally and in the art process itself. Could this have been Daniella's relationship with her mother when she was an infant? Did the mother and child ever connect in body attunement? Were their ego rhythms off beat, keeping Daniella from ever forming a basic trust? If I am accurate what does she need from me, a secondary mother to build up a basic trust?

> *The importance of the real relationship cannot be underestimated when treating psychotic disturbances. The patient must know who your are as a person and yet, paradoxically, the therapist must be very clear about his or her personal boundaries.*

So, in our second session I thought that I would start with combination drawings (Winnicott's (1971) scribble game). I remembered that Daniella needed reassurance in execution, so in our first session I drew with her. I saw this as a good place to start the second one as well. I introduced the 'You Draw a Line, I Draw a Line' game. I thought she would respond to the game because I would be working directly with her and supporting her. In the second drawing (Figure 48), Daniella quickly drew the faint lines across the page and I finished the picture by titling it *Rhinoceros*. In the third drawing

Figure 48

(Figure 49) I started and Daniella completed the picture and titled it *A Baby*. This drawing make more sense to me because I saw Daniella as a baby. In the forth drawing (Figure 50) Daniella spent a good amount of time coloring

Figure 49

Figure 50

in half the page blue. When she was done I took it and drew two people on top of her blue and titled it *The Ocean*. With this, Daniella withdrew her body and her breath. She sucked all her energy back into her space. I immediately felt the movement and felt empty inside. She had come out of my stomach, leaving me deflated like a balloon.

> *The dance of the rhinoceros and baby explore the mutual symbiosis of the patient and therapist. One is never quite sure whose baby and rhinoceros we are talking about. Once the patient expresses her oceanic longings for merger, both parties immediately feel their separateness. If the patient expressing a rebirth fantasy that became very frightening for both of them?*

A strong image comes to mind when I that about that moment of deflation. In the movie *Aliens*, the queen alien must implant and embryo into the stomach of a human to reproduce. The humans would fight for their lives to stop the embryo from planting its tentacles down their throats, but in most cases the humans would lose. Once planted the process of growth began, leading to a grotesque 'birth' where the alien would forcefully rip through the stomach and skin of the human to get out. Of course, the human character would die a painful death. It was the kind of scene one watches with ones hands over ones eyes, only allowing one eye to peek through. It was a grotesque thrill to watch this, erotic and nauseating at the same time. Could these be my feelings towards Daniella, and in turn hers towards me? Some sense of erotic merger, yet repulsion by guilt and the reality of it?

> *The expression of the rebirth fantasy creates fears of being trapped and suffocated. Both parties must claw their way out of the womb or they will die. At the same time, they each fear their ability to murder the other in the process.*

In hindsight, I can put words to that shift in energy, but it still makes me very anxious to think about it. Did I force myself into her with the idea of the combined drawings? Did she enter me with the images produced? The rhinoceros is Daniella – big and dopey, yet dream-like and floating. Her projection of herself as a baby appears so primitive and so alone. Is she asking me to take her inside of myself to for nurturing and growth? But, when I imposed myself on her (Figure 50), she retreated; the rhinoceros horn ripped through my stomach to escape. What does all this mean? It feels a bit like abuse; some strange masochist sexual act that cannot be spoken aloud. What is this doing to us? I have a fear we will swallow up each other.

> *As both patient and therapist explore their fears of being swallowed up, there is a call for developing firmer boundaries so that the mutual fears will be contained in the art form.*

Still, could some strange process be taking shape? Is there an answer in the fifth drawing (Figure 51)? Daniella first drew the green mass. Could she have taken me inside of her, using the green marker that I used in drawings 2–4?

Figure 51

Is that blue mass her self representation from drawing number four? Are we brought together by the big, round, brown oral mass? It appears as though her mouth gobbled up both of our images, then in her stomach we remained warm and secure until we finally ended up in a large 'shit'. Have our combined images been digested or spit out in rejection? Was it a good digestion ore a violently repulsive one?

> *There is an underlying tone of violence in these sessions as all art work seems to be changing, turning to shit. Will more be required from both parties in order to grow?*

Needless to say, I was glad that the session ended and that I would not have to be with her until the following week. In this time period I gave myself a chance to prepare. While looking back over Daniella's previous drawings, I realized there was simplicity to her lines and masses. Her lines were drawn across the page in faint strokes. When she made these marks, the pen was awkwardly held and her eyes continuously darted up to mine. I felt as though she was anxious and was glancing to 'mommy' for reassurance. Interestingly though, when she colored in the shapes and masses, her eyes became fixed on her work as she went about the process in a frenzy. She pressed harder with the pen. Angry and hurt tones would come out of her mouth as she asked why her parents had to get divorced. During this time I too would 'zone out' and become mesmerized by her hand moving back and forth on the paper.

> *This mesmerizing quality may be an expression for self-soothing as well as a method of auto-eroticism.*

That sensation I felt was a clue for me. I know that whenever I zone out and fall into a trance-like state, it is a defense. I am usually protecting myself from feelings I do not want to address. I do need this time to give myself space and relief, but I can get stuck in it, and that is what I felt Daniella was doing. She was becoming stuck in the two-dimensional motion of drawing back and forth. Therefore, I decided to try three-dimensional materials with her.

> *The therapist recognizes that something is going wrong and presents a material that will demand more of them.*

Daniella entered our third session with a cup of coffee, placed it right in front of her, then laid down a handful of sugar next to it. I thought this was quite interesting and a little humorous because to me, this reinforced my idea that Daniella wanted to be fed. Of course, upon asking her to place the items aside, she trailed a mess of sugar along the table and on her hands. Could that have been a passive rebellion, making a mess in front of mommy?

I proceeded to introduce wood blocks to Daniella. I had dumped a large assortment onto the table and encouraged Daniella to choose pieces she liked. Time went on and Daniella slowly slid the wood pieces around in front of her. I decided to give her more direction. We found a base for the sculpture together and I opened the glue for her to begin the project. At this point I was getting impatient. 'Damn it Daniella, what do you want from me?' I

asked myself. 'If I ask you a question you answer, "Yeah". If I turn that question around to its opposite you answer "Yeah" again. You do not tell me what you need, so how can I help you? You comply, but then you just push the pieces of wood around. Are you trying to piss me off? You want me close but then you push me away. Are you trying to make me feel like you feel? What can I do?' My head swam.

> *The issues around contact and fears of being destroyed in the relationship become a central issue in treatment.*

Again, could there have been something constructive happening between us? In the sixth drawing (Figure 52), a self-portrait of Daniella, the Figure seems to be more stable than in the first. It is more central on the page and the lines flow better than in the first figure. Could it have been the choice of materials, marker, which helped create definition and boundaries? Could it also be that the therapeutic process is building up between the two of us?

Figure 52

> *A psychic structure is being built up between patient and therapist. Each is mirroring the other and a kernel of the self is emerging.*

I felt like I had been jumping from project to project in hopes of finding one that fitted Daniella. It was a very ungrounding experience which forced me to take a deeper look at my treatment approach. I felt that two-dimensional drawing was not the best idea since Daniella tended to get 'stuck' in the process. The three-dimensional wood trial seemed like an act of compliance and impersonal on the part of Daniella. I decided to try another avenue. In our fourth session, I brought out a book filled with pictures of babies, mothers, and fathers. I laid out Daniella's previous drawings and pointed to her that the image of babies had often come up in her work. I asked her then if she wanted to continue with those images. We paged through the book, picking out images that Daniella liked. After this, we photocopied the pictures and lay them out before us. The image Daniella chose to work with was of a man and a woman on a bed with their backs turned toward each other. Daniella glued the photocopy to a large piece of white paper, and I encouraged her to draw an environment around it. She colored in a green mass underneath the picture which looked to me like a possible are and hand holding up the image. A discussion was generated by Daniella's growing energy as she colored in the green mass. Her tone was angry as she asked, 'Why did my parents have to get divorced?' From this we explored her anger and how it must be for her to have lost so many people in her life. The discourse back and forth felt right. It felt supportive and I did not feel I was pushing her too far. Out of this, Daniella boldly asked me if I was leaving.

The glimmers of an angry self emerge. There is much more of this affect that the therapist and this patient must face. It must be so frightening for Daniella to form attachments. Does she fear that everyone she touches will abandon her? As I look at her last artwork, I wonder if the green mass could be her arm and hand trying to hold her parents together. Does she feel it was her fault that her father left? Do *I* now represent another possible loss in her life?

The issues of attachment may be as important as object loss. You must have a relationship before you lose it. A self must be mirrored and recognized otherwise the patient is left with primitive fantasies and impulses.

So, what can I do; where do I move next? At first I thought that I could help Daniella move towards a more anal stage in development. It seems clear to me that she is in a regressed oral stage which is quite pre-verbal. It feels as if she wants to form a symbiotic attachment, but withdraws when we get

too close for fear of loss, or fear of aggression. I thought if I enabled her to surface her aggression there might be a shift in treatment. Now I am rethinking the situation. Daniella probably never had a healthy symbiotic union where her body and her mother's body were in synchrony. Therefore, I should look at her regression as a second chance to build the mother–child relationship, to give Daniella a chance to relate and transform the pathological mother in the therapeutic arena. She needs to learn to identify and integrate these early feelings in order to build up her ego strength. Just as I can verbalize how I feel within the relationship, I need to help Daniella begin to recognize her feelings. Thus, if together we can build something structurally, this may begin to build Daniella's language and body connectedness. The ideas of a transitional object, such as a baby doll, may give Daniella her own baby (herself) to care for and understand. Her body boundaries and the boundaries between her and me may be created and reinforced. I see it as a triangular relationship where the artwork is the physical product of our relationship (Figure 53). Through this, maybe Daniella can learn how she wants to use me in the therapeutic process. Through the physical act of

Figure 53

creating, maybe Daniella's passivity can be turned into activity. And the idea of merging, where we become 'one' can be transformed into a symbiotic self-and-other existence. This line of thinking helps me believe that my

understanding of the process so far does make some sense. Daniella and I have been inside each other and we are trying to get birth right this time around. We have to start from the beginning like a mother and newborn in order to help the baby grow up healthy. Thus the challenge begins.

> *Both patient and therapist face the prospect of making a baby and in the process develop the kernels of a newborn self in the treatment relationship. Creating a baby doll may be very productive, but the patient will have his or her own idea as to where he or she must travel in the treatment. Each party must struggle with fears of merger and the need for separating. In the process a great many explosions may arise that will require trust, clarity, and firmness.*

Reference

Winnicott, D.W. (1971) *Therapeutic Consultations in Child Psychiatry*. New York: Basic Books.

Regressive Reintegration

Anne Reilly

I met Lucy while working at a long-term residential treatment center for chronic patients. My position at the arts center is to run the painting and drawing studio. Patients are referred by their doctors to be permitted to come up and spend time in the studio. The studio space is large with big windows, plants, music, and several tables covered with newspaper on which to work. The patients' artwork is hung on every available wall space. The patients each have an individual portfolio and may ask to work with any material they desire. There is, along with traditional art materials, additional studio space for ceramics, photography and printing. The studio is open daily and the patients may stay as long as it is open.

It was my first day on the job and I was being trained by a recently graduated art therapist who came from a different orientation than I. She had recently taken the position at the arts center but was leaving because she had had a better job offer. The woman whom she had replaced, Kathy, had run the studio for five years. It was at this moment that Lucy strutted into the room and refused to sign in. She asked where Kathy was, and was told that she now worked downstairs on a unit and that I was her replacement. Lucy gave me a disapproving glance. Lucy appeared as a big, black woman in her mid-thirties who did not want to be messed with. She also seemed upset by the news of being abandoned by the staff. I felt anxious upon meeting her. I felt like chow for the hungry, abandoned, bulldog who was left behind. Lucy quickly walked over to the table demanding help with putting buttons on a coat she brought in which was not designed to have buttons. As I approached her I felt both scared and maternal towards her. It felt like her energy would take up the space of the entire studio. She seemed all over the place; her body movements were so brisk and abrupt and the

tone of her voice was curt, demanding, and deep as though she wanted to roar like a lion, but could not.

Lucy began haphazardly rummaging through the cupboards looking for buttons. I told her I had just been through the cupboards and did not see any buttons. She snapped at me and said that I did not know what the hell I was talking about because she had been there seven years and she knew far better than me what was happening in the studio. I felt perplexed looking at her, trying to take her in, but feeling extremely overwhelmed. I gave her space. Inside I was feeling knocked off my center, inadequate, and insecure about interacting with Lucy. I also felt as though I was being tested by her to see if I would be able to contain. She barked at me as though there was something she was protecting.

I found some wooden beads and offered them to her in place of the buttons. She accepted them and asked me to thread her needle. The energy shifted between us when we sat down and I began handing her the needle and thread for her to sew. As we sat there silently, I felt as though I was spoon feeding a baby. Our space became very intimate and close. Lucy would only speak to ask if she was doing it right, and I would nod yes and give her support and compliment her on her fine sewing. As I watched her sew on the buttons, I felt her energy to be more focused, contained, and connected to me. She sewed the beads on unevenly and often not close to the edge of the coat where buttons would need to be. Lucy was constantly looking to me for approval. I gave it to her but also felt a silent growl from her; if I came too close without her permission, my hand would be gnawed off.

> The patient attempts to work through her conflict regarding possible future abandonment through the metaphor of the buttonless coat. She struggles to place the button in the right place so her coat will close and she will feel warm and protected. I doubt if this could ever be expressed in a verbal manner.

After sewing on the buttons, I had the impression that Lucy was calmer than when she first came into the room. I thing the process of sitting with me and sewing contained her. I also felt less anxious and calmer after the experience. Lucy then wanted to make buttonholes for her buttons. I told her we did not have supplies for making buttonholes or buttonhole loops. She asked for a scissors and began cutting slits into her coat. As I watched her I began to feel anxious again; had I set her up for failure? I knew it was not going to work. Lucy became more and more frustrated and I tried to placate her by saying that I was sorry the project did not work out, and

maybe the buttons could be used for decorative purposes. I began feeling we were no longer working together. She no longer felt gratification, but frustration with me and the coat. At this point the energy shifted again and she gave me a piercing look, stood up, and stated she wanted to 'beat my face in'. I stood up, took two steps backwards and looked at her while I repeated that I was sorry it did not work out. I added that I could see why she would be upset and angry, but beating my face in would not solve the problem and probably would cause her to be restricted from the studio for a week. Muttering at me, she quickly gathered up her things and walked away. I stood there with my arms crossed feeling as if I had completely failed with her. I was scared about being threatened and because of my own anxiety, I felt I was unable to hold Lucy's own fear of her aggression towards me. I slowly walked over to where she was and quietly stood at a distance as she asked a friend to leave with her. Suddenly she turned to me with a friendly smile, walked over to me, and in a high-pitched voice stated she wanted to work with me on the coat and asked if I would like a bag of potato chips. She shoved the potato chips into my hand. I felt stunned but smiled and told her that I would very much like to work with her, but that the studio was closing and maybe next time we could work together. She smiled and said she would come the following day.

> *The therapist conveys to the patient that the therapeutic studio is safe and that her rage can be contained.*

After Lucy left, I was told by the art therapist who was training me that Lucy was a manipulative pain-in-the-ass patient for everyone. She disagreed with my allowing her to make slits in the coat, but my supervisor commended me saying that it was her coat and it is the patients' studio, thus, there was no real reason or way to stop her. I felt confused and very ungrounded at this point. Lucy was a handful given how the session ended, and yet, maybe in my scared, weak manner I was able to make her feel contained enough for there to be a beginning of an alliance between us. My countertransference issues here were my doubts of my ability to contain and the fear of using my aggression. I believe she picked up on my anxiety as she cut the slits and did not trust that I could contain her, therefore she acted out. In feeling Lucy's ego rhythm, I felt the need to give her more of a structured, firm holding environment that was also empathic and gentle. I felt I needed to be in touch with my own aggression in order to not feel anxious holding her primitive affects. Would I be able to hold them?

> *The discrepancy in therapeutic orientations has to do with rage and regression.*
> *One perspective attempts to restrict acting out and to build up ego strength*
> *through the building and construction of an art piece. The present therapist takes*
> *a different point of view in therapeutic perspective. She accepts raw affect as an*
> *important place for future reintegration.*

Before the next session Lucy was told by my supervisor that if she were to threaten me again she would be restricted from the center for a week. Lucy cried and begged the supervisor that her unit chief should not be told. Apparently, Lucy had been restricted before from the center and frequently had violent outbursts on her unit.

Lucy walked in looking down and I greeted her affectionately, but at a distance. She signed in and asked for brown and green construction paper, scissors, and paste. She said she wanted to make trees for her unit hallway. She sat down and I felt her somberness. I did not sense her rage as in the last session. She seemed more withdrawn and isolated. I brought her the supplies and she immediately began cutting out huge cotton-ball-shaped treetops form the green paper, and short stump-like trunks from the brown paper and pasted them together. The finished tree shapes looked like Lucy's body contour. I had the impression that she was far more organized than the previous session (Figure 54).

Maybe the fact that Lucy was given firm boundaries by the supervisor helped her to be more cohesive. As I watched her and moved around the room helping other patients, she made on eye contact with me whatsoever. She was completely involved with herself and her trees. I commented on how alive and wonderful I though her trees were. She growled and told me to go away from her. I wondered if my sweet, soothing voice lacked the firmness which Lucy responded so well to with the supervisor. I felt rejected, disdained, and only useful to her by feeding her supplies. Her energy consumed the construction paper in a devouring manner. She cut aggressively, quickly and in a way by which I felt her inner hunger; she had to make these trees as fast as possible in order to consume them whole or to get something inside out onto them.

She yelled across the room for me to get her some paints. She told me eight specific colors that she wanted. I chose to put the paints in a small ice cube container in order to limit the amount and to keep the paints separate. I chose to feed her in small doses so that she would have to call upon me to refill her paint when necessary. She would have to depend on me to supply her. I set her up and again she made me feel that she wanted me out of her

Figure 54

way. She did not want to talk to me either. I often felt that I spoke to Lucy out of anxiety and rejection. I found that if I kept silent, she would eventually initiate contact with me.

Lucy stood up to paint and I noticed she chose big paint brushes. She applied the paint generously and with a loose quality. The energy shifted when she began to use the paint. She immediately regressed and merged with the paint. She was totally unaware of what was happening around her and seemed to be in her own world. Lucy had cut out ten trees and was painting them quickly, but also with an incredible focused intensity. The painted trees began crowding her space so I decided to take newspaper and put it on the floor around her. I told her she could allow her trees to dry on the newspaper on the floor and that this would be her space. The energy shifted again between us. I felt we made contact with each other as I contained her space for her in an indirect, non-intrusive way. She made eye contact with me and handed me her trees to put on the papered floor.

> *The criterion for effectiveness of a particular intervention can be determined by observing the treatment process. In this instance, the therapeutic work facilitates the steps towards integration. When the patient requires more space, the therapist expands the boundaries rather than forcing the patient to fit into a predetermined boundary. In many respects, if the therapist attempts to go in the direction of a deep reintegration experience, flexibility and boundaries may be required.*

Lucy's trees exploded with color and were painted in an abstract expressionistic style (Figure 55). They were beautiful. Each tree was different and had its own unique personality. Lucy asked me to fill her paint try up several times and the transitional space between us seemed again to flow. I felt as though she was full of primitive imagery, and I needed to offer her some form of boundary and containment. After a half hour or so, I hat to help other patients get set up. I looked over at Lucy and found that she was no longer painting her trees but fixated on smearing her paint into a muddy mess on the newspaper in front of her. I became anxious again and concerned that her regression had caused her disorganization. In hindsight, maybe she felt safe enough with me to be able to regress and she would be able to integrate and reorganize at the regressed level. I walked over and asked her

Figure 55

what had happened to painting the trees. She snarled at me as though I caught her in the act of shitting and she was damned if she was going to allow me to take her jewels away from her. She looked at me as though I had invaded her space and would I please close the bathroom door so that she could have some privacy? She then demanded more paint. I made it clear that unless she was going to paint on her trees, I was not going to give her more paint. She gave me a dirty, mean look, sat down, and continued smearing the paint into a muddy brown. I feel that my intervention with her stopped the flow between us. I was afraid of her regressing and I believe she picked that up in me. Rather than going to where she was and helping her contain her shit, I imposed my own fear onto her by questioning what she was doing. I was the disapproving, intrusive mother. My countertransference was about feeling overwhelmed in the face of not being able to merge with her and hold her diffused, messy shit.

> *Limits can be determined by the reality of the studio situation. There is just so much paint available and just so much energy on the part of the therapist to focus on one patient. The patient must cope with this limitation. The underlying countertransference was not the therapist being overwhelmed by her guilt, but the therapist setting limits that were comfortable for her.*

Lucy was able to give herself boundaries by cutting out the tree shapes. She made contact through the trees with the physical world. Her energy shifted from being more connected to the outside to withdrawing to her inside as soon as she began working with paint. The paint helped Lucy regress and it seems she achieves something through that merger. Maybe I do not have to contain, or handle her ship, but just be an available, non-intrusive presence for her. She also appeared to be overstimulated with the paint. Given the set up of the studio, if she requests paint and I do not give it to her, we would end up in a power struggle. I feel confused whether her working with paint is actually helping her process to move. Still, after she dabbled in her mess for twenty minutes, I told her it was time to clean up. She cleaned up her mess and her presences felt more cohesive to me.

> *Regression becomes a problem if it starts spilling over into areas that were not part of the therapeutic boundaries. Lucy cleans up her mess and demonstrates that the regressive experience was manageable.*

Three days later, Lucy arrived as soon as the studio opened. She said she wanted to draw and want yellow paper. I realized she always knew what she wanted to do when she came to the studio. She appeared calmer and less disorganized to me. She was the only one in the studio so I could give her all of my attention. While she was using a pencil to draw on the yellow paper, I told her that I had found some cardboard frames in the cupboard and showed her how we could frame some of her drawings. She sad that she liked the frames. She first drew a face with big lips (Figure 56). The pencil and pastels seemed to be just the right amount of stimulation for Lucy to be able to make an image of the self emerge. The pastel's quality still gave her the ability to smear and blend, but did not seem to overstimulate her to the point where she wanted to make a diffuse, shitty mess. The face had a warm, gentle expression. It was surrounded by curly, heavy shapes as though it was being suffocated.

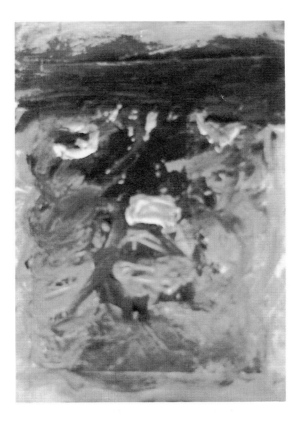

Figure 56

> *The shift into different materials helps the patient produce an image that is more integrated and cohesive than her past work. The warm, gentle face that is expressed in the patient's are work may well be the mirror of the transference/countertransference relationship.*

We framed the picture and then Lucy said she wanted to work 'bigger' and with paint. As Lucy painted I sat at a close distance across from her silently making frames for her paintings. I felt that our space had become to intimate again. I was containing her metaphorically by making the frames but I did not feel intrusive or anxious. I felt connected to her. I felt I had finally allowed myself to go to where she was and move with her flow, giving her boundaries and yet gently being a presence to whom she could connect. Again Lucy's paintings were explosions of expressionistic color. She stopped painting and I felt she was becoming overwhelmed with the painting process. She quietly sat looking at me for awhile. I decided to stay quiet myself and continued working on her frames. Lucy then picked up a brown pastel and drew another face that had a smile (Figure 57). I felt that was her nonverbal and symbolic was of letting me know we were connected. It was a touching, moving moment for me.

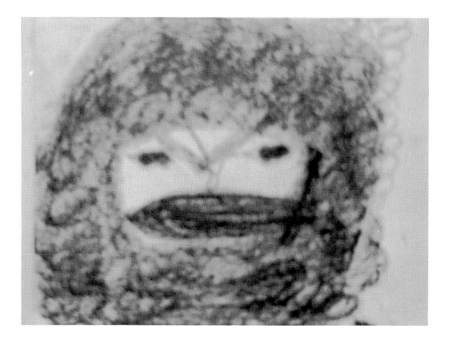

Figure 57

She then continued to paint and asked me to hurry up with the frames because she was ahead of me, having made more paintings than I had made frames. I told her that she was a speed queen and I could not keep up with her but that I would try. I felt very attracted to Lucy's paintings. I loved the way the explosions of color had a fluid quality. There was intense, thick space in her paintings that spoke to me on a very deep level. I felt these images evoked the fused state one may feel with a material or with another person. What I found lacking in her work was ground that differentiated the explosions of color and transformed them into separate entities. The space within the painting was chaotic, disorganized, and fragmented looking as though it needed an element of life to come along and begin to move the formless plasma into discreet forms.I also felt the space was constricted and needed ten times the size of paper in order to contain the explosive quality of the color. Lucy began to obliterate her explosions of color by smearing them into an even more diffuse, muddled state as I needed to attend to the other patients who were beginning to come in. She called me to come and make more frames for and; I told her I would when I had finished helping another patient.

When I returned to help her make frames, I also poured Lucy more paint. Unaware that I had paint on my hands I accidentally smeared some on the frame I had begun. Lucy responded positively to this. I realized that I was both containing her and approving of her mess by being messy myself (Figure 58).

> *The patient and therapist jointly recognize the need for holding and structure through the metaphor of frames. The use of explosive color soon deteriorates into smearing and chaotic diffuseness. The frame becomes a very important constant in facilitating and containing regression in a safe structure. For many therapists, this type of regressive expression becomes too threatening and overwhelming to tolerate. We see an example of how the level of regressive expression may be contingent on the therapist's ability to tolerate such communication. Thus, if a therapist finds such expression too overwhelming, a more appropriate structure would be called for. In short, the so-called accident becomes an important therapeutic communication. It is not contrived, but very authentic and communicates a message of approval and acceptance. If the therapist had purposely made a mess as a form of mirroring, it might have furthered the patient's anxiety.*

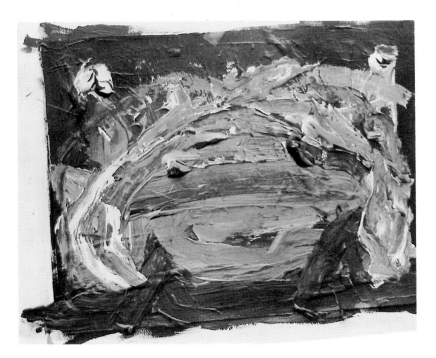

Figure 58

Figure 59

At this time, a supervisor came in and said that the studio would not be open in the afternoon due to a special event. Lucy said that she wanted to take all of her work with her; I said it would be all right, but the paint would not be dry and that they would all stick together. Again the energy shifted. She said in a disgruntled manner, 'I'm not going to bless you or anyone with my artwork'. I told her that if she needed to take care of herself by taking her work with her it was her work and that was fine. I said it in a light-hearted, detached, firm tone. She was silent for awhile and then said she would let them dry in the studio. I showed her a space that would be allotted solely for her and told her that it would be there for her to pick up when the studio opened again. Our time together ended with Lucy cleaning up and stating that she would be back the next time to pick up her work.

> *The patient's artwork may well be a blessing or a gift to the therapist. There are grandiose undertones to this message. Her regressive fused state may be a cry for a spiritual rebirth. The patient then expresses a communication of trust that indeed someone outside herself could be protective and caring.*

This was the last session I had with Lucy before writing this paper. Had she come in the next time, I was prepared to work on a framed board with cut up colored tissue paper pasted down with water and glue. I thought it would expose her to a new material in which she might be interested. I believed that the combination of cutting up the colorful paper and being messy with the glue and water might help Lucy feel fed with her regressive pulls and at the same time give her structure, form, and definition. I wanted to give her materials to work on a large scale, and at the same time give her materials that would allow her to feel contained, safe, and also a sense of master and accomplishment.

However, Lucy came in on my day off and painted over the framed pictures from the previous session. She painted the frames and covered over most of the colorful paintings with thick, dense, muddy colors. I though that she was pissed off and acting out because I was not there to hold her.

> *Once again the therapist demonstrates a fearless confrontation with the patient's regression. She is not overwhelmed by the sheer expansiveness of expression but joins her by providing a space that is safe and holding. She also provides opportunities for Lucy to destroy and reshape materials that can be molded and changed. Along with this, opportunities are provide for master through scissors that can cut, destroy, or repair.*

Given the many transitions occurring, the context in which I met Lucy was a very fragmented, chaotic, disorganized studio space, and it felt to me as though that was also what was happening within her inner life. She had lost her previous art therapist after five years. With good reason, I found her to be highly guarded and defended. At the same time, my countertransference issues with Lucy were my own pre-existing feelings regarding starting a new job, being trained, feeling overwhelmed, uncentered, chaotic, disorganized, and insecure.

In reviewing the three sessions I had with Lucy, as I slowly became focused and let down my own defenses, I found that our interaction kept screaming for me to stay centered with myself in order to give her a safe holding environment. Our transitional space needed boundaries around a defined space for Lucy to feel safe enough to merge with me if need be; borrow my ego functions in order for her to create her own ego and self, organize herself enough to feel her existence, and be able to express her fear of her own aggression and allow me to contain it, neutralize it, transform it, and give it back to her as part of her integrated ego function. Her ego rhythm felt stuck in a formless, diffused, merged state with most of her energy pulling her inwards rather than oscillating between her inner and the outer realities. Lucy's unintegrated primary process often became an overwhelming source of primitive affects and images (Robbins 1987). She appeared to have disturbed stimulus barriers. Lucy's essence felt fragmented; her life energy felt smashed, condensed into a volcano form that could erupt at any time.

The relationship between self and object were enmeshed to the point of fusion with frightening and suffocating affects (Robbins 1987). The very heart of symbiosis had been disturbed. I felt a sense of hopelessness, despair, and fragmentation in Lucy's energy. Her defenses in our transference relationship (there has not yet been a real relationship) were withdrawal, splitting, and dissociating.

Lucy's art work reflects the transference/countertransference relationship. Her paintings are not grounded and I felt unable to ground her very raw, primitive affects. The intense density and space she creates in her art work also reflects the transference issues of her feeling disorganized, muddled, fused, and needing lots of space in which to move around. Her work feels hostile with explosive colors that were smeared, in places, into muddled messes. My countertransference issues were of being thrown off center, not feeling adequate to contain her mess, and fear of becoming merged with her and losing my own ego boundaries. Her work echoes my anxiety and fear of not feeling strong enough to be able to organize, structure, and contain her mess; I have trouble enough trying to organize, structure, and give form

to my own mess. When I live in Lucy's art, I feel I am suffocating, unable to see clearly. I feel heavy and cannot differentiate myself into a form. I wan to feel open space but I want to feel contained. I want to give her trees, a ground in which to be rooted. I want to give her faces a body, and put her muddled messes into a form that would evoke in her a sense of self. I also feel an immense rage that was totally out of my control and could explode at any time.

After the sessions with Lucy, I created a multicolored tile frame in direct reaction to her formless state and my need to create a solid boundary around my expressionistic painting. The frame was also a grid which symbolizes my feeling a need to give her a structured grid for her ego rhythm to integrated her inner and outer realities. My fluid, expressionistic painting had two separate, distinct shapes that had solid ground underneath them. Both shapes were differentiated, unmuddled, and rooted in the ground. In creating this piece, I gained information on what I was feeling about Lucy. This painting also showed my defenses against merging with the other for fear of losing my own boundaries. I also tend to need a great deal of space, and have a history of not having clear, defined boundaries myself.

The process stopped between us when I was either overly intrusive or unavailable. I was too anxious to contain and set boundaries for Lucy or unable to merge with her. The process between us began to flow again when I was able to center myself and accept Lucy's fused object-related ego rather than impose my own countertransference issues onto her. I found that the chaotic, free-form environment could be extremely threatening to Lucy and I constantly was aware of lending her my ego in order for her to stay together with herself.

I plan an ego-oriented and object-relations approach to therapy with Lucy as she needs to begin to form a self. I feel her level of ego diffusion is at the level of body image, identity, and affect. The only difference in her verbal versus nonverbal forms is that there is far more discharge of her primitive, unbound affects in her art work. I would like to have a better understanding of the regressive shifts in schizophrenia. I am focusing on getting in touch with the schizophrenic part in myself and allowing it to work in our therapeutic relationship. In addition, in order for me to be able to work effectively with schizophrenic patients in the environments in which I am working, I need to understand my defenses far more, and to have more comprehension of what makes me so anxious about aggression. This setting and population will challenge me to grow in more ways than I ever imagined. I am challenged to integrate my own 'black hawk' to use it as a tool in containing and holding Lucy's ambivalence, rage, and formless state.

> *The reader is referred to Chapter 9 where Anne deals with her personal issues. The therapist refers to herself as the 'tweedy bird' who yearns to be transformed into the black hawk. We may ask ourselves if the patient mirrors some of the therapist's own wish for her animal power. When we work on such a deep level, this unconscious communication by both parties becomes a very central issue in therapy. Most importantly, Anne must own her power if the patient is to feel safe and likewise the patient must connect back to her own softness and gentleness.*
>
> *The studio atmosphere permits a good deal of regression through art. Anne feels very comfortable in this setting and now the therapeutic demand will be one of both containing and mirroring as well as building.*

Reference

Robbins, A. (1987) *The Artist as Therapist.* New York: Human Sciences Press.

Play, Art and Photography in a Therapeutic Nursery School

Ellen Nelson-Gee

The Case – Terry

This chapter is about a five-year-old girl who was one of six children in a therapeutic nursery class. I saw her both privately and in her classroom, two days a week.

Terry was a lovely girl. She was five years old, had deep speckled grey-blue eyes and, when she smiled, dimples. I met her in the fall of 1972. She came to the school late. The five boys in the therapeutic nursery class had been together a few weeks already. She became to them, alternately, a doll to fight over and share things with and a punching bag. This is how I first saw her. Her clothes were from an expensive store, and I am certain she was offered a well-balanced diet plus vitamins; yet she looked neglected, she was unhealthy, thin with pale skin. She had a constant cold and runny nose, and she was severely constipated. She often sat on the toilet for long periods of time with no results. She complained, 'My back hurts', and pointed to her buttocks. I first took her and a little boy, J., out of the room together for individual therapy; sucking her thumb, she would lie sometimes for forty minutes on the floor of the room we used.

> *The description of the patient immediately draws the reader into her world. She is a neglected, lost child who holds on tightly as a means of avoiding intrusion.*

At that time I was into what I now call my 'togetherness' period. Whatever I was doing with J., I wanted Terry to participate in, and vice versa. Whereas both children may be, on paper, 'minimally brain-damaged' and 'emotionally

disturbed', their behavior was as nearly opposite as I could have imagined. J. bounded from wall to wall; he tried to jump out the window and run into the street. Terry moved like a snail; she sniffled, whined and complained constantly about anything she was asked to do: 'I can't'. We 'couldn't' open the door to her locker, 'couldn't' button her coat. This condition I call her 'helplessness'.

> *Helplessness can be an adaptive defense that receives some response from her environment. The therapist is 'not taken in' by the patient's so-called dependency needs.*

Once in a while, however, when J. was yelling in the hall or kicking a door, Terry would imitate what he was doing. He knew from experience that he could set her off like this, and he would start to yell and look at her out of the corner of his eye. Then she would look at him, smile and start doing just what he was doing. This was really frustrating for me, but how ironic: here they were doing something together – but not together with me. At those times I would try to assure Terry that she was indeed a different person from J. and did not have to do what he did. This may certainly have confused her; not ten minutes before, I had been encouraging her to do what J. and I were doing.

Perhaps what struck me the most about Terry when I first knew her was her resistance to being touched. If I took her hand, she would yell 'No!' and pull away. A hug made her body rigid and her face terrified. Connected with this, I feel, was her real concern over getting a spot of water or paint on her clothes. In the beginning she would just cry. Later she learned to say, 'I want another shirt. I want another jeans'. (Her mother kept a supply in her locker.) It was as though contact with people's arms and faces, with paint or anything 'mutti', as she says, would permit something to be taken away from Terry, would deplete her intactness. By staying rigid and touching nothing, she perhaps feels she cannot be hurt. Terry is extremely disconnected from her body which, in being a shell protecting the Terry inside it, is not a body allowed to defecate, and be hugged and hug back, get dirty once in a while and be strong enough to perform what is required of it by the person inside.

> *When a patient's body has been deeply intruded upon, the patient does not feel that her body belongs to her.*

Finally, I should mention something which Terry brought to our first meetings along with her unhealthiness, 'helplessness', imitativeness and resistance to being touched, but which I did not recognize until much later: her testing of me. J. was flagrant in his testing, hanging out of the window or raising a block as if to throw it, all the time watching me as if to say, 'Are you going to let me do this?' Terry's testing was much more subtle in the beginning, but I feel now that she, too, was asking for limits to be put on just that behavior which she brought into the classroom. I feel she was and is asking, 'Are you going to let me get away with pretending I'm weak, copying instead of creating, resisting close contact with people who care about me?' I hope that I can show with some examples of our work together that my answer to her question is no.

I began to deal with Terry's 'helplessness' almost right away. In the fall, when she was told to put on her coat or open her locker or button her coat, her response was, 'I can't', spoken with a whine. Lately she has been saying, 'Ow, ow, ow', as if she is in pain, in order to get attention or to indicate that she 'can't' do something. When I first noticed this 'helplessness', I tried to encourage her by saying, 'I know you can do it, but if you need by help you can ask me: "I need some help".' With this exercise, which we do together whenever she becomes frustrated by what she 'can't' do, I am trying to help her to be in touch with her needs and to be able to communicate those needs to others. An example of this behavior occurred as we were walking through the park:

TERRY: Ow. My shoe.

DAISY:[1] Does your shoe hurt?

TERRY: No.

DAISY: Then what are you trying to tell me?

TERRY: Tie my shoe.

DAISY: OK. You want me to tie your shoe.
 I tied it.

This kind of helplessness is, I think, fostered in Terry by her parents and her nurse. I feel there are many things she is just not *allowed* to do for herself – simple things like buttoning her coat or picking up a pencil or tying her shoe. She expects these things to be done for her, and she does not know how to ask for them appropriately when they are not done for her. Even I, who *know* that Terry can do many things by herself and many more things

1 The author is called 'Daisy' by her patients.

with a little help, almost got 'conned' into doing something for her because of the helpless quality she exudes. We were sitting side by side on a bench in the park. She picked up a crayon and started to draw in her notebook, then she dropped it. I made a slight motion in the direction of the crayon: my instinct was to pick it up for her as I would pick up something anyone dropped. I stopped myself; she was watching me.

DAISY: Pick up the crayon.

TERRY: No, you pick it up.
 She smiled.

DAISY: It's your crayon, Terry. You dropped it. You pick it up.
 She did.

I believe that, in part, Terry's acting helpless is a dramatization of how helpless she, in fact, feels. Her parents are large and overpowering figures. I have seen both her parents ignore what she has said or, worse, contradict something she has said which is the truth. One morning before school I came out of the cafeteria with a styrofoam cup of Coke in my hand. Terry and her father were waiting for the elevator to go up to the classroom. Terry said, 'Daisy! Can I have some Coke?' Her father responded in a somewhat condescending manner, 'That's coffee, Terry'. I was slightly embarrassed to be drinking a 'kid's drink' at nine in the morning instead of a 'grown-up's' drink, but I said, 'As a matter of fact it is Coke. Have some.' I squatted down to Terry's level and saw then what six feet four inches of Daddy looks like to 42 inches of child. My feeling is that Terry has resigned herself to the idea that if Daddy or Mommy says it's coffee, who is she to argue? So instead of arguing with her parent, she becomes him or her. By this, I mean she imitates the authoritative tone and manner of speaking of a parent. One day, Terry and I went outside together. We played in the sandbox. This is what happened:

TERRY: You, Daisy.

DAISY: You want me to go into the sandbox Terry?
 I went in and picked up a stick and squatted down, and started to draw lines and circles in the sand.

TERRY: I need a pail and shovel!

DAISY: We don't have a pail and shovel today, Terry. I'm going to use this stick to make pictures.
 Terry also picked up a stick and made deep holes in the sand.

TERRY: This is Jan and Donna [*her teachers*] and J. and W. and E. [*classmates*].

DAISY: Where's Terry?
 She started poking the stick at me. I averted my face

DAISY: Terry, don't poke that stick so close to my face.
 She smiled and giggled and shook the stick.

TERRY: A temperature. Shake the temperature.

DAISY: Oh, you're taking a temperature. Do you feel sick?

TERRY: Yes.

DAISY: Where do you feel sick?

TERRY: Put the cream on, Daisy.
 Her voice was very deep at this point. It sounded like an imitation of an adult's voice.

TERRY: No, don't move. Hold still, everybody, hold still.

DAISY: You're taking a lot of temperatures.

TERRY: Hold still, everybody. I'm taking your temperature.
 She stuck the stick in my nose.

TERRY: In your nose. Then in your ear. Now in your *mouth*!
 Stuck it in my mouth.

DAISY: You're putting the temperature in a lot of places, Terry.
 Where does it really go?
 She poked it at my back.

TERRY: In the backside. It smells. Put the cream on.

DAISY: How does it smell?
 She poked it at my back.

TERRY: Hold still.
 Terry spoke in a deep voice; I sat still.

TERRY: It won't go in.

DAISY: That's because you're not *really* taking my temperature. We're
 pretending. You pull your pants down when we really take
 a temperature.
 I made two buttocks and two leg shapes in the sand and made a hole between the buttocks. I stuck in a stick.

TERRY: Make a birthday cake.

DAISY: Yes, it does look something like a birthday cake with a
 candle.
 I made a small mound and put a stick in it. She drew in the sand

and stuck a stick in it. She drew in the sand and stuck a stick in it. I drew a circle and told her it was a cake. I made the buttocks and legs again. This time she stuck the 'temperature' in. Then she went back to sticking it in my back.

TERRY: It *hurts*!

DAISY: What hurts?

TERRY: My backside. Hold still. You be Terry.

DAISY: OK. I'll be Terry. Who are you?
She did not answer.

DAISY: Are you the mommy?

TERRY: Now hold still.
Deep voice.

DAISY: It hurts, Mommy.
She held the stick at my back and waited. Then she took it away.

DAISY: It's time to go now, Terry. We're going back to the classroom.
As we walked, she held the stick and touched it to my back, just as when she was 'taking my temperature'.

TERRY: Hold still, Daisy.

DAISY: Sometimes it's time to hold still, Terry, and sometimes it's time to move. Now it's time to move.
We continued on into the classroom.

It appears that when Terry spoke in her deep voice and ordered me to 'hold still', she became the parent, teacher, nurse or even classmate who wields power over her. At the same time, as if more clearly to define her role, she made me into Terry. Another example occurred the following week as we were playing with dolls and a 'temperature' I had made out of a plastic straw:

The patient embarks on a long series of games to express her fear of anal intrusion and a need to control this anxiety.

DAISY: Look what I've brought: A doll. Let's play with the doll.

TERRY: No.
I put the doll down on the floor and took out a plastic straw.

DAISY: I'm going to take the baby's temperature.
Terry became interested.

TERRY: I'll do it…like this.
 She took off the doll's pants and shirt.

TERRY: Now lie down…don't cry…pull your pants down…get a blanket.
 She got a little cover, took off the big blanket I had placed over the doll and put that on a bigger doll.

TERRY: Now hold still: don't cry. Everybody can't get hurt. One more and that's it! One more and that's it, Daisy.
 She used the same deep, serious voice, she had the week before.

DAISY: It hurts, Mommy. I hurts.

TERRY: Hold still. Everybody gets hurt. Everybody can't get hurt. Now hold still; don't cry. Just one more and *that's it!*
 I picked up the Mother puppet and the 'thermometer.'

DAISY: Now hold still, please. I'm going to take your temperature.
 The Mother puppet takes the temperature of the doll.

DAISY: Now let's take the Mommy's temperature.

TERRY: You do it.
 I put the Mother puppet down on the floor and Terry stuck the 'thermometer' up her dress.

TERRY: Now hold still. Don't cry. Everybody can't get hurt. Just one more and that's it.
 She held the 'thermometer' in place for a few seconds then took it away.

DAISY: Now, Terry, it's time to stop our playing and go back to classroom.

Other episodes have occurred where Terry has asserted power over what is even more helpless than she. During one session, the day we started taking photographs together with a Polaroid camera, she put all the photographs we had taken so far (pictures of herself and of me) in the sand and buried them. Another time, in the classroom, I was holding a large rubber band, and she cried, 'Break it! Break it!' The next week, as we walked through the park, I saw some dandelions growing in the grass. 'Look at the dandelions, Terry.' She deliberately stepped on as many as she could. I said, 'Do you feel like stepping on all the dandelions. You want to hurt them, Terry?' She did not answer me.

> *Along with the symptoms of anal control and fear of intrusion, sadistic impulses are a very common manifestation of this type of problem.*

What I feel as still another manifestation of her helplessness is Terry's frequent practice of 'falling' down as we walk, or if I chase her as she tries to run from me. The first time I remember her falling down like that was the day that we went to the sandbox. It was the first time she had left the room with me alone and without J., the boy I took out with her for the first few months. She had been sick with a cold for a number of weeks. As we walked through the building to go outside, she said that she wanted to run.

DAISY: We run outside. Inside we walk.
 I tried to take her hand. Terry fell to the floor and smiled. Then she got up and started to run again.

DAISY: No. We don't run inside. Running is for outside.
 Outside, I took her hand and she fell to the sidewalk.

TERRY: You walk, Daisy. I'll run.
 I let go of her. She started to run, all the time looking back at me. I ran after her and she fell down again.

DAISY: Terry, you're playing a game with me. Come on. Let's go to the playground.
 Diversion away from the 'falling' seemed to make her 'forget' it momentarily.

As I see it, her falling down is a sort of 'sitdown strike' which says:

1. 'No, I won't do it the way you want me to.'

2. 'I know this annoys you because you're always in a hurry and this will slow you down.'

3. 'This will get me the attention I need.'

Because I see this behavior as a testing and attention-getting device, I try to respond to her by giving *her* rather than *her behavior* the attention she is demanding. For example, in this last episode, I tried to divert her attention away from falling down and toward the playground I know she loves. I did not say, 'What's the matter? Why are you falling down?' Instead I said, 'Terry, you're playing a game with me. Come on, let's go to the playground'. When she will not be diverted, however, and when her physical safety is concerned, I cannot pretend to ignore her 'falling' in the hope that it will stop. The following is such a session:

I went to pick up Terry, and I could hear her mother telling her to answer the door.

TERRY: It's Daisy!
She opened the door and I went inside for a few minutes.

TERRY: J.'s not here.
We had not been out together with J. for weeks.

DAISY: No, J.'s at home, just like Terry's at home now. And now it's time for us to go out to the playground.
When we got to the street and I asked her to hold my hand while we walked on the street, she took my finger until we had crossed the street. Then she said that she wanted to run.

DAISY: OK. Let's run together.
She fell down onto the sidewalk.

TERRY: No.

DAISY: Come on, Terry, let's go to the playground.
She ran to a wall and leaned forward against it, looking just like a little boy urinating against the wall. Then she crouched down and began hopping like a frog.

TERRY: I'm a frog.

DAISY: Yes, I see. Terry's pretending to be a frog, but she is really a little girl. I think it must be fun to pretend you are a frog. But I like Terry as a girl.
She fell to the ground again and dragged herself along the pavement, on her belly, just to the edge of the street.

TERRY: I'm a lion.

DAISY: You are *pretending* to be a lion. You *look* like a girl. Come on, stand up and be a girl as we cross the street.

TERRY: No.

DAISY: Well then, you stand up and walk across the street with me.

TERRY: No.
I wanted to pay less attention to her behavior, but I knew that I had to stay close beside her in case she tried to crawl into the street. The stares of the passers-by were not doing either of us any good, I felt. So, for these reasons, I picked her up, and carried her across the street, and put her down near the wall of Central Park. Again she threw herself onto the ground.

TERRY: I'm a lion.

DAISY: Would you like to go see the lion in the zoo?

TERRY: Yes.

DAISY: Let's go this way then.

TERRY: No.

DAISY: OK. Daisy's going to climb over the wall here.

TERRY: I want to climb.

DAISY: Good. Come with me.
 I helped her over the wall. She got onto the bench near the wall.

TERRY: I can't.

DAISY: Do you need help?

TERRY: Yes.

DAISY: You know how to ask for help?

TERRY: Help me climb.
 *I helped her over the wall. She fell to the ground again. This time I
 was not afraid that she would hurt herself if I ignored her and
 walked on, so that is just what I did. Pretty soon she came running
 up behind me.*

*There is a wish to embarass and humiliate the therapist, and by so doing, reverse
the tables.*

Terry's resistance to being touched has been fairly consistent since I have
known her. I have described her 'falling down' when I tried to take her hand
on the street. Not only does she fall to the ground to avoid being touched
or forced to go anywhere, but when she lies on the ground, she is A dead
weight – she appears to have no spine, no bones, no energy. Her change
from a giggling, energetic, mischievous little girl to a lump on the floor is
frightening to see. The following session took place recently:

 *As we started for the park, Terry lay on the floor, giggling and
 looking up at me.*

DAISY: Come on, Terry, let's go to the park.

TERRY: *Giggling.*
 I wanna run!
 *She grabbed for the heavy bulletin board, almost pulling it over on
 top of her.*

DAISY: No, Terry! I will *not* let you do that. Give me your hand and we are going outside.

TERRY: No hands.

DAISY: OK. You can take my finger when we cross the street.
She ran off and grabbed some postcards out of the rack where a woman was selling them, threw them on the floor, and then threw herself on the floor. It looked to me as if she had no bones in her body; the minute I would reach for her to stop her from running or doing something destructive, she would collapse onto the floor. She is afraid of being touched, I feel. I took her onto my lap and sat on the floor.

DAISY: Terry, you are not ready to go outside with me. We are going to go back to the classroom and stay there until you are ready to go outside with me.

TERRY: No.
She struggled and kicked.

DAISY: Then we'll wait here until you are ready to go outside.
Finally she became physically calmer. She wasn't struggling in my arms and she sat quietly. I stood up very slowly and extended my little finger slightly at my side and waited for her. She took hold of it and we walked slowly out of the door and across the street.

DAISY: When we get to the park, you can let go of my finger and you can run.

TERRY: No running.

DAISY: Then you can stay with me.
I sat on the top step of the stairs which go into the park. She sat down next to me. I took out her book into which we had started putting photographs the time before and showed it to her.

Certainly when Terry collapses onto the floor or pavement, she is exercising what little power she has in order to control the situation she is in. I take the lead from her; in our sessions I encourage her to make contact with me – that is, to be in control of the touching – rather than take the initiative myself. I have found that when I am calm and sitting still, she will come to me more readily than if I am moving fast, in which case she may run from me or fall down. If I hold my hand at my side and extend my little finger, she will quite often take hold of it; however, if I hold out my hand to take hers, she pulls her hand away from me and cries 'No!' In other words, I make myself physically receptive to her without being physically aggressive. I

believe Terry craves warmth and affection like any other child, but is afraid of being swallowed up by overpowering mommies and daddies in the world. Thus, she must be allowed to seek warmth and bodily contact on her own terms. In the following paragraphs are examples of Terry meeting me in her own way:

> *The patient constantly attempts to throw the therapist off her center. Attempting to regain a clear, firm, but not excitable demeanor appears to be an important part of the therapeutic contact.*

Often in the gym or on the playground I would take Terry's hand, and we would run around and around yelling at the top of our lungs: 'ONE, TWO, THREE, FOUR, FIVE, SIX!' She always looked so alive when she was doing this, and I know I felt really good doing it with her. One day in the gym she asked me to run with her and I did, once around the gym. She said 'I want to run some more!' I was tired so I said 'OK. You run to the end of the gym and back to me and I'll wait for you.' I sat on the floor with my legs spread open in front of me and my arms open wide to show her that *I* was waiting for *her*. She ran, in the stiff and unsteady way she runs, up to the wall and back towards me, laughing all the way. She ran straight to me, jumped into my arms, and knocked me over – both literally and figuratively. I was very surprised at getting so much physical contact from her. Then she said 'I wanna do it again'. And she did, again and again and again, until other children started imitating her, thus interfering with the pattern she had established. Her teachers were as amazed as was I at her embracing me apparently so strongly. I say 'apparently' because she was so stiff that holding her in my arms was like holding a piece of wood. When I gave her a little tentative hug, instead of just containing her in my arms, she wriggled free. Again, she was in control of how much physical contact there was to be. I've seen her mother, when she comes to pick up Terry, almost literally swoop down from the sky and engulf Terry with an 'Oooooh, Terrykins, give Mommy a greeeeat big hug!' At these times Terry cringes and goes stiff, just as she does when I try to hug her.

During morning playtime Terry came and sat next to me on the floor. I wanted to have some kind of contact with her whereby she could touch me actively and I could let her touch me passively:

DAISY: Let's pretend that I'm a chair and you are going to sit in the chair.
 I sat on the floor with my arms and legs stretched out. She sat stiffly on the floor between my outstretched legs.

TERRY: Let's be beds.
 She lay down.

DAISY: I'm going to lie down on this bed [*her*].
 I put my head on her chest. She rubbed my hair softly.

DAISY: It's soft. It feels good. Shall I rub your hair?

TERRY: No!
 She put her string of beads in my pocket.

TERRY: Rub your back.
 She rubbed my back.

DAISY: That feels good, Terry.
 She reached up under my shirt.

DAISY: Rub on top of my shirt, Terry.
 She tucked my shirt into my pants. A little boy, E., came over and sat very close to us. As Terry rubbed my back, I started to rub E.'s legs and to sing. Terry came and sat beside me. She was as close as she could get to me without touching me.

TERRY: I want to read.
 She got the book about Horton, the elephant. We talked about each picture. She referred to Horton as 'she': 'She's doing this. She's doing that.'

I felt good about being so physically close with Terry. It was a little strange because we were in the classroom with the other children and teachers. Also, the psychiatrist who is the head of the therapeutic nursery program was in the room. But my feeling was that I just couldn't worry about what this one or that one was thinking. They would have to speak to me about it later if they thought I was doing something wrong. No one spoke to me. Later that same day when Terry and I were at the playground with the other children, an interesting thing happened which, I think, grew from the trust which Terry and I had built together that morning.

Terry got on the swing. I got on the swing next to hers. She got off her swing and came over and pushed me on my swing.

TERRY: Don't come back.
 I got off, walked off a bit, then got back on again. I thought at first

> *that she really wanted* me *to go away; then I got the feeling that she was not talking to me but maybe to someone else to whom she wanted to say, 'Don't come back'. She pushed me again.*

TERRY: Don't come back.

DAISY: Leave me alone.

TERRY: Leave me alone.

DAISY: Go away.

TERRY: Go away.

DAISY: Put me where you want me to be.
 She pushed me to the corner of the playground.

I felt good because I had not taken her rejection personally. I felt that I could accept her telling me to go away without making her feel guilty for doing so. I feel that her exploration of me in the morning enabled her to push me away without fearing retaliation from me. In much the same way, Terry had explored and trusted me when we had the session in the sandbox and she was putting the 'temperature' in my ear, nose and mouth. Finally, during a recent session, Terry showed me where she is in relation to touching me and where she wants me to be in relation to touching her:

I sat on a bench in the park. She started a ritual of running away from me to the far end of the bench, stepping up on it and walking over to me, stepping on my lap and continuing to the end of the bench, then running to the far end of the bench again and repeating the whole thing. I said, 'Terry, I don't like to be stepped on. It hurts. Will you step over me?' This time she came to me and sort of fell across me and dragged herself over my lap to the end of the bench. I noticed that she was touching as much of me as she could – my face, my hair, my breasts, my lap, my legs. She repeated this about six or seven more times. Each time she climbed onto the bench closer to where I was sitting and hung onto me more as she crawled over me. I sat very still and made no attempt to hold her or contain her, except when it was necessary to keep her from falling from my lap onto the ground. She was almost a dead weight as she crawled. She appeared to have almost no autonomy or control of herself. It felt as if she craved my body contact, but did not know how to get it. As she went by me again and again, I would greet her and tell her it was good to see her again. Then she started to step on me again as she went past me, non-verbally saying to me: 'Are you still there? Do you care? Are you going to stop me?'

DAISY: Terry, I don't like to be stepped on.
 I was implying that Terry had the right to feel the same way.

DAISY: I like it when you touch me, but not when you hurt me. You can step over me and still touch me very gently.
She started to step over me a few more times.

DAISY: It's time to go, Terry.

TERRY: No! I wanna run.

DAISY: Go ahead. Run that way.
I pointed towards the street.

DAISY: Terry, run that way [*away*] and I'll go with you.
She started to run in the direction I had indicated and I ran after her. We both stopped at the bench with the notebooks and photographs and crayons spread out on it.

DAISY: Let's pick up our things and go inside.

TERRY: No. I wanna run.

DAISY: No, Terry. It's time to go back to the classroom and the other kids.
She walked a bit then said, 'Carry me,' and collapsed onto the ground, which was quite wet from rain.

DAISY: OK, Terry, I'll carry you across the street and then you can walk by yourself back to the classroom.
I tried to pick her up. She was a dead weight, no spring to her. Finally I lifted her, carried her across the road, and put her down on the opposite side of the street. I extended my hand for her to hold. She took hold of my little finger and held it very tightly. We walked back to the classroom without incident.

The handling of sadistic expression demands a good deal of therapeutic tact and care from the therapist. Daisy does this very well, for she gives voice to the message by the patient that ultimately was never received by the parent.

Only very recently have I given myself permission to reach out for Terry and hold her in my arms or in my lap when I feel she needs this physical limitation of her behavior. I hold her when she is acting out to the extent where, I feel, she is frightened by what she is doing and is possibly in danger of hurting herself or someone else. For instance, she was once running around trying to pull things off of shelves and walls. I took her in my arms, held her in my lap, and talked softly to her, telling her we would wait until she was ready to go outside. As little as she appears to like being touched, I know that my holding her firmly helped her to organize herself. After sitting in my lap for

a few minutes, she was able to get up and take my finger and go with me to the park.

I have mentioned that I feel Terry's apparent fear of getting messy is connected with her fear of being touched. I have tried gently to encourage her to put her fingers into 'gooey' stuff which is not dirty, such as soap suds. The following incident is an example of such therapeutic play. We had a 'tea-party' in the classroom. Afterwards, in the hopes of getting her to get her hands into something which was 'gooey' and clean, I asked her if she wanted to wash the dishes:

TERRY: No.

DAISY: OK. You fixed lunch; I'll wash up.
 I took the dishes to the sink and ran it full of soapy water and dumped the dishes in. Terry came over and took over the washing operation.

TERRY: Wash the baby's hair.

DAISY: You want to wash the baby's hair, too? OK. Finish washing the dishes first.
 She ignored this and went to get the baby doll. She put the baby into the water with the dishes. She washed the baby's hair for about five or ten minutes. She kept washing and washing his hair and rinsing and washing. She appeared really to be enjoying herself.

Two days later Terry set up a tea-party by herself and invited me to come. She said, 'Daisy, come to a tea-party'. She had set up plates, cups, a pot of 'tea', plastic fruit on a plate. I said, 'I've brought some crackers to eat'. She put a piece of fruit on each of our plates. We 'ate' and drank for a short time, then Terry said, 'Let's wash the dishes', just as I had said two days before. We took the dishes to the sink, and she filled the sink with soapy water and dumped in the dishes. The baby followed close behind. She repeated the cycle of washing, scrubbing and rinsing; washing, scrubbing and rinsing, just as she had before.

> *The patient finally gets into the mess and discovers that there is fun and laughter in such activity.*

Terry's disconnection from her own body as well as from the bodies of others is apparent in her drawings made in the following session. Terry was at the chalk board. She started drawing with a sponge, then with the chalk.

TERRY:	This is a circle [*face*]. This is the eyes…nose…mouth…body…legs…feet…ears…hair…the chin…the chin… the chin…
	Each 'chin' she added was a line coming out of the head.
TERRY:	It's a sun!
	Indeed it looked like a sun.
TERRY:	I want another shirt.
	She had gotten a little water on her shirt. The teacher came over and said she could change her shirt when she was finished at the board.
TERRY:	I'm finished.
DAISY:	Terry, let's have a tea-party.
TERRY:	No.
	She set one up later that afternoon.
DAISY:	Would you like to play with blocks?
TERRY:	No.
DAISY:	Let's draw on paper.
TERRY:	No.
	I took out paper and crayons anyway, and sat down at the table. She came over and started to draw rapidly, making about ten drawings in about twenty minutes.
TERRY:	Here's the circle…the eyes…the nose…an ear…another ear…
	and on, just as on the chalk board.

Her drawings are very bizarre, and they give a very clear picture of her extremely poor perception of her body (see Figure 60). The first drawing was a picture of 'Monny'. A larger circle was the head; a smaller one was the 'body'. Two sticks coming out of the body she called 'the legs'. Two large empty eyes, a line for a nose, a small mouth and two circles for ears comprised the face. The many 'chins' protruded in all directions from the face and even ran through the face as if to scratch the whole thing out. (I once saw Terry take a newspaper engagement picture of a young woman who looked not unlike her mother and smear the whole face with paint. She did the same thing to another photograph of a young woman on the same newspaper page, and another, and another. It was frightening to watch this fragile-looking little girl destroy these smiling, pretty – although posed and a little phony-looking – faces.)

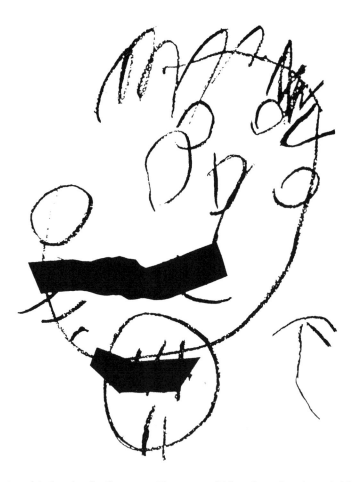

Figure 60 This drawing by five-year-old Terry could have been done by a child of
 three years. The primitive rendering of the head and the absence of a body suggest
 a poor body image. The eyes are vacant and sad. A Band-Aid has been placed
 over the mouth, perhaps as protection against invasion of food or the feared
 thermometer.

The second picture was 'Daddy and Mommy'. Their many 'chins' made them
look like pincushions. I asked her which was Daddy and which Mommy, but
she did not make that clear to me. One of the figures was only a head. The
other had the same sort of body she gave 'Mommy' in the first picture. The
next picture was of 'Momy' and 'G.', her seven-year-old brother. She put a
piece of tape on 'Mommy's' face. The next was of 'Daddy'. His many 'chins'

looked distinctly like a beard. I asked Terry if she could show me her chin. She pointed to her chin.

DAISY: Does Daddy have a beard?

TERRY: No.

DAISY: Does Daddy's face feel rough sometimes?

TERRY: Yes.
She put a piece of tape on Daddy's face.

DAISY: Oh, what are you putting on Daddy's face?

TERRY: A Band-Aid.

DAISY: Did Daddy hurt himself?

TERRY: Yes.

DAISY: What did he do?

TERRY: He hurt himself.

DAISY: Did he cut himself shaving?

TERRY: Yes.

DAISY: And now you put a Band-Aid on it for him. Does it feel better now?

TERRY: Yes.
Terry continued to make drawings and add Band-Aids. One was of 'Mrs B.', her nurse. 'Mrs B.' had a neck and a Band-Aid on her hair.

DAISY: Who is that, Terry?

TERRY: Mrs B.

DAISY: What hurts on Mrs B?

TERRY: She cut her hair.
What a fantastic connection to make between needing a Band-Aid because her Daddy cut his chin and needing one because Mrs B. cut her hair.

DAISY: How does Mrs B. feel now?

TERRY: Good.
The next picture was of 'Daisy.' She put a Band-Aid over part of Daisy's mouth. I thought, 'Oh boy, she wants to shut me up so I won't ask her any more question!'

DAISY: What hurts Daisy?

TERRY: Her pee-pee.

DAISY: Then put a Band-Aid on Daisy's pee-pee.

She put a Band-Aid on the middle of my 'body'. Terry had often complained, 'My pee-pee hurts'. My feeling is that when she said that Daisy's 'pee-pee' hurt, she saw no separation of herself from Daisy.

The next picture she drew was of the 'Burger King' (Figure 61). She put tape over 'Burger King's' mouth.

TERRY: Take her temperature.

DAISY: You want to take Burger King's temperature? Is she sick?

TERRY: No.

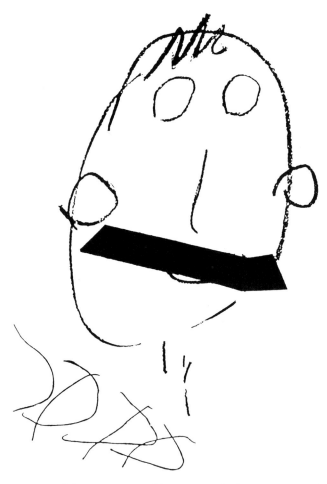

Figure 61 Terry said this picture was of 'Burger King'. She put tape over 'Burger King's' mouth. T: 'Take her temperature.' D: 'You want to take Burger King's temperature. Is she sick?' T: 'No.' D: 'What hurts?' T: 'Her pee-pee.'

DAISY: What hurts?

TERRY: Her pee-pee.
 My feeling here is that Terry feels invaded by the thermometer when
 her temperature is being taken. Perhaps she put the tape over Burger
 King's mouth in order to prevent the intrusion into either her mouth
 or her anus.

DAISY: Terry, does your pee-pee hurt you?

TERRY: My pee-pee hurts.
 At that point she saw a ruler lying on the table.

TERRY: Temperature!
 She picked it up and drew a straight line with it and put a small cir-
 cle at one end of the line.

DAISY: That looks like a temperature, Terry.
 Suddenly she pushed the crayons and paper away and would not
 draw any more. She started playing with some plastic blocks which
 are much more rigid, the compulsive type of toy she usually plays
 with, as opposed to the relatively freer medium of crayons and blank
 paper.

Later that day when we were playing with the baby doll, she took some tape
and put a 'Band-Aid' on his penis. I said 'Does the baby feel better now?'
'Yes,' said Terry.

The patient amalgamates in her mind the anus and vagina. She expresses feelings
of being mutilated and damaged.

Later, I worked with photographs we took together to try to get Terry to
look at and experience her body doing things:

DAISY: I'm going to take a picture of Terry playing in the sand.
 I took the picture and pulled it out of the camera.

DAISY: Look, Terry, what do you see?

TERRY: Terry.

DAISY: Yes, I see Terry's feet, Terry's knees, Terry's smile, Terry's rib-
 bon.

TERRY: Terry's jeans, Terry's arms.

DAISY: Terry's hair.

TERRY: Terry's teeth. Terry's gum.

DAISY: Yes, Terry is chewing gum. Now I'll take a picture of Terry chewing gum.

 She started chewing in an exaggerated way. I took the picture and showed it to her.

DAISY: What do you see?

TERRY: Terry's chewing gum.

 She took all of the pictures I had taken of her, put them in the sand and covered them over with sand.

The following occurred in another session:

TERRY: I want a picture of Terry.

DAISY: OK. I will take a picture of you.

 She looked at the camera, and I took the picture and showed it to her.

TERRY: It's another Terry.

DAISY: It's the *same* Terry. It's *another picture* of Terry.

TERRY: I want a picture of Terry.

DAISY: OK. I'll take *another picture* of Terry.

 I did.

TERRY: It's another Terry.

DAISY: It's the same Terry. It's another picture of the same Terry.

TERRY: I want a picture of Terry looking at the pictures.

DAISY: Let me take another picture of Terry looking at the pictures.

 I did.

DAISY: Who do you see?

TERRY: Terry looking at the pictures.

DAISY: That's right. Terry is looking at the pictures.

Later I added a new dimension by using a mirror as well as photographs to help Terry see her body and what it does. We sat together, alone in the classroom. The other children were on the playground.

TERRY: I want a picture of Terry.

DAISY: OK. I'll take a picture of Terry.

 She was smelling the photo emulsion on her finger at the time.

TERRY: It's mutti.

DAISY: I'm taking a picture of Terry smelling her finger and saying, 'It's mutti.'

 She looked at the picture.

TERRY: It's another Terry.

DAISY: I'll take another picture of Terry smelling her finger.
She put her finger to her nose and said, 'It's gooey'. I took the picture and she looked at it.

TERRY: It's another Terry.

DAISY: It's the same Terry. It's another *picture* of Terry.

TERRY: I want a picture of Daisy.

DAISY: You can take a picture of Daisy.
She held the camera and I helped her point it at me.

TERRY: It's another Daisy.

DAISY: It's another *picture* of Daisy.

TERRY: I want to take another picture.

DAISY: There's no more film in the camera.
She ran to the window and looked out.

DAISY: What do you see?

TERRY: P.J. and there's J. on the playground.

DAISY: Yes, you can see all the kids on the playground. Do you wish you were outside with them?

TERRY: No. I want to buy some more film.

DAISY: We will buy more film for Thursday, but you can play with the camera without the film. Would you like to do that?

TERRY: Yes. Play with the camera.
She picked up the camera and looked through the viewer out the window.

DAISY: What do you see?

I then brought over the pictures we had taken so far to review Terry's self-image. I held up the one I took of her smelling her finger.

DAISY: See the picture. See Terry. What is Terry doing?

TERRY: It's mutti.

DAISY: Yes, Terry is smelling her thumb and saying, 'It's mutti'. Can you do that like you are doing in the picture?
I put my thumb to my nose. She put her thumb to her nose.

TERRY: It's gooey.

DAISY: Yes, it was gooey. And look at this picture [*of her chewing gum*]. What is Terry doing here?

TERRY: Gum!

DAISY: Yes, Terry is chewing gum. Can you see Terry's teeth?
 I touched the picture of her teeth.

DAISY: Can you touch your teeth?

I opened my mouth wide and showed my teeth. She imitated me. I touched my teeth. She touched hers.

DAISY: Come, let's go to the mirror and bring our pictures with us.
 I was surprised that she readily came with me. We sat together on a wooden box close to the mirror.

DAISY: Here is the picture of Terry smelling her thumb.
 She looked at it.

DAISY: Now Terry can look at herself smelling her thumb. Put your thumb to your nose.
 She did. She looked at herself intently. Then she got up and ran to get some animal crackers left over from lunch. She sat eating the crackers and looking at herself in the mirror.

DAISY: Now here is a picture of Terry chewing gum.
 She looked at the picture.

DAISY: Now you can see Terry in the mirror. She is chewing.
 She looked at herself and smiled.

DAISY: Now Terry is smiling. I can see her teeth.
 I started to sing.

DAISY: Put your finger on your teeth, on your teeth.
 I put my finger on my teeth; she imitated me.

Patient and therapist now gleefully mirror each other in oral and anal ecstasy.

Terry and I continue with this body-image song, touching all parts of our bodies. For once Terry seemed to have forgotten her physical defensiveness. Then she began to sing the song that we all sing at juice-time.

TERRY: J.'s at the table, J.'s at the table, J.'s at the table having some juice.

DAISY: Who else is here?
 She sang to two other children in the class.

TERRY: Daisy's at the table…no Daisy, Terry. Sing to Pat [*a student-teacher who had left*].
 I waited, expecting Terry to sing. She did not.

DAISY: You want me to sing to Pat?

TERRY: Yes.

DAISY: Pat's at the table, Pat's at the table…

TERRY: Pat's not here.

DAISY: Oh, Terry, you fooled me.
 I now feel bad about my response. I feel I should have pursued the subject of Pat's absence. After this song, it was time to go.

DAISY: It's time to go now, Terry. Your Mommy's waiting.

TERRY: No!

DAISY: Yes. Let's go see if we can find her.

I was not fully conscious of the extent to which Terry was and is testing me until I had been working with her for many months. In the very beginning, she spoke so little, and then only to imitate someone else. So when she started saying things like, 'I want to run,' and 'I want to stay,' and 'Do this, Daisy', I was so pleased with her self-assertion that I failed to see that she was trying to discover how much she could manipulate me. I do not think there is anything wrong with allowing a child, especially one so damaged and powerless as Terry, to wield some power over an adult. I do feel, however, that it is important for the adult to be aware of the fact that she or he is being manipulated. A recent session was a turning point for me in the recognition of and connection with the game Terry was playing:

We were sitting in the park. We had just finished taking a roll of film, and she was sitting with her notebook and the photographs in her lap. She took all of the pictures out of the book, unrolled the tape which I had prepared for her to attach her pictures, put the tape in the book, and stuffed all of the pictures in the book. I took a pencil to make some quick notes and she took the pencil out of my hand.

TERRY: That's my pencil.
 She smiled.

DAISY: You may use that pencil. I have another.
 She started to scribble and draw in her notebook. I took out another pencil.

TERRY: That's Terry's pencil.

DAISY: No. I am going to use this pencil. You have another pencil.
 She scribbled in my notebook and looked up at me and smiled.

DAISY: Terry, you have your own notebook to write in.
 *She put a picture – the first photograph of her – in her notebook
 and traced around it. Then she scribbled on a few of the pictures she
 had taken of the fence in the park. She appeared to be more interested
 in the pencil, book, and tape than in the photographs.*

TERRY: I want some more tape.

DAISY: You have enough tape, Terry.
 She drew some pictures in the book.

DAISY: Who is that you are drawing?

TERRY: It's Terry.
 She wrote her name backwards and spelled it out loud.

DAISY: You wrote your name. Terry. And now it's time to go and find
 the other kids.

TERRY: No.

DAISY: What do you want to do?

TERRY: I wanna stay in the park.

DAISY: It's time to go, Terry. Come with Daisy while she moves her
 car, and then we can find the other kids in the park.

It is probable that Terry would have kept asking for each of my pencils had
I continued to give them to her. She drew on my notebook, then looked at
me and smiled. She wanted a reaction from me – anger or merely a limit to
her mischief? When I told Terry that it was time to go, she said, 'No.' I have
the feeling that she said 'no' more because she likes saying 'no' than because
she did not want to do what I had suggested. With the word 'no' she has
the power to direct or change events; the word 'yes' suggests compliance
with what someone else has determined will happen. Having begun to
connect with Terry's attempted and sometimes achieved manipulation of me,
I was able to observe what she was doing with a little more distance the
following week:

DAISY: We're going out of the room now. We're going to play together
 now.
 *We left and went towards the elevator. I was carrying crayons and
 her notebook. I gave her her notebook to carry.*

DAISY: We're going upstairs now.

TERRY: I wanna stay here.
 She sat down on the floor, opened up the book, took the pictures out
 and spread them out on the floor. People kept walking past us and
 staring at us.

DAISY: Terry, we can stay here in the hall, but we'll have to move to
 this corner.

TERRY: OK.
 We went over to the corner

TERRY: I wanna go to the park.

DAISY: OK. Get your coat and we'll go to the park.
 I wanted to go to the park, too, so I did not really connect with her
 testing of me at this point. We got our coats and went down to the
 ground floor. She got out of the elevator and started to run through
 the halls. I dropped what I was carrying and went after her. She
 started to run off again. I held her in my lap.

DAISY: You're not ready to go to the park yet. We'll wait here until you
 are ready. Let's look at some of your pictures.
 We spread the photographs out on the floor. She looked at them for a
 few minutes.

TERRY: I wanna run.
 She giggled and looked at me.

DAISY: You can run when we get outside in the park.

TERRY: I wanna run now.

DAISY: Come with me and get your notebook I left in the hall.

TERRY: No.

DAISY: Do I have to carry you?

TERRY: Carry me.

Accepting the regressive 'Carry me' does not mean that the therapist is promoting
it.

I picked her up, carried her to the hall, picked up her notebook, and went
back to the door. Terry continued to test me.

DAISY: Are you ready to walk by yourself now?

TERRY: No!

DAISY: I'm going to put you down.
 I put her down. We went out the door and she started to run up the sidewalk toward the street.

DAISY: Terry, I'd like you to hold my hand when you're on the street.

TERRY: No!

DAISY: OK. Then I'm going to stay very close to you.

TERRY: No.
 She ran and I stayed with her. She stopped and fell down on the sidewalk.

TERRY: No running, Daisy.

DAISY: You want me to carry you. All right. I'll carry you across the street.
 She was telling me what she needed: she wanted me to touch her.

DAISY: Now I'm going to put you down and we can go into the park.
 She stopped at the benches.

DAISY: Let's stay here.
 I put the notebook and photographs and crayons down on the bench.

DAISY: Here are pictures we took last time. And here is your book.

TERRY: Take some pictures.

DAISY: No. We're not going to take pictures today. We're going to look at the ones we have now.
 She opened the notebook and started to draw in it with the crayons.

It is clear to me now that in the beginning of the session I allowed Terry too many options. I went along with her every time she changed her mind Daisy 'All right, we'll stay here; OK, we'll go to the park.' It was right after we began to visit the park that I realized she could, and probably would, keep thinking of new places she wanted to go or different things she wanted to do, as long as I never said 'no.' In one session, I decided that we would go to the park, no matter what diversions she engaged in *en route*. Eventually we did get to the park, and Terry was able to ask for help along the way by asking to be carried. We then had a beautiful session, which I have described, when she began climbing on me and running away and coming back and climbing on me again and running away again. I feel she needs to know that I care enough about her to say 'no' to her self-destructive behavior and to *stay with* and *enforce* my 'no'. Her teacher, subsequent to this session, told me that she had seen Terry's mother deny Terry certain things and then give in

as Terry began to cry. Terry must learn that she can trust me to be consistent in my demands so that she may learn to be consistent in her reactions to these demands. I feel also that in my being consistent I am giving her, in a sense, a picture of who I am and what she can expect from me. A natural result of her experiencing this will be, I hope, her experiencing who she is – first in relation to me, and then by herself.

> *The patient does a good deal of testing, as well as coming and going with her therapist. Although she expresses oral and anal problems, we also see a good deal of evidence of a child who is equally testing herself out in the rapprochement stage.*

The Phantom's Mask
A Search for Meaning

Michèle M. Neuhaus

I took a deep breath and entered nervously into the small classroom that was in the midst of an English lesson. I introduced myself to the teacher and asked her if I could observe Anthony, the child with whom I would soon be involved in a therapeutic relationship. Aside from not knowing what Anthony looked like, I was feeling a tremendous sense of guilt and responsibility for disrupting the class lesson.

The students were all curious about who I was, demanding an explanation from me as to what I was doing in their class. I replied by explaining that I came to meet Anthony, because, we would be meeting together every Thursday for art therapy. Anthony looked up at me with a calm smile. His smile made me feel accepted by him and offered me a feeling of serenity in the height of pandemonium.

> *A beginning student often searches for acceptance by their patient. In this instance, the patient's smile seemed quite enough. As we will see, a patient's smile may well cover a feeling of pain and detachment.*

I built an image of a quiet and happy boy in my head and felt relieved that Anthony was not like some of his classmates who were running around like a pack of wildebeest being chased by a lion. I tried to help the teacher reorganize her class by telling the children who continued to question me to listen to their teacher. Soon, the class was back in working order as if I had never entered.

I felt awkward walking up to Anthony and introducing myself, so I just kept what I perceived to be a silent dialogue of eye contact between us to

be our introduction to each other. At the time, I felt this nonverbal dialogue to be a strong communication between us. I realized that there was something powerful about Anthony, something that kept me at a safe distance. Whenever I attempted to get close to him and introduce myself, I somehow felt his rejection and fear stinging into me. While I sat in the back of the room, I was comforted by the notion that Anthony was looking right at me. I thought that he was making contact with me as I waved Hello to him. But, I now see how my own fears of making contact with Anthony caused me to be precocious in my impression of this interaction.

> *The therapist, in spite of her uneasiness, struggles with her feelings and makes a beginning attempt to process them. By so tolerating these feelings, she makes an important step in regaining her presence in the therapeutic relationship. If she becomes too ashamed of these feelings, the disconnection and denial of them will lead to a loss of therapeutic presence.*

As I watched Anthony and his classmates, I was consumed by a feeling of dread in the thought that I would disrupt the class again when I left. This consumption of my thoughts left me detached and unable to notice the powerful information that Anthony was presenting to me. Anthony had, in fact, never really noticed me and showed little interest or connection as to who I was. It never dawned on me that I did not introduce myself to him, and I interacted only with his classmates who approached me. I was so wrapped in my own anxiety that I never really took time to experience Anthony's. Looking back, it all seems so unbelievably clear to me: Anthony was in his own world. The teacher must have said his name at least six times before he would acknowledge that she was speaking to him. The fact that at eight years old Anthony is obese, in itself, might have offered me information and insight into Anthony's inner world. Yet, I overlooked or minimized it. Matters like these escaped me at the time and all I noticed was the serene and soothing smiles that Anthony fixed on his face throughout my visit in his class. I soon left the room waving good-bye to him and telling him that I would see him soon.

Anthony came across as shy and compliant, but when the teacher spoke to him, he became distractable, anxious, and desperately attempting to avoid confrontation with her. He ignored and opposed her by reading from the wrong workbook. His eyes began to wander into space, and throughout most of my visit in his classroom a curious smile was fixed on his face. The most important fact that escaped me at the time was that Anthony showed absolutely no 'real' interest or concern for who I was. He never asked me my

name or why I was going to be with him, as did his classmates. We were strangers in the beginning and we were both terrified and anxious about actually meeting one another.

> *Some beginning hypothesis regarding the patient's withdrawal can be made. Is he frightened by his aggression, does he fear retaliation? Perhaps he does not feel worthy of contact.*

My own misgivings and illusions about beginning therapy with this patient played a role in the relationship from the moment our eyes met. Anthony offered an abundance of information to me at the start of our pre-therapy meeting. I was too consumed in my own feelings of guilt and anxiety about the meeting to have been able to notice this. I avoided and obscured the real and present issues that Anthony presented to me. My avoidance of meeting Anthony set an atmosphere and tempo for the way in which therapy would begin.

> *The awareness of this mutual avoidance can lead to some very important insights on the part of the therapist. What is the therapist's guilt all about? Is there something very powerful in her that is too dangerous to be exposed? In the above paragraph the therapist takes a further step in gaining insight by alluding to the 'dominating' parts of herself.*

I felt content and safe with my impression of Anthony being a shy and well-behaved boy who gave me an impression of calmness. I feared and denied the feelings of uneasiness and bitter ugliness that I remembered feeling when my eyes left Anthony's. It was better for me at the time to view Anthony as a pleasant and compliant boy. There was something terribly frightening for me to think that Anthony was not noticing or connecting to me. This was my fear: being rejected and disliked. For me to experience Anthony as he really was I would have to risk not liking what he was, fearing the terrifying and dominating parts of myself. Before I could accept Anthony I had to accept these feelings in myself. All of this spilled directly into our first sessions together.

Session 1: A Double Reflection of a Mirror

My first session with Anthony began by my introducing myself to him and reminding him of the time we first met. He smiled and looked at me in a curious manner. I felt that he was hesitant and confused to be with me. He

nonetheless acted in a pleasing and complying manner. I, in turn, responded to Anthony in an artificial and anxious way at this time, ignoring my basic instincts and feelings.

> *The therapist does not offer a structure for the patient to understand why he is there. As we will see, the patient reminds her of this omission. Laying down a rationale for the purpose of treatment becomes an important part of offering a patient a secure holding environment.*

He began to draw a person using brown crayon. I sat back and watched the image emerge. He drew very carefully and slowly, merging with his drawing. I began to feel a desperate need to connect with Anthony and tried to find a common bridge. As he drew, I noticed he looked at his hand often and wiggled his fingers. He then would look at his drawing and attempt to recreate the image of his hand. He could successfully distinguish in his drawing his figure's right from left hand by the placement of the thumb.

I asked Anthony if he was trying to figure out which way the hands go? He said, 'Uh-huh'. I then said, 'I use models in this way too'. He said, 'Really?' in a sort of 'who cares' way, yet remaining polite and compliant. I felt excited and impressed by Anthony's attempts to create the image in a realistic way. It reminded me of when I first began drawing and my struggle with exactness. I thought that if he knew that I used my hands as a model that he would feel more at ease with me. He would feel more connected, but it seemed to have made him feel intruded upon and observed.

> *The patient attempts to mirror a part of his body. 'Will you see my hand that wants to reach out to yours?'*

He then drew the opposite hand in a quicker and less careful way. He did not pay attention to the rendering or the positioning of the fingers. Then, suddenly he dropped the crayon exclaiming, 'OK, I'm finished!' I asked him what he wanted to do for the remaining time. He offered no suggestion so I suggested that we make a folder in which to keep his artwork. He said, 'yeah, folder.'

> *The introduction of a folder becomes a very important therapeutic step. It offers the patient a sense of continuity as well as a sense of value for the artwork. Patients and therapists may then review their artwork and observe the process that has unfolded.*

I gathered the various materials, and when I returned to Anthony he was deeply involved in drawing another figure next to the first one. Momentarily, I thought that this signified that we were making contact. However as I began to inquire about his picture he withdrew asking me how much time was left.

> *As we will see the therapist struggles with her tendency to make too many direct verbal questions in a treatment dialogue. We often ask questions when we are anxious and are threatened by the empty space between therapist and patient.*

I began to feel more and more rejected by Anthony as our engagement continued. I felt as if he had the right to treat me like this, because I did not prepare him for the session. All I could feel was intense rejection when Anthony opposed my ideas or cut himself off from our vocal communication. I could not see that he was telling me about his life and how he has been treated by others. I was feeling so responsible for his feelings of helplessness and fear that I was unable to empathetically respond to his needs. I somehow needed to be able to communicate an understanding of him.

As the session continued, I brought to Anthony's attention that it seemed that he was still unclear about who I was, since I was unclear of who he was, and felt confused about what we were doing together. He did not respond to me verbally, but separated himself by sitting across the room from me and looking at a calendar. This verified for me my feelings of separateness and confusion. I tried to use the calendar as a vehicle of communication, but when I spoke, asking Anthony to tell me today's date, he dropped the calendar and stared straight at me as if he was asking me for order and organization. There was a momentary pause. I did not know exactly what to do or say. I felt anxious and pressured to perform. I became blocked and retreated to the safety of art materials.

> *To tolerate feelings of loneliness and separateness becomes a very important part of the therapeutic interchange. We cannot deny or cover them over. Our job as therapists is to tolerate them and by doing so we make therapeutic contact with our patients.*

I broke the silence by showing him the folder that I had made for him and asked him if he wanted to decorate it. He took the folder that I made and carelessly drew on it as if I handed him more paper. He recreated his familiar figures using new colors (blue and orange) for each. I felt injured and hurt

by his response. I could not help but to feel insulted by Anthony. Instead of being able to use and understand my feelings as clues to ways in which I could help Anthony, I merged with his transference.

> *Perhaps the patient feels too unworthy in offering an image for the folder. This kind of sharing was probably too painful.*

As Anthony began to create the second figure in his drawing using an orange crayon, there was a shift that occurred. I am not sure what exactly induced this shift, but I assume it had to do with Anthony who sensed my counter-transference. He spoke to me as he drew. He asked me, 'Why you take?' I asked him to elaborate. Essentially he wanted to know who I was and why I chose to take him into art. I replied to Anthony by saying, 'What I hear you saying to me is that you are angry that nobody explained art therapy to you'. He agreed by saying with a bit more feeling, 'yeah!' I felt I owed an explanation to Anthony, so I gave him one. Trying my best to explain to him how I was chosen to be his therapist, I explained that all the children received some type of therapy. I told him that the staff decided that he might like art therapy. I then apologized to him, telling him that I was sorry that I had not let him know that I was going to be with him prior to this meeting.

> *Here we see how a so-called 'therapeutic error' can be very useful by the therapist. Owning up to her insecurity, the patient gains a sense of mastery in a therapeutic dialogue.*

When I was finally able to respond to Anthony in a real and honest way, it relieved me temporarily of my feelings of guilt and it relieved him of his anxiety. Although he still was ambivalent and slow to respond to me, I was able to separate from his transference, my own issues regarding my counter-transference, and gain some insight about it. I felt more connected to him. He showed the drawing to me and said, 'There!' He had not shown me his drawings prior to this. He got up and began to look around on his own. He asked if he could paint. I became energized and alive. I felt as if a barrier between us had been lifted.

> *As was demonstrated in the above paragraph, the authenticity of the interchange helps the therapist to master her countertransference.*

I helped him set up the easel and the paper. He began to paint and I sat back and watched him. Anthony began to describe his painting (Figure 62). He offered information about his painting freely to me. He told me that there were 1960 monsters in it. I had asked him to tell me what the monsters were doing in the picture. He replied, 'Scare the people'. As I began to inquire further about the picture, he withdrew into his painting, suggesting that he did not want to talk about it. He ignored me with his silence, and hid behind his painting. I remained silent, and waited for him to invite me back into his fictional world. Later he added, 'No dogs and smoke allowed!' I asked him if he had a dog. He said no. He asked me, 'Do you have kids at home?' I said no. I asked him if he had any younger brothers or sisters. He said yes, and told me that he has a sister. He then turned the attention back to his painting.

Figure 62 (Watercolor 12" x 15") '1960 Monsters in the Rain'

> *There are too many questions in this interchange and not enough attempts to enable playful dialogue. In our quest for understanding, we stop something else from emerging.*

I wondered what was all of this about? I became confused. I felt, at the time, that he was jumping in and out of his thoughts, making disjointed associations. I can now see that he had begun to invite me into his world, telling me about his inner world through the metaphor of monsters. I felt as if the circle that he called a monster represented time, or rather the clock on the wall. I felt that I was one of those 1960 monsters. My perception made me fear being rejected. As a result I suddenly switched to an intellectual and probing intervention as a defense against my fears. I became more confused when he blurted out 'No dogs or smoke allowed!' I wondered who said this to him at home. I was somewhat aware of the transference that he presented, except I could not get into it. I could not allow myself to enter into his past world. It seemed extremely frightening, so I cut off the communication and created an artificial and stale dialogue.

> *The therapist recognizes that there is something extremely frightening in entering his past world. Once again, Michèle demonstrates a very important axiom in therapeutic processing. There will always be defenses that are in play between therapist and patient. We struggle with them and when we are at a therapeutic loss, our awareness of these defenses in operation becomes an important step in regaining therapeutic center.*

He then told me that it was raining in his picture. I told him that I could see that it was raining on the floor too. He said angrily, 'Don't tease me!' I told him that I was not attempting to tease him. I asked him what made him think that I was teasing him and he responded, 'Rain on floor'. I said, 'You're upset because of how I said it?' He said in a hurt way, 'Yeah'. I told him that it was important for him to express this because then I knew that there were certain ways that I might say something that could hurt his feelings. He said, 'Look at the rain'. I asked, 'Are the monsters getting rained on?' There was no response. He began to become one with his painting, making chaotic strokes that he called rain.

> *The patient's fear of being teased becomes an important therapeutic part of the treatment process. His fear of being too vulnerable and exposing his inner tears (rain) was important risk-taking step on the part of the patient.*

I told him that there were only five minutes left so it was time to clean up. He did not listen to me. I asked him to step back from the painting in an attempt to have him separate from it. He had a great deal of trouble stopping, but finally was able to do so. The more demanding I became with him the more he complied.

I told him that the only rule I had was to help clean up at the end of the session. I told him I would help him with this more in the future. He helped clean up by putting his brushes in the sink and helping me clean the floor. Anthony left the room on my dismissal of 'See you next week'. He was ambivalent about leaving his drawings, asking me not to hang them up. I told him he could take them home if he wanted. He indicated that he did want to, but left the paintings when he finally left the room.

> *The rule of cleaning up at the end of the session is an important one. It produces a sense of safety for the patient so that anything that is explosive or chaotic will ultimately be contained in a very clear boundary between expression of art and the reality condition of a classroom situation.*

Session 2: Getting Too Close

Our second session began by Anthony immediately requesting paint. He began to make a tic-tac-toe board on the paper (Figure 63). He engaged in a game by himself, making the Xs and Os in turn. He made the O's win and informed me that he was the winner. I asked him who lost and he said that I did. I was feeling very left out by him playing a game that requires two people to play as if he were the two people. It made me feel rejected, as if he did not want me to join in his game. I was conscious of this feeling during this interaction and thought of it as insight into his inner world. Is this the way he feels with others, not invited to play in a game that takes two? Does he compensate and create a friend inside himself with whom he could play? I suddenly felt alone. I felt his aloneness. I began to be able to 'play' with him.

Figure 63 (Watercolor 12" x 15") 'Tic-Tac-Toe'.

The relationship moves into a play therapy mode. The game of tic-tac-toe becomes the focus in the dialogue. A more traditional therapist may well draw a limit and keep the expression in the art form. The therapist does not become too restricted by a role definition and gives the patient a playful experience of mastery and control in the relationship rather than in the art form.

I asked if we could play another round. He seemed excited, by the request. He drew the tic-tac-toe board and I asked him what he wanted to be? He made an O on the the paper and I assumed this was his way of answering my question. He then began to make an X for me. I said, 'Wait a minute,

isn't it my turn?' Anthony looked distressed as he noticed his blunder. He began to apologize to me in an obsequious manner. I said, 'Well then, if it's my turn, don't I get to choose where to place my X?' He looked worried. He crossed out the X and put an O in its place. I said, 'Maybe you should explain the rules to me'. He ignored my request. I directed him to the place the X where I wanted it to be. Again, Anthony ignored my request and instead, created the winning mark to obtain three in a row. He ardently said, 'Round two, I win'.

> *There is always a debate as to how 'hard' the therapist should play in order to win. In this instance, the patient's quest for mastery in this dialogue felt very authentic and useful.*

Winning seemed to be important to Anthony; or rather, I should say, beating me was very important. I was able to come close to him which enabled me to understand him. However, once contact was made I would soon feel dismissed by him. I took this as an insult leaving me annoyed and defensive. I became judgmental and felt injured, avoiding further contact with him. He made me feel unwanted and devalued, this is most likely how people have made him feel. I aligned myself with these feelings and defended myself from feeling any further vulnerability.

He said, 'OK, round three'. I asked him if it would be all right if I could make my own marks. He said, 'Yeah'. He let me go first. I made my X mark which on his turn he avoided blocking. I made a mark that gave me two in a row and unless he blocked me on his turn, I easily would have won. He was more concerned with his two in a row, and did not protect himself. When I saw that he did not block me I said, 'Oh, I don't know? It looks like I just might win'. He realized that I was now in the position to win. He told me to put my mark in a place that would keep me from winning. I replied, 'You think I should, put my X here? I don't think I'll win then'. He quickly made an O as if I forfeited my turn. He eagerly shouted, 'Round three, I won!' I said to Anthony, 'You win again? I don't know, I think I might have lost a turn. Boy, you don't like to lose!'

> *Once again, the therapist enters into a playful dialogue and enjoys giving the patient a sense of mastery and control.*

He began to write 'ent' and said, 'Say ant, spell ant.' I did not understand what he wanted from me. He was getting frustrated that I could not

understand what he was doing. I was getting frustrated that I could not relate to what he was doing. Anthony was searching for some control. I could not see this at the time.

> *The patient offers the image of the 'ant': all that was required was an entering into the invitation of being and feeling like an ant.*

He began to cross out the words and write new ones. I suggested that he turn the paper over so that he could have more room, and he did (Figure 64). He engaged in a guessing game with me asking me Batman trivia. I had no idea what he was asking or expected me to do. He quickly said, 'Round one, I win, you lose'. I asked him to explain the rules of this game to me. I said, 'I don't think I ever played this game'. He said, 'I ask a question, you guess the answer'. I felt organized and clear again.

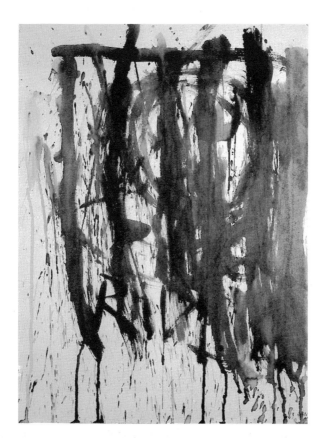

Figure 64 (Watercolor 12" x 15") 'Batman, Robin and Villains'

He asked who was the villain in *Batman: The Movie*. I said it was the Joker. He thought a moment and told me to close my eyes. I asked him when could I open them again and he told me he would let me know. He gave me permission to open my eyes and revealed that I had the correct answer. He did not say that I won; he only said that I was right. We continued this process with Catwoman and the Penguin as the villains of *Batman Returns*. I got these answers 'right' too. I had to close my eyes each time and then on Anthony's signal I would open them to find the answer. He would ask me for help after my eyes were opened as to how to spell the words that he was writing.

> *Through the game of spelling, patient and therapist enter the world of good and bad guys.*

I felt connected to Anthony during this game. I felt closer to him and I felt that we were exploring each other's boundaries and abilities to trust. I felt like he was beginning to respond to me and that we were forming a relationship. I was able to be with him. I was able to respond empathetically. I was able to play.

I said, 'You seem to know a lot about the Batman movies. I didn't see *Batman Returns*. Can you tell me about it?' He shook his head. He told me that Catwoman and Penguin were in jail. He began to make bars and told me he was making bars so that they would stay in jail. I asked him what they did to get thrown in jail. He answered, 'Rob and steal from Batman'. I said, 'So Batman stopped them from robbing and stealing?' He said, 'No, Batman and Robin stopped them'. I said, 'Oh! So Batman doesn't fight crime alone?' He did not answer me. He stopped painting and and said, 'I want to draw'. I asked if he was finished painting and he said he was. I told him that he could put away the paint materials now or he could wait until the end. He said, 'Yeah, OK.'

> *Through the metaphor of Batman and Robin, the patient requests the therapist to become his therapeutic ally. Is the patient expressing the part of himself which he views as being bad? The emergence of this material creates too much anxiety and the patient proceeds to disconnect.*

He suddenly disconnected from me. I wondered if we had become too close. Did he fear merger? Close contact? He wanted to draw on the chalkboard. I sat back silently as he scribbled marks on the board. After a while, I tried

to join him in his scribble drawing that was all over the place. I asked him if I could draw with him. I created a rectangle around his scribble to offer him containment. He began to bang dots on the board. I said, 'It makes an interesting sound'. I was so disconnected from him at this point. I was completely filled with anxiety. I lost atunement with my patient due to my over identification with his flooded feelings.

> *The patient bangs dots on the board as a means of expressing his defensive withdrawal from the intensity of the underlying feeling.*

We lost contact. No matter what I said or did Anthony screened me out. He would not respond to me and I was confused by his change. I could not figure out what had happened. I could not understand his needs.

He seemed to become anxious. I drew back to give him space and sat at he big table. He became concerned about time, reminiscent of last week, asking me every minute what time it was. I showed him where the clock was and told him when the big hand hit the nine then it would be time to go back to class.

> *The patient seeks some type of structure of time and place as a further expression of his underlying discomfort.*

I was becoming annoyed with Anthony, feeling wounded and unwanted. His sudden concern for time left me confused as did his scribble drawing. What does he want to do, slow it down or speed it up? I was feeling tremendously tense, anxious, and confused, as he stopped drawing. He paced by the door and said, 'Go now'. I said, 'Well you still have some time, but if you want to go, you have to first clean up'. He began to pace. He asked for the calendar. I could not find it under the portfolios on the table. He was becoming nervous. I did not feel like searching for the calendar. While I knew there was a short time left, I was worried that he would not clean up. I was worried how to end the session. He became insistent that I find the calendar. He pleaded that I find it. I could not and his hands began to flap. He paced impatiently back and forth, saying, 'Go now class, go now'. I asked him to help me clean up and then he could go. He did a little bit of cleaning. I tried to process his anxiety; he seemed in no condition to be headed back to class. He seemed in overdrive. The more I spoke, the more anxious he became. I could not take it any more, I released him of his obligation, and gave him permission to leave.

Anthony was anxious and I in turn got anxious and defensive. When I responded to him honestly, it relieved me of my guilt and his anxiety. He may simply have needed clarity and structure. It was apparent that I was not connecting to Anthony on a profound level. More importantly, I was not connecting within myself and thus unaware of what was taking place in this exchange.

> *The therapist blames herself for the patient's disconnection rather than seeing that his withdrawal as an attempt to regain control when threatening impulses start to overwhelm him.*

Session 3: Meeting The Phantom

Anthony came to our third session seeming more organized. He began to paint, but soon stopped the process (Figure 65) asking me if I could help him create an image of what he called the Phantom. He asked me to help him paint the Phantom's mask and I suggested that we try another painting together.

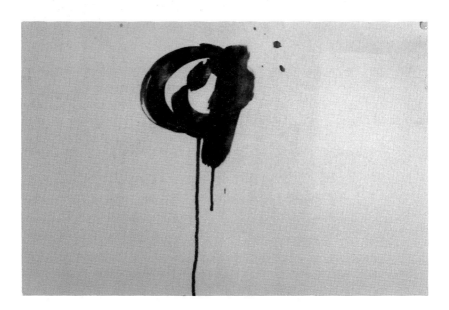

Figure 65

I helped him set up a new piece of paper (Figure 66). I said, 'Well I'm not too sure what the Phantom looks like so let's think about him together. Well, what's the first thing that we would need to do?' He said, 'Make his face'. I asked, 'What is the first thing we do to make a face?' He did not answer. I said, 'I think you had started before by making a head'. I looked at his first attempt and I said, 'See that circle, it looks like a head'. He said, 'Yeah, a head,' and drew a circle. Then I asked, 'So, what's next?' He said, 'The mask'. He then asked, 'What's a mask look like?' I went to the supply closet and got a piece of fabric. I put it across my eyes and said, 'Would the Phantom's mask look kind of like this?' He said, 'Yeah,' as he looked carefully at the fabric that laid across my eyes. After studying his model he drew a line across the circle. We then did this type of sequence for the cape and the rest of the Phantom's features.

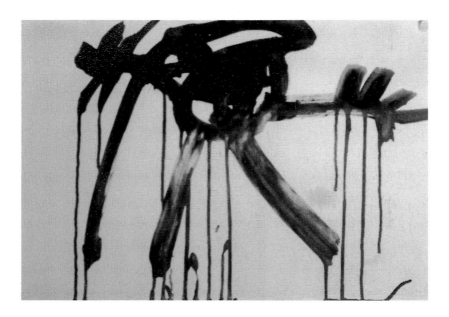

Figure 66

He began to tell me the story of the Phantom. He told me how the Phantom is very ugly and very bad. I asked, 'What makes him so bad?' He answered, 'He kills people and he's ugly'. I asked. 'Do all the people think that the Phantom is ugly?' He said, 'Yeah, everyone hates the Phantom.' I asked, 'Did the people ever like the Phantom?' He said, 'No, 'cause he's a murderer'. I

was not sure where this line of questioning was going and it did seem to make him somewhat nervous, so I suggested to Anthony the idea of making a Phantom book. I was not sure if he understood what I meant. I sat down with him at the table and asked him to dictate to me what was happening in this picture. I wrote down on another page what he said. He said, 'The Phantom I wrote "of the opera," and he told me to cross it out he's very bad, killing people and he's ugly. He murders and cuts the curtain when the piano man is playing'. I asked him if he could draw what happens next. He seemed lost. I showed him what 'the book' would look like, if he were to continue with this theme. He asked me if I read the book. I said, 'Well, I've read a *Phantom of the Opera* book, but I haven't read your book yet'. He asked as he investigated the two pieces of paper, 'This is what my book looks like?' I said, 'Well, if we put it together and make a cover it will look kind of like this'. He then asked me if I could bring my book in. I said, 'That's a possibility, would you like to see my Phantom book?' He said, 'Yes, bring it next week'. I said that I would.

> *The patient returned to the bad person inside himself. This time he is ready to explore the ugly killer inside through the metaphor of the phantom. In requesting the therapist to bring in the phantom book, he engages her as an ally in exploring and taming the killer-phantom.*

Session 4: Disappointments Accepted

I arrived at Anthony's class and to my surprise he turned to me and said in an elated tone, 'Is it time for me to go?' He was smiling in a sincere and honest way, and he walked quickly and eagerly out the door. He practically ran to the art room. I said to him, 'Boy, you seem to be in a good mood today.' He said, 'Yep!' I said, 'That's good.'

> *The patient is very pleased in that there is some continuity of the relationship outside the classroom. This facilitates object constancy.*

I was totally taken off guard by Anthony. I never knew quite what to expect from him. I never saw him running or moving quickly, and never saw him express an eagerness to go to art therapy. I was somewhat wary about his eagerness. I wondered if he was eager to leave his classroom for some reason, or if he was truly excited to attend the session. I did not see any reason for me to believe that he had an unpleasant experience in his class, so I assumed

that he was eager to attend this session and I feared that it had something to do with either the *Phantom of the Opera* book or the 'Phantom Book' that he had begun.

Unfortunately, I was not able to obtain the *Phantom of the Opera* as soon as I would have hoped and I left his artwork in the trunk of my car. I remembered that I left his paintings in my car moments before the start of his session. I thought that I should probably run to get them before I got Anthony. I decided not to, because of the rainy weather and the time that it would take away from Anthony's session. I took the chance that Anthony would not request his previous picture on the assumption that he never had asked to see 'old' work in the past. I also felt that he was not connected to the idea of making a Phantom book. I thought it was an idea I had tried to enforce on him. I took the risk of neglecting the power and significance of his painting of the Phantom. I took for granted the importance of this symbol. I did not, until now, realize how strong a symbol it is for him. Nonetheless, I had no access at the time to the book or his pictures and I feared his request for them.

The minute he opened the door of the art room he began to search desperately for something. I commented, 'It looks like you're looking for something. Can I help you find what you are searching for?' He said, 'Where's the book?' I asked, 'Which book?' He said, 'The one that you bring in for me'. I said, 'Oh, you mean the Phantom book'.

I took a deep breath to clear myself of the guilt I was feeling and to accept the fact that there really was nothing I could do at the moment. I did not have the book with me and that was that. He would have to accept that and so would I. So, I did my best to explain, and not beat my head in with guilt. I knew I felt anxious the moment he asked me about the *Phantom of the Opera*, but an amazing thing happened to me. As I began to explain the circumstances of not having the book, my anxiety and guilt lifted. I was no longer consumed by my guilt of disappointing Anthony, but instead identified with Anthony's disappointed face. I felt comfortable with this look and it did not seem to affect me or make me nervous or anxious. I felt how terribly disappointed he must have been feeling. I felt complete empathy for him. My new found clarity enabled me to process his disappointment.

The therapist acts out the induction of the disappointing love object. If she can master her guilt, it will offer an opportunity to the patient to work through his feeling of anger and disappointment.

I told him that, unfortunately, I was not able to bring the book in this week, and that I was sorry to have promised him something that I was not sure I could deliver. I further explained that I should have checked things out before I made such a promise to him. He asked me when I would bring in the book. I then told him that I probably would have it next week, but I could not promise him for sure. He sat quietly at the small art table. I said, 'Anthony, you must be terribly disappointed'. He said, 'No! I'm not disappointed'. I said, 'Are you sure? You seemed very excited about coming to art therapy today, and I thought that maybe it had something to do with expecting to see the book'. He said, 'No. I don't care about the book'. He stood up and began pacing and rocking nervously. He smiled his apparently self-soothing smile and grinded his teeth underneath.

> To admit pain is too overwhelming; it is easier to offer a self-soothing smile.

It was obvious that Anthony was upset by the missing book by the way he was acting. I wondered how could I get him to admit this and be comfortable with it. I thought it was important for him to express his dismay and anger at me. If he repressed or hid it, it seemed as if this would complicate our budding relationship by building resentment. I was aware of his anger at me, and I was able to accept it now. I wondered if he would he be able to allow his anger to show.

I told him that it was all right to be upset when you feel disappointed and that I would not be hurt if he was angry at me. I told him that I could understand if he was upset with me and that it would be hard not to feel some anger towards me by saying, 'It seems amazing how you're not upset with me. I don't know if I could be so understanding if I were in your shoes'. He stopped his anxious pacing, looked at me rather suspiciously, and grinned at me. He came over to the table I was sitting at and asked, 'Where's the calendar?' He found it right away. I said, in a soft and understanding voice, 'Gee, it's nice to have something recognizable and dependable in the heat of a letdown'. He looked at me rather confusedly as if he was not sure what I meant. I asked if he knew what I meant. He shook his head. I continued, 'Well, isn't it nice to see that the calendar is here, in spite of not having the book?' He smiled looking at the calendar. I said in a somewhat humorous tone, 'So not everything, has disappointed you today'. He looked at me, and gave a relatively understanding smile, as if he understood my poetic connections.

This is an excellent use of mirroring to overcome the patient's resistance. By demonstrating to the patient that the therapist would have trouble being so understanding, she regains therapeutic contact. Still, the patient needs some kind of concrete feeding in order to soothe himself.

Figure 67 (Markers on Newsprint 9" x 12") 'The Phantom (as described by client): Drawn with eyes'

He headed towards the cabinet where the food was stored. He looked inside and asked, 'Can I have a snack?'. He sat quietly enjoying his snack. Then, he unexpectedly began to discuss the Phantom movie. He asked if I liked the Phantom. I said, 'I don't know enough about him to like or not to like him. From what you told me about him, it would seem hard to like him, but I think there could be a part of him that I could like'. He said that he watched the movie. I asked him if he had liked it and he indicated that he did like the movie. He started to describe the Phantom to me. I began to draw what he described (Figure 67). He did not like my original rendering of the Phantom, 'because he had eyes to see with' (Figure 67). He then turned the page over and together we created the image until Anthony was satisfied (Figure 68). As he looked at this picture, he began to speak about his grandmother, saying that his grandmother liked the Phantom. I repeated

Figure 68 (Markers on Newsprint 9" x 11") 'The Phantom (redrawn by therapist and client), wearing a mask'

this to him and he corrected me by explaining that his grandma would watch the Phantom with him. I asked, 'Does she like the Phantom?' 'No! He's bad'. Then he said, 'I'm thirsty'. I replied, 'Well perhaps you can get a glass of water on your way to class?' He began to look frantically for a way to have some water, asking for a cup and standing in front of the sink. Although I felt that he was being resistant and avoiding the subject at hand, I decided to bring him to the water fountain for some water. He drank as if he was in the desert, deprived of water for months.

> *The mutual participation in drawing the phantom becomes one more step by patient and therapist as mutual allies in mastering and exploring the killer.*

When we came back, I asked, 'Do you feel better now?' He said that he did. He then looked at the pictures that we drew together and asked me where was 'his' picture of the Phantom. I told him that I had borrowed his pictures to photograph and that I had unfortunately left them in my car. He was less anxious than I expected. He said, 'You left them in your car and borrowed them?' 'Are you upset by this?' I asked. He said, 'No! I'm not upset,' in an angry tone. I said, calmly and reassuringly, 'Anthony it's OK to be angry with me. I won't hate you, if you are mad'. He said, 'I'm a little mad'. I prodded, 'Only a little?' He said, 'I'm angry at you'. I agreed, 'I can understand that, so what should we do now?' He said, 'I want to paint'. I then said, 'There's not much time left'. He said, 'How much time is left?' I told him eight minutes. There was a long pause. I broke the silence by saying, 'Boy, this session was filled with disappointments for you'. I listed them all, and said, 'But you survived them all'. He smiled sincerely at me. He said, 'How much time left now?' I said, looking at my watch, 'Let's see – one minute'. He said, 'One minute to go'. I said, 'yeah'. He stood by the door with me. I said 'OK, 30 seconds'. He said, 'Let me see this', and he grabbed my arm to see my watch. I said, 'Let's count off the seconds', and together we counted off the remaining seconds. When we were finished, he laughed a big belly laugh and said, 'Bye. Don't forget my picture and the book'. I told him, 'I won't forget the picture, but I can't promise the book'. He looked at me pensively and then said, 'OK, bye'.

> *The patient's ability to tolerate disappointment seems to have improved since the last encounter regarding this issue. However, they go to a countdown and some of the creative therapeutic dialogue takes a small holiday. The patient now must wait to see if the therapist will, once again, forget the book.*

Session 5: A Closer Look At The Mask

Anthony seemed excited about this session initially. He asked me if I had the Phantom book. I said that I did have it, and he ran into the room. When he saw the book, his eyes lit up. He was excited and showed this by jumping eagerly in his seat. He started to look through the book and he found a picture of the Phantom. His eyes bulged out of his head. He jumped back and shouted in apparent fear. I said, 'It's OK, I won't let the Phantom hurt you'.

He said in retaliation, 'The Phantom, isn't going to hurt me'. He began turning the pages. I could tell by his shaking hands that he was still afraid of this image. He smiled his comforting smile and denied his fear. I wondered how I could communicate with Anthony. How could I communicate that I really did understand him, when in fact I was not sure that I did?

He found a picture of the opera house and I explained to him what the book said about the opera house at his request. He told me then that the Phantom was bad and all the people hated him. I said, 'Well, I'm a little confused. What did the Phantom do that was so bad?' Anthony told me that he killed all the people in the opera. I inquired, 'Well, why do you think he did that?' Anthony, retaliated, 'Because he's bad'. I did not want to bombard Anthony with questions, so I asked him if he could maybe tell me the story from the beginning. He just repeated that the Phantom was bad and killed people. I suggested to Anthony that we read the story in the back of the book so that maybe together we could understand why the Phantom is so bad. He agreed.

> *The therapist asks for too much understanding as to why the phantom was so bad and the patient complies but his heart is not reading the story.*

I turned the book to the story part and began to read the characters' names. I noticed that Anthony eyes were focused away towards the window. I got the feeling that he was not interested in the story, as much as in the pictures. So, before I read the story, I showed him how many pages were in the story and said, 'OK, before I read the story, you should know that we have 25 minutes left, so do you want to spend the time reading the story or should we only read parts of the story?' He said, 'Read the story'. I began to read and he took the book away from me and turned back to the Phantom's picture looking afraid.

'I thought we were going to read the story?' He did not respond to this question. He went on to say that the Phantom was scary and be began to

get excited about the Phantom's mask. He turned to the front cover (which had just a mask and a rose), and back to the picture of the Phantom. He said he did not like the picture of the mask and the rose. I asked why he felt this way. He said, 'Because it's ugly'. I replied, 'So, the mask and rose are ugly, and the Phantom is scary?' He said, 'Yep!'

> *Putting the mask in visual form becomes another step in the mastery of the patient's fear.*

I listened to him, not offering any opinions or advice, just repeating what he said to me. He continued to look through the book and came across a picture of the Phantom with a lady. He said, 'He's kidnapping her. She's afraid. She does not like him'. The picture itself did not show that. I said, 'Well, I don't know; she doesn't look that afraid to me; it looks like she's smiling'. He said, angrily, 'No the Phantom's bad, she hates him'. I said, 'Well, OK, maybe a lot of people think the Phantom's bad, but if I remember the story right, she was the only person who liked the Phantom'. He said, 'No, she's scared'. I said, 'Well, maybe, but do you think it's OK to be scared, but still like someone?' He said, 'No one likes the Phantom.' I said, 'Well I do. We are looking at the book and talking about him and he seems very interesting to me'. He turned the page and quickly got off the subject. He began to get anxious staring back at the Phantom's picture.

> *The patient cannot quite believe that the therapist could like him in spite of the fact that he is a possessive killer. Is she the one that he would like to control and keep all to himself?*

I thought maybe if I showed Anthony an image of the Phantom, putting his makeup on, he would feel safer and not be so afraid. I thought if Anthony could see that the Phantom was not real, then maybe he would be less frightened. I overlooked how very real this hideous villain was to my patient and I myself did not want to see the dark side that my patient wanted to show me. When Anthony saw the picture he became angry and disappointed. He said, 'He's a fake. The Phantom's a fake'.

> *The line between fantasy and reality is disturbed. The patient wants to believe that the phantom is real, as the feelings inside of him equally feel real.*

I explained to him the difference between make believe and real life. I tried to make him believe that the Phantom could be alive in the play or in our imaginations. He returned to the picture of the Phantom. He seemed to pause, just staring at him. It was as if they became one together and I was no longer in the room. I became anxious and turned towards art materials, hoping Anthony could produce a story on paper. He did not seem interested in this. Instead, we looked at more pictures and he asked me technical questions about each one. Then it was time to go and he was slow to leave. Suddenly he wanted to paint and/or draw, making me feel bad for not allowing him this opportunity.

Understanding the Artwork

Both Anthony and I were defensive and feared rejection throughout most of our sessions. In effect, we were mirroring each other's defenses. Although we are now slowly building a therapeutic alliance and understanding each other, a closer look at this patient's artwork might have given clues about treatment.

A look at Anthony's artwork and art processes reveals a great deal about this client's method for survival in the world. The first images that emerged in treatment with Anthony were two figures drawn in brown crayon. The use of brown crayon in itself suggests Anthony's distorted and dark view of himself. Yet more interestingly, his drawings reveal frail and helpless figures standing on no ground, with their hands up in the air. When, I saw these figures, I thought that they were communicating a wish to connect and reach out to one another, but this in fact was my wish. Anthony, although I did not understand this at the time, touched upon the frail and helpless child within me who fears and avoids closeness and is worthy of rejection.

As the sessions continued, I began to occasionally feel more connected and accepted by Anthony, but was becoming more confused by what appeared to be odd and inconsistent behavior, as evidenced in his withdrawal. I routinely felt rejected immediately after I was sure that we were connecting and communicating. I could not understand what was happening in our engagement and often blamed myself for not being a 'good enough' therapist. I just could not decipher Anthony's nonverbal and verbal communications that often left me frustrated and annoyed. Anthony's paintings (Figures 62 and 64), began with clear and cohesive circles, shapes, and marks. It was during these times that he was able to verbalize cohesive thoughts and associations to me. It was during these times that I felt connected to Anthony. Thus, when the artwork was organized and cohesive so was our engagement. However, the closer I moved into the artwork or toward

Anthony (by asking questions or making judgmental associations), the closer I got to the confused, chaotic, and empty defenses that he uses to survive in the world. This is where I experienced the transference and countertransference issues in the artwork as well as in the relationship.

In Anthony's painting I wanted to stay in the safety of the concrete and tangible circle. I did not want to meet Anthony's 1960 monsters (Figure 62), nor the bleeding and cloudy rain. This dripping paint on the paper flooded his picture. It made the picture cluttered and disorganized. Anthony asked, 'Do you see the rain?' It was as if both the painting and the patient himself were telling me, that they were flooded, overwhelmed, drowning, asking me to help them regain control. Instead, I became anxious and distanced myself from the rain and the chaos. I could be with Anthony when he showed me his good-boy, smiling, compliant forms. I could, as others in the past could, accept the order and conformity that he presented. The moment he began to expose the chaotic, rainy parts of himself, I became frightened to see in this circle what I cannot bear within myself. Here, under the chaos of the rain lay the forgotten elements of sadness, despair, and utter loneliness that was the real relationship declaring the right to be seen. This forgotten mass of pain (the circle) became lost in its meaning, forgotten in value, and destroyed by transference and countertransference issues. The patient–therapist bond was broken by the reactive forces of my countertransference fed by Anthony's transference.

I do not believe that the patient–therapist bond was broken. They were both mirroring each other in terms of their mutual defenses.

When I view Anthony's purple and blue paintings (Figures 62–64) my eye stops at the circles and images underneath the chaos of the lines. Perhaps this suggests that the conflict in Anthony's world lies in this circle. Does this circle suggest the hidden self that fears exposure? The circle becomes covered and buried under chaos and anxiety. This chaos is a way for this child to soothe himself from fear of separateness. As soon as he feels separate, he feels as if he has fallen into a dark pit.

Anthony builds up a protective wall because he is unable to express his true feelings of loneliness and pain, yet Anthony's defenses need to be maintained until his inner image is strengthened. My goal is then to help give words and meaning to Anthony's fears and affects through the use of

clear, tangible words and images and an atunement to his affect through empathic mirroring.

I try to uncover the hidden circle, Anthony's deep-rooted pain. He pushes me away. My search is dictated by my anxiety. Yet, for this patient who has failed to experience an emotional availability of his primary love object (the mother), uncovering and exposing can only result in a feeling of rejection and/or abandonment. In order to help Anthony move through this deep emotional despair, I need to connect to my own feelings surrounding loss and abandonment. The task of treatment becomes one of building rather than uncovering. This involves such tasks as modifying grandiose notions of the self into more human and fallible notions of life and exposing 'false self' structures that cover enormous fears of emotional investment and the possibility of loss. With this framework, the real relationship that exists between patient and therapist becomes every bit important as the transference (Robbins 1987, 1988).

As I was able to be honest with Anthony, present in the real relationship, as well as confront my issues regarding rejection, a shift occurred in Anthony's artwork. I began to see the 'circle' that hid under the rain, or behind the bars, come out to play. Thus the Phantom was created, yet, he hid himself behind his mask (Figure 66). Anthony's artwork of the Phantom projected his sense of self, showing a devalued, distorted, and hideous creature, who cannot be loved or cared for. His transference directly spoke through this work. He told me, over and over, that the Phantom could never be accepted by the people. I was at a loss and felt a deep sense of hopelessness. I could not connect to this Phantom's despair and loneliness because I did not want to feel so abandoned and outcast. Yet, in order to help the communication between patient and therapist, I have to experience these feelings and not be cut off from them to help facilitate the transformation.

> *The therapist was able to regain a connection to the patient by making contact with her own distorted, devalued, and hideous self.*

I am just now, beginning to understand Anthony's fears. For him dealing with rejection means re-experiencing his unmet needs and risking being vulnerable. As his therapist, I need to create a non-intrusive holding environment using a modality that would facilitate a safe way to communicate and establish trust. I am challenged by offering this child a feeling of being held and anchored through structure and consistency, while being confronted with the transference and countertransference issues. This does not

prove to be an easy task as I am routinely made to feel rejected, helpless and as unworthy as others have made him feel. His rejection of me stirs up my own feelings of anxiety, thus leaving me uncentered and unavailable to explore the real and present issues that he brings into our sessions.

Reflections

Once a week I meet with a confused and fearful Phantom. I try to befriend this frightened image, but he puts his mask on and hides away from me. He appears quiet and shy, happily smiling under stressful conditions. When facing something new and uncertain, Anthony puts on a self-soothing smile as a quick internal reminder to act like a good boy, to comply. He wants to please others and fears showing his true self that lurks underneath, thus providing others with this good-boy mask.

He goes to great lengths to distance himself from me in the room and through his artwork. At the same time he invites me into his world and I, in turn, fear entering into it. Everything is fine as long as I do not get too close. His smile, acts as a defensive mask, and his paintings act as a shield. They are a distraction from the pain and inner loneliness of the true self that is afraid to emerge. Here I am each week with a child whose mother has been repeatedly hospitalized for bi-polar illness, an absent alcoholic father, and a strict and bossy grandmother who becomes the primary caretaker when Anthony's mother is hospitalized. Otherwise, Anthony is torn between his mother, who literally runs hot and cold, and does everything for Anthony including dressing him, and a grandmother who is strict and expects Anthony to be a grown man at the age of eight. His frustration and anger is taken out on his younger sister whom he violently beats and fights with. How terribly confusing and lonely it must be for this child to grow up in this disturbed environment. Attachment and self-image are huge issues for Anthony, as it has been repeatedly seen in our sessions together. He needs calm, consistent caring, but is terrified of letting a caring person close to him.

In order for me to establish an alliance with Anthony, I will have to enter into his world and through play, mirror his actions. Some attempts at play have already been made, but I attempted to interpret Anthony's play too quickly by asking too many probing questions. This often resulted in fragmentation or withdrawal, increasing his resistance.

As I attempted to guide Anthony into elaborating on the story of the Phantom. I wanted to get deep into the roots of his problems. I wanted Anthony to be able to tell me why the Phantom is so horrible. When he did not respond to me, I realized that it is not so much a personal rejection to

me, but a risk of being vulnerable and exposed; a risk of experiencing trauma and pain. I used techniques such as metaphors, mirroring, and storytelling at the wrong time in our sessions, ignoring my patient's cues at the moment and my own feelings. When I did connect with Anthony, I faced my own feelings of rejection and frustration. My inner anxieties increased as did my need to control and provide with more structure and or distance. My defenses tended to block and interfere with the process as well as my ability to reflect back what Anthony brought into treatment. I became more directive, anxious, and distant from my patient and we lost an atunement with each other. I was blocked and could not enter into his world which left me unable to play and explore his issues. It became emotionally exhausting to me and I often felt as if I had failed in someway.

Throughout our sessions together I was not sure of what the appropriate response or interpretation was for Anthony. When we began to touch upon the transferential/countertransferential issues of abandonment and rejection, the process would stop. Until I could confront and recognize these feelings, treatment would remain stale and stunted. The patient was stuck in his attempts to master his pain and fears. Why would he risk exposing vulnerable feelings, if he sensed that I was not able to contain them? I still must somehow learn how to play with him, without feeling rejected when he pulls away.

As I begin to explore and confront my own issues surrounding this loneliness and pain, I am able to became more available and present to Anthony. Slowly, Anthony and I are making progress. He is less anxious with me, and I feel more available and centered with him. Our last two sessions involved no artwork, just both of us sharing the same space together. The more that I am able to 'be' with Anthony, in a non-intrusive and non-judgmental way, the more he responds to me in an honest and sincere way. It is a long and difficult journey to be traveling with this masked murderer, but somehow, I have grown less afraid of him and more connected to him. I have grown in understanding this patient and his villain, who needs and wants to be bad and angry. I cannot rush him to expose his vulnerable and hurt face to me.

Keep in mind that the Phantom of Opera is a love story, and that both patient and therapist must confront the hideous part that is both envious, jealous, and possessive. Both participants have made enormous therapeutic strides in this direction. Art is utilized as a means of mastering strong libidinal impulses and feelings of self-hatred. The technique of mirroring becomes an important means of dealing with resistance. This clinical vignette gives an excellent example of play therapy technique being combined in an art therapy relationship.

References

Robbins, A. (1987) *The Artist as Therapist.* New York: Human Sciences Press.

Robbins, A. (1988) *Between Therapists: The Processing of Transference–Counter-transference Material.* New York: Human Sciences Press.

A Case of Chronic Childhood Abuse

Patricia Savage Williams

Introduction

Trauma confronts the very core of the soul and the personal beliefs and feelings of the therapist are never more challenged than when she is witness to the destruction of childhood abuse. What stirs is disbelief, horror, and shock as she questions how one being can inflict on another such pain and terror that the developing personality is deformed.

What follows is a study of the therapeutic process between a patient and me. We both have a history of childhood trauma. Together we experienced transferential and countertransferential patterns that have led me to postulate that the advanced treatment of childhood trauma requires an understanding of its effect on character formation and adaptive character style.

Our first appointment was arranged to discuss Eliza's self-referral and to decide if we would work together. Her arrival was prompt and as she quickly selected and sat in the rocking chair in my office, I was struck by the directness of her eye contact and her facile manner. I felt as if I were meeting a colleague, not a potential patient. I responded with formality.

> *The therapeutic dance begins. The therapist's formality may well be a defensive response to an induced feeling of being judged and criticized.*

Like two tigers we stalked each other in a curious circular dance. Eliza emphatically informed me that she felt successful in her past seven years of therapy where she focused on problems in her relationships, particularly with her partners and children, and her history of physical, emotional, and sexual

abuse by both parents and her ex-husband. Now she felt ready to work on 'herself' and thought that art therapy would facilitate this.

She informed me that she worked full time as a mental health therapist in the neighboring community, primarily with adolescents and female survivors of sexual abuse. She was also, as I was, completing an advanced degree in clinical studies and had hopes of working in private practice. She was well connected in the therapy community and clearly denounced the medical model for its patriarchal control and lack of inventiveness.

> *The patient utilizes the medical establishment to denounce the symbol of patriarchal control.*

I felt intimidated by her; intimated by my projection onto her that she was a more capable clinician than I. I wanted to escape but feared her pouncing on my back as one animal will do to another when it retreats. I was confused by the ambivalence of her verbal forthrightness and the threatening feelings filling the room. To survive, I needed to continue the dance.

> *Is the therapist unconsciously expressing fears of anal assault?*

I felt pulled to prove that I was strong enough for the job of individual therapy with Eliza. While I asked, she did not want to know anything about art therapy, me, or the agency where I was an intern. She said I had been recommended by the director of the local women's center, whom she admitted she had never met, but felt that this was 'recommendation enough.' She wanted to contract for service.

> *The patient plunges into a relationship as a counterphobic defense masking some of her anxiety about therapy.*

In response to her decisiveness I launched into a dissertation on my role, my supervision, background, and goals. I explained the process of art therapy and my approach to the therapeutic alliance. After ten minutes I recognized that although Eliza was focused and attentive, I had submitted to the tiger's adroit moves. I was backed into a corner and was performing to distract the challenge.

> *Again we see the therapist voicing fears of submission, which may be a combination of both transference and countertransference.*

We negotiated a contract for weekly sessions and Eliza committed herself to an agency fee. With no artwork to show for our experience together, we parted for a week.

I felt the need to distance myself from the session. I felt cornered, suspicious, and tense. I wanted to escape the hint of humiliation darkening my mind. I questioned whether I should have contracted to work with Eliza. I felt under skilled for the job.

> *Each party of the therapeutic dialogue touches upon their mutual fears of assault.*

Using these feelings, I tried to understand Eliza's childhood. She had projected two different messages simultaneously. By delineating herself as an experienced therapist, well known to the therapy community, she marked her territory and created the potential for a competition with me. But it was incongruous that she had minimal knowledge of me or the agency, had no connection with the person who recommended me, and turned down the opportunity to question me further. Although she set up a defensive position, she was not taking precautions to assure safety in a new situation.

> *It is not unusual that a patient with this background does not take precautions to assure safety in a new situation.*

I, too, felt ambivalent. I wanted to escape but instead I felt pushed to demonstrate that I was capable of working with Eliza. I knew very little about my client after this first meeting. The one thing I could be sure of was that she lived with ambivalence and double messages and sought to protect herself with defensive positioning.

We met, as scheduled, the following week. Eliza was humorous and engaging on arrival, relating anecdotes about some philosophical differences about therapy that were being acted out in the agency where she worked. There was a superficiality in her presentation that almost masked an underlying tension. The muscles in her face and neck were taut. We mirrored each other. I felt nervous and stiff and initially took refuge in her conversation.

I asked Eliza to relate what she expected from therapy. She said she wanted to stop feeling angry all the time. She could not identify the source

or target of the anger but described it as 'a rock in my stomach'. Instead of focusing on this graphic symbolic representation of her inner turmoil, I avoided connecting with her through the therapeutic mirror of the heavy, tense mass in the pit of my stomach.

The therapist moves into history taking as a defense for her countertransference anxiety.

The following history was elicited. Eliza is the first of three siblings. Her mother, deceased since 1983, was Scottish and lived 'a sad, sad life', never feeling settled in Canada and always longing for home. She had been diagnosed as schizophrenic and spent many years being treated in and out of hospitals. Her father has remarried. He is ambitious, demanding, and disappointed that his children 'haven't amounted to much'. Both siblings are psychiatrically ill. The brother, 12 years Eliza's junior is an addict, currently drinking and taking drugs, untreated. Her sister is presently stabilized on lithium, after an eight year battle with bi-polar affective disorder which surfaced after two post-partum psychoses.

Eliza is divorced from a man who physically and emotionally abused her and has engaged in a succession of 'intense, loving relationships' with men she 'discarded when they become too close'. She is currently in a relationship with a man who is 'uncommitted formally but pretty involved in spite of himself'. This, to date, has lasted eight years. She is the primary caretaker for her two children, age 21 and 17, whom she describes as 'strong-willed, determined, and pretty self-involved, normal adolescents'. Eliza's career is eleven years old. Previously she worked as an administrator of a women's centre in the wilderness of northern Manitoba, Canada. When Eliza was 29, she had two abdominal surgeries related to massive hemorrhaging. The second surgery was a hysterectomy that 'solved the problem'.

Eliza was 37 at our first meeting. I calculated that she had her first child at sixteen and had married, given birth to her second child, and divorced by age 25. She was well ensconced in her second career, but all of her training occurred while she was the sole support of her two young children. She clearly was an ambitious fighter.

We closed the second session without doing any art. I felt as if I had been watching an interview. I was not subjectively relating to this patient. I felt separated and distant, disconnected from any feeling.

When I reviewed the collected data, it was as if I was hearing it for the first time. I recognized that I felt rage and fear, but I was shocked that I did

not feel this when Eliza was in my office. I had survived the session by defending myself through intellectualization; I used the medical model method of historical data collection to frame the painful experience within an 'understandable context'. How could this woman present this history so flatly, as if she was reciting a recipe or a shopping list? How could I so similarly elicit it?

It took several more sessions before I acknowledged the similarity of our past experiences. My own parents were Irish immigrants. Unable to feel settled here, my mother retreated into mental illness. My two siblings have fared less well than I and are struggling with depressions and addictions. My marriage was a violent one that had tragic implications on my similarly aged daughters. When I drew my response to the session (Figure 69) I was surprised that it reminded me of a rock in the pit of the stomach. I felt weighted and dead.

> *Figure 69 draws our attention to the therapist's heavy dead center. There is no relationship to the mass around it. Does this mean that the therapist has encapsulated her pain?*

Figure 69

In our next session, I asked Eliza to draw her anger. She jested about her lack of artistic ability and how she could draw so that I would not think she was 'crazy' like her family. Her picture (Figure 70) was similar in shape to my drawing in response to the last session. My 'rock', was dark, heavy, and dense, surrounded by energetic movement, where Eliza's 'anger' was full of energy, and surrounded by a vast emptiness. In the former I demonstrate some relationship between the dark mass of 'self' to the frenetic and colorful 'other' that surrounds the 'rock' which is bounding with energy itself. The eye moves furtively from the interior to the exterior, perhaps searching for connection or meaning, or protectively guarding against attack on all sides of the mass.

Figure 70

Eliza's exterior is blank. Its whiteness is calmer than the colorful perimeter of my drawing. Her energetic anger is cut off from the exterior world. There is no world in relation to it. I suspect my drawing accurately depicted how Eliza was forced to isolate her rage to protect herself from an intrusive world. The whiteness in the perimeter of her drawing was possibly an indication that she felt open to a relationship, one in which her rage could become colorful and alive.

For the next seven sessions, Eliza focused on a family crisis. Her youngest child was discovered to be drinking excessively, missing school, and associ-

ating with a street gang. Eliza identified feelings of powerlessness, fear for her daughter's safety, guilt, inadequacy, and hopelessness. She could not be assisted to set limits and boundaries for herself and her daughter continued to ignore her own. Eliza developed bronchitis and pneumonia, was forced to take six weeks off work, and eventually to quit because she felt 'ashamed' counselling families and adolescents while her own was so 'out of control'.

> *Was the patient's somatic illness a symptom of the underlying depression that was precipitated by the therapy relationship?*

Eliza was unable to sleep, overate compulsively, was having night terrors and nightmares, hyper-anxiety, and suicidal thoughts. She was started and monitored on Prosac, 20 mg, by her family physician. During this time she was also prolific in creating art work in our sessions.

> *Will Prosac mask the underlying depression and prevent a further investigation into the patient's heavy black spot?*

In one tissue paper collage that she did (Figure 71) my eye goes to the black centre and then jumps to the lower left, drawn by the colors edging their way into the picture. The feeling of the piece is of temptation; a luring of

Figure 71

the self to jump out of the amorphous black hole to experience something different. Eliza described the piece as the black path she walked, with no choice but to follow it. Someone had to take care of her children, 'especially when they don't care for themselves'.

In describing a second tissue paper collage (Figure 72) Eliza said that if I could see underneath her rage, there would be a clotted, bloody mass. The centers in each picture were bright red rectangular masses. The peripheries seem non-supporting and feces-like. At this time my confusion gave way to fear. I wanted to ignore the art and focus on the unfolding crises in Eliza's life, attempting to bury the discomfort I felt from the intensity of her pain.

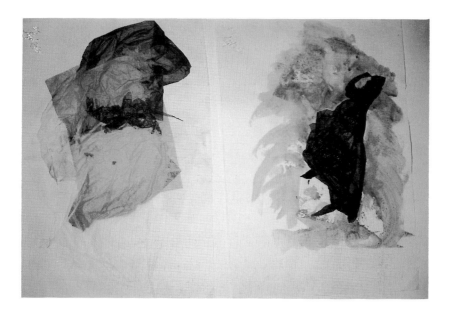

Figure 72

In a third tissue paper collage (Figure 73) the brown centre is falling off the page, unsuccessfully anchored by the two black borders. I sensed that the responsibility Eliza felt in 'walking the black path' of caring for others in life was no longer reason enough to continue living with her pain. The interior of the piece was sharp-edged and black, depicting, to me, violence. Eliza was unable to explain this piece. It was at this point that I enlisted the support of Eliza's family physician and Eliza agreed to the pharmacological

trial with Prosac. Within eight weeks, the Prosac relieved the symptoms of depression.

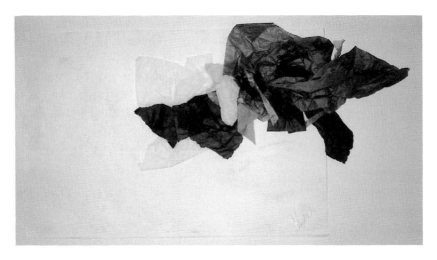

Figure 73

We see in this series of tissue paper collage that the imagery is both vivid and revealing. However, the therapist does not help the patient move into an affective connection to the depression. Is this a manifestation of the countertransference problem?

She continued to work with collage, creating similar pieces and verbalizing minimally. My role was supportive at this time. I resisted investigating her history and feelings and instead worked in an ego-supportive way, starting with creating a feeling of safety and security related to her suicidal ideation and depressive symptoms and by helping her to identify her safety needs in relation to her daughter's acting-out. It was clear that Eliza was able to set and maintain personal boundaries when another piece of artwork (Figure 74) demonstrated to me that she was feeling less hopeless. I was intrigued as she carefully folded and layered the tissue paper. The green covering caught my attention initially. My eye then darted between the two pink borders. The piece felt controlled but not threatening. I felt free to ask what was hidden within.

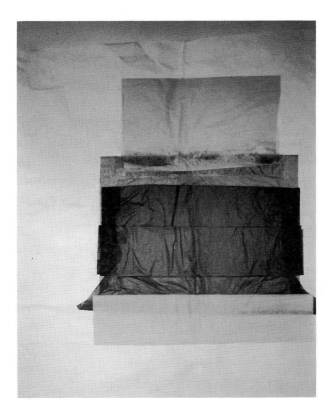

Figure 74

Is the patient unconsciously supplying reassurance to the therapist that she was not feeling so hopeless? I wonder, therefore, whether the patient has once again attempted to assume the parent role in a mother–child relationship.

I asked Eliza to tell me about being abused. She responded with the purposeful control with which she introduced herself during our first sessions. She stated that she had, through previous therapy, remembered and re-experienced the abuse by her mother, father, and her ex-husband. She had worked with various techniques in both individual and group therapy but felt that her volunteer work in the women's and rape crisis centers had been the opportunity for her to successfully integrate her history with her adult

life. It was after these experiences that she went into training for professional counselling.

I wondered if I needed to pursue the details of her abuse history. Had she really worked through these painful events? Could she be denying part, or all, of the associated fallout? What was the fallout? She was successful in her job. She sought help for a very difficult family problem, although her response of depression and suicidal thinking was extreme. It seemed as if she could cope adequately, even though, at times, she sought support. I considered that a strength. Still, something about Eliza kept haunting me.

Her artwork indicated a strengthening of ego and gave evidence of Eliza's renewed sense of self and her object relations in the following way. A series of three collages (Figure 75) had three distinct, separate forms in each. Each form was in relation to forms exterior to it. This suggested to me that Eliza saw herself as central, but in relation to others. My eye is pulled to the centre form in all three, then to the two forms bordering them. The energy flows from in to out, then in again repeatedly. The strength of the forms pulls the eye in a hypervigilant fashion, seemingly never allowing it to nest or settle. I wondered if this was how Eliza felt in her relationship with me. Eliza's description of this series was that she liked the colors and was feeling happier with these as pieces with artistic quality.

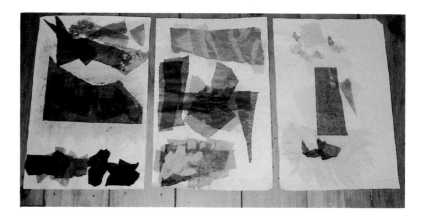

Figure 75

We were superficial, but we were safe. What was preventing me from finding out what was underlying Eliza's self-protective position? The more I penetrated the more she resisted. I felt as if I was responsible for making her succeed but incompetent at the same time. I could not win. As her therapist, I was expected to exercise my skills to help her change, but I felt as if I was getting nowhere; I felt I was putting out the best I could give and it still was not good enough. I wondered if this was how a perpetrator of child sexual abuse feels?

> *It is not unusual in the sexual abuse case that the therapist is induced into being the penetrator of the patient's defenses.*

I wondered why Eliza continued to come back to me. I guessed that she felt she was protecting me somehow, but from what? I was feeling frustrated and scared that I might be perpetuating the cycle of abuse.

Possibly in response, I misbooked our next appointment and was not there when Eliza came. In her hyper-responsible way, Eliza waited for 30 minutes before leaving a note. She assumed the blame for miscommunicating. We rescheduled, but I mistakenly double-booked the hour. When she arrived, I was in session with someone else. I apologized and rescheduled. There was no anger when we finally met. Even when I pursued this, focusing on this for half the session, Eliza persisted that the mistakes were perfectly understandable. She was protecting me at all costs.

> *It is not unusual that the therapist picks up the unconscious identification with the patient's parent and acts out the abandonment.*

I had difficulty maintaining attention during the next four sessions, shutting down to the point of dozing off twice. Eliza talked right through, effectively rousing me by moving the art supplies around.

> *Being cut off and out of it is a reliving of the maternal absent role. This often happens with a patient of this particular background.*

In supervision I struggled to understand what this experience had to say. With Eliza I felt powerless, and simultaneously shut out and locked in. The helplessness of her depression and suicidal wishes were long buried under layers of rigid overcontrol. I kept returning to the art pieces where the central

figure separates the two exterior figures. There was a split that Eliza was maintaining by overcontrolling, being hyperalert, hypervigilant, and defensive. Why were both bordering figures in all three pictures so balanced and complementary?

> *The balance was to keep everything intact, and to keep panic under control.*

Searching for direction, I reviewed the literature on Post Traumatic Stress Disorder and childhood sexual abuse. My countertransferential reactions of scheduling mishaps and dozing off during sessions connected me to the sociopolitical denial that trapped Eliza in her characterological defenses of suppression, reaction formation, denial, and dissociation. I was shielding myself from the burden of her pain and from re-experiencing my own by using the same defenses.

> *It is not unusual that a therapist, even without a similar background to the patient will utilize these defenses as a means of avoiding traumatic communication in the treatment relationship.*

Although the therapeutic relationship had stagnated, these reflections fuelled a potential for reactivating the energy flow that, in the relationship between Eliza and me, had stopped. Eliza had been 'in process' only during the darkest moments of depression. In addition, I was such a potentially threatening figure to her that she tolerated my emotional and physical absence without question.

I understood the dissociative features of my countertransference to be both a re-enactment of the sociopolitical position of denial of childhood abuse and personal protection from memories of my childhood abuse. I used the feelings of being intimidated and powerless and my reflexive response of behaving like a perpetrator with Eliza 'for her own good' to attempt to understand the process of object relations in Eliza's past and, hence, in our relationship.

To determine how I might intervene to re-establish a flow in our relationship, I drew my representation of Eliza. I created a tin man, such as the one in the *Wizard of Oz*. My associations with it were 'armored', 'hollow', 'superficially strong', 'rigid', 'unyielding and controlled', 'rusty', 'shiny', 'ambivalent', and 'split'.

> *The Tin Man in the Wizard of Oz was searching for a heart. Both parties need to discover communications that are loving and heartfelt.*

I spent the next four sessions working with Eliza on her self-representation, images of her mother and father, and of how she saw me. I was hoping the art piece would serve to integrate the transference and countertransference. The flow of energy in these four sessions was cautious and slow but less tense than I had expected. I mirrored an autonomous position, somewhat distant but open and non-judgmental. This was new territory for Eliza and she was careful and methodical, attempting to 'do it right', 'not do anything that could be interpreted as insane', and expressing 'embarrassment about my lack of artistic skill'.

The pieces themselves were static. I felt that the image of Eliza's father (figure 76) portrayed him as ungrounded, with underdeveloped feet and legs and a large, ape-like torso that, in spite of it's comparative size, seemed ineffective. The image of her mother (Figure 77) presented a body–mind

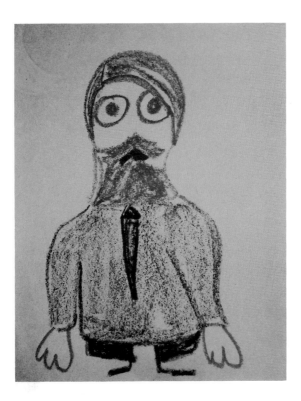

Figure 76

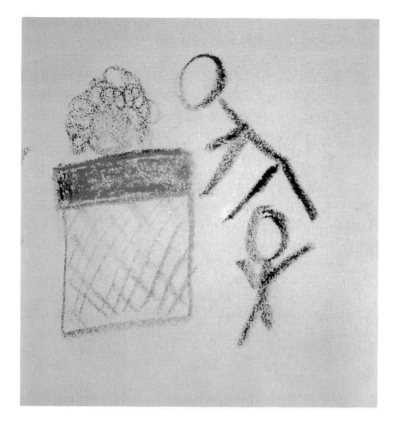

Figure 77

separateness; a facelessness that seemed somewhat lost and a body that was completely hidden.

> *The mother's encapsulation of her body may well have set the stage for the father to displace some of his sexual impulses toward the daughter.*

Eliza's self image (Figure 78) did not resemble her in any physical way. In the picture she looked like a prostitute dressed like a child. I had only seen her conservatively dressed in long skirts and jackets with her hair pulled back in a chignon.

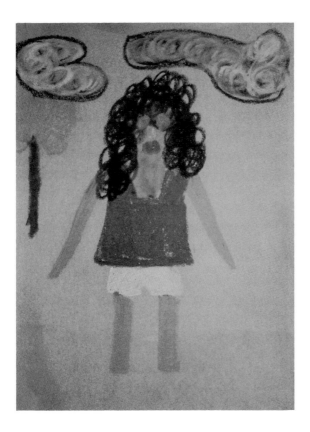

Figure 78

> *There is a potential for power in this image that is now distorted through the prostitute/child representation.*

In her depiction of how she saw me (Figure 79) the two mountains looked like frosty breasts. The rock foundation seemed potentially unstable and tentative giving a feeling of impermanence and unreliability to the whole scene. My eye was drawn to the water in the center of the picture, then to the surrounding landscape. The drawing reflected that Eliza had little continuity and support in childhood from her primary caretakers. She, consequently, was having difficulty trusting me.

Figure 79

> *The water may represent a regressive wish to return to a womblike atmosphere of safety and protection that wards off feelings of coldness and rejection.*

The commonality in all four pieces was ambivalence, something that I felt Eliza was struggling very hard to master. The difference was that her image of me was an abstraction. In retrospect, I wonder why I did not ask Eliza about this. Instead, I asked Eliza to describe her parents and her relationships with them. In a measured, but lyrical flow, she relayed details of horror and abuse. The detached intellectualization of her presentation challenged the strong affective responses that I felt. These were so strong that I fought to remain 'present' during the process.

Eliza was parentified as a child, and from an early age she was made responsible for her parents' and siblings' welfare. Her mother's schizophrenic illness was untreated for many years. She used Eliza as a confidante, engaging her daughter in inappropriate discussions, the content of which focused primarily on her marital and sexual relationship with Eliza's father. Eliza's mother attempted to cope with the disgust she felt about sexual relations through repetitive obsessive-compulsive cleaning behaviors – and for herself and her daughter – enemas, douches, and perineal cleansing were frequent rituals.

Eliza remembered an attempt by her father to awaken her by lying on top of her in bed. She felt rage and inadequacy in her relationship with him and stated that she regresses in his presence.

Eliza got pregnant and married young to escape the parental home. The marital relationship was fraught with financial and parenting difficulties. Her husband was emotionally and physically abusive to her and their two children. Reportedly, he held her prisoner for periods of hours to weeks, beating and raping her, gaining her submission and alliance. Eventually, after her shoulder was broken, she freed herself and her children. Seven years have passed, however, and the effects of the torture are indelibly etched on her character.

I had the history, but without any affect. I cannot remember reflecting on my countertransferential response to the therapeutic process at the time. I was busy preparing for two months reprieve. It was summer vacation, and I was relieved.

Countertransference and Characterological Defenses

With distance and supervisory support during my vacation, I recognized that my patient and I had been colluding. Her high degree of defensiveness was characterized primarily by the use of intellectualization and repression, essentially cutting off the expression of her direct and immediate emotional experience. Similarly, I had retreated from the pain of my own personal memories by 'directing' Eliza with structured art therapy tasks, thereby limiting the therapeutic process and containing the energy flow within a tolerable level for me. I ignored the symbolism in her depiction of me as mountains and a body of water, eliminating the risk of exploring our relationship. I wanted the control and no surprises. It was less threatening for me to avoid the symbolic material in the artwork and to maintain the therapeutic process on a verbal level. I resisted exploring my own personal experience of this relationship by avoiding doing any personal artwork. In

retrospect, I needed to acknowledge my own feelings of powerlessness, rage and dissociation.

After intense emotional scrutiny, I reconnected with my own pain. I reflected on the attempts I made to 'finish' the abusive business of my childhood. Although I had remembered, acknowledged, and verbalized painful events around my parents' emotional and sexual abuse of me, my parentified role in the family, and subsequent painful life events that took shape because of my history, I never learned how easily I could slip into a dissociative defensive position to protect myself. I had also not recognized how closely a client's pain could mirror mine.

Focusing on my personal development as a therapist, I knew I had undergone tremendous change through self-appraisal, through both individual and group process in therapy, and through learning. I had strengths and abilities which supported me through trials and difficulties. Like Eliza, I was fully aware of my painful past. Like her, too, I had received extensive training as a therapist and worked successfully in the field. What remained intact from my past was the coping style, the defensive positioning that had made survival possible. This was my countertransferential resistance.

Eliza had developed, both in life and through the process of therapy, coping skills that facilitated competent career and family management, but she adapted with a coping style that alienated her 'self', both from herself and others. She was not experiencing severe, acute symptoms. Hers were a constant state of defensiveness, emotional numbing, and hyperarousal.

I reflected on the many times in my practice that, I too, employed these subtle defenses, so subtle that they were only manifested through the counter-transferential process. I protected myself from the horrors patients and their families shared with me by desensitizing myself to the pain while still remaining alert and mindful of their process.

Eliza and I had adapted similarly. Eliza could not challenge me or my behaviour because she feared a retaliatory attack. She adapted by attempting to maintain the status quo. She protected herself by avoiding or placating the abuser. The image of Eliza's directed, focused attention in our sessions stirred in my mind. How she carefully roused me from my withdrawal by moving the art supplies, so as not to draw attention to herself, but to protect me from embarrassment, attested to her adaptive ability. She struggled to absolve me of blame in her existential task of finding hope and meaning in our therapeutic relationship. She knew she was 'seething' for she returned to treatment to 'stop feeling angry all the time'.

Traumatic Transference and Countertransference

It was clear to me that I had violated Eliza's boundaries by probing her for 'history'. I sought refuge for myself from the sympathy of our connectedness in the medical model approach and ignored the richness of the unfolding relationship. I avoided the dance. I retreated into feelings of incompetence, hopelessness and powerlessness that could all but preclude an energetic, therapeutic exchange. Where I felt I could adjust the flow of energy in my relationship with Eliza was through my countertransferential process.

In my countertransference, I embodied the silencing of Eliza's history. Together we recreated relationships from her childhood and adult life, where she was 'seen' but not really experienced. Eliza's transference was clearly depicted in her art. The images evoked a response in me, influencing the countertransference. It is at this level that effective intervention is needed in order for Eliza to recognize the strengths and weaknesses of her coping style and learn to enhance her new-found adaptive techniques.

Figure 80

She had established healing relationships in past individual and group therapy experiences, personal safety, and the ability to remember and mourn her traumatic experiences. She had reconnected with the community of survivors, as well as with the community at large, having successfully established herself in a diverse array of life involvements. The pain of her childhood diminished in threatening intensity through a commonality of survival history with other women. She had adjusted her maladaptive coping behaviors to master her adult responsibilities. Trusting herself and others remained difficult. Her adaptive style was to be on the defensive. This was the adaptive experience that remained intact, not eradicated by therapy and education.

I felt strongly that this defensive positioning is a sociopolitically rein-forced necessity. Women and children are still not safe in the world. Treatment, therefore, must address this reality by teaching the client to preserve the adaptive style to protect her from harm while making it flexible enough that she can enhance her sense of personal well-being and her

Figure 81

relationships with others. I remembered my image of Eliza as a tin man – empty inside a large protective shell.

In my attempt to defend myself against my own memories, I had not drawn my responses to the last few sessions with Eliza. To try to understand myself in the role of therapist, I reviewed the previous year's personal art journal. It was easy to identify a countertransferential pattern.

The ultimate summary of this experience is an image of a detached breast (Figure 80). It looks hot and seething, threatening any one who might wish to nurse from it. It is frenzied and energetic as the eye is pulled to the nipple and lurched upward to be caught by the entangling exterior. There is no escape as I was shuffled from the foreboding nipple to the demanding exterior, over and over again. It was a relief to turn the page.

Eliza's image of me (Figure 79) reminded me of two frosty breasts, equally uninviting but less frightening. Her image captured my lofty defensiveness and portrayed a comparative hopefulness in relation to mine. I recognized how strong my feelings of inadequacy were and searched the journal for a clue as to how I compensated for this.

There was an obvious theme. The self-image, (Figure 81), of a bloated, hollow woman, precariously balanced on inadequate lower legs and feet.

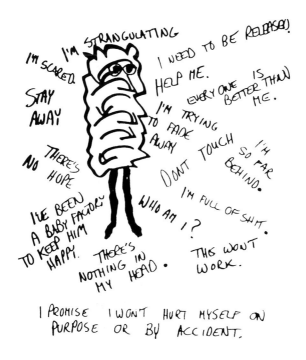

Figure 82

Her hands were hidden by her body mass and a look of surprise on her face. She had an encased, tiny voice represented by the mouse in her vagina. My eye moved between the mouse and the face and I felt stuck.

The next image (Figure 82) was drawn in response to a group therapy session I led. The woman has been deflated, bound, and gagged. There are no hands. The movement of the image is vertical, drawn downward from the helpless, searching eyes to the spindly legs. The legs give the impression that they would like to run but they are weak and inadequate for the top-heavy body.

The spindly legs are repeated in the next drawing (Figure 83). Pools of tears have fallen from the scared-looking eyes, but the red, open mouth draws the focus. The frenzied energy around the head is reminiscent of the picture of the red breast, (Figure 80). There is a disconnectedness of head and body and I am in touch with my defensive use of intellectualization, my need for

Figure 83

structure, and my relentless pursuits of higher education. But the mouth – and the words? – in the picture is hollow.

Finally, a clue – the bound body and mouth in the next two pictures (Figure 84) connect me with my fear of intimacy and relationships, and my ambivalence. The black binding of the physical body in the picture on the lefthand side traps the eye in the area of the diaphragm. I have learned that under stress I cut off my breathing by shrinking the diaphragm, breathing shallowly, and tensing. The body is fuller than the previous two pictures, giving the impression that it is about to burst. To release the pressure, the mouth must be covered, as in the picture on the right, stopping the words and to allow my 'self' to be heard. This shift stills requires that I protect my vulnerability, pacing myself so that the tiny feet can carefully negotiate the terrain.

Figure 84

Glimpses of hope are seen in the next two pictures. In the first (Figure 85) I am crouching, primitive, consumed by energy. The red at the base of the spine seems as if it will be squelched by the thorny spikes above it. I became aware of my desire to move the red in a whirling dervish up the spine, the force of which would move the body into an upright position, perhaps making it dance.

Figure 85

Figure 86

The second picture (Figure 86), recognizes the need to drown my words, to move into the nether land of the undersea world; to risk and explore.

> *In moving into the undersea world, patient and therapist must find a bodily way to explore feelings. At the same time, the risk of uncovering defenses must be carefully calibrated so as not to retraumatize the patient.*

Eliza and I had done the right things to 'heal' from the trauma of our childhoods: individual, group, and family therapy to help ourselves and our families; education, certification programs, and hours of supervision to protect and help our clients. We recognized and utilized our coping skills to succeed and we were both capable women. But we were still impaired by fear. Of what, I was not certain. I set out to explore this individually and through my relationship with Eliza.

I began in a directive way, drawing my fear, asking Eliza to draw hers. I gave voice to the different parts of my pictures and in sessions, asked Eliza to do the same. Each of us in our separate pursuits explored things that frightened us and things we felt we protected ourselves from unnecessarily. There was no resistance from Eliza to the directives. In fact, she was prolific in her artwork at home between sessions, returning with her own analysis of what her work meant.

Eliza was obviously enjoying the work that we were doing. She referred two of her friends to me for therapy and complimented me often. Superficially, this pleased me. What nagged at me was a feeling of being stuck in semi-solid tar. I still had an opportunity to get loose but the inertia was quickly solidifying. I was Eliza's director. Both Eliza and I expected me to have the ability to help her move. Move what, I asked myself, move where? Why move at all?

I realized that I needed to understand where we were in relation to one another. I felt unsure of myself. In the next session, remembering my image of the bound woman who, when freed, still protected her vulnerability, I moved back into the familiarity of verbal therapy. Still, I remained the director. Although we were able to review and discuss the process of our work together and Eliza was able to identify many positive changes that she had made, we were still skimming the surface of our relationship.

I imagined myself driving a waterski boat, towing Eliza on skis. Remembering my image of drowning the intellectual in order to explore the undersea world of the 'self', I envisioned Eliza falling into the water. As the driver of the boat, though, I was responsible for retrieving her so that she could right herself, thereby, skimming the surface of the water again on her

skis. To be of any use at all, I would have to accompany Eliza on her descent. I structured our next session with an exercise. I asked Eliza to imagine participating in a deep-sea dive with me.

She was instructed to direct the dive and to solve the problem of the acquisition of the equipment, choosing the site, and executing the dive. She was enthusiastic, setting the scene by declaring that not only had she never dived, but she was not a strong swimmer.

She listed the gear she needed and identified where to receive diving instruction. She choose a northern lake to explore, off the shore of a village that she visited in her teens. She said this was where she fantasized living in a rustic cabin, surrounded and protected by wilderness.

I flashed to the bush cabin that I had lived in on the west coast. For five years I had read by gaslight, cooked in a woodstove, and carried water from a nearby river. I felt connected to Eliza and warm.

She frequently asked me what I thought she should do, choose, or decide and when I reminded her that she was the director, she was visibly stressed and uncomfortable. I fought to resist the pressure of supposedly having all the answers. I recognized that it would be easier for me to take control. I always 'assume' that responsibility, so it was comfortable. Besides, I was somewhat irritated by her indecisiveness, and I wanted to 'get on with it.

Eliza envisioned us arriving at the dive site. We were suiting up, following the directions that she received from the sporting goods rental outlet. I asked that we mime this; I asked her to direct me, which she did. Wet-suit, mask, flippers, air-tank, mouth-piece and goggles. We jumped in. She asked, at this point, if I had dived before, I was panic-sticken. My defensive response was to 'therapeutically' suggest that she explore how she felt about whether I had or had not. I was afraid that I was not capable enough of supporting her if I admitted that I was a neophyte in the undersea world. But I also felt that we were both ready to explore how we related together. Taking a risk, I told Eliza that I had never dived before.

Although her eyes were closed, a look of panic flashed on her face. I was very aware that I was relieved that she was not looking at me. Somehow, my vulnerability was protected. I remember feeling remotely convinced that one day, perhaps sooner than later, I could facilitate this exploration of the relationship through the artwork, with open eyes. But now it was enough for both of us privately to explore the potential of loss, inadequacy and impotence together, at a mutually tolerable pace.

The symbolic language of art is a forum for the manifestation of transferential images to become embodies and evoke a countertransferential response in the therapist. Experiencing this response creates the potential for mirroring the client, and for containing her experience, so that she can engage in the process of deepening her self-knowledge, finding personal meaning and developing a flexible adaptive character style. At times, we will encounter clients whose length and depth of personal journey equals, or surpasses, our own. To embrace these challenges, we must be willing to risk the challenge of exposure, imperfection and the unknown.

The Use of Film, Photography and Art with Ghetto Adolescents

Barbara Maciag

The Case

History

I denote my three art therapy groups according to the media they preferred to use: film, art and photography. Below is additional information to help further differentiation.

Photography

This was my first art therapy group. We met for eight months at a community mental health center. Members built a darkroom to utilize the enlarger donated by a staff member; the center reimbursed me for supplies, and I lent my Canon FTb 35mm camera for the group's use. Members were most involved with photographing each other during our sessions, and occasionally their families, girlfriends, and girls passing on the streets. All members did their own developing and printing in our darkroom at the center. This group consisted of 12 Hispanic men, ages ranging between 13 and 23 years, some of whom belonged to various street gangs.

Art

We met for nine months at a public junior high school. Members used their sketchbooks as creative diaries to draw their fantasies, adventures, Winnicott 'squiggles' and 'masterpieces' (graffiti names such as *Love Factory 186*, done in multicolor, or simply *Slick*) (see Figure 13.1). We were given our own room at the school on the walls of which the group painted murals as an artistic

statement of themselves. There were two Hispanic and four Black non- or ex-gang members, including one female.

Figure 87 Graffiti names were developed and discarded rapidly in a phase-appropriate search for identity. SLICK 1's lettering resembles the slicks or tires of hotrods, a common phallic symbol for this adolescent group

Film

This group consisted of an entire division of a large local street gang. We met for three months in their clubhouse to make a film of what it is to be a street gang member. I supplied the camera, they supplied the projector and screen, and the center reimbursed me for the film. This division consisted of approximately 15 Hispanic men in adolescence or in their twenties.

Introduction

The purpose of this paper is to discern and investigate the singularities and similarities of the three groups described above. A pause to look back and sort out information and experiences can facilitate insight into old problems and more creative solutions to new ones. To look back is also a natural part of the mourning I am experiencing for my groups following termination. I feel as a mother would in the final separation from a son, not a baby but a strong and beautiful young man whose growth has been a profound experience to watch and sometimes to participate in. I feel enthusiastic at the

prospect of developing my thoughts on these three groups into some kind of frame for future reference. I also feel reluctant to begin because it is a kind of eulogy and a very final thing.

Defenses and Countertransferences

Apart from a group, one's defenses loosen and permit insights to which one was impervious while actively participating in that group. An example involves Miguel from my photography group, to whom I related primarily in terms of his extrapunitive behavior. At one point Miguel brusquely gave me an embroidered rose patch for my pants and later a leather necklace he made. On both occasions, my reaction was 'how sweet of Miguel, my monster, to do this for me' and then to take his gifts home proudly and hang them up on my bulletin board. it did not occur to me until six months later that these were sensual objects which Miguel had probably visualized my utilizing and not hanging up on my bulletin board. I used to be a great blocker when it came to sex. I am now much more relaxed in dealing with sexual material – and feel it is important for sexually repressed and confused young men to experience a calm response to their sexuality.

> *The problems of handling direct and indirect sexual overtures from young and not so young male patients presents an ongoing struggle for the young female therapist who is just entering the field. If she avoids the topic completely and deals with sexual material as being inappropriate, she loses a valuable source of contact with her patients. On the other hand, if she does not handle the subject matter with a sense of directness and calmness, she is likely to communicate a good deal of anxiety regarding these issues. The therapist is being put to the test regarding her own comfort with feelings of sexuality.*

The individual from whom I learned the most, because he made me learn the most about myself, was Ramon (Photography). I did not realize how alike we were until I had begun my own therapy, and in groping for a way to get something into focus, repeatedly heard myself saying, 'Well, it's like what happened with Ramon when...'

I myself began to experience Ramon's fear of closeness – of having experienced defensive isolation for so long and now having to decide to open up to the possibility of yet another hurt for the chance to experience love, which, coupled with self-disclosure, might even lead to self-love.

After missing a session, Ramon showed up and remarked in a surly way that I should feel lucky that he was there. I instinctively replied, 'And you

should feel lucky that I'm here'. Ramon summed up with, 'Well, that's what I'm saying – you're lucky that I'm here, and I'm lucky that you're here', denying the emotional commitment in our relationship of five months and making it a favor-being-given thing. When asked if I had fears of becoming dependent on her, I replied to my therapist, 'Why, I hadn't even considered it. My attitude is that we're both just coming here with a job to do', fiendishly denying the warm attachment I felt towards her. I am reminded of the sign Ramon made and hung on the door to our workroom, 'Danger Watch Out' in big warning letters. I now realize just what that sign meant to him, although I could not express it then.

The Day the Camera Broke and I Found Out I Was a Person

When I first began working with the street gang, I know I defensively related to them as an extension of the camera. I felt it was an ideal situation to meet in their clubhouse, but I also felt overwhelmed by the quantity of new stimuli and I figured I'd peek out at it from behind the one thing that was familiar to me. Hector, who instigated my being there, ensured that my presence would be acceptable to the group. I liked them and enjoyed being there, but had only paranoid speculations as to how they felt about me. Every session, as soon as the filming was completed, I would leave. Then one grim day we projected a new roll of film which should have been a masterpiece, and it came out disappointingly dark. Next we created a perfect lighting set-up, only to find that a gear had worn through in the camera. I had nothing to hide behind and had been at that session too short a time to feel good about leaving. By staying a while, I was able to realize it was only my fantasy that I was hidden behind a camera. The gang had been relating to me as a person all along – a person of whom they were quite fond, incidentally – and their tolerance for disappointment and anxiety was greater than mine. This they helped me to cope with in their therapeutic manner, offering me a cigarette (they smoke: I don't, but made an exception this time) and engaging me in a friendly conversation that made me feel very much with them. We've since had a mutually satisfying relationship, and I felt really relieved at discovering that I had been a person to them all along.

> *Therapists often hold on to material or the tools of art therapy as a means of protecting themselves from too much contact with their patients. This becomes particularly true during the initial stages of therapeutic contact.*

I utilized a similar defense with my photography group. When told what my fieldwork assignment was – an experience which included working in a darkroom with adolescent men – many a listener's communication, verbal or otherwise, would be, 'Boy, are you gonna get it now'. When I didn't 'get it' or even feel threatened, but instead happy and comfortable, incredibly, I associated this with the fact that I wore blue jeans. Only girls who wear dresses must 'get it'.

After a few months Ramon, who had an unconscious genius for uncovering my every defense, commented, 'Some people think that girls who never wear dresses are dykes...' I assumed he was referring to me, worried that I was providing a negative female model, braced myself and wore as dress (after discreetly waiting a few sessions). Of course no one related to me any differently because I had been a female to them all along: wearing a dress hardly changed that and only one person said, 'Barbara, you have a dress on today.'

> *The problem as to what to wear is somewhat akin to the issue of not being overly seductive or the opposite: denying one's femininity. Finding that comfortable in-between spot will be an important part of any therapist's development.*

Reality testing can be such a chore. But I also feel that my defensive behavior in these situations was prompted by a defensive need in the people I was relating to, and that when I was motivated to change it was because of a mutual growth in our relationship.

Of course I was a person to the street gang, but they probably found it hard to believe that I was interested in them other than filmically. Their transference made me feel like a camera with them until that line of communication temporarily broke down and we found the relationship could continue without a camera.

My photography group, Ramon in particular, had many conflicts about their sexuality and about relating successfully to the opposite sex. Their anxiety about self-control with women had me feeling that to be a neuter was the only way we could be comfortable together. Ramon's challenge to me to wear a dress was a symbolic test of our relationship to withstand our assorted rape fantasies should he relate to me as a woman.

Females in El Barrio

You may wonder, as I did, why I have worked with approximately 40 men and one female. As much as it is considered a macho thing for many of the young men I have worked with to hang loose and act out, many of the 'nice' females are thoroughly repressed, being let out of the house only for school and occasional grocery shopping until they are engaged. When I try to discuss the unfairness of this with the men they reply, 'I wouldn't want my sister to be out on these streets'. But even were they to be given a choice, many girls seem only to see their future security in the self-perpetuating cycle of ghetto poverty and defeatism – persuading a guy to drop out of school with her and marry to escape a smothering and unfulfilling home life, having a baby immediately to keep her company while her trapped young man takes to the streets, then lots of babies to smother-love in place of her errant husband (see Figure 88).

Figure 88

Unless he has some group, such as a street gang or social club, in which it is possible to develop one's self-esteem, the ghetto man is generally made to feel helpless and hopeless by his environment. Acquiring a woman becomes important to his self-image, as offspring become living proof of his masculinity. But ghettos do not provide jobs, so a man's feelings of impotence and inadequacy are reinforced when he cannot support his family and is driven to less socially oriented behavior to survive. Overcrowded schools and centers attend to the troublesome act-out males almost by definition – and leave the withdrawers alone, which is another reason why the groups I worked with arepredominantly male. If a female does act out, it is usually sexually, and this seems to merit ostracization, not therapy, in the community.

So I work with what I have: being something of a novelty, unmarried at 23 years of age ('no, nothing's wrong, I just do not want to get tied down caring for a baby right now…') I can at least present another alternative that may not have been considered because of the overwhelming pressure in one direction. Channel 18's *Realidades* did a program on Puerto Rican men going in the armed forces at the time of the Vietnamese conflict.

INTERVIEWER: Are you going in?

PUERTO Yeah, there's nothing for me on these
 RICAN MAN: streets…same hanging out, hustling. In the army they
 told me I could sign up to be a medic, then when get
 out I could get a job as a nurse, work in a hospital.

INTERVIEWER: What about dropping bombs on people: is that going
 to bother you at all? Or getting hit yourself?

PUERTO I hadn't thought about that at all. I think
 RICAN MAN: I've made the right decision for myself.

Race

After I made my presentation for Dr. Robbins' Advanced Seminar in Art Therapy, someone commented on the fact that I am White, working exclusively with Non-whites [*sic*] and asked how I dealt with that; and added that they would have said right at the beginning, 'Look, I know that I'm White and you're not but I think it's a lousy system too…', etc.

I know that I am not a very verbally aggressive person, but this approach instinctively turned me off. First, why should anyone believe me? Second, I do not feel as though I have to apologize for being White. I am what I am. People's eyes communicate more profoundly than the color of their skin.

When Frankie (Art) looks in the mirror when he's on LSD and sees himself with a pale face, then race becomes an important element in our therapy – not when he walks in the room and sees a White art therapist. I do feel that it is important for people to have a choice: that a Black therapist should be had if that is what is important. But I feel that it is equally vital for an individual to know that he can have a meaningful and therapeutic relationship with another human being, no matter what his or her race.

When I first worked with people who still feel close to their Puerto Rican homeland, I was very aware of entering a different culture. I found this challenging, fascinating and exciting, and have sought to gain insight into the Puerto Rican–American perspective. I feel one can go only so far unless one has a grasp of the cultural orientation of the person one is working with. Literature on the contemporary Puerto Rican–American is, to my knowledge, rather sparse. My most accurate and immediate source is the people themselves, their homes, streets, *botanicas*, music and *bodegas*.

My young group members' fantasies of me do not seem to contain race and culture as critical elements. I am reminded of the time Miguel came to visit after having left the group for a month and began speaking to me in Spanish. I stared at him with a blank look until he said, 'Barbara, that's right, you don't speak Spanish, do you?'

Milagros (Art) is working on a way for me to roll up my hair so I can have a six-foot Afro. These groups seem more concerned with establishing how alike we are, and even in the two examples I've given defining our differences, it is done mistakenly or in play. I feel this is more because of an understanding on this level than repression. I have dealt intensively with race in the course of my employment as a graphic designer for a Black community college.

The race issue should be addressed by patient and therapist fairly early in the treatment. We cannot hide from the prejudice or fears, as well as the distrust, but must at least get it out in the open.

Parents

Each group seems to have its own way of relating to parents. My 'artists' are generally eager to have me come to their homes and meet their families. They still seem to take their identity from the family and to feel secure about my seeing them in family interactions, no matter how pathological they might be. Frankie first motivated me to include parents in my experience of an

individual by bringing his mother to one of our first sessions. This experience was so pleasurable and interesting, I decided to meet other parents when a group member presented me with an opportunity to do so.

Milagros' mother (a psychotic junkie, I found out the hard way) prompted me to make a home visit by drawing in Milagros' therapy sketchbook a series of shockingly hellish pencil sketches which Milagros told me were family crests. Milagros had been exhibiting increased psychotic symptoms and my 'class' was the only one she was attending, otherwise wandering the halls of the school the rest of the week and telling her teachers she was with me. Her harried guidance counselor saw the solution as forbidding Milagros to continue with me, feeling this would get her to attend her classes. Milagros and I, in our divergent ways, were very upset by this decision, and I requested family therapy for Milaagros with an empathic psychiatric social worker from the center to which I am affiliated. As usual, everything got bogged down in red tape: the Child Welfare Board wouldn't become involved because the last time a worker went there ten months ago, he was mugged in their building. Milagros' mother's welfare status becomes threatened because of child neglect and a general 'freakout' occurs.

Angela, Milagros' mother, is so well-read and intelligent that – were she ever able to get herself together – I am confident she would prove comparable to William Burroughs, who clearly established in his brilliant and bitter *Naked Lunch* (1959) that not just dopes are on dope. What to do? Back off from the red-tape route which, at best for Angela, will probably result in further bitterness, isolation and fantasy or incarceration in a psychiatric ward of a charming local hospital? Just what real therapeutic help is available to someone in this ghetto who hasn't got Money and who is too in despair, too intelligent or too proud to assert herself at the few inadequate facilities available?

I do not feel comfortable in the Messiah role Milagros and Angela indicate they would like to see me in. Yet I have no confidence in the institutions and agencies accessible to these people. The places I would recommend are absurdly expensive with the average stay a lengthy one. Otherwise I usually have more confidence in an individual's capacity for self-healing with therapeutic help from a friend. So do I give time I don't have to give to talk and draw with Milagros and Angela because they have chosen me and I responded to a point?

The therapist expresses her distrust of the institutions with some justification. Yet is it all as clear-cut as she appears to make it?

I visit homes particularly with this group because they are the youngest and least likely to work through problems independently. For example, it is the (untherapeutic, I feel) policy of their school to transfer pupils to a local reform school for a couple of months when they exhibit behavior the school feels it cannot deal with – most notably the young men's hitting or 'feeling up' female students. Coincidentally, students are given no sex education. I don't enjoy feeling cut off from a group member and do not want him to feel abandoned by the group. My art group is especially self-disclosing and it seems too precious an experience to be arbitrarily interrupted. Since I work with the 'troublemakers', my group would be in quite a state of flux if we didn't develop a way of coping with this situation. At my request, both schools have agreed to let the students return for our art therapy sessions. That the students make the trek back confirms my position on this matter. When a transfer occurs, I visit at home to tell the family what a valuable group member their young man is because, more often than not, he is also the family scapegoat and his transfer has served to reinforce this role. Seeing the family interactions of my group member and the manner in which family members relate to me is always of value to further my understanding of the individual, as well as – it is to be hoped – enhancing his position in the family.

On the other hand, my photography men, who were older, rarely mentioned their home lives. They seemed to want to break away and make a separate identity for themselves, but the lack of jobs in El Barrio hardly made this feasible. They utilized isolation and fantasy as defenses against their disturbing home environments and were involved with presenting themselves to me almost as self-made myths. I felt it would be too penetrating to enter their real worlds until our relationship became more balanced with reality. As long as they were comfortable with it, I felt it to be just as valid for me to hear what they would like to be as to know what they really were.

> *Barbara expresses a good deal of wisdom in taking this therapeutic stance. You do not challenge the self-made myths of these patients, which could only throw them into despair.*

With my film group I have two families per person to relate to: their immediate family and the extended family of the street gang. I feel most everyone belongs to the club because of the inability of his immediate family to satisfy his basic emotional needs. This occurs in all the groups I work with, but the club provides a viable alternative to its members. The basement apartment clubhouse is received in exchange for maintenance of the above

building. It is always a comfortable refuge – when there is no place else to go – with a dark, womb-like interior with mystical day-glo paintings gleaming under a black light. There are well-defined rules, procedures, and attitudes (similar in scope, but not content, to a religious order such as the Black Muslims) consistently enforced by the most creative father-figures of the ghetto, the clique presidents.

With one exception, I have experienced the five presidents I have known as intelligent, skillful, kind, charismatic leaders who are like resident thera-pists without vacation. The members demand more attention from them than one would from a father, and I often wondered just what was in it for the leaders – not much except the enormous responsibility and love I had anticipated and confirmed talking to Shep, an ex-president of the total membership of all this street gang's divisions.

I met Shep when I went to visit Milo, Shep's brother-in-law. Although I was accompanied by two young men, I had difficulty deciding whether or not to proceed when we turned onto Milo's block; the filth and decay were menacing, like a war-zone waiting for more bombs to be dropped, even in Milo's building. But as soon as one entered their apartment, it was a different world, an immaculate and tasteful home.

Shep had just gotten out of the shower and Milo introduced him as he 'cleanest gang member that ever was'. I didn't quite know what to make of this introduction until Milo directed my attention to Shep's impeccable white sneakers and socks and elaborated on the fact that Shep had seven pairs of sneakers because he washes them as soon as he takes them off and they take a long time to dry.

Shep quickly entered trance in front of the television while Milo and I discussed his latest suspension from school and decision to quit the gang because of a personality conflict with his formerly close friend, Hector. Then Milo asked if I had the camera with me – which I did – and delightedly began viewing everyone through the telephoto lens, making them larger than life-size.

Shep disengaged himself from the television to share this experience and talked of the opportunity he had in sixth grade to make a film of the decay of his block and to show it to the police and other local authorities in order to precipitate a successful block clean-up. Then he spoke of his reasons for quitting the gang (he had had one ear open all along): too much responsi-bility; he preferred to do his own thing and let other people do theirs; and 'the other members were too dirty'. I watched this once-powerful and still highly respected young man who now rarely entered the world outside his apartment – inactivity in front of a television was his way of controlling the

helpless anger he felt at the filth outside his door – and watched his animation grow as he held the camera in his hands. You could see that film to him was perhaps the only safe and complete way of communicating his rage at the dirt and deprivation in which his people live. I thought of all the other films waiting to be made: I myself had to turn down requests to me because the center's budget allows only one roll of film a week and it is committed to the street gang project, which is very important. But this is not right for people who feel so helplessly unmotivated to be denied a creative act that would make them feel otherwise.

> *The film becomes an extremely important mirror for the patient not only to see his or her 'self', but also to create a transitional connection to the outside.*

I became involved filmically with the gang at the request of Hector. Hector is president of the junior edition of this division, less than fifteen years old. His older brother is a former president and founder of the entire division and their other brother, Trini, is the current War Counselor. When I first met Hector, I was involved with my photography group and was not interested in taking on another group. I have only so much time to give away and prefer to keep my attention concentrated. At fourteen years of age, Hector has got to be one of the world's most sophisticated manipulators. Always keeping peripherally in touch with me, when my photography group terminated he was right there with his project waiting.

Some of the gang's fantasies of me were: a teacher from Hector's school (all of the gang's members are drop-outs and I suspect this was as negative a thing to them as it was to me); a spy on the gang; and a movie star (Trini). These theories are listed in chronological order as my character tests by the gang were met. In all problems of basic mistrust, I feel a consistent presence is the surest cure.

> *The importance of the real therapeutic relationship cannot be underestimated in these therapeutic situations. The fantasies will recede once the patient develops a sense of trust and a feeling of consistency in the relationship.*

Hector was as defensive of me during this period as I would tolerate. He had had six months to assess and learn to trust me and was impatient for his gang to respond likewise. Now that his negative transference has begun, I look back with nostalgia to this time…I say this jokingly because in reality I

consider the working-through of negative transference as essential to a good therapy as the experience of positive transference.

> *Once the positive transference has been established, the relationship is now ready to hold and contain negative feelings.*

Tiny (a misnomer) was the president of the gang when we began our film. He was an ideal father figure: macho and dashing, yet respectful, kind, and helpful. He was also discreet with his power and control and interested in helping everyone to do his own thing. He quickly tuned into what I was doing with film and procured a projector and screen for the club. He led cleaning and decorating of the club via a chart delegating responsibility so that there was always some improvement on which to compliment the gang when I came. Because Tiny's and my goals and techniques were complementary, I was able to realize my ideal therapy for these boys: a therapy team of a male and a female.

I have no ethical qualms about stating that Tiny was just as good a therapist, probably even better, as I was for these young men. I just think that it is too bad that a good education is contingent upon the ability to procure money instead of the ability to be a therapist. For financial reasons, Tiny had to quit the street gang and is working as a runner for a loan shark.

Drugs

Many times I have been asked my position on drugs with the kids I work with. My feelings on the drugs themselves are similar to those expressed by Dr. Andrew Weil in his book *The Natural Mind* (1972). I refuse to be backed into a blanket statement on the use of drugs. I relate to an individual's reasons for drug use. Is he saying,

- 'I feel impotent, so look what a macho daredevil I am for taking this hit of LSD'

- 'I can't tolerate this painful loneliness and isolation any longer so I will make myself numb'

- 'I am so empty, I must do this to feel myself'

- 'I am so depressed, I am immobile; I can't function as others do normally without a hit of speed?'